Space Adrift

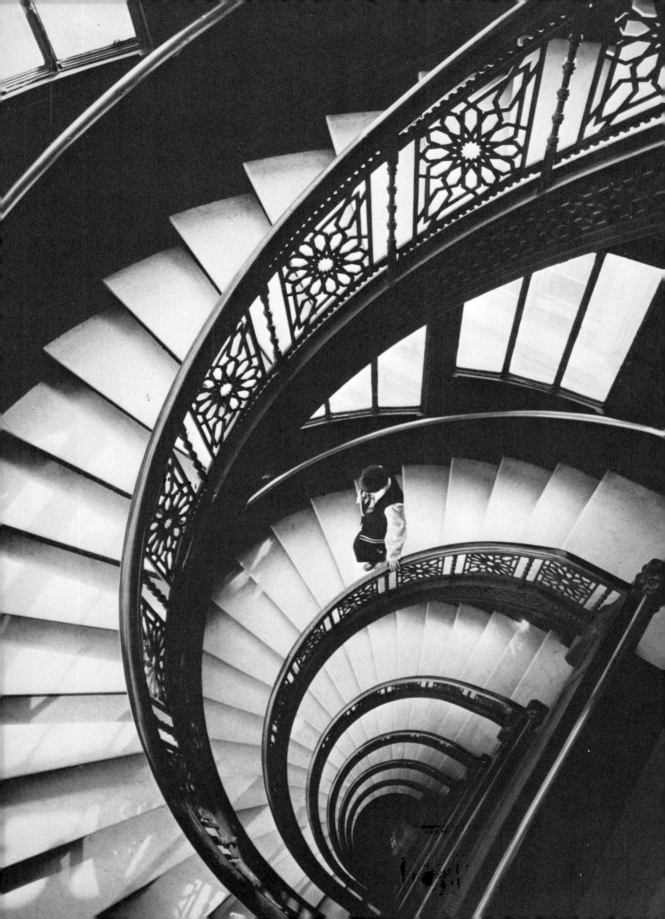

SPACE ADRIFT

Landmark Preservation and the Marketplace

JOHN J. COSTONIS

Published for the National Trust for Historic Preservation by the

UNIVERSITY OF ILLINOIS PRESS Urbana Chicago London

The study project and this publication were made possible through an urban renewal demonstration grant by the U.S. Department of Housing and Urban Development to the National Trust for Historic Preservation, under provisions of Section 314 of the Housing Act of 1954 as amended.

The University of Illinois Press is grateful to the Graham Foundation for Advanced Studies in the Fine Arts for a grant which made possible the illustrations and drawings in this volume.

Frontispiece: The Rookery, 209 S. LaSalle Street, Chicago, 1885-86, Burnham and Root. Detail of cast-iron staircase. In counterpoint to the enchantment of the Rookery's glass and iron light court (p. 113) is the charm of its cast-iron staircase, which spirals up the full height of the building.

Richard Nickel photo; courtesy Commission on Chicago Historical and Architectural Landmarks

To Maureen

Contents

Illustrations

Figures

Tables

Foreword

by James Biddle

At a rate often horrifying to Americans, the historic buildings that provide us with visual evidence of our past are being demolished or allowed to fall into such disrepair that eventual salvation becomes impossible. The rate of loss has not seemed to slacken as the American Revolution Bicentennial year — the year when we should most of all celebrate our historic buildings and sites — approaches.

With this study John J. Costonis provides substantial economic evidence of what preservationists have long contended, that old buildings can indeed be economically preserved and used, and presents an innovative plan that should give both a method and an impetus to save much of what is now being destroyed.

The core problem, which occurs not only in Chicago but in other urban, suburban, and rural areas and on the international, national, state, and local scenes, is often, as Professor Costonis points out, simply that of "Who will pay?" Governments often cannot, and owners or developers cannot or will not. But the Chicago Plan allows for the sale of unused development potential of landmark buildings for use on non-landmark sites, transferring the cost of preservation from the owner or the city to the development process itself. The technique is labeled the transfer of development rights.

Obviously, it would be simplistic to believe that a single plan or method could protect every landmark in every situation, nor can the transfer of development rights be a substitute for other techniques already in use. The success of the Chicago Plan, as this book clearly demonstrates, will be dependent upon a myriad of circumstances. However, even before publication the signs of use and success were so clear that the excitement and enthusiasm could hardly be hidden. In late March, 1973, U.S. Secretary of the Interior Rogers C. B. Morton released a report entitled "The Chicago School of Architecture." It proposes a "National Cultural Park" which would not only preserve the important architectural resources of Chicago but test new areas of federal, municipal, and private cooperation in the preservation and interpretation of America's cultural heritage.

Under the plan, the federal government itself would own little, if any, historic property but would partially fund the acquisition of the unused development rights of buildings in Chicago's Loop area. Most structures would remain in the hands of private owners and would be protected by legal covenants. The federal government would operate visitors' facilities and interpret Chicago's architectural landmarks through museum exhibits, audiovisual and printed media, and tours. Chicago

would afford the protection of its landmarks ordinance to structures within the cultural park, implement the transfer plan, administer a "development rights bank" and related revolving fund, and supervise the system of preservation restrictions and covenants. The success of the park, and of the Chicago Plan, is based on the premise that after the park is well established, the development rights bank and revolving fund, the earning power of the structures, and real estate tax relief will support the costs of building preservation. As the Loop area cultural park is established, other units from the Chicago area would be likely additions to the park, to show the complete development of the Chicago School architectural movement.

A second development, much closer to the National Trust's Washington headquarters, is also encouraging. In suburban Montgomery County, Maryland, a transfer of development rights ordinance has been adopted and recently was used to preserve a late eighteenth-century farmhouse and its outbuildings. The structure will probably be adapted for use as a community center for a high- and low-rise condominium apartment development. The building's unused development potential was transferred to adjoining property, subject to the county planning board's receipt of a facade easement covenant, approval of the proposed plans for the structure, and approval of the developer's site plan for the entire project. In Washington itself, attempts are under way to use a transfer of development rights to save the 1892 Heurich Mansion, which is located near Dupont Circle in one of the city's principal shopping and office districts.

The import for preservation of acceptance of the concept is great. Between the late 1870s and World War I, the Chicago School of Architecture created techniques and styles that have had vast international and national influence in urban construction and suburban development. Preservation battles waged — and frequently lost — in the city helped give a clear idea of the economic necessities of preservation. This resulted in the formulation of the transfer of development rights technique and because of the buildings' importance helped draw attention both to the problems and to the methods for solution. Federal and city commitment in Chicago can result in salvation for some of the most significant of America's buildings; but, more important, it will result in vitally necessary national attention for the concepts of the Chicago Plan and of the National Cultural Park proposal.

In a different manner, in Maryland, the adaptability of the idea to an area of much lower density and lesser economic pressure is being tried, and we hope proved.

For the Chicago Plan to work successfully, in Chicago or in other locations, we must gather public support. The method is one of great complexity and in many ways will provide a testing ground for preservationists' ability and willingness to educate and convince both public officials and private citizens. We believe that it is a test we will meet successfully and that the Chicago Plan will prove an effective tool, helping us to greet the Bicentennial in 1976 with a greatly reduced rate of demolition and increased public appreciation for our architectural and historical landmarks.

Recognition, no less equal to that of this plan, should be given to its author, John J. Costonis. Countless others with similar intelligence, creativity, enthusiasm, and dedication for preservation are needed to continue the American struggle to save its cultural heritage for the present and future benefit of all Americans.

It was a special opportunity for the National Trust and the Department of Housing and Urban Development to participate in this innovative concept. The National Trust is most appreciative to the officials at HUD

who understood the concept's potentials for preservation and planning and wisely awarded a demonstration grant to the National Trust for the support and publication of this study.

The National Trust for Historic Preservation has for at least twenty years demonstrated its concern for historic preservation law and the pertinent areas of land use and economics. Since 1953 it has systematically collected legal information and has issued or co-sponsored a variety of publications on preservation law and planning. In 1970 the National Trust first entered the courts, filing an *amicus curiae* brief in the U.S. Court of Appeals to support Kentucky preservationists' attempts to prevent demolition of buildings in the National Register of Historic Places. Other legal efforts have been supported through the consultant service grant program administered by the National Trust's Department of Field Services; such grants, for example, have assisted

in the fight to preserve Overton Park in Memphis, Tennessee, a battle that has not yet reached its conclusion.

With its convening of the first national Conference on Legal Techniques in Preservation, held in 1971 in Washington, D.C.; the presence of a staff attorney and expanding legal archives; and two recent major studies, the Costonis research on the transfer of development rights and a second work, in preliminary stages, of the economic impact of historic districts, the National Trust now has a growing legal service program. The great and continuing loss of historic districts, buildings, objects, sites, and structures has shown to preservationists that they, as well as the developers and wreckers, must understand and utilize legal and economic techniques.

JAMES BIDDLE, President
National Trust for
Historic Preservation
May, 1973

Preface

Losing a battle is never much fun. But it can be worth while if in the wreckage of the loss are lessons that promise success over the long haul.

A battle was lost when Chicago's Old Stock Exchange building was torn down in 1972 to make way for a commonplace forty-five-story office building. The Exchange, an 1893 gem of Louis Sullivan and Dankmar Adler, ranks with the most innovative buildings of the Chicago School of Architecture. In line with the other works of the school, this fragile business palace redefined centuries-long premises of architectural design and established the baselines for modern architectural forms, the most distinctive of which is the urban skyscraper.

My involvement in that battle began when representatives of the Chicago Chapter Foundation of the American Institute of Architects asked a Chicago civic group to which I belonged for legal assistance in the impending struggle. Listening to the foundation's appeal, I was struck with the pathos of the situation and even more so with the utterly unequal terms of the struggle. The deck was stacked against the preservationists from the outset. Their political clout was no match for that of the speculator-owners of the Exchange or of the larger development community of which they were a part. The legal tools ostensibly designed to stave off demolition offered little more than a reprieve for a few months. And the financial resources to acquire the Exchange simply were not there, assuming indeed that City Hall would have been willing to stymie the new project if it had had the funds to do so.

In retrospect, it really wasn't much of a battle despite the drama of eleventh-hour pleas, civic hand-wringing, special mayoral committees, and national publicity. The scenario ground on inexorably to its grim conclusion, the destruction of still another of the dwindling number of truly great American buildings.

Out of the battle, however, came a much clearer picture of the economic dimensions of the landmarks dilemma and a tool, development rights transfer, which promises to relieve the severe market pressures that beset urban landmarks such as the Exchange. Because a greater appreciation of both factors can turn the tide for other urban landmarks, the battle may prove to have been worth it after all.

Until recently at least, economics has been the weak suit of preservationists. Legitimately concerned with the cultural significance of landmark destruction, they have tended to skip over what is, after all, the key question for preservation — who should pay? It would

be wonderful, of course, if landmark owners could be persuaded to forgo private gain in the interests of community benefit. But in preservation as in life, wishing won't make it so. Until the cost allocation issue is realistically addressed, the Exchange scenario will recur with distressing monotony.

Development rights transfer is a promising preservation tool precisely because it does speak to the cost allocation issue. It recognizes that owners typically will not and cities cannot absorb the burdens attending the preservation of landmarks located on prime downtown sites. Through this technique, funds for preservation are generated by selling the diminutive landmark's unused development potential to builders for use on non-landmark sites. As a result, development rights transfer largely shifts preservation's costs from the city and the landmark owner to the downtown development process itself.

Initially, the Chicago Chapter Foundation had urged that Chicago adopt a version of the development rights transfer technique that had been pioneered in New York City one year earlier. Despite its ingenuity, however, the New York program had not worked well in that city and seemed even less likely to succeed in Chicago. Accordingly, I concluded that a fundamentally different proposal — the forerunner of the Chicago Plan — was required in Chicago. Regrettably, discussions on this proposal were still in progress before the pertinent subcommittee of the Chicago City Council when a court order came down authorizing the Exchange's owners to raze the building.

But the Chicago proposal did not die with the Exchange. Thanks to the support of the U.S. Department of Housing and Urban Development and of the National Trust for Historic Preservation, it has proven possible to refine the proposal, and to probe further its economic and urban design feasibility and its legal validity. In pursuing these objectives, I have also undertaken to address some of the broader implications of development rights transfer for the fields of municipal finance and urban design. In particular, what changes does the technique signal for our conventional understanding of the relationship between private property and public regulation? And what advantages does it promise for achieving urban design goals other than historic preservation? If, as Ada Louise Huxtable has written, the technique represents "one of the most hopeful and dramatic developments in urban America," these questions too merit thoughtful attention.

In my view, the study's findings vindicate Mrs. Huxtable's favorable appraisal. As one version of development rights transfer, the Chicago Plan does promise to safeguard many landmarks that would otherwise be sitting ducks in an overheated real estate market. More broadly, it incorporates a view of urban space and municipal accountability under which cities may and should influence private development decisions through their space allocation policies, exchanging space for amenities, such as urban landmarks, that cannot survive in the marketplace. In addition, the technique can advance other urban design goals that depend for their success upon the concentration or dispersal of density within the city. Sensitively coordinated with the city's comprehensive plan, for example, transfers can assist in optimizing transit system use, protecting visual corridors to scenic features within the city and facilitating land assembly.

But the Plan's advantages must be seen within the context of the study's limitations as well as of the risks that attend the Plan's implementation in any given city. The study deals principally with one class of landmarks — privately owned buildings located on prime downtown sites. Although the Plan in all probability can be adapted to safeguard other

types of landmark properties, its use in this regard is not explored in the present volume. The Plan, moreover, will not protect every urban landmark. A sluggish real estate market, overly generous zoning, advanced deterioration of the landmark building, and other difficulties may, singly or in combination, defeat the Plan's application in individual cases. Nor is the Plan offered as a substitute for conventional non-compensatory preservation programs. On the contrary, most cities will probably prefer to employ the Plan as a complement to these programs, utilizing it only when constitutional or practical obstacles demand recourse to a compensatory alternative.

Undoubtedly, the most significant qualifications that must be kept in mind in reading the study concern the urban design competence and the political will of the individual cities that adopt the Plan. The Plan simply will not work and indeed may backfire if a city's other land use policies are not thoughtfully coordinated with it. Coordination assumes that the city has formulated a set of policies that provide an integrated framework for its space allocation decisions. Regrettably, this assumption does not jibe with the actual manner in which many cities reach these decisions. Coordination also assumes that the city will hold the line on these policies by, for example, denying unwarranted bulk variances or refusing to rezone to greater densities unless cogent urban design grounds support the rezoning application. Obviously, no buyer will be found for a landmark's excess building rights if additional space is available for the asking. Hence, any city that adopts the Plan can anticipate intense pressures aimed at eroding the density limitations that the Plan prescribes to insure that a market will exist for the building rights.

The Plan's principal risks, as I see them, are two. The first is the opportunity that its administration creates for official impropriety or favoritism. This risk, which the Plan shares with a whole gamut of discretionary zoning devices that have made their appearance over the last two decades, is both real and troublesome. Significantly, however, it has not deterred innumerable American communities from adopting these devices during this period. The Plan, moreover, compares quite favorably with them in the number and character of its safeguards against administrative misfeasance. Most compelling, perhaps, is that against this risk must be weighed the certainty of further landmark attrition if nothing is done.

The second risk arises from the dearth of our experience with development rights transfer. For centuries, Anglo-American property law has proceeded on the premise that the ownership of a parcel is inseparably linked with its development potential. The same premise has governed practice in the municipal finance and urban design fields. Along comes development rights transfer with its cleavage between ownership and development potential and its seemingly extraordinary notion that the development potential of Parcel A can be severed from the bundle of rights associated with that parcel and moved to Parcel B. How do we know if the changes that development rights transfer foreshadows for our existing property system are worth the effort that their integration into that system will entail?

We don't for sure. And we are unlikely to have a definitive answer until we have had substantial experience with the technique. The posture of the property system vis-à-vis development rights transfer at the present time is much as it was when the concepts underlying condominium ownership, air rights sales, and the discretionary zoning techniques mentioned earlier were being fashioned. In each case, a prolonged period of trial and error was necessary during which legislatures, courts, the

real estate community, and the marketplace all made their contribution. The same can be anticipated for development rights transfer. The preservation of urban landmarks seems as good a starting place as any, not only because of the evident need for fresh approaches in the field but also because it offers a superb laboratory in which to commence the experiment.

This volume speaks to two audiences: general readers and specialists in urban design, municipal finance, and planning law. The general reader should be forewarned, therefore, that its more technical sections will not be easy going. They include Chapters 3 and 4, which explore the Plan's economic complexities, certain passages[1] in Chapter 6, which

[1] See pp. 150-57 *infra*.

examine doctrines of Anglo-American property law that are both ancient and intricate, and the four appendixes, which largely deal with the technicalities of the Plan's implementation. These sections can be omitted, however, with little prejudice to the general reader's appreciation of the Plan's content or of its potential for strengthening preservation in the United States. Despite their complexity, their inclusion is indispensable to achieving the volume's objectives of demonstrating the Plan's feasibility and of affording guidance to local officials and groups respecting its implementation.

JOHN J. COSTONIS
Urbana, Illinois
March, 1973

Acknowledgments

The present study was conducted under the auspices of the National Trust for Historic Preservation and funded through an Urban Demonstration grant from the U.S. Department of Housing and Urban Development. The proposal referred to as the Chicago Plan had earlier been developed in rudimentary form in a 1971 report[1] co-authored with Jared Shlaes, and was further explored in a 1972 article[2] published in the *Harvard Law Review*.

This study was collaborative in nature, involving, in addition to myself, the Real Estate Research Corporation of Chicago, Illinois, and The Okamoto Associates, Inc., of San Francisco, California. With the structure of the Chicago Plan largely fixed as a result of the two earlier papers, the goals of this study were basically three: (1) to subject the Plan to the scrutiny of specialists in real estate economics and urban design; (2) to explore the Plan's relation to existing American property and land use institutions; (3) to offer suggested legislation and guidance regarding the Plan's implementation for local governmental officials and others in the preservation field.

Robert DeVoy, Senior Vice-President, Real Estate Research Corporation, conducted the economic investigation with the assistance of Lewis Bolan and Roger Qualman of that firm. Rai Okamoto undertook the urban design analysis. Mssrs. DeVoy and Okamoto prepared separate reports on their findings which I, in turn, used in preparing Chapters 3 and 4 (dealing with the Chicago Plan and economics) and Chapter 5 (dealing with the Chicago Plan and urban design), respectively. It is a pleasure both to record my debt to these individuals and firms and to acknowledge their invaluable contributions to the present study.

The charts and figures used in Chapters 2, 3, and 4 were prepared under the direction of John F. Hartray, Jr., of Harry Weese & Associates, Chicago, Illinois, with the cooperation of the Real Estate Research Corporation in certain instances. In addition to John's work in this regard, I am indebted to him for his guidance and critical objectivity in our numerous discussions during the three years in which the Chicago Plan took shape.

Terry B. Morton, Director/Editor of the

[1] J. Costonis & J. Shlaes, *Development Rights Transfers: A Solution to Chicago's Landmarks Dilemma* (Chicago Chapter Foundation of the American Institute of Architects & National Trust for Historic Preservation, May 1971). To Mr. Shlaes must go the credit for fashioning much of the framework that ultimately provided the economic underpinnings of the Chicago Plan.

[2] Costonis, "The Chicago Plan: Incentive Zoning and the Preservation of Urban Landmarks," 85 *Harv. L. Rev.* 574 (1972).

Department of Publications of the National Trust, immediately understood the potential of the concept when she received a letter from me — a stranger — in 1970 regarding assistance from the Trust. Because of her great interest and persistence, the HUD grant was eventually secured, as was the Trust co-sponsorship of the earlier study with the AIA Chicago Chapter Foundation. Her support has continued throughout the HUD grant project as coordinator for the Trust.

Professor Robert E. Stipe of the University of North Carolina was a rigorous and challenging adviser. Preservation has no better friend.

A special note of thanks is due to Norman Marcus, Counsel, New York City Planning Commission, Jacquelin T. Robertson, former Director, Office of Midtown Planning and Development, New York City Planning Commission, and Harmon H. Goldstone and Frank B. Gilbert, Chairman and Executive Director, respectively, New York City Landmarks Commission. Their seminal work in the conception and implementation of the New York City development rights transfer program[3] and other incentive zoning programs in that city and their generous advice and guidance have proven helpful in ways that are difficult to credit fully. Peter Svirsky, Senior Planner, San Francisco Department of Planning, has been equally helpful in sharing with me the experiences of that city in the use of incentive zoning to create an urban environment of grace and amenity.

Howard Cayton and Edwin A. Stromberg of HUD and Richard L. Wentworth of the University of Illinois Press have been the overseers of the study for their respective organizations. Flexible, cooperative, and firmly committed to preservation, they have facilitated the production of this volume in countless ways. Liz Dulany has done yeoman service as my copyeditor, and to Ursula Tate go my thanks for the endless hours she spent typing the various drafts of the manuscript and otherwise assisting me in carrying this project through to completion.

[3] See pp. 54-60 *infra*.

Space Adrift

1

The Landmarks Dilemma in the United States

America's approaching Bicentennial will be a bittersweet affair. The nation will celebrate, but it will also mourn. It will celebrate the physical signs of its past that still remain as national, state, and local landmarks reflecting its architectural and cultural genius. It will mourn the countless other landmarks, sites, and buildings that have been swept away over its 200-year history. The Bicentennial will be rather like a family reunion where the living toast one another's happiness while silently marking the absence of cherished relatives now dead.

The ambivalence of the Bicentennial is simply a reflection of a larger ambivalence that afflicts historic preservation in the United States. At base, the nation has never really faced up to the hard choices that preservation poses. Hence, fervent commitment to the preservation of its architectural and historic heritage coexists uneasily with powerful impulses that are openly antithetical to preservation. Sometimes the preservation commitment prevails. More often it does not.

The commitment has fathered numerous initiatives that cannot be dismissed as mere rhetoric. Literally hundreds of preservation laws, for example, have been adopted at the municipal, state, and federal levels. These laws proclaim preservation as a social goal of utmost priority. They seek to clothe public officials with the authority to conduct effective preservation programs. Although they typically fall short of this end, their enactment nevertheless evidences the willingness of public agencies to withstand the potent opposition of special-interest groups who have little sympathy for preservation.

In addition, national, state, and local landmarks of historic or architectural significance have been protected through programs of direct public ownership and maintenance. The number of properties included in these programs has not been great, however, because of the heavy costs that the federal and state governments must absorb when they purchase properties outright. Using less direct measures, municipalities have moved to safeguard individual landmarks and entire historic districts. Programs addressed to the preservation of the latter have met with considerable success, as a stroll through the historic areas of New Orleans, Charleston, New York, and other vintage American cities attests.

The lion's share of the credit for what preservation there is in the United States, however, must go to the private sector, not to government. When all is said and done, private commitment typically stands as the sole barrier between preservation and demolition.

That commitment appears in numerous guises. Chief among these is voluntary compliance by landmark owners with municipal landmark regulations, even in cases where compliance may spell trouble on the landmark's balance sheet. Another is the establishment of revolving funds by private and nonprofit corporations, property owners' associations, and civic groups to buy up threatened landmarks or to acquire restrictions upon them. In addition, these groups have proven their worth in local preservation efforts by serving as private watchdogs on behalf of public landmark bodies and by commencing legal actions to remedy violations of the community's landmark regulations.

Despite these governmental and private initiatives, the nation's overall preservation record is bleak. A single statistic points up the problem: over a third of the 16,000 structures listed in the Historic American Buildings Survey (commenced by the federal government in 1933) are gone. More distressing than this cold statistic is the identity of the victims. The roster reads like a catalog of the nation's — and world's — most distinguished buildings, including, for example, such gems as the Old Stock Exchange building and the Garrick Theater in Chicago and New York's Pennsylvania Station. Because these buildings enriched, indeed defined the very character of the urban fabric of which they were a part, theirs is truly a grievous loss. Ominously, the forces that claimed them continue to assault the ever smaller company of remaining landmarks.

These forces are essentially four in number. First is the unfavorable attitude toward preservation of governmental agencies charged with capital improvement responsibilities, such as urban renewal or highway construction, and of influential groups within the private sector. Their single-minded pursuit of "progress" has usually meant that preservation

comes out second best. Second, real estate economics in downtown areas, the location of most of the nation's urban landmarks, often dictates that landmark properties be redeveloped with larger modern structures capable of earning a greater return. Third, constitutional and property law in the United States decidedly favor the private landowner in clashes, such as those arising in the preservation context, that pit private gain against community benefit. Finally, cities, states, and the federal government have largely failed to devise landmark programs that grapple realistically with the overriding preference of the legal system for private property rights.

It is these forces that explain the ambivalence of the nation's commitment to preservation. Bringing them to the surface is a necessary first step in the search for fresh initiatives that will safeguard landmarks without doing violence to America's deep-seated economic and legal traditions.

ATTITUDES

Pondering the loss of Chicago's Old Stock Exchange building, *Time* magazine opined that it pitted the "practical necessities of change" against "impractical, even sentimental preservation." This assessment of the relative values of preservation and redevelopment is widely shared in the United States. Until recently at least, the nation has viewed change fetishistically, identifying it with progress even at the cost of cutting itself off from its past. Unfortunately, this view has commanded the assent of both government and the private sector. Innumerable historic structures have fallen in the wake of otherwise laudable government programs. Similarly, private developers and, no doubt, the man in the street have tended to regard the razing of still another landmark with a shrug of the shoulders, uneasily content that the "practical necessities

WHY PRESERVE OLD BUILDINGS?

The elation of the citizens of Belleville, Ill., at the instant their city council approved an ordinance designating the St. Clair County Courthouse as a landmark offers as persuasive an answer as any. Aside from its architectural distinction, the courthouse was a source of identity, of familiarity, of roots for more than five generations of Bellevilleans. Two months later, elation turned to incredulity when the designation was revoked and the courthouse leveled to provide a site for a rose garden alongside the replacement county building.

of change" have once again won out over "impractical, even sentimental preservation."

But the environmental ferment of the last decade has begun to bear fruit. No longer is development for development's sake a sacred cow, wholly immune from governmental and private criticism. The trend now is to evaluate development proposals in terms of their impact upon an entire network of social and environmental values, and to reject or, at the least, require persuasive justification for proposals that are found wanting.

Two federal statutes point up this trend. The National Environmental Policy Act of 1969[1] demands that federal agencies must address the following issues in their recommendations for legislation and for other agency actions "significantly affecting the quality of the human environment": (*a*) the environmental impact of the proposed action; (*b*) any adverse environmental effects which cannot be avoided should the proposal be implemented; (*c*) alternatives to the proposed action; (*d*) the relationship between local short-term uses of man's environment and the maintenance and enhancement of long-

[1] National Environmental Policy Act, 92 U.S.C. §4332 (1970).

5

term productivity; and (*e*) any irreversible and irretrievable commitments of resources which would be involved in the proposed action should it be implemented.

Although the act is of recent vintage, conservationists have already employed it on numerous occasions to compel governmental agencies, such as the Federal Power Commission and the Atomic Energy Commission, to weigh long-term human environmental values as well as short-term programmatic goals in granting permits for or themselves carrying out environmentally significant projects.

With respect to historic preservation itself, Congress in 1966 established a procedure for the review of federally assisted projects affecting properties listed on the National Register of Historic Places. Directors of federal agencies contemplating the development or licensing of these projects must "take into account the effect of the undertaking on any [property] that is included in the National Register."[2] They are required, in addition, to "afford the Advisory Council on Historic Preservation [a federal body created by the 1966 act] a reasonable opportunity to comment with regard to such undertaking." Although the Advisory Council has not been given a veto power, its voice is influential nonetheless. Its opposition to a riverfront freeway slated to run through New Orleans' Vieux Carré, for example, is generally believed to have counted heavily in the U.S. Department of Transportation's ultimate decision to abandon the project.

Private citizens too are becoming increasingly distressed over the hitherto hidden environmental and social costs of the development fetish. Their concerns and those of consumer advocates, conservationists, preservationists, and similar groups are the stuff of everyday news. These concerns are giving rise to height-

[2] National Historic Preservation Act of 1966, 16 U.S.C. §§470(i)-(n) (1970).

6

ened citizen expectations regarding the quality of life as it is reflected in the natural and urban environments of the nation. Inherent in these expectations is an increased awareness of the unique contribution of architectural and historic landmarks to the fabric of the latter and, inevitably, a lesser willingness to trade these landmarks off in a dubious quest for progress.

ECONOMICS

More than a subtle shift in governmental and private attitudes will be required to resolve the landmarks dilemma, however. The economic burdens that preservation imposes upon landmark owners and cities must also be addressed. The failure to date to reduce these burdens to manageable proportions has proven to be the Achilles heel of preservation. Since these burdens are the subject of detailed treatment in Chapter 3, they are only briefly outlined here in order to fix the general dimensions of the dilemma.

The Landmark Owner

A number of economic factors explain why owners of centrally located urban landmarks — the prime concern of this study — have opted to demolish rather than to preserve. Skyrocketing land values undoubtedly head the list. Their impact has been graphically portrayed by Richard Nelson in a paragraph whose message for preservationists is unmistakable.

In our big cities of a half million or more population, [the] demolition of older structures was made economically feasible by parabolic increases in land values. *As a matter of fact, there are very few parcels of land in our largest cities which have not had as many as three different structures on them in the last hundred years....* Our megalopolitan cities have grown so fast ... that we have seen 25-year periods ... where

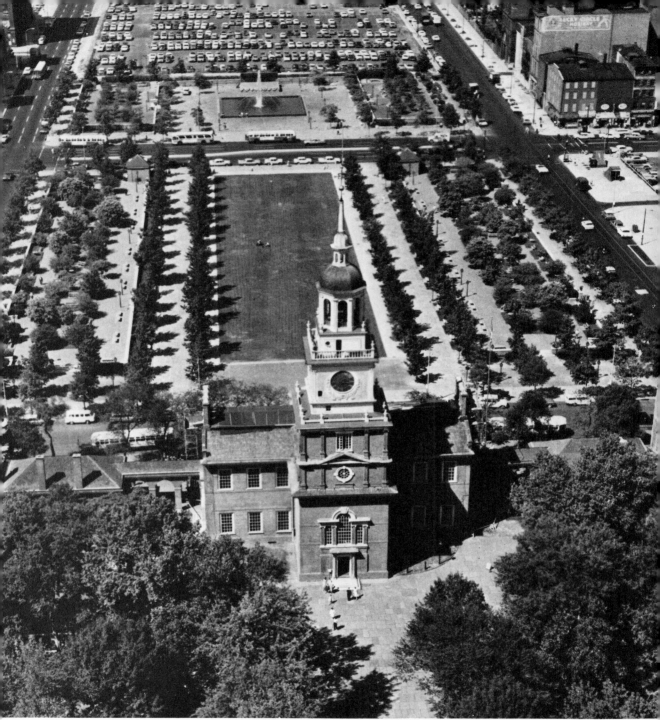

PUBLIC OWNERSHIP: A LIMITED PRESERVATION OPTION

Public ownership of landmarks has undoubted advantages, the principal one being insulation from buffeting by the private market. We needn't worry that the U.S. Department of the Interior will abruptly raze Philadelphia's Independence Hall, a National Historic Landmark (above), in favor of a lucrative seventy-story office tower. But public ownership is no panacea either. Government can afford to acquire relatively few landmarks. Other governmental programs, such as highway construction or urban renewal, may produce the same mortal consequences as the private market. Most important perhaps, landmarks typically serve the community and themselves best if left in active use and in private ownership.

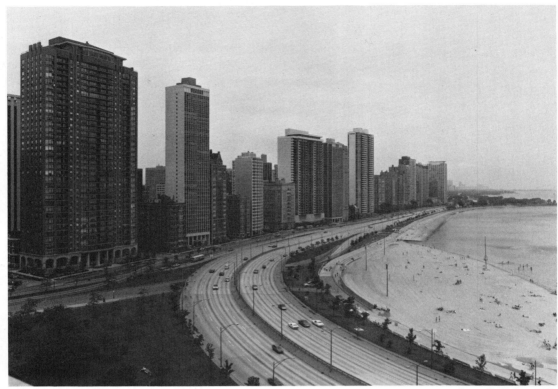

Robert Thall photo (1973)

THE IMPERMANENT CITY

To most of us, buildings speak of permanence and continuity. Given rising land values in the city's prime development areas, this impression is illusion. Sites in these areas cast off their buildings as snakes cast off their skins. These photographs of Chicago's Lake Shore Drive, which were taken only twenty years apart, vividly reflect the impermanence of the cityscape and, in doing so, dramatize the economic vulnerability of urban landmarks.

Carl Ullrich photo (1952)

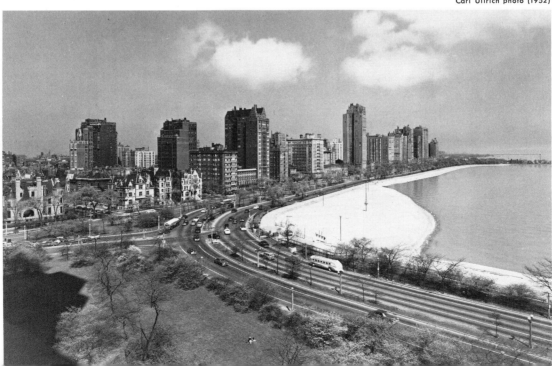

Ernest Braun photo; courtesy San Francisco Department of City Planning

ADAPTIVE RE-USE: A PRESERVATION ALTERNATIVE

San Francisco's Ghirardelli Square, containing buildings erected between 1862 and 1915, housed a chocolate factory for many years. Today it has been redeveloped to preserve the exteriors of some of these buildings while modifying their interiors to produce a complex of specialty shops, restaurants, and services which, with their terraced central plaza, kiosks, and arcades, create an atmosphere of gaiety and relaxation and also return a profit. Ghirardelli Square was formally designated a San Francisco landmark in 1970.

the land value has increased so rapidly that it has become economic to demolish even a fairly new building in order to use the land more intensively — to exploit to its highest and best use the new land value created in a short span of time.[3]

If relatively new buildings cannot survive in a climate of rising land values, it is hardly surprising that vintage landmark buildings fall victim as well.

A second factor in this unhappy picture is the diminutive size of most urban landmarks. Advances in elevatoring, steel cage construc-

[3] Nelson, "Appraisal of Air Rights," 23 *Appraisal J.* 495 (1955) (emphasis added).

tion, artificial lighting, and other building technologies that account for the scale and efficiency of modern skyscrapers were unknown when most landmarks were built. For example, Chicago's Old Stock Exchange building, a landmark that was razed in 1972, was a squat thirteen stories and contained 155,000 rentable square feet; its replacement will rise to forty-five stories and include about 900,000 rentable square feet. These figures, of course, translate into corresponding differentials in rental income.

Third, landmarks, like other buildings, undergo physical and functional obsolescence.

Physical obsolescence is not likely to be a serious problem for a landmark that has been properly constructed and maintained. While most landmarks were solidly built, some have been poorly maintained by owners who have purposely let them run down in anticipation of selling or redeveloping the landmark site. The more serious problem arises with functional obsolescence. Outmoded concepts of interior space layout, loss of much of the building's interior to courts and inefficient mechanical systems, and the decline of the surrounding neighborhood may make space in a landmark less attractive to prospective tenants than space in modern office or commercial buildings.

Finally, landmarks are typically located on small parcels. This factor would hardly bear notice were it not for the so-called zoning bonus system that many American cities have adopted over the last fifteen years. A zoning bonus permits a developer to erect a larger building in return for providing an open space amenity, such as a plaza or arcade, at his own expense.[4] Owners of small parcels, however, cannot effectively utilize bonuses because, in providing the plaza, arcade, or other open space use, they are left with insufficient land area on which to build an economic structure. As lot size decreases, higher construction becomes unprofitable because too much of the building's interior space must be given over to nonrentable uses, such as elevator cores and mechanical systems.

The introduction of the zoning bonus system has brought development on small lots to a standstill and hastened the amalgamation of smaller holdings into land assemblies of sufficient size — usually a quarter-block or more — to exploit the bonuses. Among the prime casualties in this process of amalgamation and redevelopment has been the urban landmark. It is an unfortunate paradox that bonuses,

[4] See pp. 29-32 *infra*.

10

which were intended to enhance one type of urban amenity, have had such a destructive impact upon another.

The principal burdens that a landmark owner might be required to absorb if his building is permanently designated as a landmark are basically four. First, he loses the opportunity to redevelop his site to a more profitable use and to capitalize on any shifts in ownership around it that place a premium on it for assemblage purposes. Second, he may lose income if he is unable to bring its interior space up to the standard of the buildings that compete with it for tenants, and to increase its operating efficiency through periodic renovation. Third, he may be unable to obtain mortgage financing on equal terms with owners of buildings unencumbered by landmark status. Finally, he may eventually find himself unable to operate the building at a profit as it continues to age and its net income progressively decreases.

Lest the burdens of landmark ownership be overstated, however, certain counterbalancing factors should be noted. First, landmarks are *not* imperiled in most instances because of structural unsoundness or failure to generate sufficient income to operate at a profit. The economic stigma of landmark ownership lies instead in the discrepancy between the value of a landmark property in its present state and its value as redeveloped to its most profitable use. The trade-off, in short, is not between losing money and making money; it is between making a modest return, at least over the short and mid-term future, and cashing in on the economic opportunity represented by the appreciated value of the redeveloped landmark site.

In some cases, moreover, landmark designation may tend to enhance the value of a landmark property by making it a prestige address for selected tenants. In addition, tenants may prefer space in a designated building secure

in the knowledge that they will not be subject to the vagaries of the redevelopment process and, hence, forced relocation during the period of their leasehold. Finally, even landmarks that have fallen on hard times can often be brought back to economic life through adaptive re-use. A well-known example is San Francisco's Ghirardelli Square, formerly a collection of run-down buildings that housed a chocolate factory and now a bustling tourist magnet of shops and restaurants.

The City

The city too must be prepared to absorb heavy costs if it chooses to pursue preservation vigorously. Although its administrative overhead will not be inconsiderable, its major expense arises in connection with the acquisition of threatened landmarks. As indicated presently, acquisition is the only means available under most municipal ordinances to stave off demolition.

But the city's burdens do not end with acquisition. Landmark buildings may require extensive restoration in addition to ordinary maintenance. Removing them from the real estate tax rolls by public acquisition, moreover, will deny the city not only the increased taxes that the replacement project would have yielded but also the current taxes of the landmark property. Further, redevelopment of the landmark site with a modern building may enhance the city's general economic health by revitalizing an entire block or district or by providing scarce office space at a prime downtown location.

The political costs of preservation must also be taken into account. Even the handful of municipal administrations that are willing to go to the mat in behalf of preservation may hesitate in the face of the anti-preservation stance of potent segments within the community. One segment is composed of the groups constituting the real estate industry; these include developers, building managers, financial institutions, brokers, and title insurance companies. Predictably, these groups look askance at any governmental measure that dilutes the private sector's control over real estate decisions such as those affecting land assembly, demolition, and redevelopment. Despite occasional claims to the contrary, they tend to have little use for preservation, especially if no special efforts are made to mitigate the economic burdens that it may entail for private property owners.

The preservation stance of the nationally prestigious Building Managers Association of Chicago deserves special recognition in this regard. The association's bailiwick includes Chicago's Loop area, the birthplace of the Chicago School of Architecture and of the modern skyscraper. Here Louis Sullivan, William LeBaron Jenney, John Root, Frank Lloyd Wright, and other architectural giants worked their magic at the turn of the century. The Loop then was an architectural pleasure-ground of incomparable richness, including among its treasures Sullivan's Garrick Theater, the Carson, Pirie, Scott & Company Department Store, and the Stock Exchange and Auditorium buildings; Jenney's Home Insurance and Leiter I and II buildings; and Burnham's Rookery and Monadnock buildings (the former designed with John Root, the latter with Charles Atwood). Today the honor roll has thinned — the Garrick Theater and Stock Exchange, Leiter I, and Home Insurance buildings, for example, are gone. But the surviving works of the Chicago School remain sufficient in number and quality to insure that the Loop's status as the nation's premier architectural repository remains unchallenged.

At the height of the civic explosion touched off by the demolition of Sullivan's Old Stock Exchange building in 1972, the association

11

addressed a white paper of sorts on preservation to Chicago's landmark commission. Despite its "sympathy with the objectives" of the commission, the association "regretful[ly]" declared: "We can see no way to [safeguard the surviving Chicago School buildings] unless the City, State or Federal Government purchase the property in question, spend large amounts of money toward rehabilitation and be prepared to operate the property, possibly at a loss."[5] Since outright acquisition of the ensemble of remaining Chicago School buildings is out of the question given the budgetary problems that Chicago shares with other American cities, the association's "solution," of course, is no solution at all. So long as it continues to prevail at city halls throughout the nation, preservation of urban landmarks in the United States will remain a fruitless endeavor.

Political opposition can also be anticipated from groups in the community that will be denied the benefits of public programs that would otherwise be funded out of the municipal revenues devoted to preservation. It was these groups that the Chicago City Council had in mind in refusing even to accord formal landmark status to the Old Stock Exchange building. According to the council's Committee on Cultural and Economic Development:

> The Committee feels that the aesthetic value of the Old Stock Exchange does not exceed the relative cost and, in this day of demand to meet urgent financial needs in other areas, the City of Chicago cannot afford the luxury of a building as a landmark that, though it may be treasured for historic value and architectural originality, is too far deteriorated to warrant the cost of rehabilitation. The Committee is confident

that the people of the City of Chicago would want better application of their tax dollars for we are convinced of a resultant dollar deficiency if rehabilitation were attempted — the building would become known as Chicago's White Elephant.[6]

Two comments apply to both segments. First, they wield a good deal of weight at City Hall, usually far outstripping the preservation constituency in this respect. Second, they represent perfectly legitimate interests. On the face of it, real estate development and municipal programs other than historic preservation that are funded out of public revenues are no less worthy of the sympathy of the city's policymakers than historic preservation itself. To a considerable extent, therefore, the political deck comes stacked against preservation, something that many preservationists but few city councils overlook.

THE CONSTITUTIONAL FRAMEWORK

Left to their own choice, most landmark owners can be expected to opt for redevelopment rather than preservation. Why, it might be asked, should the option rest with these owners in the first instance? Why not resolve the landmarks problem once and for all simply by decreeing that no privately owned landmark may be altered or demolished without the municipality's assent? The public benefits of landmark preservation, after all, are almost universally conceded. And the direct use of governmental power in this manner would appear to offer a sure remedy for the dilemma.

The answer rests in the constitutional doctrine of due process and in the related distinction that lawyers draw between the police and eminent domain powers of government. The due process requirement, found in the

[5] Letter from Richard M. Palmer, President, Building Managers Association of Chicago, to Samuel A. Lichtmann, Chairman, Commission on Chicago Historical and Architectural Landmarks, Aug. 6, 1970.

[6] Committee on Cultural and Economic Development, "Special Report Relative to Designation of the Old Stock Exchange Building" 6 (Aug. 1970).

FIRE: A FRIEND OF THE MARKETPLACE?

The Irwin Mansion on San Francisco's Pacific Heights had known better times as the residence of William G. Irwin, a sugar magnate. It once housed Gobelin tapestries, Tiffany stained glass, and imported European chandeliers. But it fell upon hard times and was purchased in 1953, reportedly to be wrecked for more lucrative development. Unoccupied and repeatedly vandalized in its last year, it was destroyed in 1957 by a fire of questionable origin. Its site is now occupied by a high-rise luxury apartment building.

federal and most state constitutions, protects the various prerogatives of private ownership from arbitrary or confiscatory governmental measures. One of the most valuable of these prerogatives, of course, is the property owner's interest in devoting his land to its most profitable use, even if a landmark must be razed to achieve this goal.

The distinction between the police and eminent domain powers comes into play when government restricts one or more of the prerogatives of private ownership. The police power is simply the power retained by all state governments to legislate in furtherance of the public health, safety, morals, and general welfare. The eminent domain power, on the other hand, refers to the authority of government to acquire title to or an interest in private property without the consent of its owner, but upon payment of just compensation to him. Both powers may be exercised only to advance a proper governmental purpose. They differ, however, in the critical respect that restrictions upon ownership prerogatives resulting from police power measures require no compensation, while those originating in the eminent domain power must be compensated.

In short, the due process requirement is not violated by police power measures that restrict property rights. It is breached by governmental enactments that go so far, in the view of the courts, as to amount to condemnatory acts, yet fail to provide for compensation.

How should the line be drawn between governmental programs that may legitimately be pursued under the police power and those requiring compensation? And on which side of the line will the courts place an ordinance that imposes permanent landmark status on privately owned structures?

To answer this question, a network of factors can be identified which, singly or in com-

bination, have been used by the courts to distinguish police power from condemnation measures.[7] Chief among these factors is the severity of the restriction upon private rights, usually gauged by the extent to which the measure reduces the income potential of the affected property. According to hallowed judicial usage, measures that do not prevent an owner from earning a "reasonable return" on his property will pass muster under the police power; those that preclude a reasonable return must compensate the owner for his losses.

Courts also balance the community benefits associated with the measure against the harm suffered by affected property owners. Measures that carry demonstrable advantages for the community will be more readily approved under the police power than those of dubious social merit. They review, in addition, whether the proposed measure is likely in fact to achieve its intended goal and whether alternative means are available that promise equivalent results at a lesser cost to burdened property owners.

Finally, they often inquire into the equity of imposing the costs of a municipal program upon one or a few property owners, rather than distributing the burden on a community-wide basis. (Requiring the community to proceed by eminent domain socializes the loss because the compensation received by affected property owners is typically derived from general tax revenues.)

A dichotomy to distinguish police from con-

[7] This question has been examined extensively in academic writings. See, e.g., Dunham, "A Legal and Economic Basis for City Planning," 58 *Colum. L. Rev.* 650 (1958); Michelman, "Property, Utility, and Fairness: Comments on the Ethical Foundations of 'Just Compensation' Law," 80 *Harv. L. Rev.* 1165 (1967); Sax, "Takings, Private Property and Public Rights," 81 *Yale L. J.* 149 (1971). A thoughtful analysis of the problem as it relates to historic preservation appears in Note, "The Police Power, Eminent Domain and the Preservation of Historic Property," 63 *Colum. L. Rev.* 708 (1963).

demnation measures under this heading has been proposed[8] which, while not altogether satisfactory, is serviceable for present purposes. Measures that prevent a landowner from imposing a harm upon his neighbors may be enacted under the police power; measures that compel him to confer a benefit upon the community must be enacted under the condemnation power. To illustrate: under its police power a community may prevent a landowner from conducting a nuisance industry on his property; without compensation, however, it may not force him to leave his land in its natural state to be enjoyed by the public as a forest preserve.

Merely enumerating these tests does not give us much guidance about the validity of our proposed ordinance. Decidedly abstract, they have little meaning divorced from actual contexts and factual situations. One can never be sure, moreover, which test will be given precedence in the event of conflict. It is not difficult, for example, to imagine an ordinance that both severely restricts the return on private property and carries indubitable advantages for the community.

But the picture is more complicated still because the content of these tests is not invariable, but takes on the coloration of the prevailing social, economic, and political views of the times. It was not so long ago, for example, that the legitimacy of zoning as a police power exercise was a close question in the state courts. Today that question wouldn't excite even a flicker of judicial interest. For this reason the test which differentiates between measures that compel "benefits" and those that prevent "harms" demands special caution. The benefits of one generation may become the harms of the next, especially if the two generations approach the question of environmental quality with conflicting premises.

[8] See Dunham, *supra* note 7 at 651.

But the tests do have a predictive value that is somewhat greater when applied to specific instances and evaluated in light of actual judicial pronouncements concerning preservation. Accordingly, it is useful to examine the validity of the hypothetical ordinance in terms of the three most typical instances that confront municipal landmark commissions.

CASE 1. Smith owns a building of landmark quality in the city of Greenville. He has no present intention of altering or demolishing the building. Greenville designates the building under the proposed ordinance. Smith challenges the designation in court on the *sole* ground that designation alone violates due process because it tends to depreciate the value of his property by, e.g., making it less marketable.

CASE 2. Under prudent management Smith's building of landmark quality nets a return of only 2 percent on assessed valuation of the building and land. Wishing to redevelop the site with a modern tower, he applies for a demolition permit. Greenville designates his building under the ordinance, and denies the permit. Smith challenges the ordinance in court on the ground that Greenville's attempt to regulate his property without paying him compensation violates due process under these facts.

CASE 3. Case 3 is exactly the same as Case 2 except that Smith nets an 8 percent return on the assessed value of the building and land.

Case 1 presents relatively little difficulty under the foregoing tests. Smith's chances are very slim indeed. While his property will suffer some impairment in value in terms of decreased mortgageability and marketability, the courts are not likely to regard these consequences as an adequate base for a due process claim. Numerous other zoning, planning, and municipal redevelopment measures have similar consequences, yet are not invalid because enacted under the police power. On

the specific question of landmark designation itself, moreover, the position of the judiciary does not appear to be in doubt. Rejecting a claim that landmark designation is confiscatory in and of itself, for example, the New York Supreme Court reasoned: "We deem certain of the basic questions raised to be no longer arguable. In this category is the right, within proper limitations, of the state to place restrictions on the use to be made by the owner of his own property for the cultural and aesthetic benefit of the community."[9]

Case 1 prompts a caveat, however. Our ordinance seeks to impose *permanent* landmark status on designated properties. Smith limited his attack merely to the ordinance's *present* impact on his property. If five or ten years down the line Smith's property declined in profitability to the state described in Case 2, Smith might very well prevail. It is for this reason that, as discussed presently, landmark status under most municipal ordinances is not intended to be permanent. Instead, it must be lifted upon a showing of economic hardship by the owner or simply upon his request, unless the city chooses to step in and condemn the property.

The outcome in Case 2 is also relatively free from doubt. Smith will prevail. Despite the evident community benefits of retaining the landmark, the court will be swayed by two opposing considerations. First, it is unlikely to deem a 2 percent return on assessed valuation a "reasonable return." One cannot be absolutely certain on the point because the courts have refrained from defining that concept with an accountant's precision, no doubt purposely. A 2 percent return, however, falls so far below the mean on commercially held

property and the return available on much safer investments such as government securities that it does not seem sustainable. Second, precisely because of the property's marginal profitability, the court will probably be sympathetic to Smith's plaint that the ordinance unjustly singles him out for a burden that ought to be borne by the community as a whole. After all, it is the community that wants the building, not Smith.

These two arguments were made to the court by the owners of Chicago's Garrick Theater under circumstances roughly equivalent to those outlined in Case 2. Approving both, the court observed: "It is laudable to attempt to preserve a landmark; however, it becomes unconscionable when an unwilling private party is required to bear the expense."[10]

Case 3 is the hard case. Whether Smith or the city prevails will turn primarily upon how the court construes the reasonable return criterion. Will it be content with the 8 percent figure? Or will it emphasize the discrepancy between that figure and the much greater profitability of the site if redeveloped with a modern building?

Because the precise issue has not as yet been addressed by the courts, the question must still be regarded as open. However, at least one city has come down hard against those in Smith's shoes. New York will not issue a permit for the demolition or major alteration of a designated landmark unless its owner affirmatively establishes that his current return falls below 6 percent of its assessed valuation.[11] Significantly, only one owner has made such a showing to date, even though the New York program has been in existence since 1966 and over 300 individual structures have been designated under it.

[9] Trustees of Sailor's Snug Harbor v. Platt, 29 App. Div.2d 376, 377, 288 N.Y.S.2d 314, 315 (1968). To like effect, see, e.g., Manhattan Club v. Landmark Preservation Comm'n, 51 Misc.2d 556, 273 N.Y.S.2d 848 (Sup. Ct. 1966); *In re* Opinion of the Justices, 33 Mass. 773, 128 N.E.2d 557 (1955).

[10] State *ex rel.* Marbro Corp. v. Ramsey, 28 Ill. App.2d 252, 256, 171 N.E.2d 246, 247 (1960).
[11] See New York, N.Y., Admin. Code Ann. ch. 8A, §§207-1.0q, 207-8.0 (1971).

16

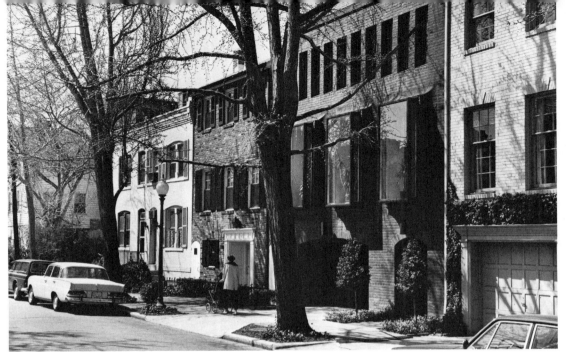

HISTORIC DISTRICTS: AMENITY ON AN AREA-WIDE BASIS

Landmark designation may extend to entire historic districts as well as to individual structures. Some of the nation's best-known preservation successes, in fact, have featured the former; these include Washington's Georgetown Historic District (above) and Boston's Louisburg Square (below).

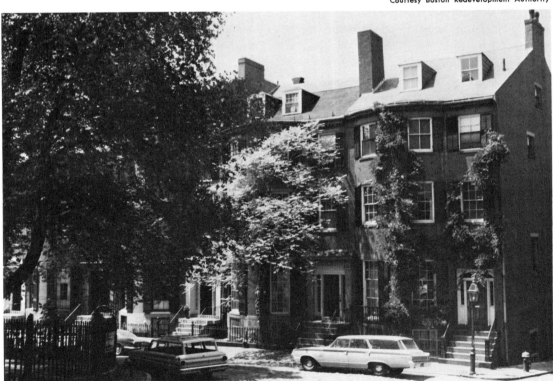

17

The refusal of the courts to invalidate zoning measures simply because they impair the value of individual properties tends to support the New York view. In many cases the magnitude of injury caused by these measures is comparable to that of preservation ordinances. Almost half a million dollars in anticipated profits, for example, was wiped out by the zoning ordinance that figured in the 1926 U.S. Supreme Court decision[12] that established the constitutionality of zoning.

Yet these zoning precedents must be approached with caution. Zoning and the preservation of individual landmarks are not identical exercises. Zoning applies generally throughout the community, not to a handful of properties. In most cases it stabilizes or enhances the value of the property that it regulates; where it drastically lowers property values, aggrieved owners may obtain variances that relax its stringent terms. Landmark ordinances, on the other hand, typically lessen the value of downtown landmark sites, often severely.[13] Hence, most of these ordinances treat *all* landmark properties as potential candidates for variances.

Zoning also fits more comfortably within the harm/benefit rationale. It is difficult to equate a zoning measure forbidding the construction of a glue factory in a residential zone with a preservation measure embargoing the demolition of a landmark. In a sense, both measures prevent a "harm." But the preservation ordinance compels the landmark owner at his own expense to confer a benefit on the community; it freezes his property in its current state while leaving unrestrained the range of development options open to his neighbors. The "harm" that it prevents, moreover, is simply the discontinuance of a community benefit fortuitously provided by the owner. In contrast, the zoning ordinance prevents the property owner from increasing the profitability of his land by engaging in an activity that would visit demonstrable physical and economic harm on his neighbors. Because it leaves the owner with precisely the same range of development options as those his neighbors enjoy, he is no worse off under it than they.

Nor will the warm judicial reception given historic districting, such as that in effect in New Orleans' Vieux Carré, necessarily carry over to the designation of individual landmarks.[14] Historic districting is more akin to zoning than to landmark designation. It too encompasses entire areas of a community rather than selected sites. Its burdens, therefore, are shared by many, rather than imposed on a few. These burdens, moreover, are not comparable to those suffered by owners of individual landmarks because historic districts are typically located in predominantly residential areas, where land values fall well below those prevalent in central commercial districts. Moreover, historic districting can usually be counted upon to increase the desirability of residing there, and hence to enhance property values by emphasizing the neighborhood's distinctiveness. Recognizing this fact, residents themselves often urge designation. Through property owners' associations and nonprofit corporations, they extend invaluable administrative and financial assistance to the municipal landmark commission in the governance and preservation of buildings within these districts. Needless to say, such cooperation is rare from owners of individual landmarks.

Finally, the community benefits of historic

[12] Village of Euclid v. Ambler Realty Co., 272 U.S. 365 (1926).
[13] See pp. 71-79 *infra*.
[14] See, e.g., Rebman v. City of Springfield, 111 Ill. App.2d 430, 250 N.E.2d 282 (1969); City of Santa Fe v. Gamble-Skogmo, Inc., 73 N.M. 410, 389 P.2d 13 (1964); City of New Orleans v. Levy, 223 La. 14, 64 So.2d 798 (1953).

districting, like those of zoning, are tangible and typically enjoy broad popular support. Its favorable impact upon property values has already been noted. In addition, it contributes to the community's general economic health by promoting tourism, an advantage that has not been lost on cities such as New Orleans and Charleston, which have strong districting provisions.

The case for landmark preservation is not as forceful, however, because its benefits are less tangible and its appeal more elitist. These differences could prove troublesome in the judicial effort to strike a balance between the community's interest in landmark preservation and its interest in minimizing the imposition of onerous burdens upon individual property owners. Pondering these differences, one commentator concluded by labeling landmark preservation a "non-zoning use of the police power."[15] The label is apt and serves to warn against an overly facile reliance upon zoning and historic districting precedents to justify the regulation of individual landmarks on a non-compensatory basis.

THE LEGISLATIVE RESPONSE TO THE PRESERVATION CHALLENGE

The challenge confronting the preservation draftsman is hardly one to be envied: devise legislation that will in fact safeguard urban landmarks while respecting the nettlesome economic and constitutional constraints portrayed in the preceding pages. The savage pace of landmark attrition in our cities signals unmistakably that the challenge has not been met. Identifying the reasons why not only provides a measure of the inadequacy of existing approaches but, more important, illuminates the path to alternatives that promise to turn the tide in favor of preservation.

[15] Note, "The Police Power, Eminent Domain, and the Preservation of Historic Property," *supra* note 7 at 722.

Municipal Programs

The municipality is the proper starting point in any survey of current preservation programs. Although landmarks may have national or even international status, their impact is greatest in their host city. They enrich its fabric by adding an aesthetic gracenote to the lives of its residents. They define its character for nonresidents. And they should figure prominently in the city's planning and zoning regime, which, if it is sensitive to urban design values at all, will recognize these buildings as precious civic assets.

But the most compelling reason for beginning at the municipal level is also the most practical: *if the cities do not carry the laboring oar, then landmarks will not be saved at all.* State and federal agencies cannot do the job given their present tools. In content and in funding, their programs make sense only on the premise that, in the main, the preservation dilemma is being successfully resolved at the local level and with local resources. These programs operate interstitially, filling in gaps here and there in what is assumed to be a basically sound municipal preservation framework.

How have the cities addressed the preservation problem? Although literally hundreds of preservation ordinances have been adopted since the nation's first in Charleston, South Carolina, in 1931, they follow a fairly consistent pattern. The typical ordinance calls for the designation of individual landmarks and of entire historic districts.[16] It enumerates the cultural, aesthetic, and historic criteria that the city landmark commission, often with the advice of the city planning commission, must take into account in proposing designation of individual buildings or of historic districts.

[16] More detailed surveys of municipal preservation legislation may be found in, e.g., J. Morrison, *Historic Preservation Law* (1965); J. Pyke, *Landmark Preservation* (Citizens Union Research Foundation, Inc., 1970).

Actual designation, however, rests with the city council.

After designation, permits for the demolition or alteration of landmarks or of buildings within historic districts must be screened by the landmark commission. If it finds that the proposed work will impair the building's historic or architectural character, it is usually given a grace period in which to try to devise a compromise plan that will safeguard the structure. The plan may include provisions for leasing, sale to third parties, or other contingencies that will prove satisfactory to the owner and insure preservation of the building; in a few municipalities, it may also include real estate tax relief. But the decision to accept the plan, it must be emphasized, lies wholly within the owner's discretion.

Should the owner reject the plan, the landmark commission may have one of three options depending upon the local ordinance. In most cities, it has no power after the grace period to stay demolition or alteration of the landmark, but can only recommend that the city council acquire it by condemnation or purchase. If the council rejects the recommendation, the landmark is lost. In a smaller group of cities, the commission may deny the permit provided that its action will not subject the owner to "undue economic hardship." New York City's 6 percent return provision illustrates this approach. A few cities authorize their landmark commissions to deny the permit outright, irrespective of economic hardship. The legal risks that these cities run are detailed in the earlier discussion of the second of the three cases involving Smith and the city of Greenville.[17]

This brief synopsis of municipal legislation prompts two comments. First, the legislation allocates preservation costs almost exclusively on an either/or basis: either the landmark owner alone must bear these costs or the city

must do so. There is no middle ground. Landmark designation and the withholding of the demolition permit during the grace period are police power exercises. At this stage, it is the landmark owner who must absorb these costs and who, under most ordinances, can rid himself of them only by insisting upon his right to demolish. But once the grace period has run, the entire financial burden shifts to the city, which, if it wishes to save the landmark, must resort to eminent domain.

Draftsmen of conventional preservation ordinances have given little thought to the use of incentives to mitigate the often severe burdens of landmark ownership. Where movement in this direction has occurred, it has usually faltered. Real estate tax abatement is an illustration. Although abatement offers a potent tool for lessening the burdens of landmark ownership, relatively few cities have been authorized by their states to grant this relief. And only a handful of the few that have received this power have actually chosen to exercise it.

Second, the ordinances have scant chance of success in the face of the economic and political impediments to preservation outlined earlier. To the extent that they assume that landmark owners will forfeit the greater profitability promised by inflated land values, they betray a startling economic naiveté. Speculators who purchase landmark properties for redevelopment have turned down the compromise proposals of landmark commissions time and time again and no doubt will continue to do so. Worse still, universities, churches, foundations, and other guardians of the culture also balk at landmark status for their buildings, albeit with more grace than one member of the Building Managers Association of Chicago, who dismisses every building constructed more than forty years ago as a "clunker."

Equally naive is the assumption that cities

[17] See pp. 15-16 *supra*.

will in fact use the power given them by ordinance to intervene at the eleventh hour and condemn the beleaguered landmark. The costs are simply too great for condemnation to serve as a practicable alternative in all but a few instances. Direct acquisition charges are likely to run into millions of dollars for landmarks in prime downtown locations.[18] The indirect costs attributable to restoration, regular maintenance, and tax revenue losses will also be substantial. With most American cities today hard pressed to provide even rudimentary public services, it is fanciful to expect that they will voluntarily take on fiscal burdens of this magnitude.

The political consequences of the decision to condemn must also be considered. Fear of these consequences has caused many city councils to balk at *designating,* let alone condemning, buildings of unquestioned architectural and historic merit. Vigorous preservation efforts are not favored by developers, financial institutions, and other segments of the real estate industry whose voices are loudest at city hall. Municipal councils are also wary of criticism from other quarters in the community that compete with preservation for a share of the public dollar.

State Legislation

Virtually all of the states have adopted some form of preservation legislation.[19] Many of the state acts are of the hortatory, plaque-awarding variety. Others, however, constitute serious attempts to support local programs as well as to address preservation questions of state-wide concern. A number of the measures presently on the books bear only peripherally on our chief concern, safeguarding urban landmarks in private ownership. Accordingly, the

discussion that follows does not exhaust the full range of state initiatives, but is confined to those that promise to facilitate this goal. Five initiatives have been selected for this purpose.

DELEGATION OF PRESERVATION POWERS TO LOCAL GOVERNMENTS

Heading the list is the delegation of power to municipalities to conduct preservation programs. Because cities possess only those powers delegated to them by the state, the so-called state "enabling acts" that delegate preservation powers afford the requisite legal foundation for local efforts.[20] The content of these enabling acts is reflected in the preceding summary of the provisions typically found in municipal preservation regulations. Thus, state acts authorize the designation of historic districts and individual landmarks, and prescribe in general terms the criteria applicable to both. They establish the procedures for designation and for subsequent building permit review, and allocate preservation responsibilities among the local governing body, landmark commission, and planning department. They also detail the city's powers with respect to purchase or condemnation of threatened buildings, cooperative arrangements with landmark owners and with other units of government, and a variety of similar matters.

In addition, the enabling acts chart alternatives for funding local preservation activities. Most authorize cities to commit their general revenues for this purpose. Similarly, many allow cities to accept gifts or grants from private sources and from state and federal agencies.

[18] See pp. 71-79 *infra.*
[19] State preservation programs are reviewed in Wilson & Winkler, "The Response of State Legislation to Historic Preservation," 36 *Law & Contemp. Prob.* 329 (1971).

[20] This statement assumes that the city in question is not located in a state that has a constitution or statute granting home rule powers to units of local government such as cities or counties. If the city does enjoy home rule powers, it can validly enact preservation ordinances pursuant to these powers, assuming — as is likely — that the courts of the state would deem preservation a matter pertaining to "local" or "municipal" affairs.

Private donations, of course, have been one of the traditional bulwarks in local preservation efforts. It is only recently that the state and federal governments have begun to funnel aid to the cities. The state may appropriate its own funds for this purpose or, when authorized by statute, serve as a conduit for the transmission of federal grants, such as those authorized under the National Historic Preservation Act of 1966. A few states have also permitted local governments to levy special taxes[21] or issue bonds.[22]

TAX INCENTIVES

A second group of state provisions establishes tax incentives for landmark ownership. A number of states expressly authorize local authorities to take the economic burdens of landmark ownership into account in assessing landmark properties.[23] States having a state income tax calculated upon the federal tax base[24] accord a charitable deduction to donors of fee or less than fee interests in landmark properties. (These donations may also qualify for the federal charitable deduction granted under Section 170(c) of the Internal Revenue Code.[25]) Some legislatures also grant exemptions from state and local taxes to selected nonprofit organizations that manage properties of state historic interest.[26] Finally, one state, Connecticut, remits to local governments sums equal to the real estate tax losses the latter sustain in abating the property taxes of landmark owners.[27]

[21] See, e.g., Ore. Rev. Stat. §358.170 (1969).
[22] See, e.g., Ill. Rev. Stat. ch. 24, §11-48.2-2(h) (1971).
[23] The problems affecting the assessment of landmark properties are discussed in Appendix IV.
[24] As of September 1972, twelve states were included in this category.
[25] The entitlement of donors of less than fee interests to a charitable deduction under Section 170 is examined in Appendix III.
[26] See, e.g., N.J. Stat. Ann. §54.4-3.52 (Supp. 1970).
[27] See Conn. Gen. Stat. Ann. §12-127a (1972).

COORDINATION WITH OTHER AREAS OF STATE LAW

Third, state acts may serve to clarify or update other areas of state law that bear on preservation. For example, a good deal of attention is now being given to the acquisition of less than fee interests in landmark properties.[28] These interests are variously labeled "development rights," "scenic" or "facade easements," or "preservation restrictions." Their enforceability raises a host of issues that traditional property law does not adequately address. Because property law is a state rather than federal concern (there are, in effect, fifty different bodies of property law in the United States), states that wish to resolve these issues may do so by adopting appropriate clarifying legislation. The latter may take form as an amendment either to the state preservation enabling act or to related state legislation.

COORDINATION WITH FEDERAL PRESERVATION PROGRAMS

Fourth, many states have responded to the incentives built into the National Historic Preservation Act of 1966[29] by increasing their direct involvement in preservation affairs. The act authorizes the National Park Service, a division of the U.S. Department of the Interior, to make grants to the states for the conduct of statewide historic surveys and for actual brick-and-mortar projects. It also establishes procedures for listing national, state, and local landmarks on the National Register of Historic Places. It has stimulated the passage of measures that centralize statewide preservation responsibilities in a single state agency, that authorize the conduct of historical surveys, and that establish procedures for the award of grants to local governments and private agencies and for intrastate coordina-

[28] See pp. 155-57 *infra.*
[29] 16 U.S.C. §470 *et seq.* (1970).

tion of efforts to list properties on the National Register.

STATE HISTORIC PRESERVATION AGENCIES

Finally, many states have charged either a state agency or a nonprofit cultural body with direct responsibility for preserving buildings, districts or sites having statewide historic, architectural, or archeological value.[30] The entity may be given either regulatory (police) or eminent domain powers or both, and is usually funded through state appropriations.

The increasing involvement of the states in preservation affairs is an encouraging sign. Their visible commitment serves as a goad to local preservation efforts. State enabling acts and related clarifying legislation provide an indispensable legal foundation for these efforts. The states, moreover, have at last begun to show some awareness of the economic dimensions of the preservation puzzle through measures authorizing local governments to levy special preservation taxes, abate real estate taxes, and issue bonds. Similarly promising is the creation of state bodies empowered to conduct surveys, draft comprehensive state preservation plans, dispense federal and state aid to local governments, and acquire historic properties.

But the fact remains that, to date at least, state measures have done almost nothing to roll back the economic forces that hold most urban landmarks hostage. Like the cities, the states have chosen not to come to grips with the hard economic realities of landmark preservation. Conceding the indispensability of state enabling and clarifying legislation, these acts are largely exercises in futility as long as the cities lack the financial resources to implement them. Again, empowering a state body to acquire historic properties, to adopt ambi-

tious plans or to distribute aid means little if the few landmarks that are actually acquired are located outside of the cities, the plans cannot be implemented for lack of funds, and the grants constitute but a drop in the bucket in relation to actual preservation costs.

Nor do the measures dealing with real estate tax abatement, bonding, or special taxing authority promise to relieve the financial burden on local governments. All they do is encourage the municipality to scan an already bare cupboard for another crust or two. Consider tax abatement, for example. Under the conventional municipal preservation ordinance, a city that lowers taxes on landmark properties reduces by the same amount the revenues available for general municipal purposes. Hence, it is not surprising that almost all of the cities that have the power to use this incentive have quietly walked away from it. Of dubious value too is the authority to float revenue or general obligation bonds. Revenue bonds must be financed from the income of the bonded facility; unlike turnpikes or port terminals, however, many landmarks will be unable to generate sufficient income through visitors' fees and the like to retire these bonds. General obligation bonds, on the other hand, are typically financed out of general taxes. Like tax abatement and the special preservation tax option, therefore, their use entails a corresponding drain upon general municipal revenues.

Two state measures that would assist local governments on the financial front are outright grants and remission of amounts lost through real estate tax abatement. Both add to rather than drain local resources. Unfortunately, state grants have not been forthcoming in significant amounts. Of all the states, moreover, only one has made provision for remission payments.[31]

[30] See Wilson & Winkler, "The Response of State Legislation to Historic Preservation," *supra* note 19 at 330-32.

[31] See p. 22 *supra*.

Federal Programs

Federal support of local preservation efforts parallels that of the states in three respects.[32] Most of it is of recent vintage, dating largely from the mid-1960s. It is premised on the existence of effective municipal programs, seeking only to supplement them with material and technical assistance. And it too has been funded at levels that fall well short of actual needs.

Although numerous federal statutes hold potential interest for preservationists,[33] the most pertinent are those allocating preservation responsibilities to the Department of the Interior and to the Department of Housing and Urban Development (HUD). The duties of the former are detailed in congressional enactments of 1935[34] and, more important, 1966.[35] Those of HUD appear as amendments to the National Housing Acts of 1949[36] and 1954.[37] The discussion that follows deals principally with the features of these acts that promise relief for the beleaguered urban landmark.

DEPARTMENT OF THE INTERIOR

In its 1935 enactment, Congress authorized the Secretary of the Interior through the National Park Service to initiate a program for identifying and marking landmarks of national significance, to acquire title or an appropriate protective interest in these landmarks, and to enter into cooperative arrangements with public or private agencies in furtherance of landmark preservation. The National Park Service responded by establishing a National Register of Historic Places and listing a number of selected properties of

national significance. In addition, a variety of cooperative agreements were made under which the National Park Service assisted local governments or itself undertook the preservation of sites and buildings of national importance. Perhaps the best known example of these projects is Independence Mall in downtown Philadelphia. Although impressive in their own right, the service's programs under the 1935 act left largely untouched the problems of safeguarding urban landmarks in private ownership.

Congress sought to remedy this omission in the more comprehensive National Historic Preservation Act of 1966. Its concern is underscored in the act's preface:

Although the major burdens of historic preservation have been borne and major efforts initiated by private agencies and individuals, and both should continue to play a vital role, it is nevertheless necessary and appropriate for the Federal Government to accelerate its historic preservation programs and activities to give maximum encouragement to agencies and individuals undertaking preservation by private means and to assist State and local governments . . . to expand and accelerate their historic preservation programs and activities.

Congress chose to pursue its redefined preservation goals through four innovations. First, it made federal monies available to the states for the formulation of comprehensive statewide historic surveys and plans and for the preservation, acquisition, and restoration of landmark properties. Second, it expanded the National Register of Historic Places to include any state or local district, site, building, structure, or object significant in American

[32] Federal preservation legislation is surveyed in Gray, "The Response of Federal Legislation to Historic Preservation," 36 *Law & Contemp. Prob.* 314 (1971).

[33] For a survey of federal legislation and programs bearing upon historic preservation, see Biddle, "Historic Preservation," 28 *Journ. of Housing* 219 (1971).

[34] Act of Aug. 21, 1935, 16 U.S.C. §431 (1970).

[35] National Historic Preservation Act of 1966, 16 U.S.C. §470 *et seq.* (1970).

[36] National Housing Act of 1949, 40 U.S.C. §1460 *et seq.* (1970).

[37] Housing Act of 1954, 40 U.S.C. §461 *et seq.* (1970).

history, architecture, archaeology, or culture, in addition to those of national significance. Third, the Secretary of the Interior authorized state historic preservation officers to head up preservation efforts at the state level. With the assistance of special state committees, these officers nominate properties within the state for listing on the National Register, devise the comprehensive state plan, and secure and administer grant monies. Finally, Congress established the Advisory Council on Historic Preservation, which, as noted earlier, may comment on the impact of federal or federally assisted projects upon any property listed in the National Register.

The innovation that promises the greatest relief for threatened urban landmarks is, of course, the preservation grants program. The latter, as well as the preservation programs of HUD, are the subject of extensive comment in Appendix I of this study. Three points only need be made at this juncture. First, though initially devoted to preservation planning activities, the Department of the Interior program now authorizes brick-and-mortar grants to be used for the acquisition and preservation of eligible landmarks by public and private agencies. Second, the National Park Service, the program's administering agency within the department, has promulgated regulations that should enable such funds as Congress appropriates for the program to be used with admirable flexibility. Third and most important, the federal appropriations record to date has been disappointing.

The fiscal status of the program since its

TABLE 1. Authorizations and Appropriations under the National Park Service Preservation Grant Program

Fiscal Year	Authorization	Appropriation
1967	$ 2,000,000	$ –0–
1968	10,000,000	300,000
1969	10,000,000	100,000
1970	10,000,000	969,000
1971	7,000,000	5,980,000
1972	10,000,000	5,980,000

Total Appropriated under 1966 Act $13,329,000

Source: National Park Service, 1972.

inception in 1967 is summarized in Table 1.

The $5,980,000 authorized for the entire grants program in 1972 would perhaps have covered the price tag of Chicago's Old Stock Exchange building. Yet that sum had to be divided up among fifty states and the National Trust, and was devoted to statewide preservation plans and surveys as well as to brick-and-mortar projects.[38] It is clear that Congress cannot make good on its promise of "maximum encouragement" for public and private preservation efforts unless it funds the preservation grants program on a more generous basis.

DEPARTMENT OF HOUSING AND URBAN DEVELOPMENT

The federal government's support of local preservation efforts is further reflected in two programs administered by HUD. The first, the Open Space Land Program,[39] consolidates three undertakings — the Open Space, Urban Beautification, and Historic Preserva-

[38] According to National Park Service figures, the specific breakdown for fiscal year 1972 was as follows: (*a*) Planning Studies — $2,214,365; (*b*) Acquisition and Development Projects — $1,781,-462; (*c*) National Trust for Historic Preservation — $1,042,023.

[39] See Housing and Urban Development Act of 1970, 42 U.S.C. §1500 d-1, amending 42 U.S.C. §1500 *et seq.* (1970). In late 1972 President Nixon declared a funding moratorium with respect to

both the Open Space Land Program and the Urban Renewal Program. The President has expressed a preference for terminating these category programs in favor of a special revenue-sharing approach under which local governments would receive federal monies largely free of the restrictions recounted in the text. A shift of this nature would increase the city's flexibility in utilizing federal funds for a Chicago Plan approach to historic preservation.

25

tion programs — that HUD had previously administered on an independent basis. The second is HUD's Urban Renewal Program,[40] which contains a noteworthy historic preservation component.

The generalizations ventured with respect to the Department of the Interior program fairly characterize HUD's programs as well. The latter also provide funds for the acquisition and preservation of eligible properties and for a variety of ancillary preservation activities. The regulations governing the grant awards are thoughtfully drawn to meet the broad range of problems that can arise in the preservation of diverse landmark types. And HUD's programs too have not suffered from a surfeit of funds.

As between the two departments, however, HUD has received greater overall financial support for its preservation activities. For example, Congress authorized $100,000,000 under the Open Space Land Act in 1972, the first year all three of the act's components were funded on a consolidated basis. Of this amount, HUD spent about $5,700,000 on preservation projects.

But the $5,700,000 figure doesn't tell the whole story. Because HUD's open space, urban beautification, and historic preservation responsibilities were integrated by statute in 1970, a single property may qualify for assistance under all three headings. Assume, by way of illustration, that a landmark occupies a congested, somewhat down-at-the-heels urban location. Under the preservation provisions of the 1970 statute, it could be acquired and restored. The urban beautification provisions offer federal assistance for the installation of public improvements, such as lighting, landscaping, and plazas that would improve the building's setting. And the open space sections empower the community to

lessen the congestion of population and buildings around the landmark by acquiring land there and redeveloping it at lower densities.

The extent to which landmarks benefited from urban beautification and open space improvements in 1972 is not known because HUD's internal bookkeeping does not reflect this breakdown. But it seems reasonable to assume that HUD's total 1972 expenditures in aid of landmark preservation substantially exceeded the $5,700,000 specifically earmarked for this purpose under the preservation component of the Open Space Land Act.

HUD's bookkeeping practices under its Urban Renewal Program create comparable problems in assessing the actual dollar amounts expended on behalf of preservation, because HUD does not carry preservation expenditures as a separate entity in its yearly Urban Renewal Program fiscal summaries. Here too, however, there can be little doubt that, properly conceived, the program offers a promising vehicle for landmark preservation. Urban renewal areas typically encompass older, downtown sections of the community where the greater numbers of its landmarks are likely to be concentrated. As pointed out in Appendix I, moreover, HUD's Urban Renewal regulations impose no ceiling on the amount that may be spent to acquire individual landmark properties, an omission of no mean significance considering the magnitude of Congress' annual urban renewal appropriations.

SUMMARY

Preservation exposes contradictory impulses in America's psyche. On one side is a genuine commitment to the goal of safeguarding the nation's historic and architectural heritage. On the other is the bias, deeply rooted in the nation's laissez-faire traditions, that private decisions should be supreme in the market-

[40] See National Housing Act of 1949, 42 U.S.C. §1460 (1970).

place despite their destructive impact on community values. It is this conflict that accounts for the grave attrition of the nation's landmarks. As long as the conflict remains submerged and its tensions unresolved, the bulldozer will continue to exact its grim toll.

The participants in the preservation drama are basically four at the present time: the landmark owner, the city, the state, and the federal government. None has a happy role. The landmark owner is forced, in the first instance at least, to bear up under what threaten to be staggering burdens. He may be required to forfeit enormously lucrative redevelopment opportunities, and to operate an inefficient structure in a fiercely competitive real estate market. That he rarely agrees to shoulder these burdens alone should surprise no one.

But the city's lot is unhappier still. The city bears the ultimate responsibility for the success or failure of local preservation efforts. Private owners look to it for economic redress. The state and federal governments have designed their own preservation programs on the premise that these efforts will be vigorous and effective. If the city fails to deal equitably with the landmark owner, it will, in the words of one commentator, "create a class of buildings which will be shunned like lepers."[41] And if its preservation efforts are not at least minimally successful, the assistance available at the state and federal levels is hardly likely to bail it out.

But the conventional preservation ordinance is not up to the task of fulfilling the expectations of landmark owners or of state and federal governments. Adopting an either/or approach, it seeks futilely to impose the full costs of preservation on the landmark owner alone or on the city. It does so by breaking the landmarks cycle into two stages. The first includes designation and the grace period during which the landmark commission searches frantically for a compromise plan; the second commences at the end of the grace period with the owner's refusal to agree to the proffered plan. The ordinance relies on the community's police power during the first stage, thereby saddling the owner with the burdens of landmark ownership on an uncompensated basis. It shifts to the condemnation solution at the second stage, however, in recognition that uncompensated regulation then might prove constitutionally vulnerable as "confiscation."

This dualism leads in most cases to hopeless deadlock. Owners will not themselves assume preservation's full burdens. And cities simply cannot do so. Hence, the landmarks come tumbling down.

State and federal programs do not offer a way out of the impasse at the present time. And this is so despite the impressive preservation initiatives that both levels of government have sponsored in recent years. State enabling legislation has grown increasingly more sophisticated and comprehensive. Signs of the states' awareness of the economic causes of the preservation impasse are beginning to appear in tax remission and expanded grant programs. For the most part, however, the states have simply tossed the preservation ball back to the local governments, albeit with their warm blessings.

The federal government has gone further in identifying the root economic problems and in designing programs, such as those of HUD and the National Park Service, that are at once flexible and realistic. But the niggardly levels at which these programs are presently funded preclude them from spearheading any dramatic changes in the preservation picture. Hopefully, the welcome if belated concern of the state and federal governments for local preservation efforts will soon be reflected in the expanded aid that the cities so urgently require.

[41] J. Pyke, *Landmark Preservation, supra* note 16 at 28.

2
The Chicago Plan

Urban landmarks are in deep trouble. Salvation, if it comes at all, must come through the cities. But current municipal preservation efforts have alienated landmark owners and failed to insure an optimal return on the limited state and federal preservation dollars that have become available in recent years. The cities, therefore, must redirect their efforts to take account of both factors. Landmark owners must be shielded from the often severe economic burdens that they suffer under the conventional preservation ordinance. And the cities' requests for federal and state aid must be held to levels that are realistic in light of the competing demands upon the resources of these governments.

No single initiative, of course, is going to usher in the New Jerusalem in preservation. As a nation, we have permitted our preserva-

tion problems to fester for too long. The economic difficulties confronting preservation, moreover, are too grave and varied to give way to any but a concert of soundly conceived approaches involving all levels of government. Despite these qualifications, the plight of at least one class of landmarks — the urban, centrally located building in private ownership — can be alleviated through incentive zoning implemented under a program referred to in this study as the "Chicago Plan."[1]

INCENTIVE ZONING: A DEPARTURE FROM TRADITIONAL PROPERTY AND LAND USE CONCEPTS

Incentive zoning[2] has evolved over the last decade in response to growing awareness that the profit motive is frequently at loggerheads with sound urban design. As the predicament

[1] Although the Plan has not as yet (Spring 1973) been adopted in Chicago, the label "Chicago Plan" nevertheless seems apt for three reasons. First, the Plan's immediate impetus was the threat to Chicago's Old Stock Exchange building, which was eventually razed in 1972. As a result of the Stock Exchange controversy, the writer co-authored a study setting forth the Plan's structure in rudimentary form. See J. Costonis & J. Shlaes, *Development Rights Transfers: A Solution to Chicago's Landmarks Dilemma* (Chicago Chapter Foundation of the American Institute of Architects & National Trust for Historic Preservation, May 1971). In addition, the Illinois legislature moved quickly to adopt a statute drafted by the writer which autho-

rized Chicago and other Illinois municipalities to implement the Plan. This statute appears in Appendix II of this study. Second, the economic case studies contained in Chapters 3 and 4 deal with four Chicago School of Architecture landmarks, each located in the Loop. Finally, a demonstration program employing the Plan has been proposed by the Department of the Interior which envisages that twelve Chicago School buildings will serve as the "cornerstone" of a "National Cultural Park" to be established principally within the Loop. See p. 62 *infra*.

[2] The literature on incentive zoning is relatively meager. The pertinent studies include N. Marcus & M. Groves, eds., *The New Zoning: Legal, Ad-*

ZONING BONUSES AND URBAN AMENITY

The amenities provided under municipal zoning bonus programs enhance the urban environment in America's center city areas. Examples include plazas such as that of the First National Bank in Chicago (above) and arcades like that of Chicago's Brunswick Building (right).

of historic preservation itself attests, the most lucrative private development decision is not necessarily one that enriches the urban environment. By modifying the economics of downtown development, incentive zoning programs seek to encourage decisions that the harsh realities of the marketplace would normally preclude. These programs have taken two principal forms to date: zoning bonuses and development rights transfers. Both proceed from the premise that in return for the right to build larger and hence more profitable structures, developers will agree to provide or finance urban amenities. They differ, however, in a variety of respects that are explored in the following paragraphs.

Zoning Bonuses

Zoning bonuses are simply additional increments of density granted as a quid pro quo for the inclusion in the developer's project of one or more specified amenities, such as plazas, arcades, subway concourses, or even theaters.[3] In theory, the amount of the bonus should equal or slightly exceed in value the cost that the developer will incur in providing the amenity.

The following example is illustrative. Suppose that Greenville wishes to encourage developers to include arcades in their downtown developments. Under the Greenville zoning ordinance, the density regularly permitted for zoning lots is determined by multiplying the area of the lot by a factor known as a floor area ratio (FAR), the product being the number of rentable square feet that may be included in the structure. A developer owning a 20,000-square-foot lot in a zoning district

having an FAR of 10, for example, may construct an office building containing 200,000 (20,000 × 10) square feet of rentable floor area. If Greenville determines that the arcade will cost the developer an additional $50,000 and that the value of a square foot of rentable floor area is $5, it will offer the developer a zoning bonus of slightly more than 10,000 square feet of rentable floor area. And if the developer opts to provide the arcade, he may then construct an office tower containing 210,-000 square feet.

But doesn't the city invite urban design chaos by trading off extra floor area for an amenity? If, for example, Greenville's underlying 200,000-square-foot limitation is rational, won't the addition of 10,000 square feet of bonus space upset the applecart by overloading public facilities and encouraging buildings that are out of scale with their neighbors? The answer to both questions depends upon how well the city's planners have done their job. Obviously, the bonus concept will backfire if bonuses are freely bestowed with inadequate attention to their design and economic consequences. Exhibit Number 1 is Chicago's zoning bonus system, which is considered at length in the following chapter.

Where cities have done their design and planning homework, on the other hand, the trade-off of space for amenity has worked to the advantage of the public as well as the developer. This is so because there is considerably more flexibility in setting the proper density for downtown parcels than the zoning codes, with their fixed numbers and precise density schedules, tend to suggest. Indeed, the use of *fixed numbers,* e.g., 200,000 square feet,

ministrative, and Economic Concepts and Techniques (1970); Costonis, "The Chicago Plan: Incentive Zoning and the Preservation of Urban Landmarks," 85 *Harv. L. Rev.* 574 (1972); Marcus, "Air Rights Transfers in New York City," 36 *Law & Contemp. Prob.* 372 (1971); Note, "Development Rights Transfers in New York City," 82

Yale L. J. 338 (1972); Comment, "Bonus or Incentive Zoning — Legal Implications," 21 *Syr. L. Rev.* 895 (1970); cf. Urban Land Institute, "New Approaches to Residential Land Development: A Study of Concepts and Innovations" (Tech. Bull. 40, 1961).

[3] See note 8, p. 130 *infra.*

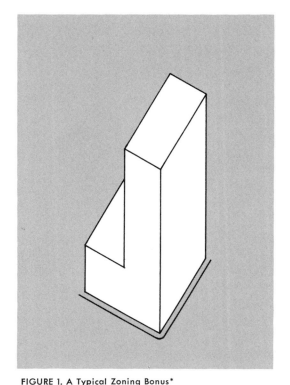

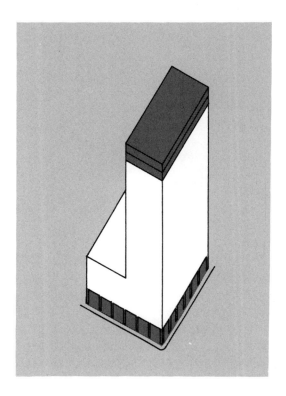

FIGURE 1. A Typical Zoning Bonus*

A. Office building utilizing maximum FAR with no bonus space.

B. Office building with an amenity (arcade) for which a zoning bonus of additional floor area is awarded.

rather than a *range of density,* e.g., between 190,000 and 210,000 square feet, is quite arbitrary from an urban design viewpoint.[4] Assuming that density increases on individual parcels are held within an overall range that is defensible in urban design terms, the allocation of density on a flexible basis, as under the bonus system, should cause no alarm on the planning side. The reason why our cities have opted to regulate density on a rigid basis lies in the legal rather than the planning domain: to protect property owners against official impropriety. A precise schedule of density limitations deprives zoning officials of the opportunity to disguise favoritism or discrimination under the mantle of "administrative discretion."

[4] See p. 132 *infra.*

The amenities called for under the bonus system afford additional flexibility in fixing the density of downtown parcels. Most are intended to increase open space at the street level or above, thereby facilitating pedestrian movement and avoiding the "dark canyon" effect experienced, for example, in New York's Wall Street area, where tall buildings cover their entire lots. A parcel that includes an open space amenity, therefore, can absorb or, as urban designers say, "digest" greater density than one that does not. Accordingly, it does not necessarily follow that because Greenville normally restricts owners of 20,000-square-foot parcels to buildings containing 200,000

* Illustrative examples are not related to text in regard to lot size and building floor area and height. The scale has been slightly exaggerated to better illustrate the concepts discussed in text.

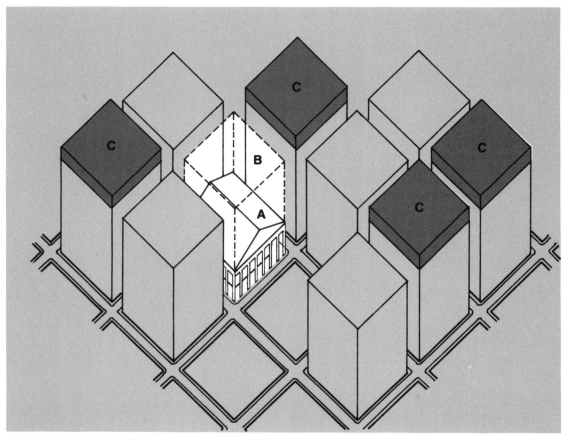

FIGURE 2. Development Rights Transfer

The landmark building (A) utilizes only a fraction of the development rights of the site, the remainder of which (B) are transferred to various other sites within a transfer district and appear as additional bulk (C) on neighboring buildings.

square feet, Greenville does violence to its planning regime when it permits developers providing arcades on 20,000-square-foot lots to erect buildings containing 210,000 feet.

Development Rights Transfers

Development rights transfers are somewhat more complicated than zoning bonuses. Their purpose is to relieve the market pressures that threaten low-density uses, such as landmarks, with replacement by high-density substitutes that promise a greater economic return. Assume, for example, that Smith, our friend from Chapter 1, owns a landmark in Green-

ville containing 100,000 square feet of rentable floor area on the same 20,000-square-foot lot used in the foregoing example. As a rational investor, Smith will be sorely tempted to tear down his landmark (the low-density use) and replace it with a building (the high-density use) containing the full 200,000 square feet allocated to the site. Under the development rights transfer technique advocated in the Chicago Plan, however, Smith would be permitted to transfer his lot's 100,000 square feet of unused development potential, referred to here as development rights, to other sites within the area. Owners of these sites will

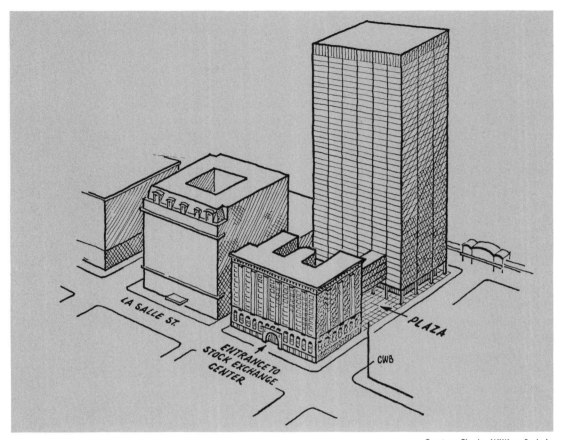

DEVELOPMENT RIGHTS TRANSFERS AND LANDMARK PRESERVATION

When the threat to Chicago's Old Stock Exchange building first became apparent in 1968-69, the Chicago Chapter Foundation of the American Institute of Architects urged that the building be protected through the transfer of its unused development rights to the lot at its rear for use in a modern office tower. Pursuant to this proposal, the tower is pictured as exceeding prevailing density limits by the amount of unused floor area at the Stock Exchange site.

presumably be prepared to pay Smith the cash value of the development rights because the latter enable them to build proportionately larger and hence more profitable structures on their sites.

Development rights transfer programs differ from zoning bonus programs with respect to the source of the additional density that is made available to developers and the location of the amenity in relation to the project incorporating the additional density. The first difference makes the transfer technique a somewhat less worrisome urban design tool than the zoning bonus; the second has the opposite effect.

The source of the extra density obtained by development rights purchasers is, of course, the low-density use from which the transfer is made. Because the excess development rights of the low-density use have already been authorized by the city's zoning code, development rights transfers do not account for any net increases in the city's density. Stated another way, transfer programs do not *create* new

space; they merely *redistribute* space that has already been authorized.

Bonus space, on the other hand, is created *ex nihilo* by the city. Unlike transfer programs, therefore, bonus programs inject new increments of density into the community. Hence, cities that adopt bonus programs must exercise special caution to insure that the prescribed amenities will in fact digest this wholly new density. To the extent that the amenities fail to do so, the city will be saddled with demands upon its public services and facilities that it is unable to satisfy.

Bonuses are less troublesome than transfers, however, from the standpoint of the relative locations of the amenity and of the structure exceeding normal zoning ceilings. Both the amenity and the larger building are located on the same lot in the bonus situation. Given this close physical proximity, the digestion rationale becomes plausible. The additional light and air or the more efficient pedestrian circulation afforded by the amenity, for example, can be shown, in rough terms at least, to cancel the potential disadvantages attributable to the building's increased floor area or the heightened pedestrian traffic that it generates.

Under the transfer component of the Chicago Plan, on the other hand, the amenity — the landmark — and the larger building may be physically distant. The digestion rationale, therefore, is not as compelling. There is no doubt that the preservation of a group of landmark buildings enriches the amenity level of the entire neighborhood. But this fact will offer little solace to the apartment dweller who finds himself in shadow all day because the building next door incorporates an additional ten stories transferred from a landmark site four blocks away. In consequence, cities adopting development rights transfer programs must be prepared to look primarily to general planning controls to avoid the risks of urban design abuse that these programs pose.

34

Incentive Zoning and Traditional Property and Land Use Conceptions: A Comparison

PUBLIC REGULATION AND PRIVATE PROPERTY

Incentive zoning frankly recognizes that the value of a downtown parcel is largely a function of public (zoning) regulation. Though seemingly obvious, the point tends to be obscured by the fixed idea, traceable to medieval English law, that one's rights with respect to land are wholly dependent upon the particular type of ownership interest or "estate" that one holds in it. Under this conception estates or interests are arranged hierarchically, with the fee simple absolute at the top followed by various types of "qualified" fees, life estates, leaseholds, and, somewhere near the bottom, the lowly license, the interest that the theatergoer's ticket gives him in his seat for an evening's performance. Zoning, a relative late-comer to the property scene, is vaguely acknowledged as modifying this picture somewhat, though alien at base to the core concept of ownership.

Serviceable in an agrarian society with the crudest of land use controls, if any, the traditional view is decidedly inadequate today. The premise that fee ownership is somehow more substantial or noble than leasehold tenure, for example, ignores that developers are often tenants rather than fee owners of the downtown parcels on which their skyscrapers are built. Similarly, the development options open to owners or tenants of these parcels are essentially a product of bulk, use, and height zoning rules imposed by government; they derive only tenuously from the supposedly "inherent" prerogatives of property ownership. The value of these parcels, moreover, is largely created by government's investment in subways, streets, sanitation and police forces, and a variety of other municipal services and facilities.

It does violence, in short, to view the owner of a parcel at, let us say, New York City's

Madison Avenue and 42nd Street as having wrested his property from the state of nature by his own hands, and as being entitled therefore to exploit it free of any but self-imposed constraints. Unlike the world of John Locke, Thomas Jefferson, and other political philosophers who advocated a relatively simplistic conception of private property, ours is a highly urbanized society in which pervasive land use regulation is imperative for the common good. It is one, moreover, in which downtown land values are largely the creature of public investment. Both factors — the necessity for land use regulation and the role of public investment as a determinant of the value of downtown property — can only increase in importance over the remainder of this century. Hence, urban space should no longer be regarded simply as "private" property, to be used as the developer's own sweet will dictates. Rather, it has become in part a public asset which cities may properly allocate through incentive zoning to achieve community goals that have consistently been frustrated under outdated but deeply engrained property and land use concepts.

SEPARATION OF OWNERSHIP AND DEVELOPMENT POTENTIAL

Incentive zoning also questions the equally hallowed premise that the development potential of any parcel must be used *only* on that parcel. This premise derives from a time when zoning and other forms of public land use regulation were unknown. Absent zoning, the notion that each parcel has a discrete amount of development potential that, upon transfer, could augment the development potential of other parcels, would make little sense. The premise is probably also tied to the geographical uniqueness of land. If each parcel of land is locationally unique, it has apparently been thought, there can be no exchange of development potential from one parcel to another.

But this reasoning is not persuasive because land, including its development potential, has a monetary equivalent that can be exchanged. This fact is affirmed every time government condemns a parcel: from the nation's beginnings, American courts and legislatures have treated the condemnation award as a fully adequate substitute for the condemned parcel. Again, private investors and speculators, undaunted by the locational uniqueness of land, routinely trade parcels on the basis of their comparative value.

The premise that development potential is non-transferable is troublesome for reasons other than faulty logic or inattention to twentieth-century property developments. *It lies at the root not only of the landmarks bind but of numerous other design and environmental problems created by pressures for the redevelopment of low-density uses to higher densities.* Examples of the latter can be multiplied virtually without end. In downtown Manhattan, the developer-owner of the Tudor Parks, described by the *New York Times* as "two quiet green islands suspended above the compacted chaos of East 42nd Street in the privately-owned Tudor City development,"[5] announces plans to erect high-rise buildings on them. In Cambridge, Massachusetts, the owner of land situated between the site of the Kennedy Library and the Charles River seeks a permit to build an eight-story Holiday Inn that will blot out the proposed three-story buildings designed by I. M. Pei for the library and shatter the delicate spatial relationships that constitute the skyline along the Charles River.[6] In rural Morris County, New Jersey, the owner of a wilderness area[7] critical to the region's ecosystem commences excavation of a massive

[5] *New York Times*, Oct. 4, 1972, p. 42, col. 4.
[6] See *New York Times*, Sept. 27, 1972, p. 49, cols. 1-4, p. 78, cols. 5-7.
[7] See Morris County Land Improvement Co. v. Parsippany-Troy Hills Tsp., 40 N.J. 539, 193 A.2d 232 (1963).

35

gravel pit as a prelude to eventual subdivision and commercial development.

Despite their varied settings, these problems are all products of the redevelopment-to-the-highest-density syndrome. So long as the premise of non-transferability prevails, the syndrome will continue to raise havoc with the nation's design, environmental, and cultural preferences. The value of land, after all, is measured by what can be done with it. To prohibit development on a particular piece of land without providing alternative sites for equivalent development is, therefore, to destroy the land's value. Yet this is precisely what our property and land use systems accomplish by virtue of their largely unexamined commitment to the non-transferability principle.

In consequence, these systems are working at cross-purposes with themselves. Because we want to preserve landmarks, parks, and wilderness areas, we prohibit redevelopment by stretching the police power to its outermost limits and, not infrequently, beyond. But by refusing to permit the bottled-up development potential to go elsewhere, we effectively destroy the land's value contrary to the constitutional ban against uncompensated takings. And because we lack the public funds to acquire the imperiled low-density resource, we are forced to acquiesce in its obliteration or redevelopment when the inevitable constitutional challenge is made.

This futile ritual of marching up the hill only to march back down again is celebrated daily in the landmark field. Landmark designation, it is clear, forestalls the use of the landmark's excess development rights. They cannot be employed in redeveloping the landmark site since redevelopment would spell the end of the landmark. Nor can they be utilized in new construction in the airspace over the landmark building, as the Penn Central Company has discovered in its futile efforts to date to per-

suade the New York City Landmarks Commission to permit it to erect a second Pan-Am tower over the Grand Central terminal. But neither can their value be recouped on alternate sites, thanks to the non-transferability principle. Their value, therefore, drops to zero. And thus the stage is set for one more landmark brouhaha, ending, almost certainly, with one less landmark.

The developments rights transfer component of the Chicago Plan breaks the linkage between the ownership of a particular site and the latter's development rights. These rights can be concentrated or dispersed as community goals and urban planning criteria dictate, and are therefore freed from the straitjacket clamped upon them by the accident of ownership. Cities can convert the landmarks' unused development rights into hard cash by authorizing their sale for use on non-landmark sites. And they can compensate landmark owners with the income derived from development rights sales. In short, they can have their cake and eat it too. Not only are landmarks preserved through the transfer program but the cities avoid either dipping into scarce general revenues or making unrealistic requests upon higher levels of government in the process.

INCENTIVE ZONING AND MUNICIPAL FINANCE

Cities have traditionally looked to general revenues to finance many of the public and quasi-public amenities that now figure prominently in incentive zoning programs. Because landmarks, open space plazas, and the like benefit the community generally, it was felt, their costs should be borne by the community as a whole. But times have changed. The increasingly severe budgetary problems of the cities have produced a situation where the facilities will not be provided at all if they must be financed exclusively out of general revenues. Hence, the search has begun for ap-

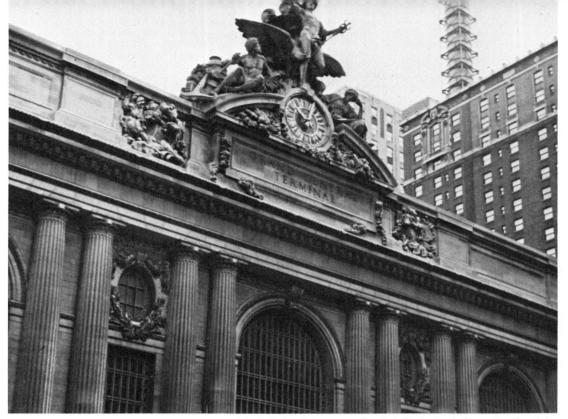

GRAND CENTRAL TERMINAL: A BATTLE
FOR AIR RIGHTS

As owner of the site of New York City's Grand Central Terminal, the New York Central Railroad has been prevented by the New York City Landmarks Commission from leasing the air rights over the terminal to a developer for the construction of an office tower directly above it. The commission has scorned the venture as, in part, an "aesthetic joke." The Penn Central Company (the New York Central's successor) thinks otherwise and has gone to court to prove its point. The decision was still pending as of spring 1973.

proaches that will enable the city to shift the cost of these facilities from the community overall to developers as a discrete segment within the community. Two principal approaches have emerged. The first is based on a cost/benefit rationale; the second justifies the shift by reference to the promotion of the community's general welfare.

Illustrative of the first approach is the municipal practice of requiring developers to absorb the costs of public facilities the need for which is created by their developments. The municipality might insist, for example, that the builder of a 150-home subdivision set aside ten acres or so for a park or, in the alternative, pay a prescribed amount into the local recreation fund. Since his subdivision is responsible for the additional recreational facilities, it is reasoned, he — rather than the community as a whole — should be required to bear their costs.[8]

This approach has its roots in the special assessment technique under which the city charges landowners for the cost of local improvements, such as curbs, gutters, and sidewalks, that are necessitated by and that uniquely benefit their specific properties. But it goes well beyond this technique by expanding the type of facility that is financed on this basis. In the past, parks or similar facilities were viewed as part of the community's general social overhead, and thus properly fundable only out of general tax levies.

The cost/benefit rationale is not helpful in the incentive zoning context however. It is difficult to see how a developer who builds an office tower can be said to create the need for preserving the city's landmarks or for providing amenities such as theaters, subway concourses, or open space plazas that zoning bonus provisions prescribe. On the contrary, the city desires these facilities *independently* of his project in most cases. The project merely serves as the vehicle for financing the costs that the city would otherwise incur in pursuing these objects itself.

If the cost/benefit rationale were applicable to incentive zoning, moreover, the city could force the developer to furnish the desired amenity and it could refuse to compensate him for his troubles. Most incentive programs do neither. They are typically cast as *options* which the developer may but need not elect. If he declines the option, he loses out on the floor area premium. On the other hand, if he furnishes the amenity or makes a payment in lieu of doing so, he receives compensation in kind in the form of lucrative development privileges not enjoyed by other property owners as a matter of right.

Support for incentive zoning programs must therefore be found in the general welfare rationale. Defenders of these programs must be prepared to argue that, as suggested earlier, urban space is in part a public asset that may be allocated to achieve community goals falling within the ambit of the general welfare. Stated so bluntly, the proposition seems a startling departure from traditional land use practice. In truth, its roots trace back at least to 1926, the year the U.S. Supreme Court gave its imprimatur to zoning in *Euclid v. Ambler Realty Company*.[9] It is, moreover, entirely a creature of the trend that has marked the following half-century to expand the legitimate ambit of governmental land use

[8] For unsuccessful legal challenges to this reasoning, see, e.g., Jenad, Inc. v. Village of Scarsdale, 18 N.Y.2d 78, 218 N.E.2d 673 (1966); Jordan v. Village of Menomonee Falls, 28 Wis.2d 608, 137 N.W.2d 442 (1965). A subdivision exaction was ruled unconstitutional by the Illinois Supreme Court in Pioneer Trust & Sav. Bank v. Village of Mount Prospect, 22 Ill.2d 375, 176 N.E.2d 799 (1961), but only because the court found that the need for the exaction (a 6.7-acre school site) was not "specifically and uniquely attributable" to the developer's subdivision. *Ibid.* at 381, 176 N.E.2d at 802.
[9] 272 U.S. 365 (1926).

powers. More detailed discussion of these essentially legal points is deferred to Chapter 6, "The Chicago Plan and the Law."

INCENTIVE ZONING AND MUNICIPAL PLANNING

Incentive zoning promises dramatic improvements in fields such as landmark preservation because it offers the city unprecedented leverage over private development decisions. But this advantage comes at a steep price: the willingness of the city to do the kind of planning homework that is all too rare at the municipal level today.

Two considerations point up why thorough planning is — or should be — an absolute prerequisite to the adoption of incentive programs. First, any incentive program, be its object landmark preservation, open space amenities, or whatever, is only one component of the city's overall planning regime. It must not be permitted either to distort that regime or fall captive to a special-interest group, such as downtown developers. To guard against both risks, the city must be clear on the identity and relative priority of the mélange of development policies that, expressly or tacitly, constitute its comprehensive plan. This is a tall order, even for cities with substantial planning staffs and a commitment to sound planning. It may well be out of reach for the remainder.

Second, the traditional zoning ordinance, which limits all lots in a zoning district to the same density ceiling, presents fewer urban design challenges than an ordinance that authorizes zoning bonuses or development rights transfers. Once its density ceilings are set, the traditional ordinance is virtually self-executing with respect to density allocations. The same cannot be said for ordinances that permit selective bulk increases. Where bonuses are awarded, the amount of the bonus space must be sensitively correlated with the prescribed amenity's capacity to offset the building's greater bulk. In the case of development rights transfers, the redistribution of the low-density use's excess rights must not occur at the cost of disrupting either the area's public services or its dimensional scale.

These problems are compounded by the fact that far less is known about the consequences of allocating density on a selective basis than municipal planners and urban design specialists are wont to admit. Current land use practice, after all, is still very much in the grip of the premises that all lots of equal size must have the same density and that the development rights of any lot must be used on that lot. Cities have had relatively little experience with approaches, such as the transfer of development rights, that question whether a system of land use regulation constructed on these premises can protect community interests against the onslaught of private market forces. Their increasing recourse to incentive zoning, moreover, reflects not so much their confidence that it will work as their knowledge that traditional techniques have not. Hence, we can expect a period of trial and error which should provide the information needed to make a cogent assessment of incentive zoning's costs and benefits. The Chicago Plan affords an opportunity to test out many of its implications on a modest scale and in the service of a cherished but ailing community goal.

THE CHICAGO PLAN: DEVELOPMENT RIGHTS TRANSFERS AND THE PRESERVATION OF URBAN LANDMARKS

An Overview

The discussion of the economics of landmark ownership in Chapter 1 touched upon four characteristics that are fairly common among urban landmarks throughout the United States. First, most are undersized in relation to current zoning and building prac-

tices. Second, most can be profitably managed. Their vulnerability does not typically derive from a negative cash flow but from the disproportionate value of their sites in relation to the landmark buildings. Third, these buildings tend to be concentrated in one or more reasonably compact areas of the city, usually in its downtown section. Finally, public services and facilities will often be most plentiful in these areas, thereby enabling them to absorb large numbers of people with greater efficiency than the city's other areas.

Taking these four characteristics as its point of departure, the Chicago Plan builds upon the development rights transfer technique to secure the preservation of urban landmarks at minimal cost to the nation's cities. Briefly, cities adopting the Plan might choose to implement it essentially on the following basis.[10] The city council, upon the recommendation of its landmark and planning commissions, begins by establishing one or more "development rights transfer districts," which, under the version of the Plan assumed here, would roughly coincide with the areas where downtown landmarks are concentrated. Upon designation of a landmark or at any time thereafter, its owner would be entitled to transfer its excess development rights to other lots within the transfer district and to receive a real estate tax reduction reflecting the property's decreased value. Transfers could be made to one or more transferee lots, but increases in bulk on the latter would be subject to defined ceilings as well as to other planning controls prescribed by ordinance. In

[10] Referring to the Chicago Plan in the singular is somewhat misleading because the precise details of its implementation in a given community will differ depending upon local circumstances and preferences. The version of the Plan set forth in the text, therefore, is intended to illustrate the Plan's general operation only, not to foreclose the use of the various alternative approaches to the Plan's implementation identified in later sections of this chapter and in the chapters that follow.

return for these benefits, the landmark owner would be required to convey a "preservation restriction" to the city. That instrument would forbid redevelopment of the site and obligate the present and future owners to maintain the building properly.

Suppose the landmark owner rejects the transfer option and insists upon redeveloping the site. In that case the city could invoke its eminent domain powers to acquire a preservation restriction and the landmark's associated development rights. Acquisition costs and other expenses of the program would be funded through a municipal "development rights bank." Into the bank would be deposited development rights that have been condemned from recalcitrant landmark owners, donated by owners of other private landmarks, and transferred from publicly owned landmarks. The city would meet program costs by selling these pooled rights from time to time subject to the same planning controls that apply to private owners.

Development rights transfers under the Chicago Plan redistribute preservation costs in a manner that should make landmark retention practicable for municipalities and landmark owners alike. Transfer authorizations — or cash awards if the city must resort to condemnation — and real estate tax relief compensate the landmark owner for his losses. Eliminating the landmark's development potential by acquisition of the preservation restriction decreases the site's value and extinguishes speculative interest in it. It is as though the site's development potential were so much air that, through the transfer mechanism, is released from a balloon. Landmarks remain in private use to serve the city's commercial needs, rather than becoming dead museum space. In turn, the city avoids outlays for outright fee acquisition, restoration, and maintenance, and may continue to tax the landmark property, albeit at a lesser rate.

DENSITY TRANSFERS WITHIN THE CENTRAL CITY: WASHINGTON, D.C.

Preservation of the Christian Heurich Memorial Mansion (at right in the model), built in 1892 and located near Washington's Dupont Circle, would be facilitated by the transfer of the landmark's unused development rights to an office building to be constructed nearby (center). Under a pending proposal, the Columbia Historical Society, owners of the landmark, will receive $525,000 from the transfer and have agreed both to devote these funds to the restoration and maintenance of the landmark and to record restrictions upon the landmark's interior, exterior, and grounds in accordance with the National Capital Planning Commission's plans for the area.

But tax losses on that property should be largely offset by increased tax yields from the larger buildings erected on the transferee sites. And in return for their contribution to the landmarks program, development rights purchasers receive full value in the form of extra floor area for their projects.

The Chicago Plan: Its Elements
THE INCENTIVE PACKAGE

The Chicago Plan compensates the landmark owner for the actual losses that he suffers upon designation. Prior to proposing designation of his property, the landmark commission will obtain an appraisal, comparable to those appearing in Chapter 3, that details the economic consequences of designation. The appraisal will also enumerate any structural defects, restoration or rehabilitation requirements, or unique maintenance problems that threaten to further intensify the burdens of private ownership. On the basis of the appraisal, the commission will then devise a package to compensate the owner that will include both an appropriate real estate tax reduction and an authorization to transfer the landmark's unused development rights. An additional subsidy, funded by the municipal development rights bank, may be included to cover losses not met by the package and to deal with any special difficulties affecting the building.

The value of the landmark's development rights may be greater or lesser at the landmark site than at the transferee site or sites. To insure that the landmark owner receives the dollar equivalent of these rights as valued at the landmark site, the landmark commission may choose between two alternatives. Under the first, it may permit or even require the landmark owner to sell these rights to the municipal development rights bank for a predetermined sum. The city itself would then resell these rights in the open market, and

thus assume the risk or enjoy the benefit of a lesser or greater return respectively. This alternative centralizes control over development rights transfers in the city and guarantees that the owner will in fact receive a specified sum for the rights. But it also requires the city to have substantial start-up funds in the bank to cover initial acquisition costs, a problem that could prove acute if the resale of these rights is delayed by a sluggish real estate market.

Second, the commission can prepare and periodically update an index of the value of a stated increment of development rights for all parcels within the development rights transfer district. With each sale of development rights by the landmark owner, a sum representing their total dollar equivalent will be debited on the basis of the figure indicated for the site to which the rights are actually transferred.

Assume, for example, that the commission fixes the dollar equivalent of the transferable rights for a given landmark at $1,000,000 and the value of a square foot of rentable floor area at $5 for Lot A and at $10 for Lot B, both lots being within the transfer district. The landmark owner would be debited $1,000,000 upon the transfer of 200,000 square feet of rentable floor area to Lot A or of 100,000 square feet of rentable floor area to Lot B. If the rights from the same landmark property are divided between the two lots, these figures would of course have to be adjusted.

As a variation of the second alternative, the commission could independently determine the value of each development rights transfer as it occurs, and debit the landmark owner's account accordingly.

The second alternative would not require a heavily capitalized development rights bank because these transfers would take place in the private sector between the landmark owner and the development rights purchasers

DENSITY TRANSFERS ON THE SUBURBAN FRINGE

The broad applicability of density transfer techniques is confirmed by the use of a density transfer to preserve Old Locust Grove Farmhouse in Montgomery County, Md. The developer of the twenty-acre tract which includes the landmark was permitted to transfer density (measured by the amount to which he would have been entitled had the landmark been razed) from the landmark to condominium apartment buildings elsewhere on the tract. In return, he agreed to restore the landmark at a cost of $70,000 and to record a facade easement in favor of the county.

with whom he chooses to deal. Offsetting this advantage is its potential for deterring the voluntary participation of landmark owners in the transfer program. They may balk because they may not wish to commit themselves in advance to accept either the figures set forth in the index of values or the commission's independent appraisal of what the owner ought to have received in an actual development rights transfer. The extent of this risk is not easily assessed, however, because downtown properties are bought and sold every day on a basis that is compatible with the appraisal techniques that are envisaged under the second approach.

The tax reduction element of the incentive package should prove especially attractive to

landmark owners because real estate taxes are the largest single item in the cost of operating downtown buildings. Tax reduction under the Plan will be geared to the drop in appraisal value that landmark properties suffer as a result of permanent designation. Since that value may plummet as much as 50 percent upon designation in some cases,[11] the corresponding tax savings will have a dramatic impact upon the profitability of landmark buildings.

The tax *reduction* called for under the Plan should not be confused with the tax *exemption* that some states extend to landmark properties. Exemptions, which are typically granted as a matter of legislative grace,

[11] See pp. 72-73 *infra*.

have been severely criticized as distorting the state taxing structure by using it to subsidize certain classes of taxpayers. Whatever the truth of that charge, it has no relevance in an evaluation of the Plan's merits. The tax reduction envisaged by the Plan must be granted as a matter of right under the constitutional or statutory provisions found in most states mandating that all real estate be assessed at "actual" or "fair market" value.[12] Inclusion of the tax reduction element in the Plan's incentive package, therefore, merely confirms existing state law respecting the assessment of encumbered properties; it does not create a tax loophole. Its practical effect is to strengthen the landmark owner's hand in his efforts to obtain fair assessments.

THE PRESERVATION RESTRICTION

Despite the added financial resources of the development rights bank, municipalities will probably be unable to acquire all of their landmarks outright or, as lawyers say, in "fee." Over and above the staggering amounts necessary for acquisition itself, the city would have to absorb restoration and maintenance expenses and cross the landmark property off the tax rolls altogether. Nor would the option of outright acquisition be desirable even if it were feasible on an across-the-board basis. Governmental acquisition often signals the conversion of landmarks into museums. Yet the character of most urban landmarks derives as much from their vital commercial presence as from their formal architectural attributes, as a visit to New York's Grand Central Station or Chicago's Rookery building confirms. Hence, they should be permitted to continue in their original use or, where appropriate, in an adaptive re-use with as little governmental interference as possible.

These are the principal reasons why the Chicago Plan envisages that cities will gen-

12 See Appendix IV.

erally acquire a less than fee preservation restriction rather than a full fee interest in landmark properties. But there are other advantages as well. The preservation restriction enables landmark owners to qualify for federal and state income tax[13] and local real estate tax[14] benefits that they might not otherwise enjoy. In addition, it is a useful vehicle for detailing the obligations attendant upon the ownership of a landmark property. These obligations can also be outlined to some extent in the municipal landmark ordinance. But the needs of both city and landmark owner are better served by an instrument that has been carefully tailored to the unique problems of individual properties. Finally, recordation of the preservation restriction in the pertinent deeds registry offers accurate notice to mortgagees, purchasers, and other interested parties of these continuing ownership obligations.

Exceptional cases will arise, however, when the city should probably choose to acquire landmark properties outright. Structural unsoundness, advanced deterioration, or changes in the surrounding neighborhood may severely erode a landmark's earning potential. Because of its marginal profitability, it may quickly become a distressed property. Municipal acquisition in fee will avoid this complication and insure that the city will not have to mount a salvage operation to protect its investment in the landmark.

What will be included in the preservation restriction? At a minimum, the restriction should address the following concerns: the legal authority upon which its acquisition is based; restrictions on use, including covenants forbidding demolition or material alteration; restoration requirements, if any, and maintenance obligations; remedies; and duration.

The basis of the city's powers to acquire and enforce preservation restrictions should

13 See Appendix III.
14 See Appendix IV.

be spelled out in the instrument. This task will be complicated in many states by the considerable confusion surrounding municipal powers to obtain less than fee interests such as preservation restrictions.[15] But it must be handled convincingly. Should the restriction not be enforceable, the Chicago Plan would quickly become unstuck. Restrictions on the demolition or alteration of the landmark property would become meaningless. The eligibility of landmark owners for certain federal and state income tax benefits and for local real estate tax relief would be seriously compromised. And the property would fail to qualify for HUD and National Park Service preservation grants, which, as pointed out in Appendix I, are conditioned on the enforceability of the less than fee interest that the grantee acquires in the aided property.

Use restrictions will be as varied as the character and setting of the individual landmarks themselves. A ban on demolition or material alteration of the landmark, of course, should appear in every preservation restriction. In addition, controls should be placed upon the erection of signs and the subdivision of or addition of new buildings to the landmark site as well as upon any use that threatens to impair the historic or architectural integrity of the landmark. Provision should be made for periodic inspection of the landmark by the municipal landmark commission and for that body's prior approval of any minor alterations of the building.

Maintenance obligations may also be variously stated. In some cases, cities may be content simply with the owner's agreement to keep the property in good repair. In others, they may insist that the owner comply with special property maintenance standards incorporated by reference into the preservation restriction. The definition of these standards should prove no more difficult for downtown

[15] See pp. 151-57 *infra*.

landmarks than for other centrally located office and commercial buildings. Mortgagees and tenants of these buildings routinely include detailed maintenance specifications in their mortgage and lease agreements.

Restoration obligations will be required only when the landmark commission determines that restoration is necessary to safeguard the landmark's historic or architectural integrity. In such cases, the financial package that the commission proposes to the landmark owner may include sums for this work. If so, the needed restoration and any attendant maintenance practices should be set forth in the preservation restriction or in proper contractual form as required by local law.

The remedies clause should identify who may sue to enforce the restriction and what type of relief may be obtained. The city itself, of course, should be a named beneficiary in every restriction. Other parties may include any state or federal agencies that have provided funds for the landmark's preservation and, perhaps, local historic societies and property owners' associations. A broad range of relief encompassing injunctive and monetary remedies should be available upon breach of the restriction by the landmark owner or his successors in title.

The most troublesome problem that the restriction must address is the time frame of preservation. Regrettably, downtown office buildings in active use offer a more acute preservation challenge than, let us say, the Great Pyramids of Egypt or, closer to home, Chicago's Water Tower. The physical life of these landmarks is virtually perpetual. Because they are not operated for profit by private owners, moreover, their economic life is not imperiled by market constraints.

Downtown office and commercial buildings are not so fortunate. Their physical and economic lives may be considerably shorter. Although there is no engineering reason why, if

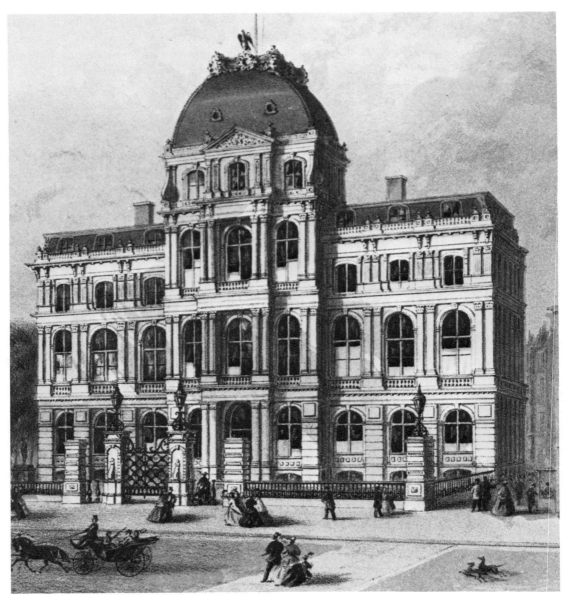

BOSTON'S OLD CITY HALL: THE OLD SERVES THE NEW

Boston, 1862, Bryant and Gilman; alterations and restoration, 1970-72, Anderson-Notter Associates, Inc., and Architectural Heritage, Inc. One of the nation's most successful examples of the adaptive re-use of a landmark is Boston's Old City Hall, shown as it appeared shortly after construction (above) and as it appears now (opposite). An imposing, granite-walled, Second Empire–style structure, it was saved from demolition or conversion into a museum by Architectural Heritage, Inc., in 1970. Through renovation of the interior, painstaking restoration of the exterior, and astute financial planning, Architectural Heritage has not only protected one of Boston's most distinctive buildings but has provided a home for a French restaurant, a bank, a law firm, and numerous other tenants as well. Old City Hall is making a profit for its sponsors and is expected to return more than $25 million in rent in lieu of taxes on a ninety-nine-year groundlease between the sponsors and the city of Boston.

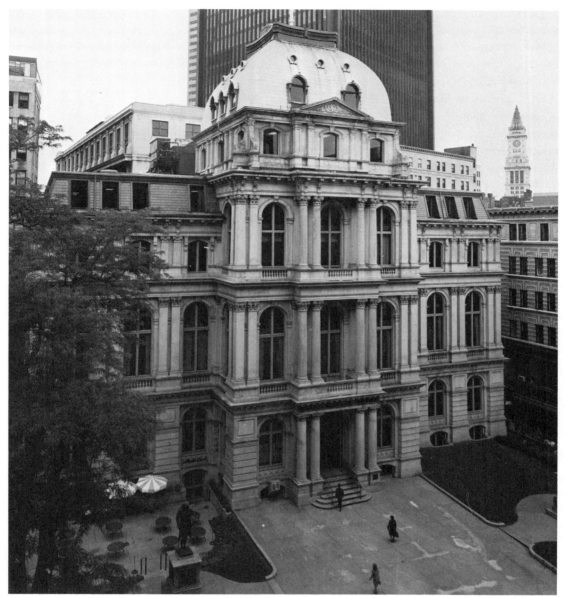

AAA photo by Jon Maguire

properly maintained, these buildings cannot stand for 200 years or more, they are vulnerable to man-made or natural casualties. Accordingly, the preservation restriction should specify what course of action is appropriate if the landmark is destroyed.

Should it require that the landmark site remain vacant indefinitely or should it permit reinstatement of the site's development rights? The first alternative would render a prime downtown site barren and deprive the city of the substantial tax revenues that would derive from the site's redevelopment. The second could provide a windfall to the landmark owner and might even encourage the deliberate destruction of landmarks by the unscrupulous. The disadvantages of both approaches can be avoided by permitting reinstatement but subject to two conditions: first, a determination by the landmark commission that the landmark's loss is not attributable to the fault of its owner; second, repurchase by the owner of the site's development rights at the then going rate.

What to do with the landmark at the end of its economic life is less easily resolved. A major premise of the Chicago Plan, it will be remembered, is that most of the urban landmarks that have not already been demolished are capable of operating at a modest profit. Hence, the incentive package is designed primarily to compensate the landmark owner for the economic opportunity that he foregoes by not redeveloping the site to capitalize on its increased land value. But the time may come when the building's operating expenses exceed its income due to functional obsolescence or to changes in the surrounding neighborhood that make continuing commercial use of the site impractical.

To deal with this problem, the restriction should contain a provision permitting the landmark owner to petition the landmark commission for relief upon a showing that

the landmark building has reached the end of its economic life. If the commission finds that the petition has merit, it may recommend one of two courses of action for the city council's approval. Either it may propose that the landmark owner receive a subsidy from the development rights bank that will enable the continued operation of the building at a predetermined rate of return, or it may recommend that the city itself acquire the landmark property.

Outright acquisition may well be practicable at this stage because the property's value will have greatly diminished by virtue of the preservation restriction affecting the site and the further depreciation of the landmark building. The city, in turn, can either use the building for its own space needs or it can rent it to an institutional user, such as a university or nonprofit corporation. In the latter instance, the rental would be set at a figure that covers the building's operating expenses and the taxes that the property would have returned had it been in private ownership.

THE DEVELOPMENT RIGHTS TRANSFER DISTRICT

The success of the Chicago Plan depends upon its feasibility from three different perspectives: those of the economist, the planner, and the lawyer. The development rights of designated landmarks must be marketable in order to provide the funds necessary to administer the Plan. The redistribution of those rights must neither overload public services or facilities nor distort the urban cityscape if the Plan is to win public support. And it must be able to withstand legal challenge or it will be shunned by prudent cities and investors.

Key to the Plan's feasibility in all three respects is the development rights transfer district. Two alternative districting techniques are considered in the following paragraphs, one of which was employed earlier to illus-

trate the Plan's operation. Since feasibility is the subject of the following four chapters, the alternative techniques are examined in outline only at this point.

Districting in Conjunction with the City's Landmarks

The version of the Chicago Plan summarized above envisages that the borders of development rights transfer districts will encompass sections of the city where most of the downtown landmarks are concentrated. Their borders will not necessarily coincide with those of traditional historic districts, such as New Orleans' Vieux Carré. Unlike historic districts, transfer districts are intended to serve essentially as marketing areas for development rights, and will usually contain only a few buildings of architectural or historical significance in relation to the total number of buildings within their boundaries. The transfer district proposed for Chicago's Loop, for example, would contain perhaps thirty to thirty-five buildings, yet cover most of Chicago's central business area. Another difference between the two types of districts concerns the scope of the landmark commission's permit review responsibilities. In transfer districts the commission reviews only those applications for alteration or demolition pertaining to designated individual landmarks; in historic districts it engages in permit review for all buildings.

Because transfer districts will overlay the city's central business areas in most instances, its borders will likely include the parcels having the city's highest land values. Indeed, it is these very land values that explain the impetus for the demolition of the city's landmarks. Accordingly, the most lucrative opportunities for the sale of development rights should be found within the transfer district itself.

But will the transfer of development rights lead to urban design abuse? This might well be the outcome if the Plan shifted all or most of a landmark's excess development rights to one or a few transfer sites or if it authorized density concentrations randomly throughout the city. But the Plan contains two principal safeguards that are designed to forestall these possibilities. First, it expressly conditions the formal establishment of a district upon determinations by the municipality's planning and landmark commissions that the redistribution of development rights will disrupt neither the area's dimensional scale nor its physical and service infrastructure, including its pedestrian and vehicular transportation systems, its utilities, its network of public services and facilities, and its environment and amenities. Second, it envisages that development rights will be dispersed throughout the entire district, the density increases on individual sites being held within bulk and height ceilings expressly selected to avoid undue urban design consequences.

The development rights transfer district also buttresses the case for the Plan's legality. Over the last decade or so, American courts and land use practitioners have come to recognize the legitimacy of incentive zoning programs that allocate density on the basis of urban design considerations. Prior to that time, zoning ordinances assigned density on a lot-by-lot basis, mandating the same maximum density for all lots of equal size within a zoning district.

Persuasive of the Plan's validity are the decisions of a number of state courts upholding so-called "density zoning."[16] Eschewing the traditional lot-by-lot approach, density zoning sets a maximum amount of bulk for an entire district, and allows developers to concentrate or disperse that bulk in accordance with prescribed planning criteria. Development rights transfers too should withstand

[16] For a detailed discussion of density zoning, see pp. 127-34 *infra*.

judicial scrutiny because, at base, they are simply an instance of density zoning. The density fixed for the transfer district by the city's zoning code remains unchanged under the Plan. But that density is redistributed within the transfer district pursuant to the various controls referred to above.

Districting Independently of the City's Landmarks

Some cities might find the districting concept advanced above too restrictive for their needs. Their landmarks may be scattered throughout the community rather than concentrated in one or a few areas. Even if concentrated, the landmarks may be located in a neighborhood where further density is not desirable either because public facilities there are already overtaxed or because more intensive development threatens its special character.

For these cities, a second approach can be suggested under which transfer districts would coincide with areas that, though presently zoned to relatively low densities, are expected to undergo intensive development soon. Whether or not they contain landmarks would be irrelevant. In rezoning them to the greater densities warranted by development expectations, the basic density levels fixed in the zoning ordinance would be deliberately skewed to levels falling somewhat short of the levels that the market and sound design standards would warrant. Developers building within these areas would then be permitted to purchase the remaining density increments from landmark owners, wherever located, or from the municipal development rights bank.

An example based upon a proposal for the restoration of Washington's Georgetown waterfront historic district illustrates this approach. As recounted by Wolf Von Eckardt, funds for restoration would be generated by the sale of the development rights of historic properties within the district.[17] But the rights would not be redistributed there because buildings incorporating them would impair the district's visual and dimensional scale. Where would the rights then go? To a predetermined zone drawn to encompass parcels bordering along Washington's new subway system, the construction of which will warrant greater densities on these parcels.

The Georgetown example illustrates that drawing the boundaries of the transfer district independently of the location of the city's landmarks can afford distinct economic and planning dividends. It enables the city to exploit vigorous construction markets that lie beyond the landmarks neighborhood and that may well enjoy higher land values than that neighborhood. And it gives the city greater flexibility in coordinating the transfer program with its other design and development objectives. Thus, Washington's goal of safeguarding the historic district's low-density character is served by transferring the development rights out of the district altogether. At the same time, optimum use of its transit facilities is encouraged by concentrating the transferred density in prescribed zones along the subway route.

But the Georgetown approach does raise a legal issue that is avoided under the first of the districting techniques. Recall that the latter does not lower the maximum density set by existing zoning for lots within the transfer district. Hence, the property owners there are no worse off after the Plan is adopted than before; on the contrary, they can improve their situation by purchasing development rights. But the Georgetown approach deliberately sets the density limitations in the transfer district at levels that are concededly lower than market conditions and planning re-

[17] See Von Eckardt, "Getting Charm and Height," *Washington Post,* Feb. 27, 1971, §C, p. 1, col. 5.

FIGURE 3. Development Rights Transfer Districts: Alternative Districting Techniques

An illustration of alternative types of development rights transfer districts. The unused development rights of landmarks located in Chicago's greater Loop area (A) may either be transferred within that area or transferred to some other area of non-landmark concentration (B) as dictated by market needs and planning criteria.

quirements warrant. As a result, its use of
the zoning power in part for fiscal ends is
considerably more visible than under the first
approach. The legal ramifications of this dif-
ference are the subject of extensive commen-
tary in Chapter 6.[18]

THE MUNICIPAL DEVELOPMENT RIGHTS BANK

Preservation is a costly affair. It is also
viewed as a luxury by most city councilmen,
who rate it somewhere near the bottom in the
scramble for the city's general revenues. As
a result, landmark attrition proceeds apace,
especially during boom periods. The develop-
ment rights bank called for in the Chicago
Plan promises to reverse the speculative tide,
heretofore overwhelming, that has engulfed
so many landmarks. By creating its own reve-
nue source — income generated from the sale
of development rights — the bank avoids the
scramble for the general revenue dollar yet
enables the city to safeguard many, perhaps
most of the urban landmarks that otherwise
appear slated for eventual demolition.

The development rights credited to the
bank will originate from three categories of
landmark properties. The most important is
privately owned landmarks that are in immi-
nent peril of demolition. As noted earlier, the
city may choose between two alternatives in
dealing with these properties. First, it may
give their owners the option of themselves
selling the properties' unused development
rights. Should the option be declined, the city
would then step in and condemn a preserva-
tion restriction and the associated develop-
ment rights in these properties. Second, the
city may require that the unused development
rights of all imperiled landmarks be sold to
the bank, thus eliminating the option of pri-
vate sales by cooperating landmark owners.

The second category of landmark properties
will also be in private ownership. But the de-

velopment rights of these landmarks will be
transferred to the bank upon donation by
their owners. The quantity of development
rights derived from this source will probably
not be substantial because most private owners
will elect to sell their development rights out-
right to the bank or on the private market.
But it should not be too quickly assumed that
private philanthropy — the mainstay of a
good deal of the nation's preservation effort
— will cease. Indeed, the dramatic improve-
ment in preservation results promised by the
Plan could well create further impetus for
private donations. In addition, the tangible
federal, state, and local tax benefits attending
the donation of a landmark's development
rights might comport more readily with an
individual owner's tax planning needs than
the tax consequences of an outright sale of
these rights.

Municipally owned landmarks constitute
the third category of landmark properties.
Their number may well equal or exceed that
of the community's privately owned land-
marks because so many of America's distin-
guished buildings were built for governmental
use. By transferring the development rights of
these buildings to the bank, the city can en-
roll an otherwise dormant municipal resource
in the service of a worthy public purpose.

The greater part of the city's preservation
costs will be covered by the sale of the devel-
opment rights of threatened properties, the
first category discussed above. Why then will
the bank also be credited with donated devel-
opment rights as well as those of publicly
owned properties? The answer is quite simple:
a cushion of development rights is needed to
absorb the shortfalls that may result from
sales from the first category.

Take, for example, the hard case, in which
a landmark exhausts all or substantially all
of the floor area allocated to its site. Sale of
its remaining rights may not provide adequate

The Chicago Plan

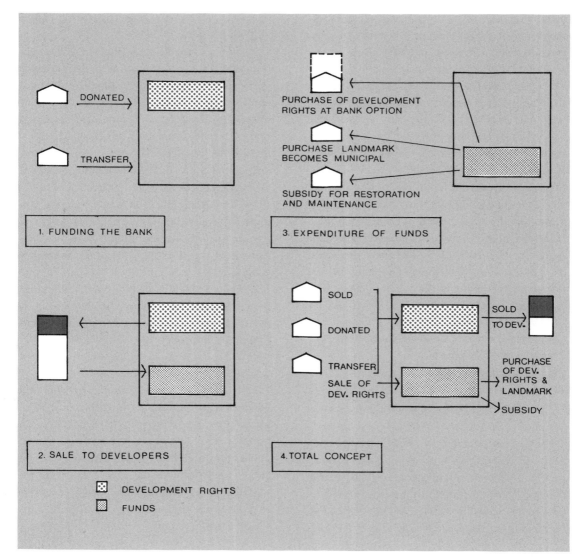

FIGURE 4. Operation of the Municipal Development Rights Bank

The municipality pools in the development rights bank the development rights that it transfers from publicly owned landmarks and that it obtains through donation or purchase from owners of private buildings. Income from the sale of the rights to developers may be used to purchase the development rights of threatened landmarks or the entire landmark property, as appropriate, and to provide subsidies for restoration and maintenance.

compensation for its owner. Again, a land-mark may require extensive restoration, the costs of which exceed amounts that could practicably be expended by a prudent investor. Its owner would be entitled to a subsidy under the Plan, yet the amount of the subsidy could well exceed the sum that can be realized through sale of the property's development rights after deduction of the value of their lost development potential. A third case is the landmark that is approaching the end of its economic life. As suggested earlier, the city may elect to subsidize the operation of the building rather than to acquire it. The city should be able to meet each of these problems as well as others not mentioned here by re-course to the cushion that the donated and municipal development rights will provide.

The Chicago Plan's Relation to Current Preservation Programs

MUNICIPAL PROGRAMS: THE NEW YORK AND SAN FRANCISCO TRANSFER PLANS

The Chicago Plan supplements rather than replaces conventional municipal programs. With the exception of the compensation issue, most of these programs address the various problems of preservation quite well. It would be difficult, for example, to improve upon the procedures contained in the better-drafted municipal ordinances for selecting individual landmarks and historic districts and for re-viewing applications that look to the altera-tion of historically significant properties.

The Plan's role is simply to buttress exist-ing preservation methods by making the re-tention of landmarks economically feasible for the landmark owner and for the city. This role requires above all that the Plan be flex-ible so that communities can adapt it to local circumstances and preferences. The concern for flexibility explains the general tone of the foregoing discussion and its frequent identifi-cation of alternative solutions to the various

problems that may arise upon the Plan's implementation.

The Plan does differ substantially, however, from existing programs that make provision for development rights transfers. At the pres-ent time, two cities, New York and San Fran-cisco, have adopted such programs. Although both programs have been on the books for a number of years, neither has given rise to an executed transfer transaction.[19] The reasons why clearly appear in an examination of the New York program (the San Francisco pro-gram is similar, though less elaborate), and are instructive for other cities that envisage the use of transfers in their own preservation programs.

Under the New York program,[20] landmark owners in specified zoning districts may trans-fer the unused development rights of land-marks to *adjacent* lots. An adjacent lot is one that is defined as contiguous to or across a street or intersection from a landmark lot; it may also be one of a series of lots that connect with the landmark lot, provided that all of these lots are in single ownership. The floor area of transferee lots may not be in-creased by more than 20 percent over prevail-ing zoning although no ceiling is set for lots in high-density commercial zones. Transfers may be made to one or several adjacent lots. Once transferred, the unused floor area is irrevocably withdrawn from the authorized floor area of the landmark lot.

Development rights transfers are subject to a wide array of controls. The New York City Landmarks Commission must be satisfied that the proposed project on the adjacent trans-

[19] One transaction involving Amster Yard, a designated landmark, apparently would have been completed had it not been stalled by the softening of Manhattan's office space market in 1971. The proposed transfer is detailed in Huxtable, "City Landmark Gets a Chance for Survival," *New York Times,* Aug. 2, 1970, §8, p. 1, col. 1.
[20] See New York, N.Y., Zoning Resolution art. VII, ch. 4, §§74-79 to -793 (1971).

feree site will be compatible with the landmark in terms of materials, design, and scale. The owners of the landmark and transferee lots must also receive the preliminary approval of the New York City Planning Commission. Their application to that body must contain a site plan for both lots showing the proposed development on the adjoining lot, a program for continuing maintenance of the landmark, and the findings of the Landmarks Commission respecting the aesthetic impact of the new project on the adjacent landmark. The Planning Commission then determines whether the proposed transfer will have an unduly detrimental effect upon the occupants of buildings in the vicinity of the transferee lot and whether the maintenance program is adequate. Final authority to approve the transfer rests with the city's Board of Estimate.

New York City has surged briskly ahead of other American cities in its attempt to meet the economic difficulties of preservation realistically rather than brushing them under the rug. In its transfer program as in its many other preservation initiatives, it has broken new ground and earned the plaudits of preservationists everywhere. Yet its transfer program has not enjoyed the reception among the city's landmark owners and development community that was anticipated. What explains the seeming paradox wherein one of the few preservation initiatives in the nation that goes out of its way to address the economic plight of landmark owners has largely been ignored by its intended beneficiaries?

The answer lies in the five drawbacks of the program that are discussed in the following paragraphs.[21]

Incentives

The principal weakness of the New York program is the inadequacy of its incentives. Limiting transfers to adjacent sites is largely self-defeating because developers in New York, as in other major cities, are already permitted to shift unused floor area to a contiguous parcel simply by registering the transferor and transferee sites as a single "zoning lot."[22] Hence, the program will prove attractive to the private sector in only two rather unusual situations: when a developer can be found who happens to own a lot across a street or intersection from the landmark, and, even rarer, when a landmark owner who owns a series of lots that connect with the landmark lot desires to build on one or more of those lots.

The adjacency restriction, moreover, severely impairs the marketability of development rights. Their value turns wholly upon the vagaries of construction activity on the small number of transferee lots that happen to adjoin the landmark lot. Nor is there any assurance that income received from the transfer of the rights will fully cover the economic burdens entailed by permanent landmark designation. As noted earlier, a variety of factors account for these burdens in addition to the landmark's size.

By permitting transfers throughout entire

[21] In addition to the evaluation of the New York City program presented in the text, the reader may wish to consult Costonis, "The Chicago Plan: Incentive Zoning and the Preservation of Urban Landmarks," *supra* note 2 at 584-89; Note, "Development Rights Transfers in New York City," *supra* note 2 at 338 *passim*. According to Jacquelin T. Robertson, director (through 1972) of the Office of Midtown Planning and Development of the New York City Planning Commission, a proposal — as yet unadopted — to amend the New York

City program to substitute district-wide transfers for adjacency transfers has been under active consideration since March 1972. Letter from Jacquelin T. Robertson to author, May 22, 1972. As the discussion in text indicates, the adjacency restriction is largely though not entirely responsible for the program's lack of success.

[22] See, e.g., Chicago, Ill., Municipal Code, Zoning Ordinance ch. 194A, art. 3.2 (1970); New York, N.Y., Zoning Resolution art. I, ch. 2, §12-10 (1971).

development rights transfer districts, on the other hand, the Chicago Plan avoids the artificial constraints that largely cripple the marketability of development rights in New York. Municipalities can draw the boundaries of these districts to include areas of high land value under either of the districting techniques discussed earlier. As a result, the market for development rights will be governed by the general vigor of the construction and real estate markets within entire transfer districts rather than by the accident of building activity on the handful of sites adjacent to a particular landmark.

The Chicago Plan also addresses the problem of compensation more rationally. It establishes the landmark owner's losses by a thorough appraisal of his property conducted prior to designation. The sums the owner receives reflect the various categories of loss that he suffers, not simply the size differential between the landmark and the larger building permitted under current zoning. Should his losses outstrip the value of the unused development rights, the city has two additional sources from which to make up the deficit. The first is real estate tax relief, itself an integral element of the Plan's incentive package. The second is the municipal development rights bank, a feature that is not present in either the New York or San Francisco programs. Income derived from the sale of donated development rights and those transferred from publicly owned landmarks will be earmarked for use in precisely such cases.

Role of the Municipality

The New York program also suffers from its dependency for its success upon the private sector's voluntary participation. But owners and developers may balk for good reason or for no reason at all. If so, the city must fall back upon the unenviable options of the con-

ventional preservation ordinance: condemnation financed through precious general revenues or acquiescence in the landmark's demolition.

The Chicago Plan enables the city to be something more than a helpless but vitally concerned onlooker. Depending upon how the Plan is implemented, the city's role can be secondary, somewhat as in New York, or it can be central. It will be the former if the city elects to abandon to the private sector the initiative for all transfers other than those involving the sale of donated development rights or the rights of publicly owned landmarks. True, the city will be able to exercise greater leverage than New York in dealing with landmark owners by virtue of the income from these sales. It can, for example, supplement the sums received by landmark owners from private sales when those sums fall short of the losses that result from designation. So long as landmark owners remain free to opt out of the Plan, however, it is doubtful whether the municipality can achieve a truly comprehensive program of landmark retention.

The prospects for this goal improve dramatically if the city is prepared to backstop private dealings by condemning preservation restrictions when landmark owners decline voluntary participation in the Plan. *The unpleasant truth is that the city will not be taken seriously by most landmark owners unless the condemnation threat is wholly credible.* The hollowness of that threat at the present time encourages owners of valuable downtown properties simply to wait the city out, confident that when the crunch between condemnation and demolition comes, the city will be found wanting. Needless to say, the owners' strategy seldom backfires.

No better test of a city's commitment to preservation can be imagined than its election between these two versions of the Chicago

Plan. It will not be easy for any city to choose the version calling for vigorous public intervention when private sales fail to safeguard threatened landmarks. By adding muscle to otherwise flaccid preservation efforts, that choice may well alienate some of the city's most potent political groups, including developers, institutional lenders, and building managers. It will, moreover, necessitate detailed market and planning studies to establish its feasibility under local economic circumstances and its acceptability in light of prevailing urban design preferences. It will also require that the staffs of the landmark and planning commissions be expanded somewhat by the addition of an appropriate number of skilled urban economists and appraisers. Finally, it will create the opportunity for favoritism and other forms of official impropriety that plague any program in which government dispenses large sums of money and lucrative franchises.

Against these potential risks must be weighed the advantage that landmark retention may finally be placed on a practicable economic footing. Vigorous administration of the Plan provides an opportunity for municipal leadership in an area where public performance has, quite frankly, been dismal.

But there are other advantages as well. Expanding the volume of transfers handled through the development rights bank should increase the funds available for conduct of the municipal preservation program. In addition, it should afford the municipal planning officials who administer the bank and oversee the transfers the experience necessary to master the intricate planning, economic, and legal challenges of this novel undertaking.

Giving the city the major say in the redistribution of rights, moreover, will enable it to expedite downtown development generally by easing the difficulties of land assembly. At the present time, developers often spend months or years trying to acquire the additional strip necessary to make their project economically feasible. Under the Plan, those who have assembled all but a small fraction of a unified tract can fill out the remainder by purchasing the equivalent of the needed "land" from the development rights bank. The privilege would be subject, of course, to appropriate safeguards concerning light, air, and other design features of these projects.

More important, centralizing control over the redistribution of development rights in the bank could provide the city with leverage to concentrate density in accordance with its other urban design goals, particularly if transfer districts are mapped without regard to the location of the city's landmarks. Representative of these goals are dispersal or concentration of particular land uses, establishment of high-rise elements at selected locations, optimization of transit system use, or fostering of renewal unassisted by government subsidy programs. Hampered by its reliance on crude density and land use categories, traditional zoning typically achieves these goals imperfectly, if at all. The development rights transfer mechanism, on the other hand, can assist the city in pinpointing density concentrations and thus achieving these urban design results on a selective basis.

Preservation of the Designated Landmarks

The New York program borrows trouble by relying essentially upon the transfer of unused floor area to relieve speculative pressures upon landmark properties. The owner still retains the right to demolish the landmark, although subject to the limitation that new construction may not exceed the landmark's former bulk. A subsequent increase in the bulk authorized for lots within the landmark's zoning district, moreover, would rekindle these speculative pressures by in effect reinstating the floor area that had previously been

transferred. Nor does the program spell out with desirable clarity the continuing obligations of landmark ownership or the means for their enforcement.

The Chicago Plan addresses these problems head on through the preservation restriction. Once recorded, the restriction forbids present or future owners of the property from demolishing or materially altering the landmark. Subsequent increases in zoning bulk are powerless to affect these proscriptions because the preservation restriction is a property interest that cannot be abrogated by police power measures. The restriction, moreover, provides a vehicle for detailing the full range of obligations associated with landmark ownership and the remedies available upon their breach.

Coordination of Landmark Designation with the Development Rights Transfer Authorization

An additional question posed by the New York program is the wisdom of granting transfer authorizations in proceedings initiated by landmark owners some time *after* formal designation of their buildings. The battle to protect threatened landmarks is often lost at the designation stage itself. Owners resist designation because of its potential economic impact. City councils likewise have refused to designate even buildings of unquestioned architectural merit, such as Chicago's Stock Exchange, fearful of treating their owners unfairly or of committing the city eventually to acquire the properties.

To overcome threshold resistance to designation, cities adopting the Chicago Plan may wish to telescope the designation and transfer allotment phases into a single proceeding. In this way, the city and the landmark owner can precisely calculate the impact of designation beforehand, and agree upon the terms of an incentive package that fully compensates the landmark owner at minimal cost to the city. If the city permits the owners themselves

to transfer the allotted development rights, its post-designation involvement will be limited to the task of insuring that the private transfers comport with urban design criteria prescribed in the local ordinance.

But a second approach can be envisaged that would retain the division between proceedings designating the landmark and those fixing the development rights transfer allotment. Instead of automatically granting such allotments upon designation, the city might do so only upon a showing that a specific property was incapable of earning a reasonable return in its landmark status. This approach borrows heavily from the New York provision, considered earlier,[23] under which a property may be retained in its landmark status without compensation unless its owner establishes that the property cannot earn a 6 percent return on its assessed valuation.

The second approach would enormously simplify the Plan's implementation. Since many — perhaps most — urban landmarks earn what the courts could deem a "reasonable return,"[24] the number of buildings figuring in the city's transfer program under this alternative would drop proportionately. Moreover, the incentive package for individual properties would not be measured by the difference between their present and their most profitable use, but by the differential between their present value and a value calculated in accordance with a rate of return that courts would find non-confiscatory. The second

[23] See note 11, p. 16 *supra*.
[24] The case study of four Chicago landmarks contained in Chapter 3 concludes that these buildings return annually approximately 7.5 percent on the investor's equity compared to a 9.5 percent annual return on equity for modern office and commercial buildings. See p. 69 *infra*. It is also noteworthy that while over 300 buildings have been designated under New York City's landmark program since its inception in 1966, the owner of only *one* of these buildings has been able to demonstrate that his rate of return fell below 6 percent of its assessed valuation.

measure obviously falls far short of the first. As a result, the costs of the program's operation would plummet, thus eliminating the need for heavy capitalization of the development rights bank. The risks of official impropriety would shrink. And the program's potential for urban design abuse would be less worrisome as a result of the sharp drop in the quantity of transferable development rights.

Despite its legality, the second approach will not meet with universal approbation. Political realities in some cities would undoubtedly make its adoption unthinkable at the present time. The political courage and community support that have been the mainstays of the New York City preservation movement are not, alas, often encountered elsewhere. Furthermore, whether a city ought to limit compensation in this way raises a fundamental issue of policy that is not easily resolved. Certainly the equities of the situation favor awarding substantial compensation to landmark owners. In the hard cases, after all, it is the community that wishes to retain the landmark, not its owner. Nor should the city overlook that regulating landmark ownership to the outer limits of the police power will inflame the opposition of the very groups whose cooperation is vital to the success of the municipal preservation effort.

Design Controls over Construction on Sites Adjacent to the Landmark Property

New York's adjacency restriction creates urban design complications that are fully as troublesome as its economic consquences. In addition to restricting transfers to sites adjacent to the landmark property, the New York program sets no ceiling on the amount of bulk that may be added to individual transferee sites located in high-density commercial zones. In consequence, the program's possibilities for urban design abuse are ominous. Consider, for example, the case of the U.S.

Customs House, a New York City landmark. Its excess development rights total some 798,-000 square feet, an amount that equals the floor area of the sixty-story Woolworth building. Redistributing this magnitude of density to one or a few adjacent lots could create intolerable congestion within the immediate vicinity of the Customs House. Worse still, by inundating the diminutive building in a sea of adjacent superdensity, it would destroy the dimensional scale so essential to the building's architectural distinction, thereby casting serious doubt on the wisdom of the trade-off of bulk for preservation.

It is for these reasons, of course, that New York really has no choice but to run transfers through the labyrinth of administrative and design procedures detailed above. But an incentive program can go only so far down the road of discretionary review — especially of an aesthetic nature — before developers will begin to find it unpalatable. Hence the tension inherent in all incentive programs between enhancing the appeal of floor-area premiums by freeing them of onerous controls and protecting the public interest through appropriate municipal supervision over the manner in which developers integrate these premiums into their projects. Should the conflict between these two objectives become irreconcilable, the public interest must prevail, as New York properly recognizes. At that point, however, the incentive program becomes an exercise in futility because it simply will not work. The trick, therefore, is to avoid or, at the very least, minimize the opportunities for eventual conflict by anticipating them while the program is still on the drawing board.

These considerations clarify why the Chicago Plan's switch to district-wide transfers is so critical to its success. Because *every* transfer under the New York program moves bulk to a site adjacent to a landmark, its aesthetic impact on the landmark must be individually

scrutinized in terms of decidedly subjective criteria. But few, if any, transfers will be made to adjacent sites as a consequence of the Plan. As noted earlier, developers in many cities may already transfer density to contiguous parcels *independently* of the Plan; hence, the Plan's incentives would hold no interest for them in the adjacency context. Moreover, the Plan vastly expands the number of potential transferee sites available under the New York approach by including within this category all parcels located in the development rights transfer district.

But what of the unusual case when, despite these factors, a transfer is nevertheless made to a site adjacent to a landmark pursuant to the Chicago Plan? Cities adopting the Plan presumably will wish to supervise the transfer much as would be done under the New York procedures. Because the incidence of this type of transfer would be so infrequent, however, they can be reasonably confident that detailed design review in these cases will not impair the Plan's overall attractiveness in the eyes of the development community.

Shifting bulk to sites adjacent to landmarks raises the most sensitive design review issues considered in this study because landmarks and their settings are the most fragile of urban artifacts. But transfers to nonadjacent sites also pose their share of problems, albeit of a less challenging nature. These problems are treated at length in Chapter 5. Two comments concerning this second category of transfers may nevertheless be appropriate at this point. First, the tension encountered in this section between gilding the incentive and protecting the public interest must also be confronted in the case of nonadjacent transfers. Second, the task of accommodating these objectives in the latter case, while by no means simple, should not prove insuperable for communities that are willing to do the planning homework called for in Chapter 5.

STATE PROGRAMS

As at the local level, flexibility is the keynote in the Chicago Plan's relation to the preservation programs of higher levels of government. By expanding the city's preservation resources, the Plan increases the likelihood that, though limited, the funding and other forms of assistance available at these levels will round out local requirements.

Two types of state initiatives should prove especially helpful in this respect. The first is direct state grants, which can be used to seed the development rights bank and thus to underwrite acquisition of preservation restrictions and subsidization of eligible properties. The second is statutory authorization to lower the assessed value of landmark properties. This authority will prove useful in the city's dealings with taxing officials, typically at the county level, and in its efforts to compensate landmark owners through an appropriate incentive package.

FEDERAL PROGRAMS

At least three distinct federal initiatives can serve as fruitful complements to the Chicago Plan. The first derives from the power that Congress granted in 1935 to the Secretary of the Interior to enter into special arrangements with local governments on behalf of historic preservation. Under this power the Secretary can offer the backing of his department and, through special legislation, of Congress as well in setting up demonstration programs utilizing the Chicago Plan in one or more cities. The second concerns the use of preservation grant monies available through HUD and the Department of the Interior to acquire preservation restrictions on designated landmarks. The third, which is premised on the view that what we have been calling "landmarks" throughout this study can, with equal justice, be deemed open space amenities, would enroll the open space component

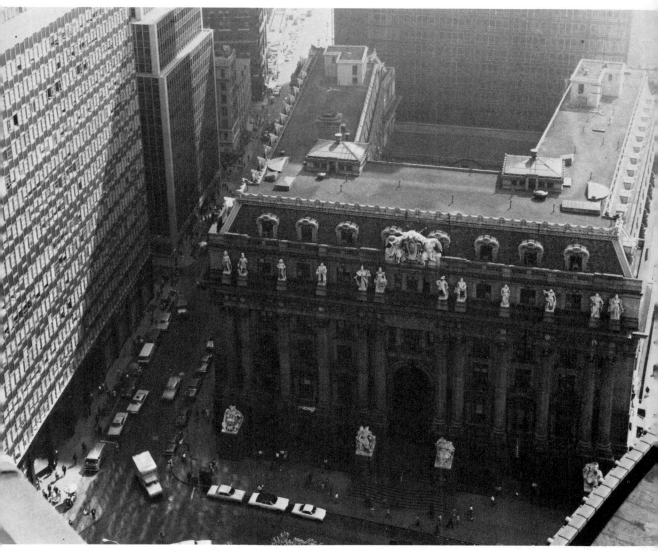

John B. Bayley photo; courtesy New York City Landmarks Preservation Commission

THE PROBLEM OF SUPERADJACENT DENSITY

Even under traditional zoning, landmarks may be engulfed by the shadows and massive density of surrounding newer buildings, as illustrated by this bird's-eye view of the U.S. Customs House, a designated New York City landmark. Although the risk is ameliorated somewhat in this case by the landmark's location alongside a park, it advises against a transfer program that assigns all of a landmark's unused development rights (equaling, for the U.S. Customs House, the floor area of the sixty-story Woolworth Building in New York City) to a handful of adjacent sites.

of HUD's Open Space Land Program in the preservation battle. This alternative offers a rationale under which municipalities could secure supplementary funding for the Plan from the vastly greater resources that HUD has allocated to the open space as contrasted with the preservation component of its Open Space Land Program.

Demonstration Programs: The Chicago Loop as a "National Cultural Park"

The Department of the Interior has already seized upon the demonstration program option in a determined effort to safeguard the best of the surviving Chicago School of Architecture landmarks. It has proposed that these buildings as well as other works of the Chicago School be brought within the rubric of a "National Cultural Park."[25] The park's "cornerstone" would be twelve landmarks located in the Loop that "portray the evolution of the skyscraper and the ensuing style change in modern architecture."[26] The list includes such buildings as the earlier-mentioned Carson, Pirie, Scott & Company Department Store and the Auditorium, Leiter II, Rookery, and Monadnock buildings. Other Chicago School buildings may be added once the park is established.

The proposal assumes that Chicago will take the necessary legislative and administrative steps to implement the Chicago Plan. Once this is done, the department will enter into a cooperative agreement with Chicago specifying the manner in which the development rights bank will be administered, the basis upon which the twelve landmarks will benefit from development rights sales, and the standards governing their preservation.

The department itself will not become a landowner as it has, for example, in its Independence Mall project in Philadelphia, but expects that landmarks will remain in private or non-federal public ownership. It assumes, moreover, that tax relief, the modest profitability of the landmarks, and, most important, the revolving funds generated by the development rights bank will defray the lion's share of the city's preservation burden. But it has identified two areas where federal financial assistance may prove essential. First, advance funding of the development rights bank will be necessary to enable the bank to acquire preservation restrictions on the twelve buildings immediately upon establishment of the park. Otherwise, the bank will be without funds until it has sold the landmarks' development rights on the open market. Second, seed money will be needed to cover administrative costs, technical advice, and interpretative facilities and visitor services.

The department's proposal points the way to a novel form of federal-local cooperation that is without precedent in American preservation affairs. Similarly unprecedented is the concept of an urban park that interprets a cultural or architectural theme of national significance, such as the work of the Chicago School. In both respects, the proposal clearly ranks with the boldest of this nation's preservation initiatives.

Preservation Grant Programs

The preservation grant programs of HUD and the National Park Service can also be used for a wide range of activities, including acquisition, restoration, and re-siting. Under present regulations, grant monies apparently

[25] See National Park Service, "The Chicago School of Architecture: A Plan for Preserving a Significant Remnant of America's Architectural Heritage" (1973). For a more detailed account of the Department of the Interior's initiative and its relation to the Chicago Plan, see Costonis, "For-

mula Found to Preserve the Past," 38 *Planning* 307-10 (ASPO, 1972); Huxtable, "A Plan for Chicago," *New York Times*, Apr. 15, 1973, §8, p. 23, col. 2.

[26] National Park Service, "The Chicago School: A Plan," *supra* note 25 at 50.

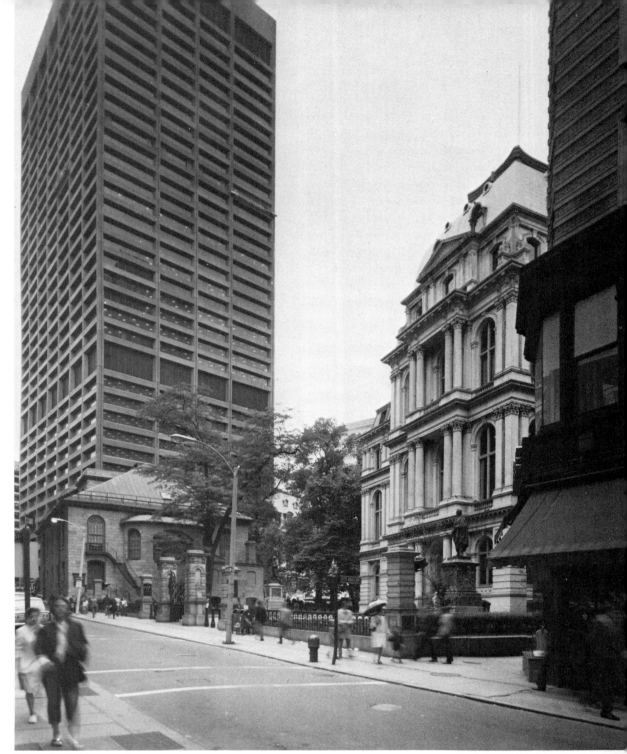

LANDMARKS AS LIGHT AND AIR PARKS

Landmark buildings like Boston's Old City Hall, which typically are low-density structures set back from street lines, provide a distinct rhythm in the cityscape, contrasting with larger modern towers not only in bulk but also in texture, planes, and architectural motif.

63

must be expended in conjunction with specific properties. Hence, they probably could not be employed generally to seed the development rights bank. The major point of interface between the Plan and the grant programs will probably occur in the city's use of federal monies to acquire preservation restrictions. Although HUD and the National Park Service permit their funds to be used for less than fee acquisition, they do so subject to the rather stringent conditions outlined in Appendix I. Given the flexibility of the preservation restriction, however, an astute city should have relatively little difficulty in satisfying these conditions.

Downtown Landmarks as Open Space Amenities

The suggestion that downtown landmarks may also be viewed as open space amenities is likely to be greeted with raised eyebrows. Our natural inclination, after all, is to think of landmarks in terms of their historic or cultural rather than their spatial significance. "Open space," moreover, tends to be equated with unbuilt areas at the street level. However plausible both assumptions may appear at first glance, they tell only part of the story. Landmarks of two, ten, or twelve stories set in the midst of towering buildings provide a distinct rhythm to the massing of bulk in downtown areas, guaranteeing light, air, and visual movement where they would not other-

wise exist. That the open space of the landmarks is not experienced at street level, moreover, hardly detracts from their status as light-and-air parks sprinkled throughout the central business district like so many "raisins in the pudding."[27] Indeed, many cities already recognize that open space at higher planes offers urban design advantages that are no less beneficial than those enjoyed at street level. It is for this reason that they award bonuses for setbacks *above* street level and even for amenities, such as recreation areas, that are found on the tops of buildings.

A sound urban design rationale exists, therefore, for concluding that the acquisition costs of the airspace over landmark buildings should qualify as an eligible project cost fundable out of the *open space* component of HUD's Open Space Land Program. (The principal function of the preservation restriction, it will be recalled, is to foreclose development in the airspace over the landmark altogether.) Should HUD accept this rationale, the program will provide a much more lucrative source of supplemental funding for the Chicago Plan in future years than it would have, for example, in 1972, when only $5,700,-000 of a total $100,000,000 appropriation was earmarked directly for preservation.

[27] The expression is that of Harmon H. Goldstone, Chairman, New York City Landmarks Commission.

3
The Chicago Plan and Economics: The Costs of Preservation

The Chicago Plan looks to development rights transfers rather than to general tax revenues to fund the municipal preservation program. Crucial to its success from an economic viewpoint, therefore, is whether it enables the city to offset the costs of its preservation program with income generated from development rights sales. That question in turn breaks down into the three issues that lie at the heart of the Plan's economic feasibility:

1. What losses do landmark owners incur when their landmark properties are encumbered with preservation restrictions?
2. Will the sale of the development rights associated with these restrictions return amounts sufficient to cover these losses?
3. What losses, if any, will the city sustain as a result either of any deficits in these transactions or of the impact of the Plan upon municipal property tax collections?

FOUR CHICAGO SCHOOL LANDMARKS AND THE CHICAGO LOOP: A CASE STUDY FOR ANALYSIS

These issues are addressed in this inquiry by means of an actual case study. The study's setting, aptly enough, is Chicago, the birthplace of the internationally renowned Chicago School of Architecture. Four classic structures[1] serve as the models for determining the type and amounts of costs that result from the acquisition of preservation restrictions on landmark properties. Major works of the Chicago School, each is a diminutive, vintage office building located on a prime downtown site in Chicago's burgeoning Loop. The Loop itself is hypothesized as the development rights transfer district in the study.

A four-stage procedure is used to establish a price tag for preservation restrictions. It begins with a general comparison of the four sample properties with their modern competitors in terms of the factors that affect the overall profitability of multi-tenant office structures. It then sets forth an appraisal technique and an algebraic formula for measuring the losses that income-producing structures are likely to sustain when the restrictions are imposed. The technique's operation is then illustrated on a step-by-step basis. Its results for all four buildings are summarized in tabular form, but one of the four buildings is singled out for specific textual discussion. Finally, these results are employed as the basis for a more general inventory of the economic variables that appear to govern the question of preservation costs.

[1] Each of the structures analyzed clearly merits designation on the basis of its architectural distinc-

TABLE 2. Present and Potential Building Area on Four Landmark Sites

Landmark	Present Size (sq. ft.)	Potential Size (sq. ft.)	Landmark as Percent of Potential Building
A	295,000	625,000	47.2
B	368,000	854,000	43.1
C	65,800	111,725	58.9
D	300,000	807,000	37.2
Total	1,028,800	2,397,725	
Difference	1,368,925 sq. ft.		

Source: Real Estate Research Corporation, 1972.

The marketability of development rights and the cost implications of the Plan for the city are examined in the following chapter. The first step in probing the question of marketability is devising a methodology for valuing development rights. The methodology is applied to determine the incremental increases in land value that a hypothetical Loop parcel would experience if structures incorporating stated amounts of development rights were constructed upon it. These increases in land value are then translated into a development rights value equivalent. Again, the resulting conclusions provide a foundation for fixing the general conditions that appear to determine whether or not the income from development rights sales will prove roughly equivalent to the costs of acquiring preservation restrictions.

The next chapter also probes the cost implications of the Plan for the city by reviewing two matters. First, it examines the extent to which the increased property taxes returned by the larger structures built on transferee sites are likely to offset the reduced taxes returned by landmark structures. Second, it addresses the likely capacity of the municipal development rights bank to cover any re-

maining net losses that the city might sustain under the Plan. The chapter closes with a general summary of the conditions that appear to govern the Plan's overall economic feasibility.

THE COSTS OF DESIGNATION

Landmarks and Their Modern Competitors: A Comparison

Prior to discussing the cost question in detail, it is useful to compare the four sample landmarks with modern office structures in terms of the factors that determine their respective profitability. The following paragraphs summarize the major points of comparison between these two groups of properties.

SIZE

The four Chicago School buildings contain a total of 1,028,800 square feet of building area, as indicated in Table 2. If redeveloped with modern office buildings under current zoning, the four sites could be expected to contain approximately 2,397,725 square feet.[2] The difference between the potential and actual development on these sites, therefore,

tion. The data concerning the buildings was gathered from published sources and public documents and supplemented by discussions with appropriate property owners and building managers. Because its intended use is *solely* to illustrate the analytic tech-

niques discussed in the text, the buildings are referred to as Landmarks A, B, C, and D, rather than by name.

[2] See pp. 85-86 *infra* for a discussion of the manner in which this figure was determined.

AAA photo by Jon Maguire

LANDMARKS: CAN THEY COMPETE IN THE SPACE MARKET?

Landmarks, the conventional wisdom holds, are unable to compete with newer buildings for tenants because they are "obsolete." Perhaps so, if the tenant is to be a major corporation requiring a large volume of efficiently designed, if wholly bland, space. But quite the opposite is often true for other kinds of tenants — law firms, banks, architects, or retailers of such merchandise as fine-quality rugs, jewelry, or high-fashion clothing. For them, the landmark offers prestige, amenity, and, in many cases, a prime business location as well. Each of these advantages is enjoyed in abundance by tenants in Boston's Old City Hall, a view from the interior of which is shown above.

is 1,368,925 square feet. Table 2 also indicates the percentage of maximum zoning potential to which each of the four sites is presently developed. Figure 5 depicts the difference in size between the existing buildings and their potential replacements.

VACANCY RATES

The four landmark structures match or exceed newer buildings in terms of occupancy rates. Because of their prestige addresses and central locations, the landmarks generally rent at or just below a full 100 percent rate. The anticipated vacancy rate for modern structures, on the other hand, is generally fixed in the 5 to 10 percent range, but may vary from that range depending upon current demand for office space.

PHYSICAL OBSOLESCENCE

The landmarks have been periodically remodeled to make them reasonably competitive with newer office buildings. Remodeling has proven feasible for these properties because their owners have been able to receive the increased rentals (over and above inflationary increases) necessary to finance this work. Each of the landmarks is a sound, well-maintained building at the present time.

FUNCTIONAL OBSOLESCENCE

The landmarks typically have slow elevators, inefficient climate control systems, wasted space, and substandard lighting. Some of these problems, such as outmoded floor plans resulting from the structures' interior courts, are difficult to cure at all. Others, such as inferior climate control, can be remedied but only at a cost that may not be justified by corresponding rental increases.

RENT LEVELS

Rent levels tend to average 20 to 25 percent less for landmark buildings than for new

buildings comparably located. The average rental of the landmark space is $6 to $7 per square foot. Newer buildings rent for $8.50 to $9 per square foot on the average.

OPERATING EXPENSES

Operating costs for the old buildings average 41 percent of gross income compared with 28 percent for new buildings. The latter are more easily maintained and experience fewer breakdowns with their modern equipment. More efficient heating and cooling systems also reduce their operating costs.

REAL ESTATE TAXES

Older buildings are not exempt from the pressure of rising taxes. About 19 percent of their income is absorbed by real estate taxes. New buildings pay a higher percentage of their gross income for taxes — about 24 percent after they achieve normal occupancy.

NET INCOME BEFORE RECAPTURE

Net income for the landmark buildings is about 35 percent of gross. The comparable figure for new buildings is 43 percent. Out of this amount must come financing charges, including interest and amortization of the outstanding mortgage debt.

DEPRECIATION

Under the federal income tax laws, depreciation on wasteable assets may be offset against net income.[3] If annual depreciation is greater than net income, the excess depreciation can be used to shelter income the owner may receive from other sources.[4] The depreciable base of landmark buildings, of course, falls well short of the corresponding figure for the more costly structures that could be erected on their sites.

[3] See Int. Rev. Code of 1954 §167.
[4] See Int. Rev. Code of 1954 §161.

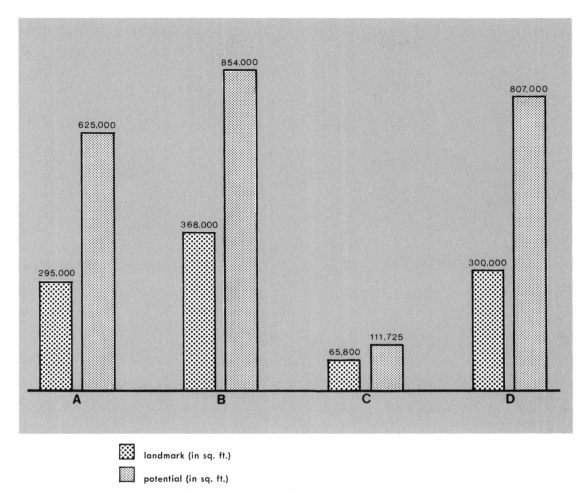

FIGURE 5. Comparison of Landmark Size with Potential Building for Site

SUMMARY

Figure 6 compares the income distribution of a typical landmark office building with that of a modern office building. Chicago landmarks are often able to return sheltered cash flow to the ownership after expenses and capital charges. But the return on equity is not as great as it would be if the zoning potential were fully utilized at that site, and the tax shelter is far thinner. Under typical financing, it is estimated that landmark owners can obtain an annual cash return on equity of about 7.5 percent. The equity holders of new buildings, on the other hand, receive about 9.5 percent.

Valuation of the Preservation Restriction

AN APPRAISAL TECHNIQUE AND A FORMULA

The value of a preservation restriction equals the difference between the landmark property's value prior to and after acquisition of the restriction. Stated another way, it is determined by subtracting the property's present value from its fair market value, i.e., its value as determined by its "highest and best

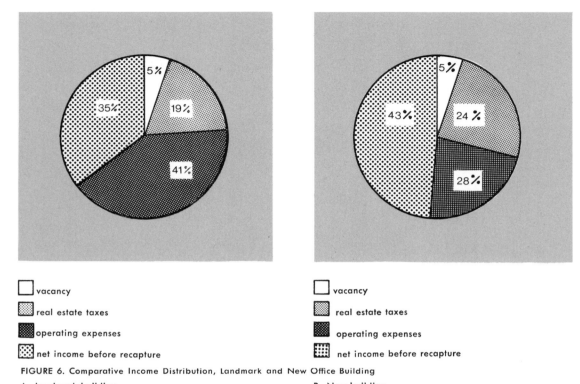

vacancy

real estate taxes

operating expenses

net income before recapture

vacancy

real estate taxes

operating expenses

net income before recapture

FIGURE 6. Comparative Income Distribution, Landmark and New Office Building

A. Landmark building. B. New building.

Source: Building Owners' and Managers' Association, exchange report; Cook County Assessor's Office; Real Estate Research Corporation

use." Fair market value is fixed by correlating value estimates established under the three traditional value approaches: Reproduction Cost, Market Data, and Income.

While each of these approaches is useful in setting the value of the building that could be built on the landmark site under current zoning, the first two are not helpful in valuing the landmark building itself. The Reproduction Cost approach, which requires precise estimates of depreciation including physical decline and functional obsolescence, is extremely difficult to apply in the case of landmark buildings. The Market Data approach operates on the basis of the sale of properties comparable to the property being valued. Landmarks or buildings of equivalent age and character, however, are not actively traded on the market.

But the Income approach does provide a reliable estimate of the landmark building's value. It focuses upon the net annual income that the building is able to return to the ownership after deductions for real estate taxes and other operating expenses. Use of the Income approach, moreover, conforms with the practices of lending institutions, which gauge the ability of a property to meet mortgage payments upon its earning power.

The object of employing the Income approach is to establish the effect of the imposition of a preservation restriction upon the landmark owner's equity. Its application requires an examination of typical financing practices in the market for similar buildings. Assuming that rational investors will seek through financial leverage to obtain the greatest possible return on equity, the owners of

70

the "before and after" buildings will secure as much mortgage financing as possible. From the operating statement, then, it is necessary to calculate cash flow to equity both for the landmark and for its replacement. Since the owner will receive this cash flow over a period of time, the amounts are discounted at a reasonable rate of interest for an expected projection period to estimate the present value of the cash flow to equity. At the end of the projection period, a reversionary or salvage value will remain which must be estimated and discounted to present value.

The present value of the equity in each building, therefore, is the sum of present value of equity cash flow and present value of the reversion. The value of the preservation restriction approximates the difference between the present value of the equity position for the landmark and that of the potential building for its site.

Two additional factors must be considered in order to arrive at the final price tag for the restriction. The first is the expenses related to demolition and other activities necessary to get the redevelopment project under way. The second is the reduction in real estate taxes that the landmark owner should enjoy in consequence of the depreciation his property suffers when encumbered by the restriction. These factors decrease the amount represented by the difference between the equity positions of the landmark and replacement structures.

The foregoing technique can be expressed by the following formula:

$$\text{DAMAGES} = (\text{ECF}_{\text{PV}} + \text{REV}_{\text{PV}}) - (\text{ecf}_{\text{pv}} + \text{rev}_{\text{pv}}) - D$$

Where: 1. DAMAGES[5] represents the value of the preservation restriction.

[5] The term "Damages" is used in an economic rather than a legal sense. As the discussion of the constitutional implications of landmark designation in Chapter 1 emphasizes, many losses that would be deemed damages from an economic viewpoint would not be so regarded by the courts.

2. ECF_{PV} represents the present value of equity cash flow of the potential building.

3. REV_{PV} represents the present value of reversionary value of the potential building.

4. ecf_{pv} represents present value of equity cash flow of the landmark building after property tax reduction.

5. rev_{pv} represents the present value of the landmark's reversionary value.

6. D represents demolition and miscellaneous expenses of getting the new project under way.

This formula provides an accurate measure of the losses resulting from permanent landmark status. Assuming typical financing and stabilized income statements, and relying on the Income approach to value, it yields a reasonable assessment of the losses that the landmark owner suffers. The key to its accuracy lies in close scrutiny of the marketplace to obtain the raw data required for analysis. Competent appraisers should experience little difficulty employing it in any city or for any income-producing property.

APPLICATION OF THE TECHNIQUE: A CASE STUDY

Applying the technique and related formula to particular cases is a two-phase process. The first phase requires a thorough examination of the proposed landmark to determine its present financial condition, its estimated present value, and, most important, the present value of the owner's equity in it. The second phase necessitates a similar evaluation of the replacement building. Table 3 summarizes the results of these calculations as applied to the four sample buildings and to their potential replacements.

To illustrate the methodology underlying the figures in Table 3, a step-by-step examination of its application to Landmark A follows.

TABLE 3. Calculation of the Value of Preservation Restrictions — Four Chicago Landmarks

Reference		Landmark A		Landmark B	
		Existing	Potential	Existing	Potential
1	Gross Building Size (sq. ft.)	295,000	625,000	368,000	854,000
	Efficiency Factor	.75	.80	.75	.80
2	Net Rentable Space (sq. ft.)	220,000	500,000	276,000	683,200
	Average Rental	$ 6.50	$ 8.50	$ 6.00	$ 8.50
	Gross Income	$1,430,000	$ 4,250,000	$1,656,000	$ 5,807,200
	Vacancy and Credit Loss @ 5%	$ 71,500	$ 212,500	$ 82,800	$ 290,360
	Effective Gross Income	$1,358,500	$ 4,037,500	$1,573,200	$ 5,516,840
3	Real Estate Taxes	$ 246,173	$ 1,009,375	$ 273,345	$ 1,379,210
	Other Operating Expenses	$ 611,325	$ 1,211,250	$ 707,940	$ 1,655,052
4	Net Income before Recapture	$ 501,002	$ 1,816,875	$ 591,915	$ 2,482,578
5	Overall Capitalization Rate	.10	.09	.10	.09
	Value Estimate – Income Approach	$5,010,000	$20,188,000	$5,920,000	$27,584,000
6	Loan-to-Value Ratio	.80	.90	.80	.90
7	Estimated Mortgage Amount	$4,008,000	$18,169,200	$4,736,000	$24,825,600
	Interest Rate	8.75%	8.50%	8.75%	8.50%
	Mortgage Term – Years	20	35	20	35
	Factor – Installment to Amortize $1.00	.106080	.089616	.106080	.089616
	Annual Debt Service	$ 425,168	$ 1,628,251	$ 502,394	$ 2,224,770
	Cash Flow to Equity (NIBR – Debt Service)	$ 75,823	$ 188,624	$ 89,521	$ 257,808
8	Discount Rate	6%	6%	6%	6%
	Projection Period – Years	20	35	20	35
	Factor – Present Value of Annuity of $1.00	11.469921	14.498246	11.469921	14.498246
	Present Value of Cash Flow to Equity	$ 869,683	$ 2,734,717	$1,026,798	$ 3,737,763
9	Estimate of Reversionary Value	$2,505,000	$10,094,000	$2,960,000	$13,792,000
	Discount Rate	6%	6%	6%	6%
	Projection Period – Years	20	35	20	35
	Factor – Present Value of Reversion of $1.00	.311805	.130105	.311805	.130105
	Present Value of Reversion	$ 781,071	$ 1,313,279	$ 922,942	$ 1,794,408
10	Present Value of Equity	$1,650,754	$ 4,047,996	$1,949,740	$ 5,532,171
11	Difference in Equity Values		$ 2,397,242		$ 3,582,431
	Demolition Costs		584,220		605,000
12	Damages to Landmark Owner (without tax reduction)		$ 1,813,022		$ 2,977,431
	Damages after 25% Tax Reduction		$ 1,107,128		$ 2,193,622

Source: Real Estate Research Corporation, 1972.

Reference		Landmark C		Landmark D	
		Existing	Potential	Existing	Potential
	Gross Building Size (sq. ft.)	65,800	111,725	300,000	807,000
1	Efficiency Factor	.75	.80	.75	.80
2	Net Rentable Space (sq. ft.)	49,350	89,380	225,000	645,600
	Average Rental	$ 7.00	$ 9.00	$ 7.00	$ 9.00
	Gross Income	$ 350,000	$ 804,420	$1,575,000	$ 5,810,400
	Vacancy and Credit Loss @ 5%	$ 17,000	$ 40,220	$ 78,750	$ 290,520
	Effective Gross Income	$ 333,000	$ 764,200	$1,496,250	$ 5,519,880
3	Real Estate Taxes	$ 109,444	$ 191,049	$ 299,250	$ 1,379,970
	Other Operating Expenses	$ 149,850	$ 229,259	$ 673,312	$ 1,655,964
4	Net Income before Recapture	$ 73,706	$ 343,889	$ 523,687	$ 2,483,946
5	Overall Capitalization Rate	.10	.09	.10	.09
	Value Estimate – Income Approach	$ 740,000	$ 3,821,000	$5,237,000	$27,600,000
6	Loan-to-Value Ratio	.80	.90	.80	.90
7	Estimated Mortgage Amount	$ 592,000	$ 3,438,900	$4,189,600	$24,840,000
	Interest Rate	8.75%	8.50%	8.75%	8.50%
	Mortgage Term – Years	20	35	20	35
	Factor – Installment to Amortize $1.00	.106080	.089616	.106080	.089616
	Annual Debt Service	$ 62,799	$ 308,180	$ 444,432	$ 2,226,061
	Cash Flow to Equity (NIBR – Debt Service)	$ 10,907	$ 35,709	$ 79,255	$ 257,885
8	Discount Rate	6%	6%	6%	6%
	Projection Period – Years	20	35	20	35
	Factor – Present Value of Annuity of $1.00	11.469921	14.498246	11.469921	14.498246
	Present Value of Cash Flow to Equity	$ 125,102	$ 517,717	$ 909,048	$ 3,738,880
9	Estimate of Reversionary Value	$ 370,000	$ 1,910,000	$2,618,500	$13,800,000
	Discount Rate	6%	6%	6%	6%
	Projection Period – Years	20	35	20	35
	Factor – Present Value of Reversion of $1.00	.311805	.130105	.311805	.130105
	Present Value of Reversion	$ 115,367	$ 248,500	$ 816,461	$ 1,795,449
10	Present Value of Equity	$ 240,469	$ 766,217	$1,725,509	$ 5,534,329
11	Difference in Equity Values		$ 525,748		$ 3,808,820
	Demolition Costs		123,000		270,000
12	Damages to Landmark Owner (without tax reduction)		$ 402,748		$ 3,538,820
	Damages after 25% Tax Reduction		$ 88,920		$ 2,680,732

Landmark A occupies a corner lot, a prime commercial location. Presently used as an office building, it contains approximately 295,-000 square feet. The building is well managed, enjoys a low vacancy rate, and commands an average rental of $6.50 per square foot of rentable space per year. The zoning for the site, with reasonable bonuses for setbacks, would allow construction of 625,000 gross square feet. Considering location and current demand for office space, a new building on this site could command an average rental of $8.50 per square foot. Table 3 shows a standard pro forma operating statement of income and expenses. The following numbered paragraphs explain the rationale supporting each step of the analysis, and are keyed to the reference numbers appearing in the far left-hand column of Table 3.

1. The "efficiency factor" or ratio of net rentable square feet to gross square feet is approximately .80 in new buildings, but only .75 in landmarks. Given the same gross square footage, therefore, the former are more profitable because a larger percentage of their interior space figures in the building's income production. New building design accounts for the differential because it incorporates planning factors that minimize wasted or non-rentable space, of which interior courts and elevator shafts are examples, respectively.

2. The net rentable space is multiplied by the average rental to determine the estimated gross income, from which is deducted an amount for vacancy and credit losses to determine effective gross income.

3. From the effective gross income are deducted real estate taxes and other operating expenses. Depreciation — a non-cash expense — is not included in the latter figure because the purpose of the appraisal is to determine net income before recapture (NIBR). The percentage of gross income allocated to expenses and taxes varies between landmark

and new buildings as reflected in Figure 2 as well as in Table 3.

4. Total expenses are deducted from effective gross income to derive NIBR, or, stated in the alternative, net income before depreciation and capital charges. NIBR is crucial to the entire analysis because it is this figure which, when capitalized, determines the value of the property (land and building).

5. NIBR is capitalized in accordance with the following formula:

$$V = I/R$$
$$\text{Where } V = \text{Value}$$
$$I = \text{NIBR}$$
$$R = \text{Capitalization Rate}$$

Market practices must be examined in selecting R, the capitalization rate. While a variety of indexes may be used for this purpose, the Mortgage-Equity Split Rate has been selected in this analysis. That index determines the overall capitalization rate on the basis of the amount of value financed with mortgage money and the amount considered as equity. A survey of insurance companies in mid-1972 revealed that mortgage money was then available at 8½ percent for new structures and 8¾ percent for older buildings. The equity component is less easily determined. Equity holders demand a yield on investment commensurate with risk. Current investors anticipate a return of at least 10 percent. Since older buildings are considered to entail greater risk than modern ones, investors in landmark properties will probably seek a 14 percent return and those involved with newer buildings an 11 percent return. These data are reflected in Table 4.

6. The next task is to determine the amount and length of the mortgages that are likely to be available for landmark and newer properties. Loan to value ratios, interest rates, and amortization schedules will differ depending upon the character of the mortgaged property. In office building financing, lenders fix these

TABLE 4. Capitalization of NIBR

	Landmark			Potential		
	Percent	Rate	Total	Percent	Rate	Total
Mortgage	80	.0875	.0700	90	.085	.0765
Equity	20	.1400	.0280	10	.110	.0110
Capitalization Rate[a]			.0980			.0875
Rounded to			.10, or 10%			.09, or 9%

[a] The capitalization rates are used in conjunction with NIBR to estimate value according to the formula $I/R = Value$.

Landmark A — $ 501,002/.10 = $ 5,010,000
Potential — $1,816,875/.09 = $20,188,000

Source: Real Estate Research Corporation, 1972.

elements on the basis of the property's earning expectations, viewed in terms both of annual return and of the number of years over which this return can prudently be forecast. In consequence, owners of new buildings can obtain more favorable terms than landmark owners because the economic life of newer buildings will be expected to exceed that of landmarks. The quality of the newer buildings' income stream will also be more favorably regarded because of the risk element considered above.

Current lending practices confirm these judgments. At the present time, modern structures qualify for amortization periods of up to thirty-five years; the term for older buildings is about twenty years. Interest rates for the two types of buildings do not differ greatly, but lenders require a ⅛ to ¼ percent premium for taking a mortgage on older buildings. Hence, the interest rates used in preparing Table 3 are 8½ percent for the new building and 8¾ percent for the landmark.

The loan-to-value ratios for the two types of properties show a greater gap than the interest rates. Base ratios are currently 66⅔ percent of fair market value on an old building and 75 percent on a new building. Each property is evaluated on its own merits, however. If a good proposal is unlikely to get off the ground due to the lack of equity dollars, a lender may be willing to raise the loan-to-value ratio rather than have the developer

pay higher interest rates to a secondary financing source. By "keeping the deal clean" of secondary financing, the lender is more likely to receive his payments promptly because the owner will not be squeezed by high financing costs. The 66⅔-75-percent loan-to-value ratios, therefore, serve as a floor from which to negotiate. On the basis of current financing practices, loan-to-value ratios of 80 and 90 percent have been selected for landmark and new buildings respectively.

7. The value estimates are multiplied by the loan-to-value ratios to determine the dollar amount of the mortgage. Then an annual constant factor is applied to fix the annual amount of the mortgage payment, or annual debt service requirement as indicated in Table 5. This payment covers the interest and principal due over the life of the loan. The factor is derived from standard tables that are calculated on the basis of interest rate and repayment period.

By deducting annual debt service requirements from NIBR, equity cash flow is determined. This amount represents the cash available to the equity owner, and is his annual return on his investment. Under the assumptions made in the study, this income would be fully sheltered from income taxes for both the landmark and the potential building.

8. A projection period must be selected in estimating the present value of the equity

TABLE 5. Determination of Annual Cash Flow to Equity

	Value	Loan/ Value	Mortgage Amount	Factor	Debt Service	Annual Cash Flow to Equity
Landmark	$ 5,010,000	80%	$ 4,008,000	.106080	$ 425,168	$ 75,823
Potential	20,188,000	90%	18,169,200	.089616	1,628,251	188,624

Source: Real Estate Research Corporation, 1972.

TABLE 6. Value of Preservation Restrictions for Four Chicago Landmarks

Landmark	Total Square Feet	Percent of Maximum FAR Developed	Present Market Value	Damages Incurred with Designation as Landmark	Damages as a Percent of Present Market Value
A	295,000	47.2	$5,010,000	$1,813,000	36.2
B	368,000	43.1	5,920,000	2,977,000	50.3
C	65,800	58.9	740,000	403,000	54.5
D	300,000	37.2	5,237,000	3,539,000	67.6

Source: Real Estate Research Corporation, 1972.

cash flow. In this case, that period has been chosen to coincide with the mortgage term. This choice acknowledges that the income expectations of the landmark building cannot be projected in perpetuity, but must be viewed within a reasonable time frame.

The discount rate should be equivalent to the rate of interest that a prudent investor could expect to receive if the annuity (equity cash flow) were invested at a conservative rate each year. A 6 percent rate was selected because it represents the current yield on medium-term (eight to ten years) U.S. Treasury bonds.

9. The same rate and term must be used in discounting the reversionary value back to present value. The selection of a reversionary value must, by the nature of the task, be estimated. Nevertheless, reversionary values are used routinely in real estate investment analysis since, in considering his yield, the real estate investor must estimate what he expects annually, plus what he expects to receive in a lump sum at the end of the projection period.

10. Present value of equity is the sum of both present value of equity cash flow and present value of the reversion. The difference in these sums for each property represents the approximate cost of the preservation restriction.

11. The landmark property's "before and after" value differential must be reduced by demolition costs. This amount is estimated by multiplying the cost of demolition per cubic foot by the number of cubic feet in the structure. It varies with the degree of difficulty of removal, ranging from 11 to 18 cents per cubic foot in Chicago. Since the sample landmarks appear to pose no special demolition problems, their demolition costs were estimated at 12 to 13 cents per cubic foot.

12. Finally, the effect of a real estate tax reduction must be considered. As pointed out elsewhere,[6] properties encumbered by preservation restrictions should be assessed at a correspondingly lower rate under the laws of most states. Table 6 indicates that the four landmarks suffer a weighted average loss in

[6] See Appendix IV *infra*.

76

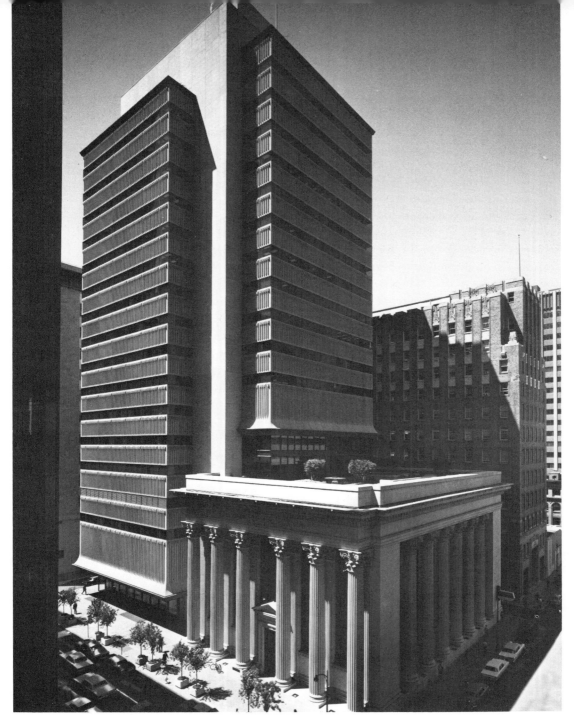

INTEGRATION OF THE OLD AND THE NEW ON A SINGLE SITE: ANOTHER PRESERVATION SOLUTION

Sensitive design and thoughtful concern for values not recorded on the balance sheet can often provide a solution other than demolition. They resulted in the preservation of San Francisco's Bank of California building constructed in 1908 and designed by Bliss and Faville. Despite the small site, the Bank of California erected a new twenty-one-story structure tower by use of a cantilever over the 1908 building and a combination of the floor area ratio of both portions of the site. The 1908 building, which is still in active use, was declared a San Francisco landmark in 1968.

value of about 50 percent of present market value. Many assessors, however, are likely to contest this figure. Like lenders and appraisers, they tend to assess downtown properties essentially on the basis of income potential despite the usual statutory direction to use the "fair value" standard.[7] The former approach, of course, would rule out a tax reduction for landmark buildings because their rental income is not likely to decline, at least over the short and mid-term. On the contrary, it may increase due to the building's heightened prestige and the protection that designation offers from forced relocation as a result of the building's demolition.

It is unlikely, therefore, that a 50 percent reduction in assessed valuation would be granted for the four landmark buildings. On the other hand, a reduction on the order of 25 percent might be acceptable to an assessor, especially if an intergovernmental agreement of the kind recommended in Appendix IV exists between the landmark commission and the assessor's office. A decrease of that magnitude will substantially increase the return on the landmark owner's investment by reducing the difference in present values between the landmark equity position and the possible equity in a larger building at the site. Table 7 reflects the relation of property taxes to the sample landmarks' effective gross income. Table 8 summarizes the reduction in damages that results from a 25 percent tax reduction on these properties.

THE IMPLICATIONS OF LONG-TERM OWNERSHIP

The Chicago Plan envisages that the preservation restriction acquired by the city in landmark properties will be a permanent interest. As noted earlier,[8] however, the finite economic and physical lives of landmark properties require that the city periodically re-

evaluate each property to determine whether its continued retention in private ownership remains feasible.

After designation of a building that is earning its own way, the following phenomena might be anticipated:

1. continuation of improvement in its occupancy and rental levels;
2. continuation of profitability due to reduced taxes;
3. decline in marketability;
4. decline in market price.

For the foreseeable future, it is reasonable to expect that landmarks will remain competitive in the marketplace. The two Chicago landmarks with virtually 100 percent occupancy, for example, are likely to continue to enjoy satisfactory occupancy levels. Owners of the remaining two landmarks can spend some of the funds provided by the property tax reduction for renovation, thereby increasing their buildings' appeal to potential tenants and increasing existing occupancy levels.

The marketability of the landmarks will decrease. The profit-motivated investor will look elsewhere since the landmarks' speculative value is diminished. In addition to the thin tax shelter and modest earnings that typify existing landmarks, little potential for capital gains attends ownership of these buildings. An important hedge against inflation, capital gains prospects figure prominently in the calculations of real estate investors.

The sales prices of designated landmarks will reflect their lack of development potential. The reduction in value should be approximately equal to damages calculated at the time of designation, less an adjustment for time. Purchasers of landmarks who acknowledge their limited speculative potential may find their investment quite satisfactory for a limited time because the income on these buildings may produce a high return on a low purchase price. But the price these build-

[7] *Ibid.*
[8] See pp. 45–48 *supra.*

TABLE 7. Relationship of Property Taxes to Effective Gross Income

Landmark	Effective Gross Income	Real Estate Taxes	Real Estate Taxes as a Percent of Effective Gross Income
A	$1,358,500	$246,173	18.1
B	1,573,200	273,345	17.4
C	333,000	109,444	32.9
D	1,496,250	299,250	20.0

Source: Real Estate Research Corporation, 1972.

TABLE 8. Preservation Restriction Costs per Square Foot of Undeveloped Space

Landmark	Unused Potential (sq. ft.)	Costs Incurred with Designation as a Landmark		Costs as a Percent of Present Market Value	
		No Tax Reduction	25% Tax Reduction	No Property Tax Reduction	25% Property Tax Reduction
A	330,000	$1,813,000	$1,107,100	36.2	22.1
B	486,000	2,977,000	2,193,600	50.3	37.1
C	45,925	403,000	88,900	54.5	12.0
D	507,000	3,539,000	2,680,700	67.6	51.2
Total	1,368,925	$8,732,000	$6,070,300		

Source: Real Estate Research Corporation, 1972.

ings will bring upon resale will be low because they remain encumbered by preservation restrictions. Overall yield, therefore, which measures both income and reversionary value, probably would be nominal.

While these considerations may deter purchase or continued ownership of landmarks by speculators, they also suggest that nonprofit organizations may find landmark ownership entirely feasible. Two reasons prompt this comment. First, initial acquisition costs will be severely depressed by the preservation restrictions. Second, the lowered reversionary value of the properties is likely to play a less significant role in the calculations of these organizations.

CONCLUSIONS

The cost of a preservation restriction is essentially a function of two factors:

1. *the relative size of the landmark and the replacement building;*
2. *the relative return on investment of the landmark and the replacement building.*

Underlying these elements are four variables that are essential to the calculation of this cost: *market demand for space, zoning, lot size,* and *location.* Each influences the differential in building size and in return on investment. In combination, they largely shape the market inputs, such as rental levels, vacancy rates, and the like, that are used in calculating preservation costs. Because of their central role, they are discussed in further detail below.

Market Demand for Space

Fundamental to the cost question is the existence of a healthy market demand for new construction in the general vicinity of the

landmark buildings. Without such demand, economic pressure for their demolition would largely vanish. In fact, it is probably fair to conclude that preservation's best friend to date has been bad economic times.

Conversely, vigorous demand increases land values, thereby introducing the bane of preservation — the discrepancy between the inflated value of landmark sites and the minimum earning potential of landmark buildings. No better illustration of this unfortunate cycle can be cited than Chicago itself. The loss of that city's Garrick Theater and Old Stock Exchange and the perilous state of its remaining Chicago School landmarks is directly attributable to the construction boom that Chicago has been experiencing since the mid-1950s.

Zoning

Municipal zoning measures also play a key role. Given a healthy market for new construction, their effect can be simply stated: *the more generous their density allocations the greater the cost of the preservation restriction and vice versa.* This point is not well understood, least of all by the cities themselves when they ascribe the loss of their landmarks to the supposedly autonomous forces of the private market. The fact of the matter is that governmental decisions are at least as responsible for landmark attrition as the vicissitudes of the marketplace. Developers in Chicago and elsewhere do not destroy landmarks because they are unrelenting philistines. As rational investors seeking maximum return on the dollar, they do so because this course of action is virtually forced upon them by the zoning rules that the city itself fixes.[9]

These rules, therefore, deserve close scrutiny from at least three perspectives. First, precisely how do generous zoning provisions drive up the costs that the landmark owner suffers? Second, what impact do these provisions have upon other development decisions that lead eventually to landmark attrition as well as to other unfortunate urban design consequences? Third, how may these rules be modified to facilitate rather than frustrate landmark preservation under incentive programs such as the Chicago Plan? The first two of these questions are addressed below following a brief review of the principal techniques currently used by American cities to regulate zoning density. The third is taken up in the next chapter in conjunction with a discussion of the relative appeal to developers of additional floor area derived from zoning bonuses and from the Plan's development rights transfers.

ALTERNATIVE TECHNIQUES FOR ALLOCATING DENSITY

The generosity of a city's zoning depends upon two factors: the technique by which it regulates density and the level at which it fixes that density. Most American cities regulate density in accordance with one or more of the following techniques: envelope zoning, tower coverage zoning, floor area ratio (FAR) zoning without bonuses, and FAR zoning with bonuses. Envelope zoning, the most traditional of these techniques, imposes precise restrictions both on the permissible bulk of a building and on its location on a zoning lot. Typically, it establishes minimum front, rear, and side yard setbacks, and limits the height of the building

[9] This point figures prominently in the earlier-mentioned letter of the Building Managers Association of Chicago, as quoted at p. 12 *supra*: "Under the present zoning laws of the City of Chicago, it is more and more necessary to put together large pieces of property so that the incentives of the zon-ing law to persuade a developer to set back and leave open areas can be used to its maximum. Therefore, if a landmark building remained, it could very easily block an important land assembly." Letter from Richard M. Palmer, President, Building Managers Association of Chicago, to Samuel A. Lichtmann, Chairman, Commission on Chicago Historical and Architectural Landmarks, Aug. 6, 1970.

to a specified number of feet or stories. These restrictions in turn limit the number of square feet of building space that may be built on a lot. Figure 7 illustrates this technique.

Tower coverage zoning takes a second tack. Limiting neither height nor placement, it requires only that the building's coverage of the lot not exceed a stated maximum percentage of the lot. Its purpose is to insure that a specified amount of open space will be provided in conjunction with a building erected on the lot. A 40 percent tower coverage requirement, for example, leaves a developer free to construct a building of any height anywhere on his lot provided that the building covers no more than 40 percent of the total site. Figure 8 indicates how this provision works.

FAR zoning without bonuses directly regulates the number of square feet permitted in a building constructed on the lot, but normally allows more design flexibility by allowing a number of possible design configurations. For example, an FAR of 10 means that a ten-story building can be built covering 100 percent of the site; a twenty-story building, using 50 percent of the site; or a forty-story building, using 25 percent of the site. In each of these instances, the total number of square feet that

FIGURE 7. Envelope Zoning

Height limitation: 10 stories or 100 ft.; rear yard setback: 20 ft.; side yard setback: 5 ft.; front yard setback: 10 ft.; lot size: 100' x 100' = 10,000 sq. ft.; maximum building bulk: 70' x 90' = 6,300 sq. ft. x 10 stories = 63,000 sq. ft. gross building space.

FIGURE 8. Tower Coverage Zoning

Typical provisions: building may cover no more than 40 percent of the total site. No height restriction.

81

FIGURE 9. Floor Area Ratio Zoning without Bonuses

Typical provision: maximum FAR: 10. If 50,000-sq.-ft. lot, then maximum of 500,000 sq. ft. of building space permitted (50,000 sq. ft. x 10 FAR). (A) 10-story building, 100 percent site coverage; (B) 20-story building, 50 percent coverage; (C) 40-story building, 25 percent coverage.

the building may contain remains constant. Figure 9 illustrates this approach.

FAR zoning with bonuses simply adds to the foregoing density allocation whatever amount of bonus space the developer earns by furnishing a specified amenity. If, for example, a developer agrees to provide an open plaza, thereby increasing public open space, he may be permitted to increase his FAR from 10 (as cited above) to a higher figure, thus entitling him to include a greater number of square feet of building area in his project. Figure 10 illustrates how the bonus system is applied.

FIGURE 10. Floor Area Ratio Zoning with Bonuses

Typical provision: maximum FAR: 10. Typical bonus provision: for each sq. ft. of yard area provided at grade level ad-
joining any street and which extends upward unobstructed to the sky, 10 additional sq. ft. of floor area may be added
to the maximum FAR. (A) 10-story building, 100 percent site coverage. If 50,000-sq.-ft. lot and FAR of 10, then maximum
of 500,000 sq. ft. of building space possible. (B) 20-story building, 50 percent site coverage. If 50,000-sq.-ft. site, then
applicable bonus = 250,000 sq. ft. (25,000 sq. ft. of open space x 10 sq. ft. of floor area). Maximum building size:
750,000 sq. ft.

ZONING AND PRESERVATION COSTS:
THE CHICAGO EXPERIENCE

The Chicago zoning ordinance, which em-
ploys the FAR-with-bonuses technique, repre-
sents the most detrimental type of zoning from
the viewpoint of minimizing the value of pres-
ervation restrictions. It combines generous
basic FARs with prodigal bonuses. The FAR
of 16, which prevails in the Loop, is among
the highest of any city in the United States.
But the real excitement is found in the bonus
space allocations. Under them it is theoreti-
cally possible for the owner of a half-block site

to double this base FAR and build a seventy-
four-story building containing about 2,500,000
square feet. More startling yet, they enable
the owner of a full-block site to increase his
FAR from 16 to 39.3, the latter permitting a
140-story building with close to 6,000,000
square feet. Figures 11 and 12 reflect these
possibilities. For comparison purposes, New
York's Empire State Building is 102 stories
tall, contains 2,120,836 square feet, occupies
a site of 83,860 square feet, and has an FAR
of 25.3.[10]

[10] Source: Rental Office, Empire State Building.

83

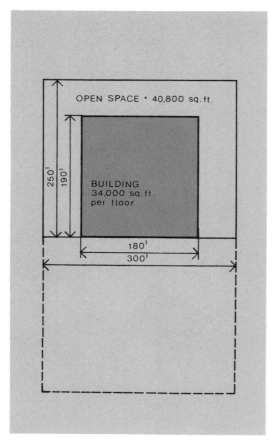

FIGURE 11. Half-Block Site (B6-7 Zoning District) with Maximum FAR and Frontage on Three Streets

(1) Basic FAR, 16. (2) Setback 20' or more on 3 streets at 2.5/street, all stories above grade,* 7.5. (3) Setback ground floor at 2.5 open area of lot ÷ gross lot area,* 1.36. (4) Setback upper floors at .4 open area of lot ÷ gross lot area (assume 40-story building),* .22/floor, 8.8. (5) Maximum FAR, 33.66, or 33.7. (6) Maximum floor area, 2,527,500 sq. ft. (7) No. of floors, 74.

* Bonus space

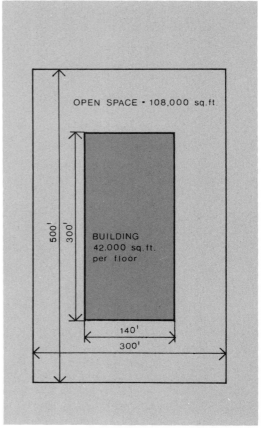

FIGURE 12. Full-Block Site (B6-7 Zoning District) with Maximum FAR

(1) Basic FAR, 16. (2) Setback 20' or more on 4 streets at 2.5/street, all stories above grade,* 10. (3) Setback ground floor at 2.5 open area of lot ÷ gross lot area,* 1.8. (4) Setback upper floors at .4 open area of lot ÷ gross lot area (assume 40-story building),* .288/floor, 11.5. (5) Maximum FAR, 39.3. (6) Maximum floor area, 5,895,000 sq. ft. (7) No. of floors, 140.

* Bonus space

So liberal is Chicago's zoning that it is virtually impossible to fix a precise theoretical maximum for the number of square feet that may be built on Loop parcels of a half-block or more, and quite difficult to do so for smaller lots. As a result, developer-owners of larger parcels in the Loop rarely build to the limits of the zoning ordinance. The cost per square foot for new construction rises in proportion to the height of the building, becoming impractical before those limits are reached. Further, to take advantage of the bonus provisions, developers would have to construct unusually tall buildings with a relatively small number of square feet per floor. The resulting structures would be inefficient because a dis-

proportionate amount of their space would be lost to elevator shafts, utility systems, and other non-rentable uses. Hence, in designing their projects, Chicago developers generally strike a balance between the maximum that zoning allows and the economics of large building construction.

Three consequences that impinge directly on the question of preservation restriction costs flow from Chicago-type zoning. First, that zoning drives these costs up inordinately by opening a huge gap between the size of the landmark buildings and the size of their potential replacements. For example, Landmark B sits on a 26,400-square-foot lot and contains 368,000 interior square feet for an effective FAR of 13.9. A replacement building taking full advantage of the basic bulk allocations

and the bonus provisions of Chicago's ordinance could quite feasibly contain 854,000 square feet. Its FAR would more than double, from 13.9 to 32.3. The same point appears in considering the four sample landmarks collectively. At present, they contain 1,028,800 square feet; their replacement buildings, however, would contain an estimated 2,397,725 square feet. The difference of 1,368,925 square feet between these two figures largely accounts for the total gross damages tab for the four buildings of $8,732,000. These relationships are represented schematically in Figures 13 and 14.

Second, Chicago's bonuses both complicate the calculation of preservation restriction costs and further increase their amount. Consider, for example, the options open to a developer

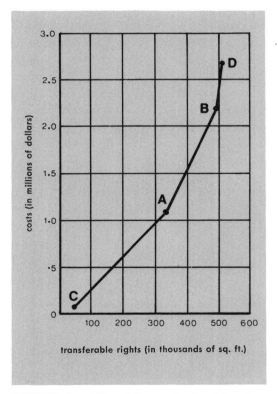

FIGURE 13. Correlation of Preservation Restriction Costs with Transferable Development Rights

FIGURE 14. Relationship of Existing Building Square Footage to Preservation Restriction Costs

85

who owns a Loop corner lot 160 by 250 feet with a frontage on two streets in a "B6-7" bulk district. That district's base FAR of 16 could be escalated by the following bonuses, among others:[11]

	Bonus
a. Setback of 20 feet or more on each of two streets for all stories above grade (bonus of 2.5 per street setback)	5.0
b. Setback at ground level — 40 feet from two streets (bonus of 2.5 times open area at ground level divided by gross lot area)	1.0
c. Setback at upper floors above the ground floor — 40 feet from two streets for (an illustrative) 30 stories (bonus of .4 times open area of each floor divided by gross lot area)	4.5
Total Bonuses	10.5

Which, if any, of these bonuses the developer selects rests wholly within his discretion. But the courts might well find that he is entitled to any or all of them as a *matter of right* because Chicago's ordinance in no way conditions them upon prior approval by city officials. This conclusion would be extremely damaging to the city should it seek to acquire a preservation restriction through condemnation proceedings. Condemnation awards are measured by the condemned property's "highest and best use." In the case of Loop parcels, the latter would then be fixed not in relation to the parcel's base FAR alone but in terms of that FAR plus such additional bonus space as seems reasonable in light of current market demands for office space.

In consequence, the size of the replacement buildings for the four sample sites (or for any others in a district in which bonuses are applicable) may not be determinable simply by multiplying the square footage of the site by the base FAR of 16. Instead, a much larger

[11] See Chicago, Ill., Municipal Code, Zoning Ordinance ch. 194A, art. 8.5-6 (1970).

size may have to be fixed on the basis of an estimate that considers the individual site's configuration as well as typical developer requirements as to overall building size, square feet of building space per floor, and total floor area. This technique was used in arriving at the size of the replacement buildings for the four sample sites.

Third, bonus zoning as practiced in Chicago may also increase costs by adding a substantial assemblage premium to the calculation in cases where speculators own both the landmark site and adjoining land at the time the restriction is acquired. These cases may not be infrequent because the relatively smaller size of many landmark sites makes them prime targets for inclusion in land assemblages. Bonus zoning encourages assemblage — and therefore landmark demolition — because bonuses can be employed to greater advantage on larger holdings. The number of square feet that can be built on a given parcel under the bonus system rises geometrically in proportion to lot size. In addition, large sites afford greater flexibility in providing the setbacks and open space required for the bonuses. Finally, enough lot area for efficient construction remains on these sites after deductions for setbacks and open space.[12]

LAND ASSEMBLY AND THE LOW-DENSITY USE

Zoning ordinances that allocate density under the FAR-with-bonuses technique began to appear in American cities in the late 1950s

[12] The observations in the text concerning the Chicago zoning ordinance prompt an important qualification concerning the extent to which the cost of acquiring a preservation restriction in Chicago is representative of what the cost might be in other American cities. Without a tax reduction, these costs in Chicago range from a low of 36.2 percent to a high of 67.6 percent of the landmark property's fair market value, or, stated in dollar amounts, from $740,000 to $5,237,000. With a 25 percent tax reduction, the corresponding figures are 12 percent and 51.2 percent, or, in dollar terms, $88,990 to $2,680,000. Because zoning as liberal as Chicago's is found in few, if any, other American

and early 1960s. The results attributable to them since then have been mixed. In many instances, the plazas, arcades, and other facilities that they encouraged have enhanced the amenity levels of the urban downtown, particularly when the bonuses allotted for these facilities were held to reasonable levels. Regrettably, however, many cities have awarded premium space profligately. Worse still, they have been so dazzled by the prospect of open space amenities that they have ignored the havoc that an untamed bonus system can wreak upon other types of amenities deserving of equal or greater consideration.

The chief victim of this shortsightedness has been the low-density use located on the smaller downtown parcel. Landmarks are of course a prime illustration, but hardly the only one. Because generous space allocations can best be exploited only on larger parcels, the small parcel use is the first to go when the real estate market begins to heat up. As a result, bonuses have largely accounted for the frenzied land assembly maneuvers of downtown speculators whose concern for the buildings or uses occupying the parcels targeted for redevelopment goes no further than the expense of their demolition.

Accounts of the unhappy consequences of insensitively administered zoning bonus programs tell the story graphically. Writing of the impact of New York City's zoning bonus program upon that city's redeveloped Sixth Avenue, Ada Louise Huxtable grimaced: "The zoning is a failure in urbanistic terms — or

how a city looks and works. The zoning, combined with the rising cost of land and building, has been the definitive factor in driving out the small enterprises, the shops, restaurants and services that make New York a decent and pleasurable place in which to live and work. In their place is a cold parade of standard business structures set back aimlessly from the street on blank plazas that ignore each other."[13]

Predictably, Chicago's bonus system also gets poor marks. Its impact upon development within the Loop was described as follows in a study co-authored by the present writer:

> It is from [the zoning bonus] provisions in [Chicago's zoning] ordinance that the pressure arises to merge properties in the Central Business District in order to create large lots with multiple street frontages which can benefit from them. This pressure in itself has imposed burdens on certain landmark structures and has driven from the Loop a host of small merchants and service businesses which are sorely missed. It has also tended to render uncompetitive the smaller office building and commercial structure which might otherwise have been built in the downtown area by pushing land values upward and by limiting the development potential of smaller sites as compared to larger ones. While many people in the real estate field prefer block-front structures for esthetic as well as for economic reasons, there is little question that these structures do tend to reduce the diversity and vitality of downtown streets and to reduce the general convenience and attractiveness of the ordinary office worker's day by reducing shopping opportunities and service facilities. The long range benefits of eliminating the small retailer, shoe repair man, tailor shop, book store and loft-type business from the Central Area economy also appear somewhat doubtful.[14]

cities, these figures are undoubtedly in excess of the acquisition costs that would result if the four sample properties were located elsewhere. These costs, moreover, were calculated by adding to the basic density allocations of the Chicago ordinance substantial bonus premiums designed to correlate with the building practices of Chicago developers at the present time. In no event, therefore, should they be viewed as indicative of any kind of "national average" respecting percentage of loss resulting from landmark designation.

[13] Huxtable, "Thinking Man's Zoning," *New York Times*, Mar. 7, 1971, §2, p. 22, col. 1.
[14] J. Costonis & J. Shlaes, *Development Rights Transfers: A Solution to Chicago's Landmarks Di-*

The point of these comments is not that bonuses should be banished from the municipal zoning ordinance. On the contrary, bonuses are a milestone in the struggle of cities to achieve greater leverage over private land use decisions that vitally affect community goals. There have been enough success stories in the use of bonuses to date, moreover, to render absurd the notion that bonuses are evil per se. Rather, the challenge is to see to it that bonuses are used more discerningly to insure that in the trade-off of space for amenity, the city — and the public interest — will come out at least as well as the developer or, perhaps, even better. The Chicago Plan affords a fertile device for achieving this result, as suggested in the following chapter.

Lot Size

Because the three principal ways in which lot size affects the costs question have already been reviewed in the zoning discussion, its role need only be summarized here. First, lot size plays a key part in determining the permitted size of a project, whether under the envelope, tower coverage, or FAR bulk regulation techniques. Second, it strongly influences whether or not a given project will include bonus space (where bonuses are available), since the premiums granted for setbacks and other open space amenities are feasible only on lots of

lemma 17 (Chicago Chapter Foundation of the American Institute of Architects & National Trust for Historic Preservation, May 1971).

sufficient minimum size. Finally, it offers a useful index for gauging whether any given parcel is likely to come under pressure for inclusion in a land assemblage or whether the parcel will itself serve as the site for a new project.

Location

The value of real estate depends in large measure upon its location. The extremely high costs recorded for the preservation restrictions on the four sample landmarks reflect the location of these buildings in the central business district of a major metropolitan area. Even within a central business district, however, different locations have varying effects upon real estate values as determined by the local market. Thus, properties located only a block apart may have significantly different land values.

Other Variables

Other important variables include interest rates, mortgage terms, vacancy rates, and the expectations of equity holders. Because these variables are dependent upon normal fluctuations in the marketplace over time, however, their impact on the calculation of damages is relative to the point in time at which the calculation is made. At any one point in time, moreover, these variables will hold constant for the cost calculations on any landmark building.

4
The Chicago Plan and Economics:
The Marketability of Development Rights

The previous chapter has documented that the preservation of urban landmarks located on high-density downtown sites can be an extremely costly undertaking. This chapter examines whether the development rights transfer mechanism can meet financial challenges of the magnitude that is likely to be encountered in this undertaking. The inquiry is divided into two basic questions. First, what are development rights worth? Included in this question is the design of a methodology for valuing development rights and the identification of the key variables that appear to govern their value. Second, how is this value influenced by liberal zoning codes, such as those of Chicago and some other major cities? The response to the second question includes a discussion of possible modifications in these codes that will facilitate the marketability of development rights despite the availability of generous zoning bonuses.

This chapter also considers the fiscal implications of the Plan for cities that adopt it. The specific question addressed is whether the combination of increased property tax yields that will be realized on transferee sites and of income derived from the sale of donated public and private development rights will be sufficient to balance any net costs that cities

may incur in implementing the Plan. The chapter concludes with a summary of the general conditions that appear to govern the Plan's economic feasibility.

THE MARKETABILITY OF DEVELOPMENT RIGHTS

The Land Residual Method

It is axiomatic that a developer will pay a price for development rights which is proportionate to the value that they add to his site. Hence, purchase of development rights is tantamount to purchase of additional land. The approach selected in this study for measuring the value that development rights add to the parcels on which they are used is the Land Residual Method. In addition to its routine use by professional real estate appraisers, the Land Residual Method carries the advantage of complementing the methodology employed in the previous chapter to calculate the cost of acquiring a preservation restriction. The Land Residual Method includes the following steps:

1. establishment of a building cost estimate;
2. calculation of net income before recapture (NIBR);
3. deduction from NIBR of the income re-

quirements of the improvements, including interest and recapture, to determine income residual imputable to the land;

4. capitalization of the land residual at current interest rates to determine market value.

The method can be illustrated by using it to measure the difference in land values that would result from the construction of three successively larger buildings on the same site in Chicago's Loop. Hypothetical office buildings containing 400,000, 425,000 and 450,000 square feet respectively and a constant site size of 20,000 square feet are assumed. Other assumptions include construction costs of $35 per square foot, a 5 percent vacancy and credit loss, property taxes equaling 24 percent of gross annual income, and other operating expenses of 28 percent. Finally, rent levels of $9.50, $10.00, $10.50, and $11.00 per square foot are utilized.

Table 9 shows the base building size, with increments of 25,000 square feet, and its impact on land values, assuming different average rent levels. The first step in the procedure is to estimate NIBR, the methodology for which is discussed in the previous chapter. Then the developer must estimate the construction cost for the building being examined. Unit costs of average quality construction, localized to Chicago, are in the vicinity of $35 per square foot. The calculation of total costs is then a product of unit cost of construction times the gross building size plus additions for basements and special equipment.

Once NIBR and the cost estimates are known, a capitalization rate applicable to the project is determined by examining current interest rates for long-term mortgages and

selecting an appropriate projection period. An 8.5 percent interest rate and a fifty-year period are used in this analysis. A capitalization rate known as an "Inwood Factor"[1] is also employed. Although a simple straight-line capitalization may be used as an alternative, it is likely that sophisticated developers would elect the use of the Inwood Factor, which, unlike the former, gives consideration to the reinvestment value of invested funds.

The capitalization rate is then multiplied by the total cost of the building to determine the annual capital requirement for the building alone. This amount is deducted from NIBR to yield the amount of income imputable to the land, or income residual to the land. The latter sum is capitalized at current interest rates to determine the value of the land. Since land does not depreciate in value, it is capitalized into perpetuity at the market rate of interest.

Once the developer has estimated the land value under various assumptions of building size and rental, he can then compare the effect on land value resulting from the added building size. In this way he is able to estimate the worth of the rights at his particular location.

When the above analysis is performed for the different-sized buildings being considered by the developer, the difference in land value represents the value of the transferable development rights. Using a $9.50 rent level, Table 10 illustrates the effect of increased density on land values, applying the Land Residual Method.

Similar analysis for other rent levels shows that the value of the rights to the developer is positively correlated with the rent level expected at that site, as indicated in Table 11.

The economic feasibility of the development

[1] The Inwood Factor is a method for determining the present worth of an income stream, utilizing principles of compound interest. The present worth is the basis of interest and amortization tables for the customary full amortizing mortgage. Features of the Inwood Method are: (1) annual income requirement, to satisfy recapture and interest, is an equal annual amount; (2) recapture installments are relatively low to begin with but increase each year; (3) interest is received each year on the remaining amount of investment.

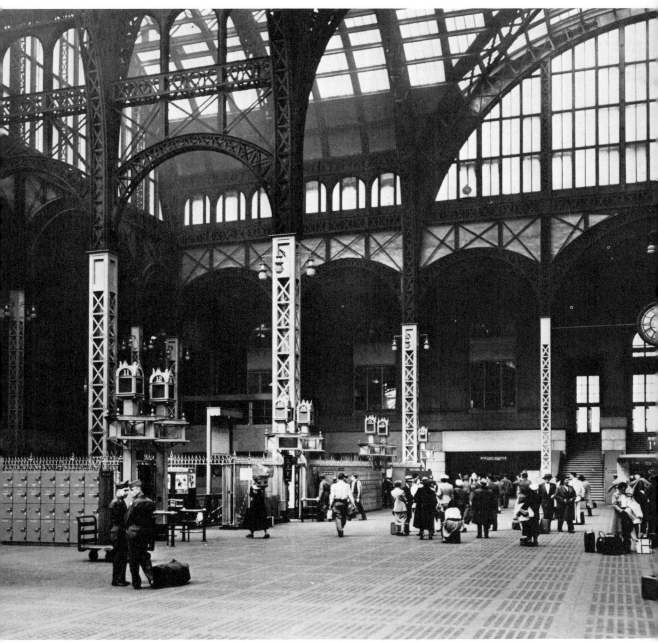

PENNSYLVANIA STATION

New York City, 1906-10 to 1963-66, McKim, Mead and White. Railroad terminals have been particularly hard hit by speculative market pressures, aggravated by the declining economic fortunes of the railroads, which, in self-defense, have begun selling off their properties. The Santa Fe Railroad, for example, now advertises itself as "the nation's longest real estate company." Landmarks that have fallen include New York City's Pennsylvania Station, Chicago's Grand Central Station, and Philadelphia's Broad Street Station. Presently threatened are New York City's Grand Central Terminal (see p. 37) and Cincinnati's Union Station.

Table 9. Land Residual Technique for Estimating Land and Development Rights Values

	$9.50 Rent Level			$10.00 Rent Level		
Gross Building Size (sq. ft.)	400,000	425,000	450,000	400,000	425,000	450,000
Efficiency Factor	.80	.80	.80	.80	.80	.80
Net Rentable Size (sq. ft.)	320,000	340,000	360,000	320,000	340,000	360,000
Average Rental	$ 9.50	$ 9.50	$ 9.50	$ 10.00	$ 10.00	$ 10.00
Gross Income	$ 3,040,000	$ 3,230,000	$ 3,420,000	$ 3,200,000	$ 3,400,000	$ 3,600,000
Vacancy and Credit Loss @ 5%	$ 152,000	$ 161,500	$ 171,000	$ 160,000	$ 170,000	$ 180,000
Effective Gross Income	$ 2,888,000	$ 3,068,500	$ 3,249,000	$ 3,040,000	$ 3,230,000	$ 3,420,000
Real Estate Taxes	$ 722,000	$ 767,125	$ 812,250	$ 760,000	$ 807,500	$ 855,000
Operating Expenses	$ 866,400	$ 920,550	$ 974,700	$ 912,000	$ 969,000	$ 1,026,000
Net Income before Recapture (NIBR)	$ 1,299,600	$ 1,380,825	$ 1,462,050	$ 1,368,000	$ 1,453,500	$ 1,539,000
Unit Construction Cost per Square Foot	$ 35	$ 35	$ 35	$ 35	$ 35	$ 35
Total Cost[a]	$14,112,000	$14,994,000	$15,876,000	$14,112,000	$14,994,000	$15,876,000
NIBR	$ 1,299,600	$ 1,380,825	$ 1,462,050	$ 1,368,000	$ 1,453,500	$ 1,539,000
Capitalization Rate (Inwood Method)	.0864	.0864	.0864	.0864	.0864	.0864
Projection Period – Years	50	50	50	50	50	50
Interest Rate	8.5%	8.5%	8.5%	8.5%	8.5%	8.5%
Cost times Capitalization Rate (Building Requirement)	$ 1,220,170	$ 1,296,430	$ 1,372,691	$ 1,220,170	$ 1,296,430	$ 1,372,691
Land Residual Income	$ 79,430	$ 84,395	$ 89,359	$ 147,830	$ 157,070	$ 166,309
Interest Rate	8.5%	8.5%	8.5%	8.5%	8.5%	8.5%
Land Value	$ 934,470	$ 992,882	$ 1,051,277	$ 1,739,176	$ 1,847,882	$ 1,956,576
Difference in Land Values Attributable to Added Density		$ 58,412	$ 116,807		$ 108,706	$ 217,400
Value of Transferable Rights per Square Foot		$ 2.33	$ 2.33		$ 4.34	$ 4.34

a Cost calculations are not a product of building size multiplied by unit costs. Other cost factors are included but not detailed above.
Source: Real Estate Research Corporation, 1972.

	$10.50 Rent Level			$11.00 Rent Level		
Gross Building Size (sq. ft.)	400,000	425,000	450,000	400,000	425,000	450,000
Efficiency Factor	.80	.80	.80	.80	.80	.80
Net Rentable Size (sq. ft.)	320,000	340,000	360,000	320,000	340,000	360,000
Average Rental	$ 10.50	$ 10.50	$ 10.50	$ 11.00	$ 11.00	$ 11.00
Gross Income	$ 3,360,000	$ 3,570,000	$ 3,780,000	$ 3,520,000	$ 3,740,000	$ 3,960,000
Vacancy and Credit Loss @ 5%	$ 168,000	$ 178,500	$ 189,000	$ 176,000	$ 187,000	$ 198,000
Effective Gross Income	$ 3,192,000	$ 3,391,500	$ 3,591,000	$ 3,344,000	$ 3,553,000	$ 3,762,000
Real Estate Taxes	$ 798,000	$ 847,875	$ 897,750	$ 836,000	$ 888,250	$ 940,500
Operating Expenses	$ 957,600	$ 1,017,450	$ 1,077,300	$ 1,003,200	$ 1,065,900	$ 1,128,600
Net Income before Recapture (NIBR)	$ 1,436,400	$ 1,526,175	$ 1,615,950	$ 1,504,800	$ 1,598,850	$ 1,692,900
Unit Construction Cost per Square Foot	$ 35	$ 35	$ 35	$ 35	$ 35	$ 35
Total Cost[a]	$14,112,000	$14,994,000	$15,876,000	$14,112,000	$14,994,000	$15,876,000
NIBR	$ 1,436,400	$ 1,526,175	$ 1,615,950	$ 1,504,800	$ 1,598,850	$ 1,692,900
Capitalization Rate (Inwood Method)	.0864	.0864	.0864	.0864	.0864	.0864
Projection Period—Years	50	50	50	50	50	50
Interest Rate	8.5%	8.5%	8.5%	8.5%	8.5%	8.5%
Cost times Capitalization Rate (Building Requirement)	$ 1,220,170	$ 1,296,430	$ 1,372,691	$ 1,220,170	$ 1,296,430	$ 1,372,691
Land Residual Income	$ 216,213	$ 229,745	$ 243,259	$ 284,630	$ 302,420	$ 320,209
Interest Rate	8.5%	8.5%	8.5%	8.5%	8.5%	8.5%
Land Value	$ 2,543,682	$ 2,702,882	$ 2,861,870	$ 3,348,588	$ 3,557,882	$ 3,767,164
Difference in Land Values Attributable to Added Density		$ 159,200	$ 318,188		$ 209,294	$ 418,576
Value of Transferable Rights per Square Foot		$ 6.36	$ 6.36		$ 8.35	$ 8.35

TABLE 10. Effect of Increased Density on Land Value

Building Size (sq. ft.)	400,000	425,000	450,000	475,000
Cost of Improvements	$14,112,000	$14,994,000	$15,876,000	$16,758,000
Net Income before Recapture	$ 1,299,600	$ 1,380,825	$ 1,462,050	$ 1,543,275
Capitalization Rate (Inwood Method)	.0864	.0864	.0864	.0864
Cost times Capitalization Rate	$ 1,220,170	$ 1,296,430	$ 1,372,691	$ 1,448,952
Land Residual Income	$ 79,430	$ 84,395	$ 89,359	$ 94,323
Land Capitalization Rate	.085	.085	.085	.085
Land Value	$ 934,470	$ 992,882	$ 1,051,277	$ 1,109,682
Land Value per Square Foot (20,000-sq.-ft. lot)	$ 46.72	$ 49.64	$ 52.56	$ 55.48
Value of Additional Development Rights (25,000 sq. ft.)		$ 58,412	$ 116,807	$ 175,212

Source: Real Estate Research Corporation, 1972.

TABLE 11. Relationship of Rent Level to Value of Transferable Development Rights

Rent Level per Square Foot	Value per Square Foot of Transferable Development Rights
$ 9.50	$2.33
10.00	4.34
10.50	6.36
11.00	8.35

Source: Real Estate Research Corporation, 1972.

rights transfer mechanism can be tested by comparing the results of this analysis with the earlier determination of the cost of acquiring preservation restrictions on the four Chicago landmarks. The latter costs were estimated at about $6 million. Since the excess development rights of the four sites were estimated at approximately 1.4 million square feet, the rights would have to be sold at $4.43 per square foot to offset the $6 million acquisition cost. Table 10 indicates that, *given Chicago's existing zoning and office space market,* the development rights will return between $2.33 and $8.35 per square foot on a scale of rental levels running from $9.50 to $11 per square foot per year. Assuming that rental levels for the buildings incorporating the rights fall within the median rental range (between $10 and $10.50 per square foot per year), income derived from sale of the development rights

of the four sample sites will exceed the costs of the restrictions. These rights would sell at even higher prices, moreover, if the modifications that are suggested presently were introduced into the Chicago zoning ordinance.

Variables Affecting the Marketability of Development Rights

The price that development rights will bring on the open market depends principally upon two factors: *market demand for new construction* and *applicable zoning.* In the absence of market demand for new construction, of course, development rights will not be saleable because there will be no new construction into which they can be incorporated. Similarly, a sluggish real estate market may mean that prevailing rental levels in the locality will fall below the floor necessary to insure that the city's receipts from development rights sales match its outlays for preservation restrictions.

In cities that are losing landmarks due to rising land values, it is a good bet that the necessary market will exist. Without a strong construction market, the value of landmark sites would not have skyrocketed and thus the sites would not have come under pressure for redevelopment with the larger structures required to capitalize on these increases in value. Despite this probability, the existence of a

strong market should not be left to surmise but should be addressed in a thorough study before any city adopts the Plan.

The municipal zoning code must also be closely scrutinized because the more restrictive its provisions, the greater the applicability of the development rights transfer mechanism and vice versa. If the density authorizations of the zoning code equal or exceed those that would be justified on the basis of market demand, of course, the developer will have no incentive to purchase the additional density offered to him under the Chicago Plan.

THE PROBLEM OF LIBERAL ZONING

Building Efficiency vs. Contemporary Zoning

We have already seen that generous zoning can drastically inflate the cost of preservation restrictions. How does that zoning influence the marketability of development rights? The response to that question depends upon the precise manner in which the zoning is deemed generous. If it permits the construction of buildings that are both large *and* efficient, development rights sales will suffer. But if it authorizes buildings that decline in efficiency as they increase in size, development rights sales may prosper even though the zoning prescribes a very high theoretical bulk maximum.

Building efficiency is measured by the ratio of the total square feet of building space in a structure to its net rentable square feet. It is influenced by three key factors, which also affect the relationship between zoning and the marketability of development rights. These factors may be expressed as follows:

1. The smaller the floor area (building space per floor), the greater the building cost per square foot.
2. The more regular the perimeter of a building, the lower the cost per square foot and total construction costs.

3. The greater the number of stories in a building, the higher the cost per square foot, and thus the total construction costs.

FLOOR AREA SIZE

Sophisticated developers seek to achieve high building efficiency by minimizing non-revenue-producing space. Buildings containing small floor areas tend to be inefficient because a relatively higher proportion of their total gross square footage must be devoted to non-rentable uses. Subject to project requirements, building design, and lot configuration, for example, a developer can usually achieve 80 percent efficiency or better with floors of 20,000 square feet. But that figure will drop to 78 percent on floors of 16,000 square feet. Figure 15 illustrates this comparison.

Buildings with larger floor areas also cost less to construct. Figure 16 demonstrates how construction costs per square foot decline as floor size increases.

PERIMETER CONFIGURATION

As Figure 17 indicates, the cost of new construction rises in direct proportion to the number of lineal perimeter feet. Thus, holding all other factors constant, the more regular the shape of the perimeter walls of the new building, the lower the cost per square foot and total construction costs.

BUILDING HEIGHT

Costs per square foot also increase in proportion to the height of the building. The Marshall Valuation Service estimates that for each story over the first three stories in a building, costs per square foot will increase approximately 8 percent per floor. Figure 18 reflects this relationship.

On the basis of these three factors, a developer can build most profitably by designing his building:

FIGURE 15. Comparison of Efficiency, Large and Small Area Floors

(A) 20,000-sq.-ft. floor area: 16,000 sq. ft. rentable, 4,000 sq. ft. unrentable; 80 percent efficiency. (B) 16,000-sq.-ft. floor area, 12,500 sq. ft. rentable, 3,500 sq. ft. unrentable; 78 percent efficiency.

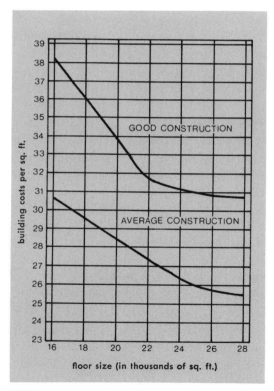

FIGURE 16. Building Costs, High-Rise Office Buildings, Chicago, 1972

Source: Dodge Building Cost Calculation and Valuation Guide

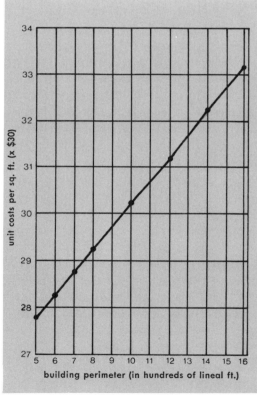

FIGURE 17. Building Costs Related to Perimeter Size

Assume base cost of $30 per sq. ft. and 16,000 sq. ft. per floor.

Source: Marshall Valuation Service

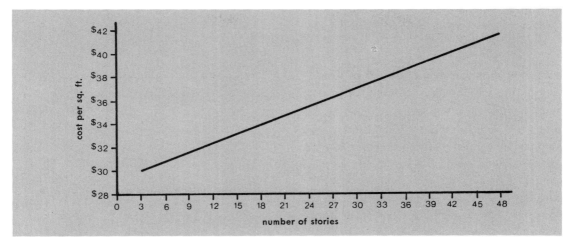

FIGURE 18. Cost per Square Foot Related to Building Height
Source: Marshall Valuation Service

1. to create as large a number of square feet per floor as possible up to at least 28,000 square feet per floor;

2. to accommodate as much square footage as possible on his lower floors;

3. to minimize the perimeter of his building by designing it to approximate the shape of a square.

Modern zoning codes, however, frustrate the developer on all three counts. In their pursuit of open space amenities, they encourage or even mandate greater building setbacks, thus requiring developers to design their buildings to include a smaller number of square feet of building space per floor and a greater number of stories. Hence the key to the marketability of development rights on other than smaller sites in cities with generous zoning bonus provisions rests in the capacity of the rights to remedy the imbalance between building efficiency and liberal zoning.

The Chicago Zoning Ordinance: A Case Study

The impact of building efficiency factors on the relation between liberal zoning and the marketability of development rights can be tested by returning to Chicago's zoning ordinance. Generous both in its basic bulk allocations and in its bonuses, the ordinance poses as difficult an obstacle to the transfer mechanism as is likely to be encountered in any American city. But the following case study confirms that development rights can hold their own in competition with zoning bonuses to the extent that constraints upon the use of bonus space render the resulting building inefficient under one or more of the criteria of efficiency identified above. More specifically, the study establishes that:

1. Development rights will probably be unsaleable on Loop lots of a half-block or more because bonus space can be efficiently incorporated into buildings constructed on these lots.

2. Development rights will have a firm market on lots of a quarter-block or less because bonus space cannot be efficiently used on such lots.

3. If the Chicago ordinance were modified marginally to take account of the building efficiency factors identified above, development rights would prove more attractive

97

than bonus space as a source of increased density, *even on lots of more than a quarter-block.*

DEVELOPMENT ON LOTS OF A HALF-BLOCK OR MORE

Efficient as well as large buildings can be built on lots of a half-block or more under Chicago's bonus provisions for the three reasons noted earlier: the geometric relation between bonuses and the size of the lot; the greater flexibility afforded by large lots for arranging open space and setbacks; and, most important, the availability of sufficient building area on these lots for efficient structures, even after deduction of lot area for the open space and setbacks. These reasons explain why buildings of 6,000,000 and 2,500,000 square feet can be built on Loop lots of a block and a half-block respectively, as illustrated in Figures 11 and 12 of the preceding chapter. Since gross space amounts approaching this range can be incorporated into efficient building configurations on lots of a half-block or more, development rights hold no attraction for the owners of these lots.

DEVELOPMENT ON LOTS OF A QUARTER-BLOCK OR LESS

The same relationship between size and efficiency does not hold true for buildings constructed on lots of a quarter-block or less. These lots provide relatively little flexibility for manipulating setback lines or setting aside the open space required for bonuses. Hence, the attempt to utilize bonus space on them would prove fruitless because the profitability of the resulting building would be severely impaired by its low efficiency ratio. These considerations account for the per-square-foot value of development rights recorded in Table 9 above. Figures 19 and 20 illustrate the maximum range of building space that could feasibly be constructed using bonuses on lots of 10,000 square feet and 37,500 square feet (a quarter-block) respectively.

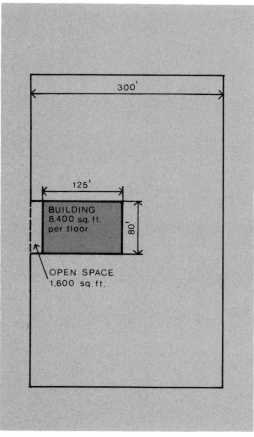

FIGURE 19. 10,000-Square-Foot Site (B6-7 Zoning District) with Maximum FAR and Frontage on One Street

(1) Basic FAR, 16. (2) Setback 20' or more on 1 street at 2.5/street, all stories above grade,* 2.5. (3) Setback ground floor at 2.5 open area of lot ÷ gross lot area,* .4. (4) Setback upper floors at .4 open area of lot ÷ gross lot area (assume 20-story building),* .06/floor, 1.2. (5) Maximum FAR, 20.1. (6) Maximum floor area, 201,000 sq. ft. (7) No. of floors, 24.

* Bonus space

DEVELOPMENT ON LOTS LARGER THAN A QUARTER-BLOCK

The relative profitability of zoning bonuses and development rights transfers is less clear for lots falling within the quarter- to half-block bracket. But it is certain that floor area derived from transfers would be worth more than bonus space to the developer if he

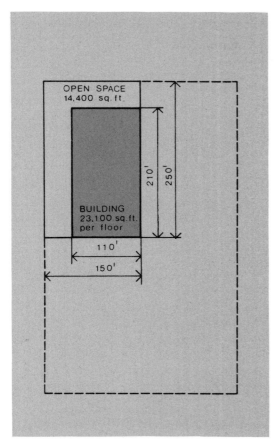

FIGURE 20. Quarter-Block Site (B6-7 Zoning District) with Maximum FAR and Frontage on Two Streets

(1) Basic FAR, 16. (2) Setback 20' or more on 2 streets at 2.5/street, all stories above grade,* 5. (3) Setback ground floor at 2.5 open area of lot ÷ gross lot area,* 1. (4) Setback upper floors at .4 open area of lot ÷ gross lot area (assume 30-story building),* .15/floor, 4.5. (5) Maximum FAR, 26.5. (6) Maximum floor area, 993,750 sq. ft. (7) No. of floors, 43.

* Bonus space

were permitted to use the floor area to construct a more efficient building than he is presently allowed to build with the bonus space. This proposition can be demonstrated by means of a comparative analysis of the effect on land values of additional density as derived from these two sources. The analysis assumes that the inefficient building configurations presently mandated by the bonus

provisions of the Chicago ordinance remain unchanged, but that increased tower coverage will be permitted on development rights transferee sites of more than a quarter-block.

Floor Size

Table 12 addresses the relationship between floor size and building costs by charting the effect on residual land values of progressively increasing the floor area of a twenty-five-story building from a base figure of 16,000 square feet per floor.

If increased tower coverage is permitted, the development rights will have an even greater value than that suggested earlier — $2.33 per square foot at $9.50 rental levels. Table 13 reflects these modified estimates.

That development rights are more lucrative than zoning bonuses is easily demonstrated given the above assumptions. Indeed, zoning bonuses may actually *decrease* residual land value, as Table 14 indicates. That table reflects the impact on land value of adding 25,000 square feet to a hypothetical base structure containing 400,000 square feet by means, first, of a development rights transfer and, second, of a zoning bonus. Using a $9.50-per-square-foot rent level, the base structure returns a land value of $934,470. If 25,000 square feet is added *in larger floor areas* through a development rights transfer, a unit cost savings results, average rentals remain constant, and land value becomes $1,210,765. If 25,000 square feet is added *in additional stories* through a zoning bonus, on the other hand, the unit costs are raised and the return to the land *drops* from $934,470 to $920,600, a loss of $13,870.

Efficiency Ratio

Buildings with higher efficiency ratios return more value to their sites than buildings with lower ratios. Typical office ratios are about .80 for new, multi-tenant buildings and slightly higher for single-tenancy structures.

TABLE 12. Relationship of Floor Size and Building Lots to Valuation of Development Rights

Gross Building Space (sq. ft.)	400,000	425,000	450,000	475,000
Floor Size (sq. ft.)	16,000	17,000	18,000	19,000
Unit Cost per Square Foot	$ 35.00	$ 34.50	$ 34.00	$ 33.50
Total Cost	$14,112,000	$14,779,800	$15,422,400	$16,039,800
Net Income before Recapture ($9.50 rental)	$ 1,299,600	$ 1,380,825	$ 1,462,050	$ 1,543,275
Capitalization Rate (Inwood Method)	.0864	.0864	.0864	.0864
Cost times Capitalization Rate	$ 1,220,170	$ 1,277,910	$ 1,333,471	$ 1,386,854
Land Residual Income	$ 79,430	$ 102,915	$ 128,579	$ 156,421
Land Capitalization Rate	.085	.085	.085	.085
Land Value	$ 934,470	$ 1,210,765	$ 1,512,694	$ 1,840,247
Land Value per Square Foot (20,000-sq.-ft. lot)	$ 46.72	$ 60.54	$ 75.63	$ 92.01

Source: Real Estate Research Corporation, 1972.

TABLE 13. Valuation of Development Rights Related to Amount of Rights Purchased

Building Size (sq. ft.)	400,000	425,000	450,000	475,000
Land Value Change		+$267,295	+$569,224	+$896,777
Incremental Development Rights (sq. ft.)		25,000	50,000	75,000
Value of Rights per Square Foot		$ 10.69	$ 11.38	$ 11.95

Source: Real Estate Research Corporation, 1972.

TABLE 14. Value Estimates of Zoning Bonuses and Transferable Development Residuals

	Base	Base with Added Floor Size (Development Rights)	Base with Added Stories (Zoning Bonus)
Gross Building Space (sq. ft.)	400,000	425,000	425,000
Floor Size (sq. ft.)	16,000	17,000	16,000
Unit Cost per Square Foot	$ 35.00	$ 34.50	$ 35.50
Total Cost	$14,112,000	$14,779,800	$15,199,500
Net Income before Recapture	$ 1,299,600	$ 1,380,825	$ 1,392,450
Capitalization Rate (Inwood Method)	.0864	.0864	.0864
Cost times Capitalization Rate	$ 1,220,170	$ 1,277,910	$ 1,314,199
Land Residual Income	$ 79,430	$ 102,915	$ 78,251
Land Capitalization Rate	.085	.085	.085
Land Value	$ 834,470	$ 1,210,765	$ 920,600
Gain (or loss) in Land Value		$ 267,295	($ 13,870)

Source: Real Estate Research Corporation, 1972.

By requiring the developer to build higher, zoning bonuses detract from efficiency because the rentable floor area on each of the building's floors is reduced by the correspondingly greater allocation of space for elevator shafts, restrooms, corridors, and mechanical equip-ment. Given the alternative of a higher building or one with larger floors, therefore, developers will elect the latter.

Any increase in efficiency can be converted directly into income dollars. Assuming a 1 percent increase in the efficiency of a 400,000-

TABLE 15. Value Estimates of Development Rights Assuming Increase in Efficiency[a]

Gross Building Space (sq. ft.)	400,000	425,000	450,000	475,000
Floor Size (sq. ft.)	16,000	17,000	18,000	19,000
Total Cost ($35 per sq. ft.)	$14,112,000	$14,994,000	$15,876,000	$16,758,000
NIBR	$ 1,299,600	$ 1,398,085	$ 1,498,601	$ 1,601,147
Capitalization Rate (Inwood Method)	.0846	.0846	.0846	.0846
Cost times Capitalization Rate	$ 1,220,170	$ 1,296,430	$ 1,372,698	$ 1,448,952
Land Residual Income	$ 79,930	$ 101,655	$ 125,909	$ 152,195
Interest Rate	.085	.085	.085	.085
Land Value	$ 934,470	$ 1,195,941	$ 1,481,289	$ 1,790,529
Land Value per Square Foot (20,000-sq.-ft. lot)	$ 46.72	$ 59.79	$ 74.06	$ 89.52

[a] Assumes 1 percent increase in efficiency with each additional 25,000 square feet of space.
Source: Real Estate Research Corporation, 1972.

TABLE 16. The Effect of Building Size and Efficiency on the Valuation of Development Rights

Gross Building Space (sq. ft.)	400,000	425,000	450,000	475,000
Land Value Change		+$261,471	+$546,819	+$856,059
Development Rights (sq. ft.)		25,000	50,000	75,000
Value per Square Foot		$ 10.46	$ 10.94	$ 11.41

Source: Real Estate Research Corporation, 1972.

square-foot office structure, NIBR varies as follows with each 25,000-square-foot increment in size:

Size (sq. ft.)	NIBR ($9.50 rental)
400,000	$1,299,600
425,000 (.80 efficiency)	$1,380,825
425,000 (.81 efficiency)	$1,398,085
Difference in NIBR attributed to 1 percent increase in efficiency	$17,260

An increase in efficiency, therefore, improves the profitability of the overall project if it can be realized along with an increase in size. Table 15 reflects the impact on land value — and hence the value of development rights — that results from improved building efficiency resulting from larger floor sizes.

In multi-tenant office buildings, utility cores (elevators, plumbing, and restrooms) are offset from the center of the building, thereby providing a smaller office depth on one side of the core than on the other. In this manner,

both small and large space users can be accommodated on each floor. Increasing the floor size can be accomplished by expanding the depth of the large space user's side of the structure. In Figure 21 the proportions of the original design have been altered as indicated by the dotted lines. The effect of this alteration is to raise the value of the transferable development rights, as reflected in Table 16.

One other factor considered by developers in selecting a building configuration is the effect that additional building size will have on operating costs. A higher building or a larger floor area may not be substantially different when viewed in terms of incremental costs. The addition of a single story or a total of 1,000 square feet of floor space, for example, is not likely to make a great difference in operating costs. But it is clear that a large addition to building size would add less to operating costs if it took the form of increased

101

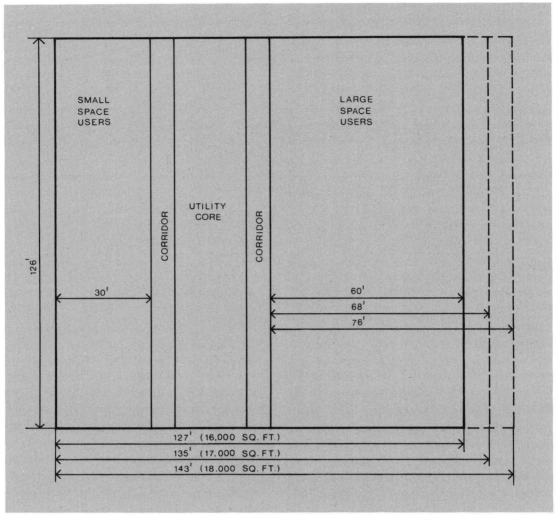

FIGURE 21. Possible Floor Design, Multi-Tenant Office Structure

floor size rather than additional stories. Climate control, lighting, and maintenance can be provided more economically for larger floor sizes. And such factors as heat and cooling losses are created chiefly at the building perimeter rather than in the building's central areas. In the absence of hard data on this subject, no effort has been made to quantify the relationships involved. The view that these relationships exist, however, is widely held among those experienced in office building management.

Zoning Modifications

Cities with generous zoning codes that wish to expand the market for development rights can do so in one of three ways. First, bulk allocations permitted as of right could be revised downward to levels falling somewhat short of market needs. To the extent that this

alternative calls for "downzoning" central business district land, however, it is utterly unrealistic. The howl that would go up from the development community would scotch the idea before it saw the light of day. But the Georgetown proposal mentioned in Chapter 2 suggests a less direct and perhaps more politically palatable use of the same idea. That proposal focused upon areas of the city that are *presently* zoned to relatively low densities, but that are about to experience intensive development or redevelopment. Under it, the city would increase the basic densities in the area, but not so high as to wipe out the market for development rights.

The remaining two alternatives are intended to strengthen development rights in their competition with zoning bonuses for developer attention. Under the first, cities might *require* developers to look to the development rights bank for a stated percentage of any floor area premium. If, for example, a developer wanted an additional 40,000 square feet of floor area and the city mandated that at least 25 percent of any premium space must derive from the bank, the developer would be forced to obtain 10,000 square feet in development rights before being allowed to have recourse to the bonus provisions. The second, which harks back to the discussion in the preceding section, simply entails modifying the zoning ordinance so that development rights can be employed more efficiently than bonus space. In all likelihood, these changes will take the form of permitting development rights purchasers to construct buildings having somewhat greater tower coverage — perhaps between 1 and 5 percent — than would otherwise be authorized under the ordinance.

Not all cities will find either or both of these alternatives appealing. Some may rate conventional open space amenities, such as plazas and arcades, more highly than landmarks on their scale of amenities. Others may be reluctant to trade off tower coverage for landmark preservation. Obviously, each city must be its own arbiter in such matters.

Before reaching a decision, however, cities would do well to consider four factors that tend to tip the scale in favor of the suggested alternatives. First, the single-minded pursuit of conventional open space amenities through the zoning bonus system over the last fifteen years has spawned grave urban design imbalances such as those recounted in New York City and Chicago.[2] The proposed alternatives promise to serve as partial correctives to that system by protecting at least one category of low-density use. Second, landmarks themselves also qualify as open space amenities in their role as downtown light and air parks. Their aesthetic contribution in this regard is beyond question, something that cannot be said as easily about the blank plazas that surround the block-front, institutionally tenanted structures that typically engorge bonus space. Third, the tower coverage adjustments called for by the second alternative are wholly within municipal control. Given the marginal nature of the adjustments and the setting of many transferee sites, the somewhat greater bulk of the buildings constructed on these sites will probably go unnoticed. Should a city's urban design character be so fragile that it will be damaged by, let us say, a 3 percent tower coverage increase, the alternative should not be pursued. Finally, bulk increases of the kind envisaged under the second alternative are routinely granted to developers under the guise of "variances."[3] What this means, of course, is that the developer gets his space anyway, but the public gets nothing. The public deserves better.

[2] See p. 87 *supra.*
[3] The relationship between development rights transfers and variances is considered at pp. 159-60 *infra.*

THE CHICAGO PLAN
AND MUNICIPAL FINANCE

A fundamental premise of this study is that the Chicago Plan will not prove economically feasible if it adversely affects municipal finances. Two elements of the Plan are intended to forestall that result: (1) the offset between the lower property taxes on landmark sites and the increased tax yield on transferee sites; (2) the sale from the municipal development rights bank of donated public and private rights to cover any net losses not covered by the sale of condemned (or purchased) development rights. An examination of both elements in terms of their likely operation in the Chicago context warrants the conclusion that the city will suffer little if any loss under the Plan.

Property Tax Collections

Two of the sample buildings, Landmarks A and C, have been analyzed to determine the Plan's implications for municipal property tax collections. Landmark A contains 295,000 square feet of gross building space and 220,000 square feet of net rentable space. Its current annual taxes are $266,173. A replacement building on its site would contain about 625,000 gross square feet and 500,000 square feet of net rentable space. Its estimated effective gross income would equal about $4,037,-500, accounting for an annual tax yield of about $1,009,375.

As a consequence of the preservation restriction encumbrance, Landmark A's taxes would fall to about $184,630 per year (assuming a 25 percent reduction). But the 330,000 square feet of development rights would return an estimated $828,721 in additional annual taxes upon their incorporation into construction on transferee sites.

Under the Plan, therefore, Chicago would receive a total of $1,013,351 annually in property taxes — $828,721 from taxes generated

by the development rights plus $184,630 from the landmark structure itself. If the landmark were demolished in favor of the replacement building, on the other hand, the city would receive about $1,009,375. The result: Chicago would *gain* an estimated $3,976 per year in property tax revenues while making possible the preservation of Landmark A.

Landmark C contains 65,800 gross square feet of building space and 49,350 square feet of net rentable space. The highest and best use for this site is estimated at 111,725 gross square feet, of which an estimated 89,380 square feet is net rentable space. This building presently pays $109,444 per year in property taxes, while its replacement structure would pay an estimated $191,049, a difference of $81,605 per year. The building's site, however, contains some 45,925 square feet of excess development rights, which should yield about $83,930 annually in property taxes. Adding to this figure the property taxes of $82,083 returned by the landmark structure (reduced from its present level by 25 percent) produces a total estimate of $166,013 per year in property taxes. By comparison, the replacement building project would yield some $191,049 annually, thus indicating a net *loss* to Chicago of $25,036.

Tables 17 and 18 summarize these data for Landmarks A and C respectively.

Three observations seem warranted on the basis of this analysis. First, the city will suffer a net tax loss under the Plan only when the size discrepancy between the landmark and its replacement structure is extremely large, as in the Landmark C example. Second, these net losses will be reduced somewhat by net tax gains, such as those recorded by Landmark A. Finally, remaining net tax losses, which will not be substantial, can be liquidated by income generated through the sale of donated public and private development rights from the municipal development rights bank.

TABLE 17. Property Tax Collections, Landmark A Site

1. *Present Building*
 Size: 295,000 gross sq. ft.
 Present property taxes: $246,173
2. *Highest and Best Use (assumes proposed landmark structure demolished and replaced):*
 Estimated building size: 625,000 gross sq. ft.
 Estimated effective gross
 income: $4,037,500
 Estimated property taxes: $1,009,375
3. *330,000 gross square feet of development rights sold to developer and property taxes on landmark structure reduced by 25 percent:*
 a. Property taxes yielded from development rights: 330,000 gross sq. ft. × 81 percent efficiency = 267,300 net rentable sq. ft. At an average rental of $9.50 per sq. ft. yielding $3,489,350, less vacancy and credit loss factor of 5 percent = $3,314,883. Property taxes estimated at 25 percent, or $828,721.
 b. Property taxes from landmark structure: $246,173 × 75 percent = $184,630.
 c. a + b = $828,721 + $184,630 = $1,013,351

Source: Real Estate Research Corporation, 1972.

TABLE 18. Property Tax Collections, Landmark C Site

1. *Present Building*
 Size: 65,800 gross sq. ft.
 Present property taxes: $109,444
2. *Highest and Best Use (assumes proposed landmark structure demolished and replaced):*
 Estimated building size: 111,725 gross sq. ft.
 Estimated effective gross
 income: $764,200
 Estimated property taxes: $191,049
3. *45,925 gross sq. ft. of development rights sold to developer and property taxes on landmark structure reduced by 25 percent:*
 a. Property taxes yielded from development rights: 45,925 gross sq. ft. × 81 percent efficiency = 37,199 net rentable sq. ft. At an average rental of $9.50 per sq. ft. yielding $353,391, less vacancy and credit loss factor of 5 percent = $335,721. Property taxes estimated at 25 percent, or $83,930.
 b. Property taxes from landmark structure: $109,444 × 75 percent = $82,083.
 c. a + b = $83,930 + $82,083 = $166,013

Source: Real Estate Research Corporation, 1972.

The Municipal Development Rights Bank

Two views of the operational scope of the municipal development rights bank were identified earlier.[4] Under the first, the bank would sell the development rights of threatened private landmarks only if their owners refused the option to do so themselves. The second would have the bank acquire the rights in all cases, and act as the sole medium for development rights sales. The second alternative is assumed in the following discussion of the bank's impact on the Plan's economic feasibility. Also assumed are the real estate market conditions that currently prevail in Chicago's Loop area.

The heaviest burden on the bank will be outlays for preservation restrictions. Other costs might include financing charges for these outlays, special subsidies, administrative overhead, and incidental expenses. On the basis

[4] See pp. 56-57 *supra.*

of prior analysis, it is anticipated that returns from development rights sales will be more than adequate to cover these costs given a reasonable market for space.

If the four Chicago buildings were designated, for example, the cost of acquiring preservation restrictions on them (after a 25 percent tax reduction) would be approximately $6,070,000. In exchange, the bank would acquire development rights equaling about 1,368,925 square feet, with an average cost of $4.43 per square foot. It was shown above that at $9.50 per square foot rent levels, the rights range in value from $2.33 to approximately $11 per square foot, depending on the benefits the additional size will bring the developer. These rights will increase in value over time, moreover, because rent levels, with which they are positively correlated, will experience similar increases.

Another test for the probable accuracy of

the foregoing value predictions is to compare development rights value to land value. If land value equals $100 per square foot and the effective FAR is 20, then $100 divided by 20 equals $5 or $100 per square foot of land. If the rights placed in the bank are worth $4.43 per square foot, then $4.43 times an FAR of 20 equals $88.60 per square foot. In other words, the rights can be used economically on land worth at least $88 per square foot if they are sold at cost.

The Plan's allowance for donation of development rights to the bank from private or governmental sources provides further assurance that the bank will not operate at a loss. In certain cases the tax benefits associated with donations will provide adequate incentives to encourage private philanthropy. And the city, which will probably own a fair number of designated landmarks, will have an opportunity to convert their excess development rights into taxable real estate. In consequence, the bank should generate a reserve fund that can be used to absorb deficits not covered by the sale of the development rights of threatened landmarks.

Certain "start-up" costs will be encountered as the bank is established. The most important of these will be the advance funding necessary to compensate owners of the first landmark buildings on which preservation restrictions are acquired. Funds for this purpose could come from a variety of sources. For example, the city might issue revenue bonds, guaranteeing their retirement through the sale of development rights. Or the bank's initial capitalization requirements might be met through a combination of federal and state grants or loans, municipal budget allocations, private financial donations, and, most important, the early sale of *donated* private or public development rights.

In brief, the bank can be expected to operate at a surplus for the following reasons:

1. The assumed average cost of development rights — $4.43 per square foot in the Chicago case study — is in the low end of the range of estimated values established in that study.

2. Calculations of the value of the rights were made at a rent level of $9.50 per square foot. But rentals will increase over time, resulting in higher rights values.

3. The cost of the rights can be compared to a minimum land value of about $71 per square foot ($4.43 per square foot of development rights times a 16 FAR). Since much of the land in Chicago's Loop sells in the $100 to $400 range per square foot, the rights can be considered a bargain.

4. Donated private and public development rights will provide a substantial cushion that should insulate the bank from any net losses.

SUMMARY

Conclusions

The economic feasibility of the Chicago Plan has been tested by examining its application to four Chicago School office buildings. The case study developed and applied a methodology for determining the cost of acquiring preservation restrictions on the four properties. It then analyzed the concept of transferring the excess development rights of the four structures to new projects, using a number of theoretical assumptions and a methodology similar in nature to that employed in measuring the value of preservation restrictions.

The Chicago Plan is economically feasible given the conditions and the data set forth in this and the preceding chapter. The Plan will enable the city to compensate landmark owners for the losses they suffer upon permanent designation. Whether considered by themselves or in relation to zoning bonuses,

moreover, development rights will add sufficient value increments to transferee sites to merit a sales price that should cover the costs of the municipal preservation program. Finally, losses, if any, under the Plan will be so small as to be virtually insignificant; in some cases cities may actually enjoy a minimal net gain in their property tax collections.

General Conditions Governing the Plan's Economic Feasibility

The study's sample base of four buildings located in a single city is too narrow to permit an unqualified judgment of the Plan's feasibility in any and all contexts. The number of buildings is small. They represent only one kind of urban landmark — downtown, multitenant office structures in private ownership. And Chicago's zoning and real estate market are not duplicated in all cities throughout the United States. Hence, further investigation is in order before the impact of varying local circumstances on the Plan's operation can be precisely gauged.

Undue modesty concerning the potential applicability of the Plan elsewhere would be misplaced, however. In at least three respects, the circumstances in Chicago are considerably more prejudicial to the Plan's successful implementation than those that are likely to be encountered elsewhere. First, Chicago's zoning is probably more generous than that of any other American city. But generous zoning spells trouble for the Plan because it both increases the damages that landmark owners suffer and impairs the marketability of development rights. Second, Chicago's burgeoning real estate market, which has been operating at white heat since 1957, has set in motion virtually intolerable pressures for the demolition of landmark buildings, as the loss of many Chicago School buildings during this period confirms. Finally, no class of landmarks offers a graver preservation challenge than

those examined in this study — downtown office buildings that are in private and often speculative ownership and that sit on some of the city's most valuable land. The Plan's feasibility in the face of obstacles as formidable as these warrants confidence that it will work in less trying contexts elsewhere.

The principal variables that govern the Plan's economic feasibility include the following:

MARKET DEMAND FOR NEW CONSTRUCTION

Absent a healthy market for new construction, the Plan will not be effective because sites to which development rights can be transferred will be lacking. On the other hand, landmarks located in cities having a sluggish real estate market will be free in most instances of the very pressures that the Chicago Plan was devised to meet.

ZONING

Restrictive zoning codes lower the cost of preservation restrictions and increase the market for development rights. Liberal codes produce the opposite effect. The analysis of the Chicago ordinance, one of the nation's most liberal, supports the following three conclusions: (1) development rights have little value on sites larger than a half-block given the ordinance's present bonus provisions; (2) if the ordinance were modified to permit greater tower coverage for buildings incorporating development rights, the rights would have substantial value on sites larger than a quarter-block; and (3) even without these modifications, the rights have sufficient value on sites of a quarter-block or less to fund an effective municipal preservation program.

RENT LEVELS

The higher the anticipated rent level of the structure on the transferee site, the greater the value of the development rights. Analysis

indicates that at a rent level of $9.50 per square foot, the development rights for one square foot of building space are worth $2.33 in Chicago's Loop. At a rent level of $11 per square foot, this value increases to $8.35. The rent level is a function of the overall relationship between supply and demand, location, basic land cost, construction and operating costs, and building amenities and services.

BUILDING EFFICIENCY

The larger the number of square feet of building space per floor (up to 28,000 square feet), the lower the number of floors, and the more regular the perimeter of a building, the lower the construction and operating costs per square foot. Based on these factors, a developer will be able to build more profitably with development rights than with bonus space if the city permits him to cover a greater percentage of his lot with his building rather than to increase the size of the building by adding more floors, each with a smaller number of square feet. It is this latter arrangement that is encouraged by the provisions of many current ordinances.

TYPE OF TRANSFEREE AREA

Chicago's Central Business District — an area with a multiplicity of land uses, considerable growth potential, and very high land values — served as the basis for the case study of the Plan's economic feasibility. There is nothing in the analysis, however, which suggests that the Plan will work only in other similar areas. On the contrary, the Plan should prove successful in outlying portions of a city with very different land values and land uses, provided that growth potential exists there.

LAND USE

While the analysis dealt essentially with office buildings, the Plan should work equally well with any other type of revenue-producing use, such as high-rise apartment construction for example.

CITY SIZE

Assuming proper zoning and a firm market demand for new construction, the Plan should work in cities both large and small. But city size is likely to be relevant to the capacity of municipal officials to administer the Plan. Appraising landmark buildings, establishing development rights transfer districts, managing the development rights bank, coordinating the Plan with the city's other urban design goals, and the various other tasks associated with the Plan's implementation may require a level of expertise and staffing that are not within the reach of smaller cities.

ATTITUDE OF THE CITY

As critical to the Plan's success as any of the previous factors is firm municipal support for the Plan and for historic preservation generally. Among the many forms which that support must take are the following: conduct of thorough background studies; appropriate revision, if necessary, of the municipal preservation and zoning ordinances; coordination of the Plan with the city's other urban design goals, some of which may conflict with historic preservation; and, most important, even-handed administration of the Plan in all its aspects, including the determination of loss suffered upon designation and the sale of rights through the municipal development rights bank.

The Chicago School of Architecture: A Sampling

The flames of the 1871 fire that leveled most of Chicago ignited the movement internationally known as the Chicago School of Architecture. From the last quarter of the nineteenth century to the first quarter of the twentieth, the movement introduced style changes in architecture as epochal as any of those that preceded it. The ultimate product of the movement's innovations was modern architecture itself and its most exemplary form, the skyscraper.

The Chicago School of Architecture numbered among its ranks such luminaries as Louis H. Sullivan, Dankmar Adler, Daniel H. Burnham, John Root, William LeBaron Jenney, and Frank Lloyd Wright. From their marriage of building technology with the needs of modern commerce sprang the buildings portrayed in this section as well as many other buildings in Chicago and other American cities. In these buildings techniques affecting all phases of modern high-rise construction were pioneered — including those relating to support and foundation systems, steel cage construction, fenestration patterns, and elevator and utility systems. But these men were great architects as well as shrewd technicians. Hence their buildings revealed a distinctive philosophy of the purposes and uses of architecture in a world moving in directions completely unlike those of the world in which the prevailing architectural styles of their time were spawned. It was a philosophy both visionary and durable, as its impact upon architectural thought to this day attests.

Richard Nickel photo; courtesy Commission on Chicago Historical and Architectural Landmarks

OLD STOCK EXCHANGE BUILDING

1893, Adler and Sullivan. Demolished 1972. A business palace of strength and grace, the Old Stock Exchange building fell victim as much to visionless leadership — public and private — as to the real estate juggernaut that has flattened so many other Chicago School buildings. Its loss stands in silent mockery of Chicago's motto — "I will." Unless a sane balance is soon struck between private advantage and public interest, the remaining landmarks of the school will travel the same path, instant disposables in the pop-top, throw-away age.

110

OLD STOCK EXCHANGE BUILDING: DETAIL

Sullivan's fascination with ornament enlivens the magnificent arch over the building's LaSalle Street entrance. Encircled in delicate tracery is a replica of Chicago's first all-brick building, which was erected on the landmark's site in 1837. (Richard Nickel, widely known for his photographs of Chicago landmarks, was killed in 1972 while taking pictures in the wreckage of the Stock Exchange.)

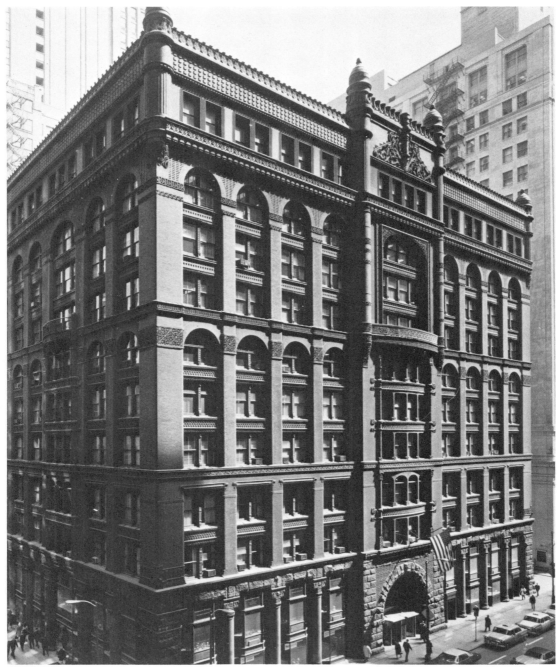

Richard Nickel photo; courtesy Commission on Chicago Historical and Architectural Landmarks

THE ROOKERY

209 S. LaSalle Street, 1885-86, Burnham and Root. Deriving its name from the popularity of prior buildings on its site as a roosting place for Chicago's pigeons, the Rookery is one of the great monuments to masonry architecture. It is also a fully rented, thoroughly functional office building offering some of the most sought-after commercial space in Chicago's Loop.

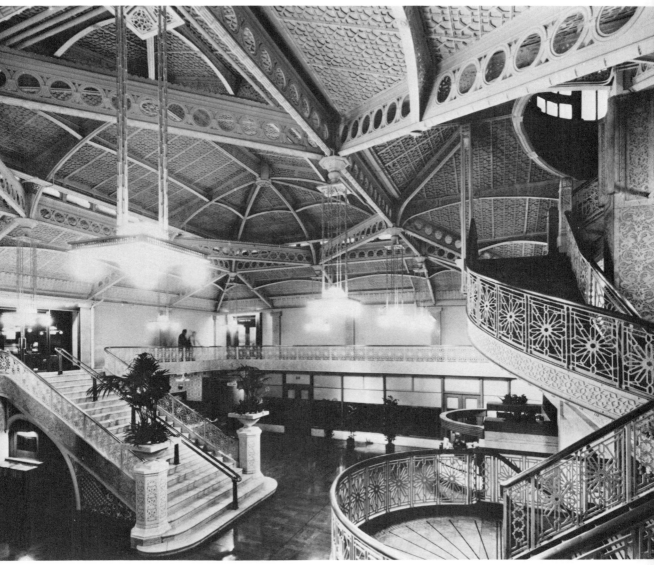

THE ROOKERY: LIGHT COURT

Interior redesigned by Frank Lloyd Wright in 1905. Domed in glass and iron, the Rookery's light court enchants with its delicate tracery, spiraling staircases, and suspended lighting.

CARSON, PIRIE, SCOTT & COMPANY DEPARTMENT STORE

State and Madison Streets, 1899, 1903-4, Sullivan; addition of 1906, Burnham and Company. The last of Sullivan's major works, the Carson, Pirie, Scott & Company Department Store is universally praised for the perfection of its fenestration pattern, the aesthetic use of steel cage construction, and the rich ornamentation of its first two stories.

114

Richard Nickel photo; courtesy Commission on Chicago Historical and Architectural Landmarks

CARSON, PIRIE, SCOTT STORE: DETAIL OF ENTRANCE

MONADNOCK BUILDING

53 W. Jackson Boulevard, 1889-91, Burnham and Root. The "ultimate logical step in strictly functional construction with masonry bearing walls ... the last great building in the ancient tradition of masonry architecture," according to architectural historian Carl W. Condit. The Monadnock Building, like its neighbor the Rookery, is a fully rented office building whose prestige enables it to command premium rentals.

116

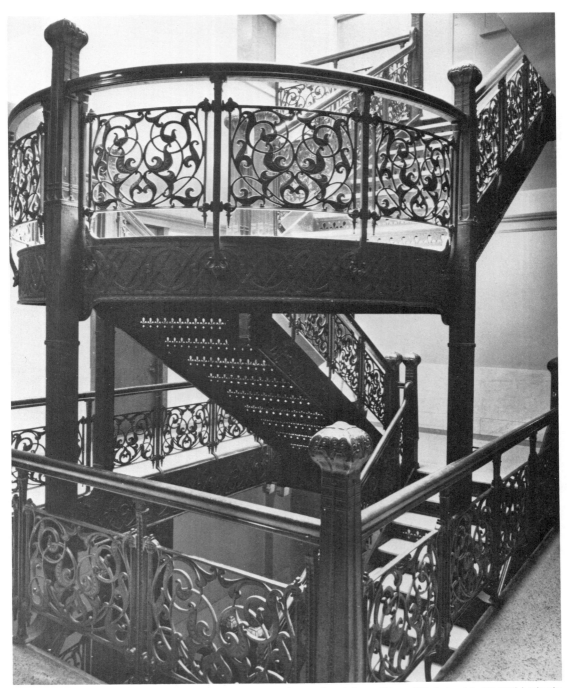

MONADNOCK BUILDING: STAIRCASE

118

GARRICK THEATER

Sullivan's love of rich ornamentation embellishing bold structural forms is apparent from this photograph of the theater's vault, balcony, and interior orchestra wall.

SCHILLER BUILDING (GARRICK THEATER)

1891-92, Adler and Sullivan. In the Schiller Building (opposite, left) the design genius of Louis Sullivan and the engineering skills of Dankmar Adler were combined to produce a structure aptly described by Sullivan as "proud and soaring." Demolished in 1961 after years of neglect and deterioration, the Schiller's site is now a parking lot. At the building's right is the Borden Block (1879-80), also by Adler and Sullivan, which was razed in 1916.

119

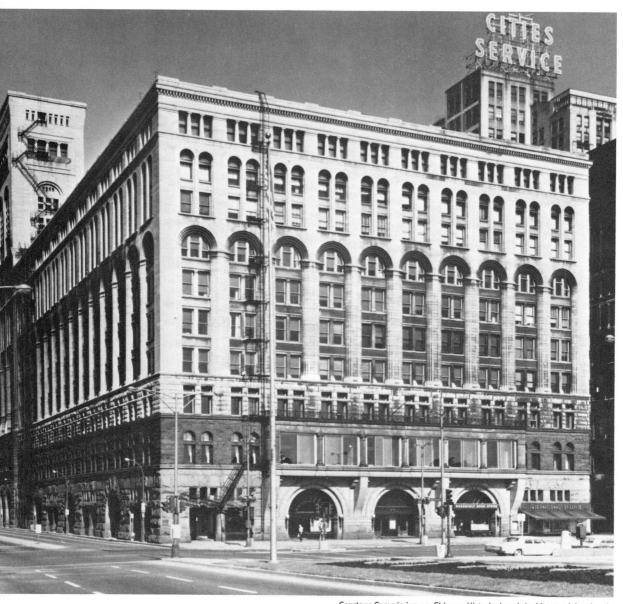

AUDITORIUM BUILDING

Michigan Avenue and Congress Parkway, 1887-89, Adler and Sullivan; restoration of theater, 1967, Harry Weese & Associates. The Auditorium, the building that assured the reputations of Adler and Sullivan, is a preservation success in a city that has known few. By the herculean efforts of the Auditorium Theater Council, more than $3,000,000 was raised to restore the building's 4,200-seat theater in 1967 to its earlier grandeur and to active use (the theater had shut its doors in 1940). With the remainder of the Auditorium's former hotel, office, and commercial space now converted into classrooms and offices for Roosevelt University, its owner, this is one Chicago landmark that appears to be safe, at least for the present.

120

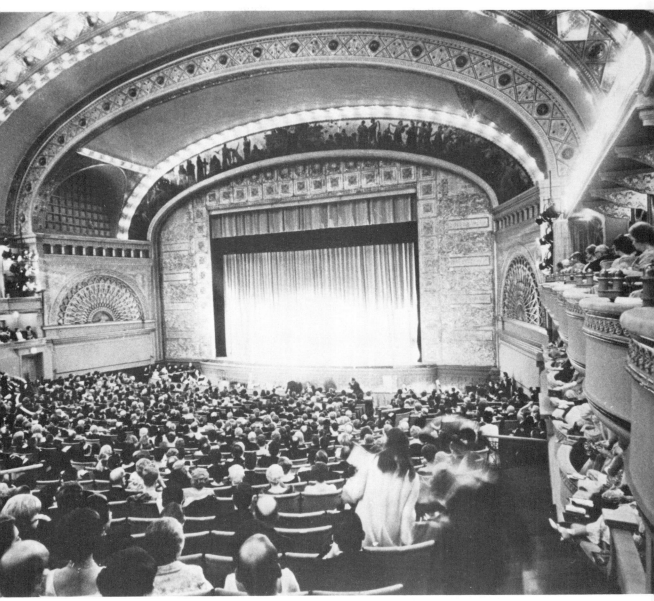

Richard Nickel photo; courtesy Commission on Chicago Historical and Architectural Landmarks
AUDITORIUM BUILDING: THEATER

RELIANCE BUILDING

32 N. State Street, 1894-95, Burnham and Company (Atwood, design architect). The Chicago School's most refined expression of curtain wall construction, the Reliance Building anticipates the work of Mies van der Rohe, LeCorbusier, and other influential moderns by more than a quarter of a century. Freed from any load-bearing function by the building's system of steel cage construction, its walls of glass and delicate terra cotta impart a lightness and grace unknown to masonry construction.

RELIANCE BUILDING: DETAIL

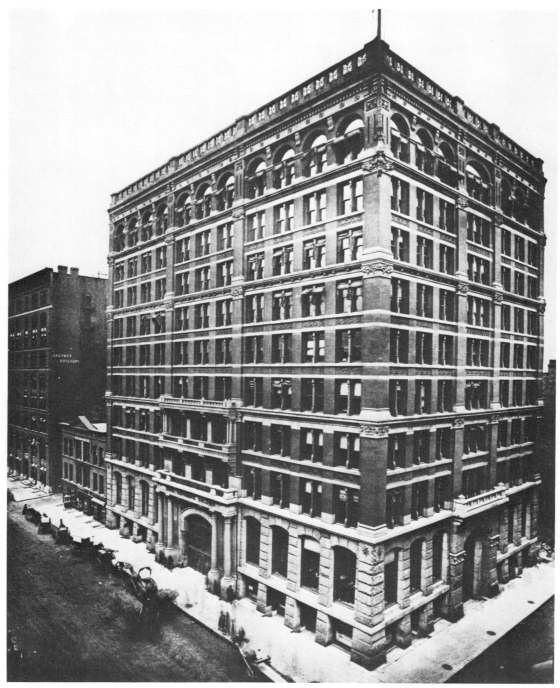

HOME INSURANCE BUILDING

1884-85, Jenney and Mundie. Because of its status as the first multi-story office structure whose weight was carried principally by a steel skeleton rather than by load-bearing masonry walls, the Home Insurance building is generally regarded as the progenitor of the modern skyscraper. It was demolished in 1931 to make way for a larger office building.

MARQUETTE BUILDING

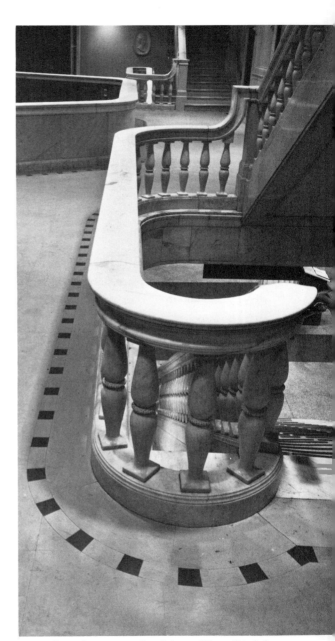

MARQUETTE BUILDING: STAIRCASE

140 S. Dearborn Street, 1893-94, Holabird and Roche. Owen Aldis, agent for the Marquette Building's developers, set forth eight principles for the design of a profitable, first-class office building, all of which Holabird and Roche followed to the letter. The result was a building that today remains functional, handsomely appointed, and fully rented, yet stands as an aesthetic and structural milestone in the Chicago School's development of the cellular wall. The recent assembly of the entire block of which the landmark's parcel is a part, however, is an ominous sign that the Marquette Building's days may be numbered despite its profitability.

5
The Chicago Plan and Urban Design

The Chicago Plan departs from conventional land use techniques by transferring the excess density of landmarks to other sites within development rights transfer districts. In some cases transferee sites may be adjacent to the landmark property from which they derive; usually, however, they will be some distance away, especially if the boundaries of the transfer district are drawn independently of the area where the city's landmarks tend to be concentrated. The Plan poses rather distinct urban design challenges depending upon whether the rights go to adjacent or to nonadjacent sites. Its safeguards regarding adjacency transfers are essentially the same as those of the New York City transfer program — municipal review on a case-by-case basis with special attention to the transfer's aesthetic impact upon the landmark.[1]

Its safeguards with respect to nonadjacency transfers provide the topic for this chapter. The question posed is whether the risks of urban design abuse that attend nonadjacent transfers can be satisfactorily overcome by cities adopting the Plan. Three preliminary observations will help to clarify the scope and direction of the following discussion. First, only one of the two alternative districting techniques identified earlier[2] will figure in the discussion, namely, districting in conjunction with the city's landmarks. Districting independently of the city's landmarks, as suggested by the Georgetown proposal, does not merit special attention here. The problems that are inherent in setting bulk limitations in such districts are essentially the same as those that arise in setting them for a conventional zoning district, the single difference being that the densities permitted as of right in the former are skewed somewhat below the levels that market demand and conventional planning criteria would otherwise warrant.[3]

Second, the following paragraphs do not purport to explore the full range of urban design complications and opportunities that attend the Plan's implementation in various cities throughout the nation. Local circumstances, as reflected in prevailing development patterns, zoning, topography, community values, and similar factors, are simply too diverse. What might prove acceptable in major metropolitan centers such as New York or Chicago might well be disastrous in smaller cities such as Savannah or Santa Fe. Instead, the aim of the discussion is to establish a *framework for urban design analysis* which

[1] See pp. 54-55 *supra*.

[2] See pp. 48-52 *supra*.
[3] See p. 50 *supra*.

zeroes in on the principal questions that cities adopting the Plan must be prepared to confront. How any specific city goes about resolving these problems depends entirely upon local urban design conditions and preferences.

Third, a dichotomy is posed in the following discussion between "major" and "minor" bulk increases as a practical means for resolving the potential conflict between the goals of making development rights as salable as possible and guarding against the risk of urban design abuse. It assumes that the city will correlate the degree of its supervision over transfers with the quantity of floor area transferred. Public review of minor increases, such as the addition of a floor or less to a fifty-story building, will be of a routine, expedited nature. But that review will be considerably more searching for major transfers, illustrated, for example, by the addition of a 20 percent bulk premium to a multi-block planned unit development.

Correlating the character of public review with the amount of floor area transferred also seems realistic from the developer's viewpoint. He is unlikely to conclude that the economic benefits of minor transfers warrant the delays and uncertainties of numerous discretionary municipal approvals. But he will probably find that the prospects for substantially greater gains will make it worth his while to go this route if he contemplates a major transfer.

The task of drawing the line between major and minor bulk increases must fall to the individual city because of the differing local circumstances referred to earlier. Obviously, the addition of four stories of height or of 3 percent of tower coverage to structures in New York or Chicago could produce entirely different urban design consequences than corresponding additions in Savannah or Santa Fe. Even within a single city, moreover, these additions might prove inconsequential in certain types of development, such as large-scale office or residential complexes, but quite damaging in areas characterized by low density or uniform cornice lines. What can be stressed in this study, however, is that, on balance, experience with incentive zoning measures over the last decade supports the premise that sufficient latitude exists in setting density requirements to accommodate the selective bulk modifications that the Plan envisages.

THE CHICAGO PLAN: AN URBAN DESIGN RATIONALE

Until quite recently, planners have assumed that, without exception, the individual lot must serve as the unit of development control. That assumption has been reflected principally in the prevailing interpretation of the requirement found in most state zoning enabling acts that regulations must be "uniform" for all lots within a zoning district.[4] The uniformity requirement has traditionally been interpreted to mean that all lots of equivalent size within a district are subject to the same maximum density allocation. That interpretation, of course, is incompatible with the Plan, which permits larger buildings to be erected on transferee lots than on other lots of the same size within the development rights transfer district.

But land use professionals have come in recent years to question whether that interpretation is responsive to the full range of development challenges faced by the city. Their concerns are basically four in number.[5] First, the premise that density must be allo-

[4] The quoted language is taken from Section 2 of the Standard State Zoning Enabling Act prepared by the U.S. Department of Commerce in 1926 for adoption by the states. An identical or substantially equivalent provision appears in most of the current state zoning enabling acts.
[5] For criticisms of traditional zoning and land use practice, see, e.g., N. Marcus & M. Groves, eds., *The New Zoning: Legal, Administrative, and Economic Concepts and Techniques* (1970); Symposium, "Planned Unit Development," 114 *U. Pa. L. Rev.* (1965).

127

cated on a lot-by-lot basis may hamper sound community-wide planning and promote sterile design on individual lots. Second, it assumes that development still occurs lot by lot despite the contrary practice of coordinated, large parcel development in urban renewal areas and on the metropolitan fringe. Third, by ignoring the special needs and functions of a community's distinctive areas, it exposes these areas to the destructive impact of private market decisions. Finally, it blocks communities from implementing incentive zoning measures, such as the Chicago Plan, that promise to offset this impact.

Without denying that the traditional view of uniformity retains its vitality in many land use contexts, planners have proposed alternative approaches to meet specific development problems not adequately addressed by that view. Two of these approaches — density zoning and the special development district — serve as twin pillars upon which the urban design case for the Plan rests. Density zoning prescribes a maximum amount or range of bulk for an area as a whole rather than ladling density out for each lot within the area. It gives developers the option of concentrating or dispersing bulk in accordance with flexible site planning and urban design criteria.

The technique is illustrated by two innovative land use techniques, cluster and planned unit development (PUD) zoning, both of which, to date, have been used principally in the suburbs. Cluster zoning ordinances offer the developer a trade: if he agrees to devote a prescribed percentage of his tract to a community use, such as a park or schoolground, he is permitted in return to build the same number of residential units that he formerly could have built on the tract as a whole. Assume, for example, that a developer owns a tract containing 100 buildable acres in a residential district zoned for one-acre-minimum lots. Under the cluster option, he might be allowed to build his 100 houses on 75 acres if he agrees to dedicate the remaining 25 acres to the community as a park.

PUD ordinances go further. In addition to permitting modifications in lot size within the project area, they relax building type and use restrictions as well. Within the same PUD project, for example, single-family units may exist alongside mid-rise apartment buildings, and residential uses adjacent to light industry.

The Chicago Plan is also an instance of density zoning. The overall density for the development rights transfer district is fixed by the density requirements of the various bulk zones within the district, the transfer district being merely an "overlay zone" superimposed upon the existing bulk zones. Total density therefore remains constant despite increases on transferee sites because the latter are matched by corresponding decreases on the landmark sites. Stated another way, cities adopting the version of the Chicago Plan under which transfer districts encompass areas of landmark concentration merely redistribute the density that has already been authorized for these areas by the zoning code; they do not create additional density as in the case of zoning bonuses.

The special development district complements density zoning by particularizing the development goals that guide the distribution or redistribution of density there.[6] Prior to establishing a special development district, the community must carefully evaluate the distinct functions and needs of the area in question, and select the goals that will shape future development there. Typically, these

[6] The most perceptive treatment of the special development district, as used in Manhattan and elsewhere, is to be found in the writings of Ada Louise Huxtable. See, e.g., "Concept Points to 'City of Future,'" *New York Times*, Dec. 6, 1970, §8, p. 1, col. 3; "Thinking Man's Zoning," *New York Times*, Mar. 7, 1971, §2, p. 22, col. 1; "A Solid Dross City," *New York Times*, Mar. 14, 1971, §2, p. 16, col. 5.

FIGURE 22. Comparison of Traditional and Cluster Zoning Density Allocations

The traditional zoning ordinance allocates density zoning on a lot-by-lot basis, prescribing the same maximum density for all lots within the zoning district (A). Under cluster zoning (B), a total amount of density is prescribed for an entire area and the developer is permitted to concentrate or disperse that density within the area in accordance with flexible site planning criteria.

goals are recorded in a detailed design plan which becomes an official community planning document.

Perhaps the most thoughtfully conceived special development district in the United States today is New York City's Special Greenwich Street Development District,[7] which encompasses a twenty-nine-square-block area between the World Trade Center and Battery Park. Its purpose is to safeguard the area against the threat of congestion posed by the 9,000,000 square feet of new office space that has been plunked down there in the form of two 110-story World Trade Center office towers. District regulations include a map and a manual which prescribe a firm area network of circulation features consisting of open and covered arcades, pedestrian bridges, subway connections, elevated plazas,

FIGURE 23. Planned Unit Development

In addition to permitting the developer to arrange density within his project on a flexible basis, planned unit development zoning ordinances also allow for a mixture of compatible uses and building types.

[7] See New York, N.Y., Zoning Resolution art. VIII, ch. 6, §86-00 *et seq.* (1971).

and the like. Developers building within the district are required to provide some of these features and may elect to provide others. In return for these features or for payment of prescribed sums into a subway improvement fund, they receive increases both in floor area and in tower coverage.

The Greenwich district improves upon New York's previous special development districts[8] in two significant respects. First, the desired features are expressly mapped so that every lot owner knows beforehand which mandatory and optional features he must or may provide in return for the increased floor area and tower coverage. Second, the area plan is so specific and the schedule of bonuses so precise that developers need not negotiate with the Planning Commission, submit their development plans for site and design review, or secure special permits, all of which are par for the course under the regulations applicable within the other development districts.

The Chicago Plan also utilizes the special development districting device. Transfer districts covering areas of landmark concentration are, in fact, merely special development districts under a different name. They too encompass areas of the community that are unique because of the location there of many

[8] See, e.g., New York, N.Y., Zoning Resolution art. VIII, ch. 1, §81-00 *et seq.* (1971) (creating a Special Theater District); New York, N.Y., Zoning Resolution art. VIII, ch. 7, §87-00 *et seq.* (1971) (creating a Fifth Avenue Retail District).

The Special Theater District includes the area between Fortieth and Fifty-seventh streets and Sixth and Eighth avenues. Developers owning parcels within the district who agree to include a legitimate theater within their projects may receive an increase of up to 20 percent in the floor area authorized for their parcels under prevailing zoning.

The Fifth Avenue Retail District encompasses Fifth Avenue between Thirty-eighth and Fifty-ninth streets. It mandates that the two lower floors of any building constructed within the district be used for retail purposes. Developers who elect to provide more than the minimum retail space will be given additional floor area to be used for apartments or hotel accommodations.

of the community's landmark buildings. The community's goal in establishing transfer districts, of course, is to safeguard the landmarks within them from destruction. As will be seen later, moreover, development rights transfer districts are established only after thorough examination of the area's character and formulation of a detailed area plan for landmark preservation.

In their departure from traditional land use practice, density zoning and the special development district directly pose an issue that appears in numerous guises throughout this study: is there sufficient latitude in the zoning code to permit selective density increases without laying the foundation for urban design imbalance? At first glance, no. Permitting these increases appears to cast doubt on the reasonableness either of the code's basic density requirements or of the selective increases themselves. If the density limitations prescribed in the code are sound, relaxing them for some property owners would seem to invite planning disorder in the form of congestion, overloaded public facilities and services, and buildings that are wholly out of scale with their neighbors. If the limitations are unduly stringent, on the other hand, the proper course would seem to lie in liberalizing them on a pro rata basis for all lots within the district. But to retain the existing limitations for most property owners while relaxing them for a few creates the impression of sacrificing sensible planning at the altar of fiscal opportunism.

Considerations such as these induced Beverly Moss Spatt, as a member of New York City's Planning Commission, to berate the transfer mechanism as a "gimmick" that "can only lead to an unplanned future — to chaos."[9]

[9] Dissent from Resolution CP-21166 of the New York City Planning Commission to the Board of Estimate, May 13, 1970 (authorizing the transfer of development rights from designated landmarks in public ownership).

SERENITY AMIDST GOTHAM'S FRENZY

Landmarks dispel the city's sameness with the unexpected, the contrasting. An example is New York City's Amster Yard, described in *House Beautiful* as "a green, ivy-carpeted, shaded enclave astonishingly hidden away in backyard space on New York's East 49th Street, not half a block away from the river of traffic that roars up Third Avenue." Amster Yard is also notable as the focus of a development rights transfer transaction under the New York City transfer program that, though all but completed, had to be suspended when that city's office space market precipitously softened in 1970. The sales price of Amster Yard's unused development rights was fixed at $494,731, of which $100,000 was to have been set aside in trust for maintenance of the landmark.

Despite their apparent cogency, these considerations are flawed by their implicit premise that each zoning lot has a single, proper bulk level which can be determined with mathematical precision. In consequence, they attribute a degree of exactitude, hence incontestability, to the numbers in the code that is without foundation either in fact or in sound planning policy.

The truth of the matter is that these numbers are little more than pragmatic approximations of densities that, it is hoped, will further a variety of urban design and growth objectives. A partial listing of these objectives includes the following: stabilizing property values; insuring an adequate supply of light, air, and open space; regulating population; rationing demands upon public services and facilities; and accommodating the need for additional office, commercial, and residential space.[10]

Translating these goals into numbers partakes more of art than science.[11] Various projections of slippery data must be undertaken, such as correlating population density with demands upon public services, or predicting office space absorption rates over the near or long term. More important, priorities must be established in selecting development objectives for the city, and in resolving the conflicts that

inevitably divide these objectives. For example, does the city wish to retain its low-density character, or should its projected office space needs be satisfied at the cost of losing its unique skyline? These clashes are untangled not on the planner's slide rule but in the political arena. In San Francisco, as an illustration, the foregoing question so exercised a group of residents that they succeeded in having put on the ballot a proposition that would have required voter approval for the construction of any building over six stories, or seventy-two feet. Despite a slogan that condemned the further "manhattanization" of San Francisco's skyline, the proposition was defeated.[12]

In sum, the numbers in the code fall considerably short of Platonic absolutes, the slightest deviation from which threatens planning chaos. Indeed, the most comprehensive inquiry into the optimum size of downtown buildings yet undertaken has concluded just the opposite:

> Conclusive quantitative proof of the desirability of [the amenities that attend lower densities] is almost impossible, as is also the setting up of any unqualified standard for safety and well-being below which we should not go. The general indications would lead to the belief that, while sunlight, air, outlook, privacy, the avoidance of a sense of "shut-in-ness" and of actual congestion are highly desirable, *we are not able to set up a minimum which, let us say, if curtailed by 10 per cent would spell disaster or if augmented by 10 per cent would spell relative happiness and prosperity.*[13]

What all this means, of course, is that room exists within the interstices of the zoning code for the bulk modifications that the Plan anticipates. Whether office buildings in the down-

[10] For a detailed examination of the objects served by zoning density provisions, see, e.g., E. Shultz & W. Simmons, *Offices in the Sky* 280 *et seq.* (1959); Note, "Building Size, Shape, and Placement Regulations: Bulk Control Zoning Reexamined," 60 *Yale L. J.* 506 (1951).

[11] Accounts of this process may be found in, e.g., G. Ford, *Building Height, Bulk and Form* (Harvard City Planning Studies II, 1931); S. Toll, *Zoned American* 184 (1969); Randall, "The Question of Size: A Re-approach to the Study of Zoning," 54 *Arch. Forum* 117 (1931). For excellent analyses of the process by which the city of San Francisco arrived at the bulk levels of its present zoning ordinance, see Ruth, "Economic Aspects of the San Francisco Zoning Ordinance Bonus System," in Marcus & Groves, eds., *New Zoning* 159; Svirsky, "San Francisco: The Downtown Development Bonus System," in *ibid.* 139.

[12] See *New York Times*, Nov. 4, 1971, p. 36, col. 1.

[13] Randall, "The Question of Size," *supra* note 11 at 117. The results of the study referred to in the text are more fully summarized in G. Ford, *Building Height, Bulk and Form, supra* note 11.

town sections of our major cities are permitted to rise to sixty-five instead of sixty-two stories or to cover 43 rather than 40 percent of their lots typically does not present an issue of great moment. From a planning perspective, it is important only that this range of stories or extent of tower coverage offers a practicable basis for implementing the particular city's design and growth goals.

Why then haven't our cities assumed a more flexible posture toward density allocations? A major consideration, no doubt, is their quite understandable reluctance to create opportunities for official impropriety. To meet this troublesome problem, appropriate standards and procedures governing the administration of selective bulk increases are absolutely essential.

The Chicago Plan is girded with these safeguards to a far greater extent than is common in other zoning programs that allocate density in a flexible manner.[14] Thus, landmark owners or, derivatively, the city may transfer only

that quantity of floor area that competent appraisal determines is necessary to compensate the landmark owner for his loss. Development rights purchasers must buy the floor area at its going value on the open market, which therefore makes the price in this as in countless other instances in which surplus public property is disposed of through public sale. All phases of the appraisal and sale procedures, moreover, are open to public scrutiny and to challenge at public hearings, and if necessary in the courts as well. Finally, state and federal review of the regularity of various aspects of the Plan's administration will exist if the individual city has had recourse to preservation funds offered by these governments.

Even with these safeguards, the possibility of official favoritism or corruption cannot be ruled out. There is only so much, after all, that a well-drafted law can guarantee. It is for this reason that the keystone to the Plan's success is the individual city's attitude toward the Plan's administration and toward preservation generally. Presumably, a city that is sufficiently committed on both counts to shoulder the not inconsiderable burdens entailed in adopting the Plan will not acquiesce in the defeat of the Plan's objectives through official misfeasance.

Deserving of equal or perhaps even greater billing as an explanation of the cities' avoidance of flexible density measures is a second consideration: *few American cities have really begun to think seriously about the design implications of the manner in which they allocate space.*[15] Without such forethought, of course, selective bulk increases would occur

[14] Under the PUD regulations of the Chicago Zoning Ordinance, for example, the standards governing density increases provide only that "the intensity of use — Floor Area Ratio and Density Pattern — [must] be in conformity with current city planning requirements and with that [*sic*] of surrounding land use and zoning, and be so distributed as to avoid undue concentration in any one portion of the subject area...." "Rules, Regulations & Procedures in Relation to Planned Development Amendments to the Chicago Zoning Ordinance" as amended 2 (June 27, 1963, as amended).

Under the New York City Special Theater District regulations (see note 8 *supra*), the Planning Commission, in its "discretion," may grant up to a 20 percent increase in authorized floor area for developers who agree to include a theater in their projects if the commission finds one or more of the following: that the theater's size and type are "appropriate" to district needs; that it contains "rehearsal and other supporting facilities"; that it "facilitates circulation within the area"; that restaurants and other amenities "useful" to the district are provided; that the project's distribution of bulk provides "adequate light and air" for its neighbors; and that modifications of height and setback requirements are necessary to produce "good design objectives." See New York, N.Y., Zoning Resolution art. VIII, ch. 1, §81-00 (1971).

[15] Urban design literature crackles with indictments of the cities' blindness to the urban design implications of their spatial allocations. See generally S. Toll, *Zoned American* (1969); E. Higbee, *The Squeeze: Cities without Space* (1960); cf. Huxtable, "Thinking Man's Zoning," *New York Times*, Mar. 7, 1971, §2, p. 22, col. 1; Huxtable, "A Solid Dross City," *New York Times,* Mar. 14, 1971, §2, p. 16, col. 5.

in a design vacuum and would be better left forgotten. All too rare is the sensitive treatment of urban space evidenced in New York City's Special Greenwich Street Development District or, to take another example, in the Urban Design Plan[16] prepared by San Francisco to guide its development. Instead, our cities resort to mechanistic, quantitative formulas, conceived independently of the character of the city's diverse areas and clamped down upon them with the heavy touch of a Proscrustes. Worse still, the integrity of even this process is constantly jeopardized and frequently compromised by special interests that lobby for space "policies" that can hardly be said to serve the public interest.[17]

Seen from this perspective, the Plan serves as a catalyst rather than as a barrier to intelligent planning. If nothing else, it forces the city to open its eyes to the actual costs and benefits of its existing space allocation policies — or non-policies. Cities that grossly overzone or that encourage severe leakage in their space policies by unwarranted rezonings and variances will not find it so easy to disown responsibility when the landmarks fall and other serendipitous uses are driven from their downtown areas. They may begin to ask some troubling questions, such as precisely for *whom* and for *what* are they allocating their space. And they may even be moved to ponder why a noted geographer would write:

Space is not just a commodity for speculation and trade. It is the one, precious, absolutely limited, irreplaceable, and non-transferrable element of the habitat. Of all other substances that go to make up a metropolitan environment, the few square miles that it occupies are its most vital possession. How that space is used will af-

fect the lives of generations. It will influence the vitality of commerce, the cultural level of the people, the tax rate, and the general quality of downtown daily living. . . . space cannot be stretched, exchanged, shrunk or moved. What a community does with this one ingredient of its existence will affect its vigor, utility, and beauty for all human time.[18]

Some cities, no doubt, would continue much as before, finding that worthy goals, though previously unarticulated, in fact support what they have been doing. It could be, for example, that Chicago would deliberately choose to sacrifice its remaining Chicago School landmarks if it concludes that doing so is the only way it can create a real estate climate in which a 110-story Sears or 96-story John Hancock building will be built. Then again, it just might decide that these buildings are the realtor's equivalent of the SST: terribly attractive in a world that loves bigness for bigness' sake, but ultimately unacceptable because of their cultural, environmental, and human costs. We don't know. But no matter how Chicago came out, it would at least have made its decision fully conscious of the latter's costs and alternatives.

THE CHICAGO PLAN AND URBAN DESIGN ABUSE

Urban Design Controls

If development rights were haphazardly redistributed within a transfer district, at least two kinds of urban design abuse might result. First, severe overloads might be experienced by the district's physical and service infrastructure, including its pedestrian and vehicular transport systems, its utilities, its network

[16] For an account of the Urban Design Plan's formulation, see Svirsky, "San Francisco Limits the Buildings to See the Sky," 39 *Planning* 9-14 (ASPO, 1973).
[17] Numerous examples, such as the "monument complex" that leads some corporations to construct

enormous headquarter buildings that totally destroy the spatial relationships of the areas in which the buildings are located, are detailed in S. Toll, *Zoned American, supra* note 15 *passim*.
[18] E. Higbee, *The Squeeze: Cities without Space, supra* note 15 at 326.

Robert Thall photo

SEARS TOWER — THE WORLD'S TALLEST — AND "BIG JOHN"

Chicago's Sears Tower (above) and John Hancock Building (below), rising 110 and 96 stories respectively, are awesome achievements of modern technology and commerce. But the market and zoning conditions that make them possible also threaten to shatter the delicate urban design balance that makes the city a diversified and exciting place in which to work and live.

Robert Thall photo

of public services and facilities, and its environment and amenities. Second, the district's visual and dimensional character might be impaired by the introduction of structures wholly out of scale with their neighbors. The principal object of the Plan's urban design controls, of course, is to minimize its potential for disruption under either heading.

But these controls have a positive function as well. Through them the city can coordinate development rights transfers with the accomplishment of other urban design goals that depend in part or whole upon the pattern of density concentrations within the district. Representative of such goals in addition to landmark preservation itself are dispersal or concentration of selected land uses, establishment of high-rise elements at defined locations, optimization of transit system use, or fostering of renewal unassisted by government subsidy programs. Traditional zoning often does not provide the latitude necessary for sensitive evaluation of development proposals in terms of their compatibility with these larger concerns. In contrast, the transfer mechanism provides a tool that the city can use to channel density selectively to predetermined locations in furtherance of these goals.

The Plan addresses both the negative and positive objectives through a two-stage system of controls. The first stage occurs when the development rights transfer district is formally established; the second, at the time the transfers actually take place. The municipal landmark and planning commissions usher in the first stage by conducting a joint investigation of the proposed district. The landmark commission inventories the number and type of landmarks there, and estimates the amount of space that may be subject to transfer upon their designation. The planning commission reviews the compatibility of the likely volume of transfers with the area's existing character and its development goals as defined in such

sources as the city's comprehensive plan, its capital improvements program, and its detailed plan, if any, for the area in question. The two commissions then record their findings and recommendations in a report which serves as the basis for the city council's eventual decision to approve or decline the proposed district.

The second-stage controls, which are similarly intended to insure the rational distribution of space within the district, are four in number. The first is the city's threshold determination of how many buildings it actually chooses to designate. Since the quantity of transferable development rights is strictly linked to the number of landmarks, the city can limit that quantity by restricting the number of designations that it makes. It is most unlikely, however, that any city will be forced on this account to exclude from designation any of its truly meritorious buildings. The capacity of the overall transfer district to absorb redistributed density can be expected to outstrip the excess development rights of such buildings. And the problem will virtually disappear in cities that choose the option mentioned earlier[19] of authorizing transfers only for landmarks earning less than a prescribed rate of return rather than for all landmarks. Since only a small percentage of landmarks will meet this test, the quantity of transferable development rights will shrink accordingly.

Second, as an instance of density zoning, the Plan does not increase the total density authorized within the transfer district by existing zoning. It merely shifts density from underutilized landmark lots to appropriate transferee sites. As a result, heightened demands on the district's physical infrastructure will be experienced only at the individual transferee sites rather than throughout the

[19] See pp. 58-59 *supra.*

entire district, as would occur if all lots there were upzoned to the densities permitted on these sites.

Third, the impact of density increases on specific transferee sites will be regulated by height and bulk ceilings that the city fixes for these sites. As suggested at the beginning of this chapter, the city can authorize two types of increase, "major" and "minor," which are differentiated by the amount of additional bulk or height permitted on the individual transferee site. Minor increases are those which have a marginal impact on the existing physical infrastructure and visual and dimensional character of the site's environs. Major increases, on the other hand, threaten to impair these elements unless subjected to rigorous site planning and design review.

Because transfers under the Chicago Plan may be made throughout entire development rights transfer districts, large blocks of development rights deriving from a single landmark site can be dispersed in relatively small increments to numerous transferee sites. In this respect the Plan differs from the New York transfer program, which requires that all of the landmark's excess development rights go to a handful of adjacent sites.

But cities will probably wish to retain the option of authorizing major increases as well. They may encounter development proposals, such as those for large-scale office or residential PUDs, for which increased quantities of development rights can be utilized without urban design disruption. Moreover, permitting these increases may support other urban design goals, such as optimization of transit use, that assume high-density concentrations at selected points. Major increases should be allowed, however, only in conjunction with more detailed municipal supervision. Their impact on the environs of the transferee site should be carefully evaluated beforehand, and additional requirements, including the provi-

sion of on-site link-ups with the public transit system or the widening of sidewalks and other pedestrian spaces, should be imposed where appropriate.

Fourth, the Plan's potential for urban design disruption can be further minimized by identifying "sensitive" areas within the transfer district where density increases would be prohibited altogether. This objective can be accomplished in various ways. The city could, for example, measure sensitivity on the basis of an index of land uses and densities paralleling those of its zoning code. It might decide that high-rise office or residential uses or bulk zones with an FAR of 10 or more do not fall within the sensitive category, and that transfers may therefore be made to lots located in comparable use or bulk zones. Or the city could evaluate the existing character of various geographical areas within the transfer district and exclude transfers from areas where they might prove incompatible. Under this approach, for example, transfers might not be allowed in areas containing a predominant, unique building type, such as the lovely brownstones found on Manhattan's East and West sides, or from areas that are graced by uniform or harmonious cornice lines. To the extent that the development rights transfer district coincides with the city's central business district, of course, the problem of sensitivity is not likely to be as pressing. Even these districts, however, may contain sections that would be detrimentally affected by the density increases envisaged under the Plan.

Application of the Plan's Safeguards to Selected Urban Design Problems

The foregoing discussion of the Plan's urban design safeguards touched briefly on a number of problems that cities may encounter in overseeing development rights transfers. The following paragraphs address these problems more systematically in exploring the contribu-

OFF-LIMITS FOR DEVELOPMENT RIGHTS TRANSFERS

American cities contain many blocks or sections, such as Chicago's State Parkway (above) and Alta Vista Terrace (below), that are distinguished by low densities, nearly uniform cornice lines, and charming design motifs. Development rights transfers are not appropriate in these sensitive areas because the transfers may upset their dimensional scale and set off speculative pressures that would endanger their special character.

tion that the safeguards can make to their satisfactory resolution.

VISUAL AND DIMENSIONAL SCALE

Selective increases in bulk and height can lead to buildings that are out of scale with their neighbors. This result can be avoided by application of two of the Plan's controls: the sensitive area concept and bulk and height ceilings for individual transferee sites. Areas characterized by uniform cornice lines, a unique skyline, distinctive building types, or other elements that transfers threaten to disrupt can be identified as sensitive areas within which transfers are prohibited.

Ceilings on bulk and height can be set for the remaining sections of the development rights transfer district on the basis of existing or desired patterns of development. If the district largely coincides with the city's central business district and contains large buildings and an irregular skyline, the addition of minor increases in bulk or height will not produce disharmonious visual or dimensional patterns. Most transfer districts will in fact be of this type. Nor will similar increases create undue consequences if the area is in transition to greater densities independently of the Plan. Major increases in both kinds of areas should be permitted only if the city has concluded through site plan and design review, measured against the urban design and preservation components of its general plan, that the proposed project can be made compatible with the existing or expected scale of development within the area. Major or minor increases can also be used affirmatively to produce desired visual or dimensional effects. If, for example, the city wishes to create or enhance visual corridors to a prominent physical or architectural feature such as Chicago's Lakefront or Washington's federal Capitol, it can do so by massing or dispersing bulk at appropriate points along these corridors.

PEDESTRIAN MOVEMENT

Surprisingly little hard data is available concerning the correlation of building size with pedestrian traffic. As a general matter, it is clear that sidewalk size is usually standardized without regard to adjacent uses. It is known, moreover, that certain kinds of uses generate more traffic than others. For example, restaurants increase traffic from 2.5 to 4.8 times as much as office buildings, and retail stores from 2 to 7 times as much. It is also recognized that the peak periods of traffic differ among various uses. The most extensive use of pedestrian space in the vicinity of office buildings, for example, occurs at the beginning of the workday, at midday, and at the end of the workday, the space being underutilized during the remainder of the day and hardly at all during the evening.

Accordingly, cities adopting the Plan should conduct pedestrian traffic studies of their own to develop more precise data applicable to the locality. On the basis of these studies and the foregoing generalizations, cities can pinpoint the various levels of density at which specific amounts of additional on-site or public pedestrian space are required given the existing space resources and their levels of utilization within the transfer district. In addition, the information gathered in these studies should assist the cities in devising policies concerning the mixing of uses within individual structures in order to achieve fuller utilization of the space throughout the twenty-four-hour day.

The Plan envisages that studies of this nature will be conducted by the municipal planning department prior to recommending the establishment of individual development rights transfer districts. It also assumes that the pedestrian space usage guidelines contained in these studies will play a key role in quantifying the difference between major and minor development rights transfers. Finally, it contemplates that these guidelines will serve as

DIMENSION AND DISSONANCE IN THE CITYSCAPE

The eye reacts kindly to proportion and scale in urban design, but it recoils from a cityscape in which bulk is experienced haphazardly, with enormous high rises dwarfing smaller buildings.

one of the bases of site plan review for projects incorporating major increases, and thus for determining the additional on-site or public space improvements that will be prerequisites to project approval.

PUBLIC AND PRIVATE TRANSPORTATION SYSTEMS

Selective bulk increases will also expand usage of public transportation systems and of on-site access to collector points along transit lines. A minor density increase is unlikely to necessitate an expansion of the transit facilities serving the immediate area. But multiple transfers to a single area for, let us say, a large-scale PUD should be coordinated with the city's comprehensive plan and capital improvements program to insure both that the addition is desirable and that the necessary transit facilities will be available when needed. As a general matter, however, an independent decision of the city to expand its transit facilities in a given area will be the impetus for shifting development rights there rather than the other way around. Instead of disrupting the public transit system, therefore, development rights transfers promise to encourage more efficient patterns of transit usage.

Access to public transit is frequently provided by on-site improvements such as arcades or concourses. Unlike the transit system itself, these improvements fall within the developer's control. Hence, the city should consider their adequacy in reviewing site plans for proposed projects incorporating major density increases. Similar review has been commonplace in the zoning bonus programs of a number of American cities over the last decade.

Significant increases in motor vehicle traffic may accompany major density increases in cities lacking adequate public transit systems. The extent to which increased vehicular access and on-site parking requirements should be imposed for projects on transferee sites using major increases will depend upon two factors.

The first is the character of the public and private parking facilities within or nearby the transfer district, including their type, location, capacity, and degree of present usage. The second is the relationship between the cost of providing these improvements and the attractiveness of development rights to potential purchasers. Clearly these requirements can be increased only so far before the economic advantages of development rights become marginal. Should that point be reached in particular situations before the parking needs of the public are met, the city either should take steps to expand existing parking capacity or should reject the major increase.

UTILITY SYSTEMS

The foregoing comments concerning the impact of selective bulk increases on the transfer district's pedestrian movement and transportation systems apply with equal force to its utility system. Again, increases in demands upon, e.g., the district's sewer, storm drainage, or water supply facilities are not likely to be sufficiently great in the case of minor increases to warrant expansion of the facilities. Conversely, major increases will require expansion to accommodate heightened user levels resulting from increased population at the transferee site. An examination of the relationship between building size and utility demand and of the degree of utilization of the district's present utility system. should constitute integral elements of the report that the municipal planning commission prepares for the city council at the time the district is established.

RELATION TO LANDMARK BUILDINGS

The design complications posed by transfers to sites adjacent to landmark buildings have already been considered at length.[20] It is sufficient here only to re-emphasize that discussion's two principal conclusions: (1) relatively

[20] See pp. 59-60 *supra*.

141

few transfers under the Chicago Plan will go to sites adjacent to landmark properties; (2) those that do will be required to pass muster under exacting standards and procedures comparable to the ones utilized in the New York program.

SOCIAL AND POLITICAL CONSEQUENCES

Community acceptance has traditionally played a small role as an urban design criterion. With the increasing opposition of community groups to urban renewal, highway, and other public projects, however, it has rapidly moved to the forefront in planning deliberations. Development rights transfers too can arouse community opposition by setting in motion developmental trends that clash with citizen preferences.

Consider, for example, the following two controversies, each of which was ignited by an incentive zoning proposal of the New York City Planning Commission. Under the first, the commission sought to increase the supply of low-income housing on the Lower East Side by awarding bonuses to developers who either slated 15 percent of the units in their buildings for low-income rental or contributed to a fund to be used to acquire public housing sites. Despite the commission's good intentions, the proposal was torn apart by area residents, who blasted it as a "give-away" to developers and as a trick to displace low-income ethnic groups from the neighborhood.[21]

The commission's goal under its second proposal was to safeguard the Upper East Side's handsome brownstone buildings by permitting their owners to transfer their excess development rights to the corner lots on each side of their respective blocks. This proposal too fell before the onslaught of neighborhood groups. In addition to being castigated as a give-away, it was also condemned as a ruse

to enable owners of the corner lots to break free from the rent control restrictions affecting their present buildings by redeveloping their sites with high-rent, mid-rise apartment buildings.[22]

The lesson of these illustrations for any city that adopts the Chicago Plan is unmistakable. Like New York, the city will be acting for the best of motives. And like the selective bulk modifications called for by the two incentive zoning proposals, development rights transfers under the Plan will have definite economic and social implications that go well beyond historic preservation itself. In fleshing out the framework of controls enumerated in this section, therefore, the city must take special care to identify and accommodate community values that stand to be threatened by the transfers. Otherwise, the Plan may fail for lack of popular support.

AMENITIES WITHIN THE TRANSFER DISTRICT

The Plan's contributions to amenity levels within the transfer district are both direct and incidental. By facilitating the preservation of landmark buildings, of course, the Plan enriches the urban environment in a variety of ways. Landmarks are a repository of the community's and nation's architectural traditions and genius. As visible points of reference, they orient stranger and resident alike, thereby responding to the practical need of getting around the city and to the more fundamental emotional yearning for security and familiarity. Landmarks also enable their viewers to experience space and movement, two phenomena that lie at the heart of urban design aesthetics. Different rates of speed, purposes of movement, and sizes and shapes of objects and space largely constitute the urban design aesthetic experience. The distribution patterns and settings of landmarks denote the passage

[21] See *New York Times*, Jan. 1, 1971, p. 1, col. 4.

[22] See Note, "Development Rights Transfers in New York City," 82 *Yale L. J.* 338, 361-67 (1972).

TIME, SPACE, AND THE URBAN DESIGN EXPERIENCE

Harmoniously related buildings from different periods enrich the observer's sense of time and space as components of the urban design experience. Buildings from three centuries — Faneuil Hall (eighteenth), the Fish Building (nineteenth), and the Fish Building addition (twentieth) — are sensitively related in scale and space.

of space and time, and hence intimately involve the viewer in that experience.

Landmarks also represent a direct and visible expression of the values of the community which, in turn, serves collaboratively as their author. The presence of vintage, well-maintained buildings in active use tells the observer that the community has chosen to retain continuity with its past and is prepared to embrace the urban design and economic implications of its choice. In a dynamic society, which has coined the terms "throwaway" and "planned obsolescence," landmarks

symbolize the community's attitude toward age in general. By forestalling the untimely death of these environmental artifacts and rejecting the mindless tendency toward accelerated obsolescence, the community affirms its reverence for age and, ultimately, for humanity as well.

The Plan's incidental contributions to the district's amenities are two, each of which has highlighted an earlier discussion. First, the Plan augments the open space amenities of the downtown area because the landmarks that it preserves also serve a distinctive func-

143

tion as light-and-air parks. But an important difference between landmarks and conventional open space amenities such as plazas must be recognized lest the open space advantages of the Plan be overstated. Landmarks do not stand in the same relationship to the larger buildings on transferee sites that exists between conventional open space amenities and buildings incorporating bonus space. The latter amenities are located on the same parcel as the building and, in theory at least, digest its added bulk *at the site*. Landmarks, on the other hand, will often be located some distance from the transferee sites. Hence, the Plan requires the additional urban design controls enumerated in this chapter in order to deal with the consequences of the greater bulk, as experienced at the transferee site.

Second, the Plan can serve as a vehicle for taming unbridled zoning bonus programs which, in seeking to encourage conventional open space amenities, have caused the less fortunate urban design consequences described earlier in New York[23] and Chicago.[24] To its credit, New York has recognized these consequences and has begun to coordinate its zoning bonus program with other urban design techniques, such as special development districting, that are sensitive to area-wide urban design considerations.[25] Bonuses are granted more selectively on the basis of area

plans and integrated development programs. Developer freedom to choose among a group of amenities in obtaining bonus space has been replaced with a system under which the city establishes a hierarchy of amenities and mandates the order in which they may be elected.[26]

The opportunities for coordinating the Chicago Plan with these techniques to bring about more balanced urban design results are limited only by the city's imagination. As one form of special development district, the development rights transfer district offers an excellent framework for allocating space more rationally on an area-wide basis. The background studies and development goals that give the latter district its substance permit deliberate rather than random space redistribution. They also enable the city to secure a sounder balance between the provision of typical bonus amenities, such as plazas and arcades, with other forms of amenity, such as landmark preservation itself. In line with the foregoing innovations, for example, it should not prove difficult for a city to rate amenities, and to require that developers obtain additional space from the development rights bank rather than from bonuses if the bonus system is encouraging landmark destruction.

[23] See p. 87 *supra*.
[24] *Ibid.*
[25] See pp. 129-30 *supra*.
[26] *Ibid.*

6
The Chicago Plan and the Law

Preservation's toughest legal problem is distinguishing between measures that cities may implement under the police power and those that must be bottomed on the condemnation power. When may the city take a free ride and when must it pay? Imprecise tests based on lowered rates of return and on the balance between community advantage and individual hardship have little predictive value except in the obvious situations portrayed as Cases 1 and 2 in Chapter 1. Unfortunately, the hard case, Case 3 in that chapter, is the one that typically confronts city councils. Surrounded by political and economic as well as legal uncertainties, it has usually been the one that got away. It is the Old Stock Exchange building in Chicago, Pennsylvania Station in New York, and countless other landmarks whose demise is recorded in the Historic American Buildings Survey.

By compensating the landmark owner for the loss of his property's development potential, the Chicago Plan solves the legal problem. It also lessens the economic and, it can be anticipated, the political ones as well.

But the Plan does pose three new legal issues of its own. One is the validity of condemning and reselling the development rights of threatened landmarks. The second concerns the acquisition and enforceability of preservation restrictions. The third centers on the propriety of permitting development rights purchasers to build larger structures than other property owners within development rights transfer districts. Although none of these issues should pose insuperable obstacles to the Plan's underlying legal validity, each bears careful scrutiny. Cities, landmark owners, and the real estate industry are entitled to nothing less. Given the high political and financial stakes of their participation in the Plan, they will be at least as anxious about the Plan's prospects in a court challenge as they are about its economic and planning feasibility.[1]

CONDEMNATION AND RESALE OF DEVELOPMENT RIGHTS

A key feature of the Plan is the linkage between the condemnation of landmark development rights and their resale at other locations. Condemnation, it will be recalled, is necessary

[1] This chapter has been adapted from Costonis, "The Chicago Plan: Incentive Zoning and the Preservation of Urban Landmarks," 85 *Harv. L. Rev.* 574, 602-34 (1972). Readers desiring a more technical presentation of the legal issues discussed in the text or more exhaustive citation of pertinent legal authorities should consult that article.

145

when a landmark owner declines voluntarily to participate in the Plan, and insists instead upon redeveloping the landmark site. Resale of the condemned development rights provides the funds to cover the condemnation costs which the city would otherwise be unable to bear.

The charge most frequently leveled at public programs that are based in some measure on the condemnation power is violation of the "public use" requirement of state and federal constitutions. As applied to the Plan, the charge masks three quite separate contentions. First, the public will not "use" the condemned interest in the same sense that it uses property condemned for a civic center or a post office. Second, the true beneficiaries of the Plan are not members of the public at all, but a small group of private entrepreneurs, the development rights purchasers. Finally, the Plan is a disguised scheme for recapturing the costs of a public program that should be funded out of general revenues rather than through the condemnation and resale of development rights.

Use by the Public

The first of these objections is the least worrisome. Its premise that public use means physical use or occupation by the public has long since been discredited. Most courts now equate public use with public benefit, and sustain programs that advance recognized public purposes.[2] Decisions dating back to the nineteenth century have accorded historic preservation this recognition.[3] But even those courts that still accept the use-by-the-public test have little difficulty with programs, such as the Plan, that envisage condemnation of less than fee interests. The public "use," these courts

[2] See, e.g., Gohld Realty Co. v. Hartford, 141 Conn. 135, 104 A.2d 365 (1954).
[3] See, e.g., United States v. Gettysburg Elec. Ry., 160 U.S. 668 (1896); Roe v. Kansas *ex rel.* Smith, 278 U.S. 191 (1929).

note, consists in the public's visual enjoyment of the site or facility that has been safeguarded by means of the less than fee acquisition.[4]

Private Benefit

Nor will the Plan succumb to the objection that it advantages a handful of developers rather than the public generally. It is true, of course, that landmark owners and development rights purchasers receive preferential treatment under the Plan. But identifiable private groups are similarly benefited in every governmental program that relies in part upon private enterprise for its success.

Take urban renewal for example. Municipalities devise urban renewal plans and condemn and clear slum sites. Actual redevelopment, however, is carried out by private developers, who, after all, are in business to earn a profit. Yet the argument has long since been laid to rest that urban renewal violates the public use requirement simply because one of its consequences is the enrichment of private developers.[5]

Clearly, private enterprise will not engage in cooperative ventures with government unless it can do so on a profitable basis. The courts are well aware of this fact. They recognize too that a wide array of socially beneficial public programs, such as urban renewal, would falter without the private sector's participation. Accordingly, they refuse to invalidate these programs simply because private entrepreneurs are incidentally benefited under them.[6] Instead, the courts intervene only if

[4] See, e.g., Kamrowski v. State, 31 Wis.2d 256, 142 N.W.2d 793 (1966); Kansas City v. Liebi, 298 Mo. 569, 252 S.W. 404 (1923); *In re* New York, 57 App. Div. 166, 173, 68 N.Y.S. 196, 200-01, *aff'd per curiam,* 167 N.Y. 624, 60 N.E. 1108 (1901).
[5] See, e.g., Belovsky v. Redevelopment Auth., 357 Pa. 329, 340, 54 A.2d 277, 282 (1947).
[6] See, e.g., Papadinis v. City of Somerville, 331 Mass. 627, 632, 121 N.E.2d 714, 717 (1954).

private gain is so disproportionate to public benefit that the challenged program amounts to a virtual fraud on the public.[7]

The chances that the Plan will fall before the private-gain objection are virtually nil. Two private groups are benefited under the Plan: landmark owners and development rights purchasers. In both cases, however, the degree of benefit is strictly circumscribed. Landmark owners — or, derivatively, the city — may transfer only that amount of development rights that competent appraisal determines is necessary in conjunction with tax relief to compensate owners for their losses. Development rights purchasers must pay a price for the development rights that represents their going value on the open market. All phases of the appraisal and sale procedures, moreover, are open to public scrutiny, to challenge at public hearings, and, should opponents of a particular transfer choose, to appeal before the courts as well. So circumscribed, the private benefits under the Plan hardly seem disproportionate to the advantages that the community will receive through the preservation of cherished buildings.

Recoupment

The final public use objection zeroes in on the city's reliance upon the condemnation power to recoup its preservation costs. Opponents of the Plan may seek to analogize this feature to the constitutionally proscribed practice of "excess condemnation." Under that practice a public agency deliberately condemns a greater amount of land than it needs with the intent of recapturing its project costs by selling off the excess at an appreciated value upon the project's completion. For example, land adjoining a proposed highway right-of-way will increase in value in consequence of the lucrative highway-related uses to which it can be devoted. A state highway department would be vulnerable to constitutional attack, however, if, in addition to the highway right-of-way, it condemned a swath of land 500 feet wide on both sides of the right-of-way for eventual resale at a healthy profit. Despite the lowered costs of the highway program, the courts would probably invalidate the scheme as an instance of excess condemnation.[8]

Uneasiness with excess condemnation reflects a number of concerns. The key objection goes to the propriety of using condemnation, one of the harshest of governmental powers, to fund public programs, rather than resorting to general taxation for this purpose. Even municipal poverty, it is felt, does not justify such drastic interference with private ownership. Another is that government has no place in the private real estate market. For some commentators, this concern is ideological: governmental entrepreneurship is viewed as a form of "socialism." For others, it is eminently practical: the private sector is simply unable to compete with government, which is untaxed, unregulated, and able to raise capital more cheaply. Further, the wisdom of public participation in high-risk ventures has been questioned by those who point to the spectacular failure of a number of excess condemnation experiments in nineteenth-century Europe. Finally, the opportunities for corruption and favoritism that are inherent in recoupment programs are thought to outweigh whatever financial benefits these programs promise for the public.[9]

Despite these concerns, the courts have carefully refrained from a blanket indictment

[7] See, e.g., Denihan Enterprises, Inc. v. O'Dwyer, 302 N.Y. 451, 99 N.E.2d 235 (1951).

[8] See, e.g., Cincinnati v. Vester, 33 F.2d 242 (6th Cir. 1929), aff'd, 281 U.S. 439 (1939).

[9] For an exhaustive analysis of the policies favoring and opposing excess condemnation, see R. Cushman, *Excess Condemnation* (1917).

of all public programs that contain a recoupment element. They recognize that the expanded responsibilities of government in this day have created needs for public funding that outstrip revenues available under conventional taxing methods. Accordingly, they have struggled to develop a rationale that enables worthy programs to go ahead, while proscribing abuses of the condemnation power aimed solely at raising public revenues. They have found this rationale in the formula that *recoupment is permissible if it is "incidental" to an independently valid public use.*

Three groups of cases illustrate the formula's application. The first includes the "by-product" cases,[10] so labeled because the issue litigated in them is the propriety of government selling a by-product of the condemned interest. Among the best known of the by-product cases are those in which a public agency sells electric power generated at dam installations that it builds on condemned property. Private power companies have strenuously objected to these sales, citing the various objections to excess condemnation enumerated earlier. But the courts have uniformly rejected the challenge. They reason instead that sale of the electricity by-product is merely incidental to the flood control and navigation improvement responsibilities of the agency.[11]

Having established this linkage between recoupment and an underlying public use, the courts also identify three supporting grounds for their position. First, the sales enable government to lower the costs of public programs. Second, they advance community welfare by providing funds to meet vital public needs that might otherwise go unmet. Third, they encourage the productive use of valuable re-

sources. Throughout these cases runs a *leitmotif* of pragmatism, reflected in the following language of a leading U.S. Supreme Court decision on condemnation practices: "The cost of public projects is a relevant element. . . . the Government just as anyone else, is not required to proceed oblivious to elements of costs. . . . And when serious problems are created by its public projects, the Government is not barred from making a commonsense adjustment in the interest of all the public."[12]

Recoupment in the second group of cases takes the form of rentals paid by private tenants to public agencies that have erected buildings on condemned land. The controversial World Trade Center, a project of the New York Port Authority, is illustrative. Ostensibly built to provide headquarters space for governmental bodies that regulate international trade, most of the center's space is actually rented to private firms, many of which deal exclusively in domestic commerce. Citing this fact, challengers of the project argued that it is little more than a disguised real estate venture designed primarily to meet the Port Authority's overall capital needs. But New York's highest court disagreed.[13] In its view the rentals are merely incidental to a valid public use, the centralization of international trade activities in the New York–New Jersey bistate area. Similar reasoning appears in court opinions that sustain the lease of space to private firms in port terminals,[14] municipal parking facilities,[15] and other structures built on condemned land.

Like the by-product cases, the leasing prece-

[10] See, e.g., Ashawander v. TVA, 297 U.S. 288 (1936); United States v. Chandler-Dunbar Water Power Co., 229 U.S. 53 (1913).

[11] *Ibid.*

[12] United States *ex rel.* TVA v. Welch, 327 U.S. 546, 554 (1946).

[13] Courtesy Sandwich Shop, Inc. v. Port Auth., 12 N.Y.2d 379, 190 N.E.2d 402, 240 N.Y.S.2d 1 (1963).

[14] See, e.g., Lerch v. Maryland Port Auth., 240 Md. 438, 214 A.2d 761 (1965).

[15] See, e.g., Court St. Parking Co. v. Boston, 336 Mass. 224, 143 N.E.2d 683 (1957).

A RECENT CASUALTY

The Emery Byrd Thayer Building in Kansas City, Mo., designed by Van Brunt and Howe and built in 1890, was razed in 1973 so that its site could be more profitably utilized for a high-rise building — or a parking lot.

dents reflect judicial sympathy for public projects that could not be conducted without recoupment and that deal with needs that private enterprise has failed to address. Similarly, they reflect the judiciary's view that governmental competition with the private sector is not objectionable so long as the challenged project in fact serves an independent public purpose, such as furnishing parks, transportation, or governmental facilities. Charges that leasing arrangements open the way to "outside land speculation" or other abuses are given little credence. The time to raise these objections, the courts point out, is when the feared abuses materialize. Otherwise, public agencies are presumed to act in compliance with legislative mandate.

Resale rather than lease of condemned land is the target of attack in the third group of cases. Urban renewal is again illustrative. To renew their deteriorating sections, cities condemn land from one private group, the present owners, and sell it to a second, the developers. Resale has two objectives: first, it enables the cities to recapture a significant portion of their acquisition costs; second, it puts the land in the hands of those who will actually redevelop it. Opponents of urban renewal have concentrated their fire on the first of these objectives, which in their view raises the specter of widespread land profiteering by government.

Again, however, the courts have refused to block programs that look to fiscal techniques other than general taxation to accommodate the vastly expanded responsibilities of government in this century. They have sustained the resale of urban renewal land by viewing resale as a subsidiary element of an overall program that promises the redevelopment of blighted areas, a worthy public use. They note in addition that resale is a sign of sound municipal stewardship because it lessens the capital costs of renewal programs and returns publicly

owned land to the tax rolls and to productive endeavor.[16]

The by-product, leasing, and resale precedents are persuasive that the courts will deem the recoupment feature of the Chicago Plan incidental to the recognized public use of preserving landmarks. The consequences attending the resale of condemned development rights are identical with those approved in these precedents. The public's fiscal burden is lessened through recoupment. A community need — historic preservation — is satisfied that would otherwise go begging in the face of the economic obstacles that to date have barred successful preservation efforts. And the productive use of valuable resources — the dormant development potential of public and private landmarks — is made possible by incorporating this potential into buildings erected on transferee sites.

THE PRESERVATION RESTRICTION

If the Chicago Plan envisaged outright municipal ownership of all landmark properties, there would be no need to address the legal issues surrounding the preservation restriction. Because municipal ownership is neither feasible nor desirable except in the case of landmarks actually used by the public or those of marginal profitability, however, the Plan shifts its emphasis to less than fee acquisition.

This shift poses two fundamental legal issues. The first is essentially one of fairness: does the city deny justice to landmark owners by opting to acquire only a protective interest rather than the fee in their properties? The second goes to the enforceability of the preservation restriction. It has two branches, one based in the case law of the relevant state and one in its statute law. The question to be asked under the first heading is whether the

[16] See, e.g., *In re* Slum Clearance, 331 Mich. 714, 722, 50 N.W.2d 340, 344 (1951).

150

preservation restriction can be subsumed under any of the traditional less than fee interests that have received judicial approval. If not, the question becomes statutory: has the state legislature modified the case law through an appropriate enactment that assures the enforceability of the preservation restriction?

Pontiac Improvement Co. v. Board of Commissioners[17] demonstrates that judicial concern over the fairness and enforceability of less than fee takings may result in their invalidation. In *Pontiac,* the Cleveland Park Commission sought through condemnation to limit the development of a private parcel that adjoined a park to insure that use of the former would be compatible with the neighboring park use. Proceeding under a statute that authorized it to condemn the "fee or any lesser interest in real estate," the commission did not acquire the parcel outright but simply imposed controls respecting drainage, planting, use, and new construction on the parcel. The commission, however, was rebuffed in court.

Condemnation of the parcel's development potential in this manner was inherently unfair, the court believed, because it left the private owner with all of the responsibilities but few of the privileges of ownership. Nor was the court satisfied that the type of interest that the commission sought to acquire had firm standing in case or statute law. The court was unable to fit it within any of the less than fee molds that had traditionally been approved by the judiciary. And it was adamant that vague statutory authority to acquire the "fee or any lesser interest in real estate" was not intended to authorize the commission to acquire the novel interest that it sought in *Pontiac.* The court's dissatisfaction on these counts led it to conclude that, whatever the nature of that interest, the

[17] 104 Ohio St. 447, 135 N.E. 635 (1922).

respective obligations of the commission and the property owner to which it gave rise were too obscure to be enforceable.

Acquisition in Fee

Few courts today would agree with the general proposition that a less than fee taking is unfair to the landowner. On the contrary, they insist that public authorities neither may nor should condemn a greater interest in or amount of land than the public use necessitates.[18] In this way, they note, both public outlays and governmental interference with private ownership are significantly reduced.[19]

The fairness objection seems especially inappropriate in the case of most urban landmarks. Even without subsidy, landmark properties can typically be operated at a modest profit. With tax relief and the development rights package, their worth rises to the value they would have if they were redeveloped to their full economic potential. Hence, the city does not saddle their owners with a white elephant when it acquires a preservation restriction in them.

The situation is quite different, of course, if the building returns only marginal amounts at the time it is considered for designation. In such cases, the city should opt for outright acquisition with a view to using it either for municipal space needs or for lease or resale to a nonprofit or institutional buyer. A similar concern explains the earlier recommendation[20] that cities adopting the Plan make provision for periodic re-evaluation of landmark properties on which they hold preservation restrictions. Practical and perhaps constitutional difficulties may frustrate municipal expectations that such properties can be preserved "forever" through the use of restrictions.

[18] See, e.g., Miller v. Commissioners of Lincoln Park, 278 Ill. 400, 116 N.E. 178 (1917).
[19] *Ibid.*
[20] See p. 48 *supra.*

Acquisition and Enforceability of a Less Than Fee Interest

JUDICIALLY RECOGNIZED INTERESTS

Under routine contract principles, the city will be able to enforce the preservation restriction against the landmark owner who executed it. The more difficult question concerns enforcement against successors of that owner. Suppose, for example, that Smith was the landmark owner who executed the restriction and that the property has since come into the hands of Jones through numerous intermediate conveyances. Jones announces his intention to demolish the landmark. May the city enforce the anti-demolition provision of the preservation restriction against Jones despite the fact that Jones has not personally agreed with the city to be bound by the restriction?

This is a question of property, not contract, law. Restated in traditional property terms, it asks if the burden, i.e., the anti-demolition requirement, of the preservation restriction "runs" with the landmark property, thereby binding whoever happens to own that property whether or not he has expressly consented to the restriction. The American courts, following the English property law precedents, have decreed that remote takers of burdened property such as Jones may be bound by three types of less than fee interests: easements, real covenants, and equitable servitudes. Because restraints on property are not favored, however, the courts have created a network of technical requirements that these interests must satisfy as a condition to their enforceability. The survey of these requirements that follows is intended to identify the major

obstacles that may stand in the way of bringing the preservation restriction under the rubric of one or more of these interests.[21]

Easements

Of the three judicially recognized less than fee interests, preservation restrictions are most likely to be compared to negative easements. The latter obligate owners of land subject to them, the so-called "servient estate," to refrain from using it in ways that would be perfectly legitimate were the servient estate not subject to the easement. (An affirmative easement, on the other hand, gives its holder certain rights in the servient estate, such as, for example, a right of way over it to the holder's own land.) The classical example of a negative easement is the easement for light and air, which a property owner obtains to prevent his neighbor from erecting structures on the servient estate that threaten to cut off light and air from his own land, the so-called "dominant estate."

But labeling the preservation restriction a species of negative easement suffers at least three drawbacks, all relating to the technical limitations that the courts have imposed upon easements as tools for controlling land use. First, in the view of some courts and commentators negative easements are restricted to the four types approved in the early English cases: easements for light, for air, for support of a building, and for the flow of an artificial stream.[22] It is true that preservation restrictions resemble easements for light and air because they too prevent the landmark owner from cutting off light and air to surrounding parcels by increasing the bulk of his building.

[21] More exhaustive treatments of this highly technical subject may be found in, e.g., R. Brenneman, *Private Approaches to the Preservation of Open Land* 20-64 (1967); N. Williams, "Land Acquisition for Outdoor Recreation — Analysis of Selected Legal Problems" 37-55 (Outdoor Recreation Resources Review Commission, Study Rpt. 16, 1962).

[22] See 2 *American Law of Property* §§8.5, 9.12, 9.24 (A. J. Casner, ed., 1952). But this assessment of contemporary case law is vigorously contested by N. Williams, "Land Acquisition for Outdoor Recreation," *supra* note 21 at 49-50 & nn. 72-76.

But they go beyond these easements because they also curtail the power of the landmark owner to alter or demolish the landmark building.

Second, some courts refuse to enforce easements that are not "appurtenant" to a dominant estate.[23] An easement is appurtenant if it benefits the owner of the dominant estate in the physical use and enjoyment of his land and was created expressly for the purpose of conferring that benefit. Easements for light and air are illustrative. Their benefits are localized to the property of their holders; they enhance the dominant estates by assuring that the light and air of these estates will not be impaired by construction on the servient estates next door.

Easements that are not appurtenant are deemed to be "in gross." The holders of these easements are benefited in some respect other than their status as owners of adjacent parcels. For example, public utility easements are easements in gross because their value to the utility company lies not in enhancing other lands owned by the latter but in providing pipeline or transmission line rights of way necessary for the company's operations. As this example points up, holders of easements in gross typically do not own land adjacent to the servient estate, and thus have no dominant estate that the easement can be said to benefit.

How does this analysis apply to the enforceability of preservation restrictions, which we are assuming will be analogized to easements? The servient estate is the landmark parcel because it is burdened with the restriction. The city, of course, is the holder of the restriction. If the city owns property adjacent to the landmark that qualifies as a dominant estate, it should be successful in convincing the court that the restriction is appurtenant, and hence

[23] See 2 *American Law of Property* §8.2. But see N. Williams, "Land Acquisition for Outdoor Recreation," *supra* note 21 at 51.

that its burden runs to the successor of the landmark owner who executed it. But municipal ownership of adjacent lands will be wholly fortuitous. Where this element is not present, the city must hope that the courts will categorize as the dominant estate either city-owned properties within the general vicinity of the landmark or the public rights of way that border upon it. Otherwise, the restriction will be found to be in gross and therefore unenforceable against remote takers of the landmark property.

Real Covenants

It is even less likely that the courts will equate a preservation restriction with a real covenant. To see why, it is necessary to consider how a real covenant is created. The most common example is afforded by the real covenants contained in the deeds of purchasers of lots in a residential subdivision. In order to enhance the marketability of these lots, developers typically include a series of restrictions in the deeds concerning construction and use that protect the character of the subdivision. Once recorded, the real covenants become binding upon the purchasers and upon their successors; they will be enforceable by the developer and, if the deeds provide, by owners of lots within the subdivision.

This pattern will not often be duplicated in the landmark context. Crucial to the pattern is that the dominant and servient estates were originally in common ownership and that the restriction was imposed on the servient estate at the time ownership was divided. The developer in our example began as the common owner of all the lots in the subdivision, and encumbered each of them as he sold them off. At that point they became servient estates subject to the burdens of the real covenants, while the land he retained became the dominant estate. As owner of the latter, he — or subsequent purchasers of these lots — is able

CHANGING NEIGHBORHOODS, VULNERABLE LANDMARKS

The redevelopment of a neighborhood to predominantly higher densities and more intensive use patterns has been the undoing of many urban landmarks. It accounts for the loss of New York City's Jerome Mansion, a stately Second Empire—style residence within what was once a well-to-do residential neighborhood. The landmark's preservation became increasingly tenuous as the neighborhood shifted to higher densities and to uses that were not congenial to its former status. Demolished in 1967, the Jerome Mansion is the only formally designated New York City landmark that has been lost to date.

to enforce the covenants against the original and subsequent purchasers of the burdened lots.

Only rarely will the city have been the common owner of a dominant and a servient (landmark) estate. In almost all cases under the Chicago Plan, the city will be acquiring preservation restrictions in properties to which it is a total stranger. Two exceptions not directly related to the Chicago Plan bear mention, however. One arises when a city through its urban renewal program actually acquires historic properties· for subsequent resale to private bidders. The second appears in the programs of private preservation groups, such as Historic Charleston, Inc., which also purchase historic properties for subsequent resale. In both instances, astute lawyers should be able to arrange the details of the purchase and resale transaction to satisfy the common ownership requirements.

A second difference between the subdivision example and the landmark situation has already been considered in the easement discussion: the city will have difficulty meeting the appurtenancy requirement while the developer will not. The developer can enforce the real covenant against subsequent takers because he can show that breach of these covenants will adversely affect the marketability of the remaining lots in the subdivision. Both as entrepreneur and as homeowner, his losses will be tangible if, for example, a successor to a lot purchaser places a mobile home in the subdivision in violation of deed covenants that prohibit the construction of houses worth less than $50,000. The city, on the other hand, may own no land that will qualify as a dominant estate and, even if it does, it may be unable to show that the breach of a preservation restriction damages it in its status as owner of that land.

Equitable Servitudes

The most promising route is to cast the preservation restriction as an equitable servitude. Servitudes emerged in English property law in response to the frustrations that arose from the rigidities of the easement and real covenant. Thus, unlike negative easements, equitable servitudes are not restricted to the four categories mentioned earlier, but may incorporate any obligation that does not violate public policy. Nor must there have been common ownership of the dominant and servient estates prior to the execution of servitudes as in the case of real covenants. Servitudes are enforceable by injunction, and may include affirmative as well as negative duties. In contrast, real covenants only give rise to an action for money damages; in some jurisdictions, moreover, they may not include affirmative duties,[24] a qualification that could prove troublesome if the city wished to bind future owners to stated maintenance requirements. Servitudes must reflect the intent of their draftsmen to bind future takers of the burdened estate who, in turn, must have notice of their existence. But these conditions are easily satisfied by careful draftsmanship and by the proper use of the local deeds registry.

Unfortunately, servitudes too are hamstrung by the appurtenancy requirement in most jurisdictions.[25] If held in gross, they probably will not be enforceable against subsequent takers of burdened landmark properties. So again, municipalities must be prepared to argue that publicly owned property, whether adjacent to or near landmark property, will be directly benefited by enforcement of a servitude.

STATUTORY LESS THAN FEE INTERESTS

Historic preservation statutes frequently parallel the *Pontiac* statute by authorizing cities to acquire a "fee or lesser interest" in

[24] See, e.g., Miller v. Clary, 210 N.Y. 127, 103 N.E. 1114 (1913).

[25] See R. Brenneman, *Private Approaches to the Preservation of Open Land, supra* note 21 at 59.

155

real property. Assuming that a jurisdiction refuses to give effect to a preservation restriction because of incompatible prior case law, would it sustain the city's power to acquire and enforce the interest on the basis of this general statutory language? While there are no decisions directly on point, *Pontiac* suggests the range of difficulties that can be raised. But most courts have taken a different tack and favor a practical construction of these statutes free of the technicalities of an earlier day. Interpreting a statute of this nature, Oliver Wendell Holmes tersely expressed this view as follows: "It is plain . . . that the purpose of the taking must fix the extent of the right. The right, whether it is called easement or by any other name, is statutory, and must be construed to be large enough to accomplish all that it has taken to do."[26]

Further evidence of the willingness of the courts to construe these statutes favorably to the municipality appears in a group of Minnesota cases[27] interpreting a statute[28] that authorizes cities to zone through condemnation. Adopted in 1916 when the constitutionality of zoning as a police power exercise was still unclear, the statute empowers cities to purchase or condemn the development potential of land in "designated residential districts" in order to prevent the construction of other than low-density residential structures in these districts. This statutory interest, in fact, is identical to a preservation restriction except that it does not prevent the owner of improved land from demolishing or altering the improvements.

In a variety of challenges to the statute since 1916, opponents launched *Pontiac*-type assaults, urging that cities lacked the power

to acquire the interest, either under prior case law or under the statute. The Minnesota courts have spurned these challenges despite their obvious perplexity concerning the relation between the statutory interest and its common-law cousin. In the key opinion interpreting the statute, for example, the Minnesota Supreme Court variously identified the interest as an "easement," a "negative easement," a "reciprocal negative easement," a "restrictive [real] covenant," and, for good measure, a "negative equitable easement."[29] The lesson of these cases is that a sympathetic judiciary will find a way to uphold the preservation restriction, even if its only basis is a paper-thin statutory foundation.

STATUTORY REFORM

Legislatures in a number of states have grown restive with the ambiguities and sterile formalities of existing law. Recognizing that the law has impeded the accomplishment of valuable community goals such as highway beautification and open space and historic preservation, they have come forth with a variety of legislative initiatives. The latter break down basically into three groups of statutes.

One group[30] expressly empowers public agencies to condemn less than fee interests, generically denominated as "scenic easements," "facade easements," or "development rights." No effort is made to define the content of these labels or explicitly to abrogate the case law technicalities that have clouded the enforceability of these interests in the past. That neither omission will prove damaging, however, is pointed up by a recent decision of the Wisconsin Supreme Court which approved

[26] Newton v. Perry, 163 Mass. 319, 321, 39 N.E. 1032, 1032 (1895).
[27] See, e.g., Burger v. City of St. Paul, 241 Minn. 285, 64 N.W.2d 73 (1954); State *ex rel.* Madsen v. Houghton, 182 Minn. 77, 233 N.W. 831 (1930).
[28] Minn. Stat. Ann. §§462.12-.14 (1963).

[29] Burger v. City of St. Paul, 241 Minn. 285, 293, 294, 297, 299, 64 N.W.2d 73, 78, 79, 80, 81 (1954).
[30] See, e.g., Cal. Gov't Code §§6950-54 (West 1966); Wis. Stat. Ann. §23.30 (Supp. 1971); N.C. Gen. Stat. ch. 121, §157A (1971).

a statute authorizing the acquisition of "scenic easements" along the Great River Road.[31] The court emphatically approved the acquisition of these interests in an opinion that did not even mention the possible difficulties posed by the evident discrepancies between the statutory "easement" and its case law antecedents.

A second group of statutes makes express but limited encroachments upon the case law technicalities. Chief among this group are the Maryland[32] and Virginia[33] statutes that eliminate the troublesome appurtenancy requirement by conferring express legislative sanction upon "easements in gross."

The third group is the most satisfactory from the standpoint of historic preservation. The statutes in this group go beyond those of the former two groups by specifying the content of the less than fee interest and by spelling out comprehensively the case law formalities that it discards.[34] For example, the Illinois Historic Preservation Enabling Act defines a preservation restriction as follows:

> A preservation restriction is a right, whether or not stated in the form of a restriction, easement, covenant or condition, in any deed, will or other instrument executed by or on behalf of the owner of the land or in any order of taking, appropriate to the preservation of areas, places, buildings or structures to forbid or limit acts of demolition, alteration, use or other acts detrimental to the preservation of the areas, places, buildings or structures. . . . Preservation restrictions shall not be unenforceable on account of lack of privity of estate or contract, or of lack of benefit to particular land. . . .[35]

The validity of the preservation restriction is assured by the Illinois statute. The interest is given an independent statutory foundation, irrespective of its being termed an easement, real covenant, or equitable servitude or of its acquisition through purchase or condemnation. Whether or not the city owns land appurtenant to the landmark property or has held the dominant adjacent estate and the servient landmark estate in common ownership is irrelevant to the enforceability of that interest. By the systematic clarification of an intolerably opaque area of the law, the Illinois act and its companions in other states enable cities and the private sector to participate in the Chicago Plan confident that some hoary doctrine will not frustrate their reasonable expectations.

DEVELOPMENT RIGHTS TRANSFERS

Under traditional land use practice, zoning bulk is distributed in equal amounts to lots of equal size within the same zoning district. Thus, in a high-density office district with an assigned FAR of 16, all owners of zoning lots containing 20,000 square feet are entitled to construct buildings containing a maximum of 320,000 (16 x 20,000) square feet of interior floor space. Under the Chicago Plan, however, if one of these owners purchased 10,000 square feet of floor area from a landmark owner or the municipal development rights bank, he would be permitted to construct a building containing a total of 330,000 (320,000 + 10,000) square feet.

What potential legal objections attend the city's decision to relax its zoning bulk restrictions in this manner? Three different objections can be envisaged. The first is that preferential treatment of development rights purchasers violates the requirement of "uniformity" found in most state zoning enabling

[31] Kamrowski v. State, 31 Wis.2d 256, 142 N.W.2d 793 (1966).

[32] Md. Ann. Code art. 21, §8 (1957).

[33] Va. Code Ann. §21.12 (Supp. 1971).

[34] See Conn. Gen. Stat. Rev. P.A. No. 173, §2 [Jan. 1971] Conn. Leg. Service No. 2 (May 26, 1971); Ill. Rev. Stat. ch. 24, §11-48.2-1A(2) (1971); Mass. Gen. Laws Ann. ch. 184, §32 (Supp. 1970).

[35] Ill. Rev. Stat. ch. 24, §11-48.2-1A(2) (1971), reproduced in Appendix II of this study.

acts and denies equal protection to the remaining property owners within the district. The second is that transfers are invalid as "disguised variances." The third deems the practice an arbitrary planning exercise which, therefore, contravenes the constitutional requirement of due process. The specific ground of "arbitrariness" differs depending upon whether the transfer district encompasses the area of landmark concentration or has been mapped independently of that area. Each of these objections is considered in the following paragraphs.

Uniformity

The uniformity objection may rest on two distinct bases, one statutory and the other constitutional. The relevant statutory text is the requirement that "all [zoning] regulations shall be uniform for each class or kind of building throughout each district."[36] The constitutional text is the equal protection clause of the Fourteenth Amendment[37] of the federal Constitution and the counterpart of that provision which is found in all state constitutions as well. Commentators are agreed, however, that the statutory requirement of uniformity is simply duplicative of the constitutional requirement of equal protection.[38] Because a zoning measure that passes muster under the latter will also satisfy the former, the uniformity objection is treated as single in nature in the following discussion.

The uniformity objection is an outgrowth of the traditional view that density may only be allocated on a lot-by-lot basis.[39] That view has come under increasing fire in recent years and has been spurned altogether by proponents of density zoning. Its current status in the courts can be tested, therefore, by examining representative judicial opinions that address the issue of the compatibility of density zoning with the uniformity requirement.

A survey of the relevant precedents has produced no decision that has invalidated a density zoning measure on the ground that it denies uniform treatment to affected property owners.[40] On the contrary, the courts have reasoned that the requirement is satisfied by equal application of the zoning regulations to all similarly situated property owners within the pertinent zoning district. Whether or not the end product of development decisions there is the same in terms of comparative project bulk, height, or area is not determinative of the issue in their view.

[36] Advisory Committee on Zoning, Department of Commerce, *A Standard State Zoning Enabling Act under Which Municipalities May Adopt Zoning Regulations* 2 (rev. ed. 1926).

[37] Section 1 of the Fourteenth Amendment to the U.S. Constitution provides in relevant part: ". . . nor shall any State deprive any person of life, liberty, or property, without due process of law; nor deny to any person within its jurisdiction the equal protection of the laws."

[38] See, e.g., E. Basset, *Zoning* 50 (1940); Haar, "In Accordance with a Comprehensive Plan," 68 *Harv. L. Rev.* 1154, 1172 (1955).

[39] See pp. 127-34 *supra.*

[40] See, e.g., Orinda Homeowners Comm. v. Board of Supervisors, 11 Cal. App.3d 768, 90 Cal. Rptr. 88 (Ct. App. 1970); Chrinko v. South Brunswick Tp. Planning Bd., 77 N.J. Super. 594, 187 A.2d 221 (L. Div. 1963); Cheney v. Village 2 at New Hope, Inc., 429 Pa. 626, 241 A.2d 81 (1968). The rock on which some density zoning ordinances have foundered has not been the uniformity objection but the challenge of improper delegation of legislative power. See, e.g., Millbrae Ass'n for Residential Survival v. City of Millbrae, 262 Cal. App.2d 222, 242-43, 69 Cal. Rptr. 251, 265-66 (1968); Hiscox v. Levine, 31 Misc.2d 151, 216 N.Y.S.2d 801 (Sup. Ct. 1961). See generally Krasnowiecki, "Planned Unit Development: A Challenge to Established Legal Theory and Practice of Land Use Control," 114 *U. Pa. L. Rev.* 47 (1965); Mandelker, "Delegation of Power and Function in Zoning Administration," 1963 *Wash. L. Q.* 60 (1963). Although the decisions are hardly consistent (compare Cheney v. Village 2 at New Hope, Inc., *supra,* with Hiscox v. Levine, *supra*), some courts have invalidated these measures on the ground that the regulation of bulk and area requirements on a district-wide basis is a legislative function that cannot be delegated to a planning commission, an administrative agency. See, e.g., Millbrae Ass'n for Residential Survival v. City of Millbrae, *supra.*

Two fairly recent zoning opinions illustrate the point. In the first,[41] a cluster zoning provision was challenged on uniformity grounds because it permitted developers who agreed to donate land to community use to build houses on smaller lots than those mandated for developers who rejected the cluster option. The court met and rejected the uniformity objection head on. In its view, the clustering technique "accomplishes uniformity because the option is open to all developers within a zoning district."[42]

The same rationale appears in a subsequent opinion upholding a PUD ordinance against the charge of non-uniform application of district regulations concerning building types:

A residential planned unit development . . . does not conflict with [the uniformity provision] merely by reason of the fact that the units are not uniform, that is, they are not all single family dwellings and perhaps the multifamily units differ among themselves. [The uniformity provision] provides that the *regulations* shall be uniform for each class or kind of building or use of land throughout the zone. It does not state that the units must be alike even as to their character, whether single family or multi-family.[43]

So defined, the uniformity requirement is satisfied under the Chicago Plan.[44] The key inquiry according to these precedents is whether lot owners within a development rights transfer district will be given a rea-

sonable opportunity to acquire development rights. It is *not* whether the proposal will ultimately permit some owners to build larger buildings than other owners. The Plan insures reasonable access by mandating that, in addition to appropriate planning controls, sales of rights from the development rights bank comply with the same statutory standards relating to public bidding and sale that are applicable to the disposal of surplus municipal property generally.

Transfers as "Disguised Variances"

One of the most easily misunderstood aspects of the Plan is the relationship between development rights transfers and zoning bulk variances. Superficial acquaintance with the Plan might suggest that, at base, transfers and variances are interchangeable, transfers differing from the latter only in that transfers may be freely bought and sold. Not only is this conclusion inaccurate, but it could well prove fatal to the Plan on at least two fronts. First, it threatens to destroy public confidence in the Plan because it conjures up visions of cities trafficking in variances like so many medieval popes selling off benefices to the highest bidder. Second, were transfers simply disguised variances, they could not survive legal challenge. Under most state zoning enabling acts, variances must be administered by the local board of zoning appeals and may be granted only if the applicant establishes

[41] Chrinko v. South Brunswick Tp. Planning Bd., 77 N.J. Super. 594, 187 A.2d 221 (L. Div. 1963).
[42] *Ibid.* at 601, 187 A.2d at 225.
[43] Orinda Homeowners Comm. v. Board of Supervisors, 11 Cal. App.3d 768, 773, 90 Cal. Rptr. 88, 90-91 (Ct. App. 1970).
[44] Whether the uniformity provision is even applicable to bulk or area regulations is dubious. On its face, it appears to deal only with use restrictions. See p. 158 *supra.* But see Ind. Ann. Stat. §53-755(1) (1964): "Regulations as to *height, area, bulk* and use of buildings and as to the area of *yards, courts* and *open spaces* shall be uniform for each class of buildings throughout each district" (emphasis added). At least one court has held the

uniformity requirement inapplicable to bulk restrictions. See Scrutton v. County of Sacramento, 275 Cal. App.2d 412, 418, 79 Cal. Rptr. 872, 877 (1969). Numerous others have implied this result. See, e.g., Rockhill v. Township of Chesterfield, 23 N.J. 117, 126, 128 A.2d 473, 478 (1957); Walker v. Elkin, 254 N.C. 85, 118 S.E.2d 1 (1961). These decisions appear to recognize that use zoning has a more immediate impact upon community welfare than bulk or area zoning. Hence, they do not insist that the latter secure mathematical uniformity, but seem willing to approve the flexible application of bulk or area regulations even in traditional bulk zones.

that he will suffer "practical difficulty or unnecessary hardship" in the use of his land if the variance is not granted.[45] Development rights transfers, of course, comport with neither requirement.

Confusing a development rights transfer with a bulk variance because both entail preferential treatment for the landowner, however, is akin to identifying a golf ball with the moon simply because both are round. Despite their superficial similarity, transfers and variances can easily be distinguished on at least three separate grounds. First, cities that allow transfers do so to preserve landmarks, not to relieve development rights purchasers of economic hardship. Hence, no equivalence of purpose exists between transfers and variances. Second, transfers are an instance of density zoning, a technique which has no relevance whatever to variances. The planning rationale underlying the two therefore differs. Finally, the right of the development rights purchaser to build to greater bulk originates in the density regulations applicable within the transfer district, which, it will be recalled, is an overlay zone superimposed upon the existing bulk districts within its geographic boundaries. Accordingly, when the development rights purchaser exercises that right, he *conforms with* rather than *deviates from* the express letter of the density regulations.

Transfers and bulk variances are not wholly unrelated, however. Variance administration has been roundly condemned because, as numerous studies have confirmed,[46] boards of zoning appeals grant variances freely with

little regard for the statutory requirement of economic hardship. What better way to end this form of planning dereliction than to require landowners who seek bulk variances on spurious grounds to purchase the additional bulk from the development rights bank or from landmark owners? Clearly, if cities that adopt the Plan do not crack down on their variance-granting practices, the resultant space leakage could well undermine the market for development rights. Why, after all, would a developer buy these rights when he can have them for the asking from his friendly alderman?

Substantive Due Process and the Charge of Arbitrariness

Development rights transfers under the Chicago Plan might also encounter challenge on the substantive due process ground of arbitrariness. The gist of the attack will differ depending upon whether the city establishes its transfer districts in conjunction with or independently of its areas of landmark concentration. If the former, opponents of the Plan may claim that selective bulk increases will undermine the city's existing zoning regime because they encourage the construction of buildings that, by hypothesis, are larger than the buildings that the current regime permits. If transfer districts are mapped independently of the city's landmarks, on the other hand, the charge is likely to be that regulating the development potential of private property in this manner constitutes a misuse of the zoning power. Although neither charge ought to prevail on the merits, both could prove troublesome to a court seeing the Plan for the first time.

DUE PROCESS AND DISTRICTING IN CONJUNCTION WITH THE COMMUNITY'S LANDMARKS

The objection that the Plan undermines the community's current zoning assumes, first,

[45] See, e.g., Advisory Committee on Zoning, Dep't of Commerce, *A Standard State Zoning Enabling Act, supra* note 36 at §7; Cal. Gov't Code §65906 (West 1966).

[46] See, e.g., R. Babcock, *The Zoning Game* 7 (1966); S. Toll, *Zoned American* 184 (1969); Dukeminier & Stapleton, "The Zoning Board of Adjustment: A Case Study in Misrule," 50 *Ky. L. J.* 273 (1962).

that the court will actively second-guess the wisdom of the community's land use determinations and, second, that the Plan lacks a rational foundation in urban design theory sufficient to withstand whatever degree of review the court chooses to exercise. Both assumptions are very shaky indeed. As to the first, the American judiciary has traditionally accorded the widest possible deference to legislative measures that are challenged on the substantive due process ground, striking down only those measures that are utterly lacking in rational foundation.[47] In the land use field, it has been especially sympathetic to local experimentation since the 1926 *Euclid* decision of the U.S. Supreme Court, and has approved a variety of innovative techniques that communities have designed to meet pressing development problems.[48] The judiciary's posture in this regard is perhaps best summed up in the following words of a respected land use commentator: "The courts should and will approve a flexible regulatory device where it is shown that its use sensibly relates to public objectives identified in advance in a planning process and is justified by a detailed explanation showing the actual relationship between the objective and the action."[49] Hence, it would be surprising indeed if the courts were to change course and quibble with the wisdom or the arithmetic of a thoughtfully conceived local version of the Plan.

The charge that development rights transfers are synonymous with urban design chaos also seems misplaced insofar as the Chicago Plan is concerned.[50] If the reasoning of Chapter 5 is sound, the Plan, properly adapted to local circumstances, not only avoids that charge, but may actually enhance the quality of urban design within the transfer district.

DUE PROCESS AND DISTRICTING INDEPENDENTLY OF THE COMMUNITY'S LANDMARKS

Quite different due process issues are raised by the version of the Plan under which transfer districts are mapped independently of areas of landmark concentration. They center on the deliberate skewing of density within the districts to levels that fall short of those dictated by construction demand and health and safety considerations, a strategy that buttresses the marketability of transferred development rights. No threat of urban design abuse is posed by this version because density increases will simply bring the total density on transferee sites up to the level that would have been permitted without the Plan. But the Plan might be challenged as a misuse of the zoning power on two other counts. The first is that the Plan "confiscates" the property rights of landowners within the transfer district by zoning to densities that concededly fall below the ceiling warranted by market demand and the requirements of community

[47] See, e.g., West Coast Hotel v. Parrish, 300 U.S. 379 (1937); Nebbia v. New York, 291 U.S. 502 (1934).
[48] See cases and authorities cited in notes 55-74 *infra*.
[49] Heyman, "Innovative Land Regulation and Comprehensive Planning," in N. Marcus & M. Groves, eds., *The New Zoning: Legal, Administrative, and Economic Concepts and Techniques* 40 (1970).
[50] As the discussion at pp. 54-60 makes clear, I share many of the serious misgivings about the New York City transfer program that have been voiced by other critics of that program. See Spatt, "Dissent from Resolution Cp-21166 of the New York City Planning Commission to the Board of

Estimate, May 13, 1970"; Note, "Development Rights Transfer in New York City," 82 *Yale L. J.* 338, 371 (1972). But the guiding premise of this study is that the transfer technique is sufficiently flexible to allow for its employment in schemes, such as the Chicago Plan, that capitalize upon its unprecedented economic and planning advantages while avoiding the conceded deficiencies of the New York City program. So conceived, the technique has won Ada Louise Huxtable's plaudits as "one of the most dramatic and hopeful developments in urban America." "A Solid Dross City," *New York Times*, Mar. 14, 1971, §2, p. 16, col. 5 (commenting on the use of the technique in conjunction with the Chicago Plan).

health and safety. The second questions whether the Plan's use of zoning in part to buttress the market for development rights exceeds the legitimate ambit of the zoning power by employing it as a fiscal rather than as a regulatory tool.

Of these two arguments, the first is less troublesome by far. It mistakenly assumes that government must zone so as to guarantee property owners the greatest economic return possible on their land, subject only to restraints absolutely compelled in the interests of public health and safety. Under this view, zoning law is essentially an appendage of the ancient law of nuisance, which permitted the community or adjacent landowners to enjoin only noxious or otherwise harmful uses of private property. Although not without appeal to some state courts in the early part of this century,[51] the view was quickly and irrevocably snuffed out by the U.S. Supreme Court in *Euclid v. Ambler Realty Company.*[52] Despite its extraordinarily conservative property philosophy, the *Euclid* court upheld as nonconfiscatory a zoning measure that halved the value of the complainant's property, causing it an estimated loss of $400,000.

Inherent in the court's opinion is a more flexible attitude toward the confiscation issue that has received virtually unanimous support in the half-century since *Euclid: a zoning measure that reduces the value of private property is not confiscatory so long as the property can be devoted to some reasonable albeit less profitable use and the measure advances the community's general welfare.* Statements of this position appear in numerous

contemporary zoning opinions, but nowhere as succinctly as in the 1972 New York decision, *Golden v. Planning Board:*

> Every restriction on the use of property entails hardships for some individual owners. Those difficulties are invariably the product of police regulation and the pecuniary profits of the individual must in the long run be subordinated to the needs of the community. *The fact that the [zoning] ordinance limits the use of, and may depreciate the value of ... property will not render it unconstitutional, however, unless it can be shown that the measure is either unreasonable in terms of necessity or the diminution in value is such as to be tantamount to a confiscation.* Diminution, in turn, is a relative factor, and though its magnitude is an [index] of a taking, it does not of itself establish a confiscation.[53]

The "necessity" for the Plan can be taken as proved in view of the sad state of landmark preservation in our cities today. The claim that the Plan is confiscatory will therefore prevail only if the density permitted as of right in the transfer district is so low as to deprive landowners there of a reasonable return on their property. But restrictions this drastic are wholly out of the question. All that is envisaged under the Plan are deductions of perhaps 5 to 15 percent from the density that would otherwise have been permitted as of right. As both *Golden* and *Euclid* illustrate, far greater exactions are routinely sustained as non-confiscatory.

The objection that the Plan subverts the

[51] For an excellent summary of the division among state courts on this issue before 1920, see the conflicting authorities cited in State *ex rel.* Lachtman v. Houghton, 134 Minn. 226, 240-45, 158 N.W. 1017, 1023-25 (1916) (dissenting opinion). See generally Cribbet, "Changing Concepts in the Law of Land Use," 50 *Iowa L. Rev.* 245 (1967).

[52] 272 U.S. 365 (1926).

[53] 30 N.Y.2d 359, 381, 334 N.Y.S.2d 138, 154-55, 285 N.E.2d 291, 304 (1972). The issue posed in *Golden* was the constitutionality of a zoning ordinance that deferred the right of a residential developer to build a subdivision on his land for the lesser of a period of eighteen years or until the community's public facilities were adequate to service the subdivision. The community sought through this ordinance to "phase" private development to correlate with its own capital improvements program. Despite the grave impact of the ordinance on complainant's land, the court refused to declare it confiscatory.

DEVELOPMENT RIGHTS TRANSFERS AND THE PRESERVATION OF HISTORIC AREAS

The Chicago Plan is intended principally to safeguard individual landmark buildings. But it may be adapted to preserve entire historic blocks, such as the Quincy Market block in Boston (lower right foreground), which may be zoned for higher densities than are incorporated in the existing buildings there. If surrounding areas are being redeveloped to greater densities, as, for example, the Government Center area (upper left), transfers could be made from the historic block to the latter. A transfer of this nature is envisaged in the Georgetown proposal discussed at p. 50.

zoning power by using it in part for fiscal purposes is not as easily dismissed. Its reception before a given court will almost certainly turn upon that court's conception of the breadth of the zoning power, including both the techniques that zoning may employ and the objects that it may serve. Were zoning conceived narrowly as a branch of nuisance law, for example, facilitating historic preservation through the Plan's development rights transfer component would likely be found to exceed the legitimate ambit of the zoning power in both technique and object.

But the case for the Plan's legitimacy is nail hard precisely because the courts have rejected this parochial stance and have actively encouraged communities to employ zoning creatively to meet a wide variety of land use challenges. As long ago as *Euclid* itself, no less a body than the U.S. Supreme Court went out of its way to emphasize the latitude that communities enjoy in this regard:

> Building zone laws are of modern origin. They began in this country about twenty-five years ago. Until recent years, urban life was completely simple; but with the great increase and concentration of population, problems have developed, and are constantly developing, which require, and will continue to require, additional restrictions in respect of the use and occupation of private lands in urban communities. Regulations, the wisdom, necessity and va-

lidity of which, as applied to existing conditions, are so apparent that they are now uniformly sustained, a century ago, or even half a century ago, probably would have been rejected as arbitrary or oppressive. Such regulations are sustained, under the complex conditions of our day, for reasons analogous to those which justify traffic regulations, which, before the advent of automobiles and rapid street transit railways, would have been condemned as fatally arbitrary and unreasonable.[54]

Post-*Euclid* developments have fully borne out the court's expectation that the growing complexity of urban life would both necessitate and call forth innovative land use responses from the cities. As a result, zoning has come a long way from its humble origins as an offshoot of nuisance law, seeking merely to protect residential areas from the sulfurous fumes of brick factories and steel mills. It now bars eyesores, such as junkyards[55] and billboards,[56] and encourages open space.[57] It safeguards our cities' unique theater,[58] retail,[59] and historic districts.[60] It strengthens the fiscal position of the community by allocating appropriate amounts of its land base for desirable tax ratables such as clean industry.[61] It encourages balanced growth, keeping the community's expansion in step with its existing or planned public services.[62] And it secures numerous other public objectives, few of which can be bottomed on restrictive nuisance grounds.[63]

[54] 272 U.S. at 386, 387 (1926).

[55] See, e.g., Oregon City v. Hartke, 240 Or. 35, 400 P.2d 255 (1965); City of St. Louis v. Friedman, 358 Mo. 681, 216 S.W.2d 475 (1948).

[56] See, e.g., Cromwell v. Ferrier, 19 N.Y.2d 263, 279 N.Y.S.2d 22, 225 N.E.2d 749 (1967).

[57] See pp. 128-29 *supra*.

On the subject of aesthetic zoning generally, see, e.g., Dukeminier, "Zoning for Aesthetic Objectives: A Reappraisal," 20 *Law & Contemp. Prob.* 218 (1955); Note, "Zoning, Aesthetics and the First Amendment," 64 *Colum. L. Rev.* 81 (1964).

[58] See the discussion of Manhattan's Special Theater District, note 8, p. 130 *supra*.

[59] See the discussion of Manhattan's Fifth Avenue Retail District, *ibid.*

[60] See pp. 3, 19-20 *supra*.

[61] See Vickers v. Township Comm'n, 37 N.J. 232, 181 A.2d 129 (1962), *cert. denied,* 371 U.S. 233 (1963). See generally Mott & Wehrly, "The Prohibition of Residential Developments in Industrial Districts" (Urban Land Institute, Tech. Bull., Nov. 1948).

[62] See Golden v. Planning Board, 30 N.Y.2d 359, 334 N.Y.S.2d 138, 285 N.E.2d 291 (1972).

[63] An exhaustive summary of the various zoning purposes that have received judicial approbation in the half-century since *Euclid* is found in D. Hagman, *Urban Planning and Land Development Control Law* 86-99 (1971).

Zoning's techniques have proliferated alongside zoning's objectives. Many of the post-*Euclid* refinements in technique have already been seen in this study,[64] including cluster zoning,[65] overlay zoning,[66] planned unit development,[67] special development districting,[68] zoning bonuses,[69] and development rights transfers[70] themselves. Others include holding zones,[71] floating zones,[72] timed or "phased development,"[73] and the special exception.[74]

A remarkable aspect of this dramatic expansion of zoning's purposes and techniques is that it was engineered almost single-handedly by the courts. State legislatures largely got out of the zoning picture after passing vague zoning enabling acts in the 1920s and 1930s that authorized communities to zone on behalf of public "health, safety, morals, or general welfare."[75] The courts quickly seized on the general welfare concept to convert zoning from an anti-nuisance curiosity into the comprehensive land use tool that it has become today. Illustrative of this judicial activism is *Wulfsohn v. Burden*,[76] a 1935 New York

Court of Appeals decision that sustained bulk and area regulations within apartment districts. Rejecting the charge that the regulations were invalid because they aimed in part at "aesthetic" ends, the court reasoned: "The police power is not limited to regulations designed to promote public health, public morals or public safety or to the suppression of what is offensive, disorderly, or unsanitary, but extends to so dealing with conditions which exist as to bring out of them the greatest welfare of the people by promoting public convenience or general prosperity."[77]

It is against this background of post-*Euclid* zoning developments that the Plan's constitutional validity must be assessed. Two questions are central to the assessment. First, does the support of historic preservation through zoning fall within the ambit of the "general welfare"? Second, is the Plan's districting technique a proper means for securing this objective?

The first question admits of no doubt whatever.[78] But while there is no constitutional

[64] Techniques in addition to those mentioned in text are enumerated in *ibid.* at 101-22.

[65] See pp. 128-29 *supra.*

[66] See pp. 48-52 *supra.*

[67] See pp. 128-29 *supra.*

[68] See pp. 128-30 *supra.*

[69] See pp. 30-32 *supra.*

[70] See pp. 32-34 *supra.*

[71] The purpose of the holding zone designation is to prevent a specific area from undergoing intensive development. Communities resort to this device when they are unsure as to the proper zoning for the area or when they wish to encourage intensive development in other areas, perhaps because of the greater availability of public services there. Usually low-density uses, such as single-family dwellings on one-acre lots, are the only uses permitted in the holding zone. See Kutcher v. Town Planning Comm'n, 138 Conn. 705, 88 A.2d 538 (1952).

[72] A floating zone is similar to traditional zones except that it is not mapped beforehand. Instead, property owners who wish to have their land governed by its regulations initiate an application to have their land rezoned to that status. Should they succeed, the zone then becomes affixed to their land. The floating zone device is intended to permit communities to respond more sensitively to de-

velopment challenges than they can through crude premapped zones. See Beall v. Montgomery County Council, 240 Md. 77, 212 A.2d 751 (1965).

[73] See note 53 *supra.*

[74] Communities have had recourse to the special exception technique to regulate uses, such as clubs and schools, which, while generally desirable, could adversely affect the neighborhood if not subjected to case-by-case review. For an example of this technique, see Kotrich v. County of DuPage, 19 Ill.2d 181, 166 N.E.2d 601 (1960).

[75] The quoted language derives from Section 1 of the Standard State Zoning Enabling Act referred to in note 36 *supra.* The full text reads as follows: "For the purposes of promoting health, safety, morals, or the general welfare of the community, the legislative body of cities and incorporated villages is hereby empowered to regulate and restrict the height, number of stories, and size of buildings and other structures, the percentage of lot that may be occupied, the size of yards, courts, and other open spaces, the density of population, and the location and use of buildings, structures, and land for trade, industry, residence, or other purposes."

[76] 241 N.Y. 288, 150 N.E. 120 (1935).

[77] *Ibid.* at 298, 150 N.E. at 122 (1935).

[78] See D. Hagman, *Urban Planning and Land Development Control Law, supra* note 63 at 96-98.

impediment to zoning in support of historic preservation, the question still remains whether the community has in fact been authorized by the state legislature to do so. Judicial opinions can be found which reason simply that because historic preservation is a legitimate police power objective, it therefore falls under the general welfare clause of the zoning enabling act.[79] Others appear to suggest that express legislative recognition that preservation advances the general welfare is needed before communities may affirmatively zone on behalf of preservation.[80] The optimum way to resolve any doubts is to secure the passage of state enabling legislation, such as that in Appendix II, that expressly approves the use of zoning on behalf of preservation.

The second question cannot be answered definitively until the Plan comes before the courts. Confidence that the Plan's districting technique will pass muster seems entirely justified, however. The judiciary's record since *Euclid* has overwhelmingly favored innovations that strengthen the community's management of its land use policies.[81] On the face of it, the Plan's districting technique is certainly no more radical a departure from traditional land use practice than other techniques, such as floating and PUD zoning, that many courts have already embraced. Indeed, the latter are markedly more controversial because they deal flexibly with *use* requirements instead of or in addition to bulk requirements, even though use modifica-

tions have proven more perplexing from the very outset of land use regulation.[82] As pointed out in the previous section, moreover, the courts seldom venture into a detailed review of the mechanics of a legislative measure that is challenged on due process grounds. If they find that the measure is a proper subject for legislative attention, they readily approve its mechanics unless the latter are grossly unreasonable or violate some affirmative requirement of law. The Plan, it seems fair to say, is not deficient on either count.

Finally, the precedents that bear most closely on the problem are decidedly auspicious. They are composed of the density zoning cases considered earlier,[83] which, implicitly at least, recognize that within reasonable limits urban space is a public asset that communities may distribute as the general welfare dictates. It is true, of course, that the density zoning techniques examined in these cases are paralleled more closely by zoning bonuses than development rights transfers. Like bonuses, density zoning rearranges bulk within the *same* site or unified tract; the Plan, on the other hand, coordinates bulk adjustments on *physically separate* parcels. But if the urban design consequences can be as favorable under the transfer approach as under the bonus or cluster system — a position that has been defended throughout this study — then the version of the Plan under discussion should prove no less acceptable on the constitutional plane than density zoning.

[79] See City of Santa Fe v. Gamble-Skogmo, Inc., 73 N.M. 410, 415, 389 P.2d 13, 17 (1967).
[80] See Rebman v. City of Springfield, 111 Ill. App.2d 430, 440, 250 N.E.2d 282, 287 (1969).
[81] See cases and authorities cited in notes 55-74 *supra.*
[82] See Heyman, "Innovative Land Regulation and Comprehensive Planning," *supra* note 49 at 32-33. One of the most telling evidences of the judiciary's differentiation between use and bulk

questions is the greater discretion that courts concede to zoning boards of appeals in the granting of bulk rather than use variances. Similarly, the zoning ordinances of many communities restrict the variance-granting powers of these boards essentially to bulk or bulk-related variances. See Chicago, Ill., Municipal Code, Zoning Ordinance ch. 194, art. 11.7-4 (1970).
[83] See cases cited in note 40 *supra.*

7
Some Concluding Observations

GENERAL

American attitudes toward the natural and human environment have undergone a startling reversal in recent years. The callous indifference to environmental values that has been a pervasive theme in the nation's development appears to be giving way to a growing reverence for these values. Resources that were taken for granted just a short time ago are now the object of widespread apprehension. Air, water, animal species, and landmarks themselves are no longer generally regarded as freely exploitable for private gain. They are seen instead as delicate and finite resources which are indispensable to human physical and emotional well-being.

Regrettably, it has largely been the force of events, not rational human choice, that has brought about this reversal. The sheer weight of the countless social and cultural losses that have resulted from prior indifference has been the principal impetus for change. Unhealthy air and water, disappearing animal species, and profligate land management and urban design policies have wrenched the national psyche from that indifference and compelled it to confront the root issue of environmental accountability.

As with good intentions, however, mere consciousness of the problem is not enough.

Knowledge and political commitment are also required. We must both understand the existing economic, legal, and cultural framework that has produced these unfortunate consequences, and develop the techniques and practices that will make the concept of environmental accountability more than a pretentious slogan. Furthermore, we must create a political climate that is receptive to the changes that are necessary to redress the balance between private advantage and community welfare. Without this climate, the knowledge is not likely to amount to very much. Few endeavors threaten more rigidly held beliefs or more potent interest groups than the effort to translate environmental values into workable community programs.

In this regard the stresses besetting historic preservation in the United States provide in microcosm an accurate picture of those impeding environmental protection generally. Wholesale destruction of landmarks has occurred because the prevailing economic, legal, and attitudinal framework governing urban land use decisions all but compels that result. Exclusive concern for the development of downtown parcels to what, ironically, is termed their "highest and best use" has meant that only the most profitable buildings have survived. Governmental initiatives to safe-

guard landmarks from demolition have been faltering and ill-conceived for the most part. Their limited potential for success has all too often been forfeited by governmental timidity in the face of the well-organized and financed resistance of special-interest groups.

The Chicago Plan offers a corrective to this picture that is rational, practical, and, in its treatment of landmark owners, distinctly conservative. It does not sweep under the rug either the economic burdens of landmark retention or the constitutional impediments attending governmental interference with private ownership. Instead, it brings both factors out into the open. And it proposes a solution that does violence to neither because it works within the nation's constitutional and laissez-faire traditions instead of fighting against them.

By recognizing that preservation is an *economic* problem first and foremost, the Plan should serve as a valuable complement to other suggested approaches to historic and environmental protection that tend to submerge the economic factor in a legalistic framework. Conservationists, for example, have pushed hard for what can be termed a "procedural" solution to environmental preservation. As reflected in the National Environmental Policy Act[1] and in environmental literature,[2] it envisages three major changes in the framework within which environmental decisions are made. First, it advocates that members of the public be given broader standing to challenge development proposals in court. Second, it requires that the proponents of a development proposal

having a significant environmental impact must evaluate the proposal on a cost/benefit basis, including among the "costs" a variety of environmental values as well as the more traditional financial considerations. Finally, it places the burden of proof on the proponents to show that the project was selected only after a thorough consideration of these cost/benefit factors.

The legislative and judicial victories won by conservationists under this approach have been impressive to date. But looking down the road a bit further, one wonders how long these victories will outlast the euphoria that environmental causes have touched off in the last few years. Signs that the euphoria is beginning to wear off appear with increasing frequency in presidential and gubernatorial vetoes of environmental bills, in speeches of cabinet officials, and in the protestations of the very groups that are the ostensible beneficiaries of strict environmental quality standards. Worse still, we may be in for an environmental backlash as the full economic costs of environmental protection become more widely understood.

In addition, the procedural approach offers protection only to resources that are threatened by governmentally sponsored or assisted projects.[3] But many of the nation's most precious resources are imperiled by other causes. The urban landmarks considered in this study, for example, are in private ownership and have been decimated in most cases by private market forces, not by governmental projects.

[1] National Environmental Policy Act, 92 U.S.C. §4332 (1970); cf. National Historic Preservation Act of 1966, 16 U.S.C. §§470(i)-(n) (1970).
[2] See generally J. Sax, *Defending the Environment* (1971); Baldwin, "Historic Preservation in the Context of Environmental Law: Mutual Interest in Amenity," 36 *Law & Contemp. Prob.* 432 (1971); Sax, "The Public Trust Doctrine in Natural Resource Law," 68 *Mich. L. Rev.* 473 (1970).

[3] The 1972 California Supreme Court decision in Friends of Mammoth v. Bd. of Supervisors, 104 Cal. Rptr. 161, 502 P.2d 1049 (1972), constitutes the only authoritative construction of environmental legislation to date that applies the environmental impact statement requirement to private development. In *Friends of Mammoth* the court held that the absence of an impact statement invalidated the county board of supervisors' approval of a privately sponsored recreation community development. Whether this precedent will prove influential in states other than California is unclear.

A resource threatened by public programs, moreover, receives only limited protection under the approach. Should the development agency convince the court that the benefits of the project outweigh the environmental damage that it will cause — and these agencies are becoming more adept at the task every day — the resource will be lost.

The economic factor virtually disappears altogether in Professor Christopher Stone's provocative thesis that "we give legal rights to forests, oceans, rivers and other so-called 'natural objects' in the environment — indeed, to the natural environment as a whole."[4] In support of his thesis, Stone does a brilliant job of demonstrating that there is no *jurisprudential* reason why natural objects and, perhaps, landmarks[5] cannot have rights in their own stead. Despite a semantic wizardry worthy of Lewis Carroll's Humpty Dumpty, however, Stone is not altogether convincing. His analysis does not deal adequately with the far more important question whether there are any *economic* reasons for according or refusing to accord these rights. Without an examination of the problem from this angle, it is impossible to resolve the policy issue that lies at the heart of Stone's thesis, namely, whether environmental resources *ought* to have rights superior to those that American constitutional and economic practice have traditionally accorded to the "owners" of these resources.

Perhaps Stone's thesis assumes that its proposed new category of rights will attach simply by virtue of an authoritative determination that the resource in question possesses environmental or historic significance. Much as we might be inclined to cheer this result, the assumption leaves much to be desired. Legally, it pretty much wipes out the due process requirement of compensation by disabling the landmark owner, for example, from tearing down his building once the city has designated it under the police power.[6] At the very least, the "right" of the building to immunity from destruction would appear to limit severely the currently recognized "right" of its "owner" to demolish it or to be compensated for its retention. And if that is the result that Stone seeks, what is to be said of the fairness of letting the potentially enormous economic costs of preservation fall solely upon the landmark owner even though it is the community that wants the building preserved?

Nor does Stone's thesis appeal in terms of its prospects for legislative implementation, at least where the resource in question is in private ownership. There is nothing in the cities' preservation record, for example, that suggests that they would enact non-compensatory landmark ordinances even if they could do so legally. On the contrary, developers, lenders, and downtown property owners would almost certainly kill a proposal of this nature before it saw the light of day.

In short, we probably should not expect too much from innovations such as the procedural approach and Professor Stone's proposal, despite our admiration for the commitment to environmental and historical preservation that both represent. In concentrating their fire essentially upon the desirability of saving these resources, they tend to obscure the economic sources of the preservation dilemma. Hardly anyone today denies that these resources ought to be saved. The gut issue is

[4] Stone, "Should Trees Have Standing? — Toward Legal Rights for Natural Objects," 45 *So. Cal. L. Rev.* 456 (1972). Stone's thesis is endorsed in the dissenting opinion of Justice Douglas in Sierra Club v. Morton, 405 U.S. 727, 742 (1972).

[5] Professor Stone also envisages the possibility that non-natural objects of environmental and historical significance should be granted rights in their own stead. See Stone, "Should Trees Have Standing?," *supra* note 4 at n. 26.

[6] The similarity is patent between Stone's thesis and the hypothetical ordinance, discussed at p. 12 *supra,* empowering communities to impose permanent landmark status on a non-compensated basis.

who should pay. Regrettably, that question is barely touched by either approach. The Plan, on the other hand, meets this issue head on without doing violence to the legitimate interests of any of the groups that it affects.

Although the Plan's advantages in this regard are easily enough grasped, the view of urban space that animates it is somewhat more novel. From the Plan's perspective, cities are sculptural objects, existing within and defined by their space. Urban space, therefore, is no less precious than landmarks, air, water, and other natural and man-made resources in the quest for environmental betterment. Hence, the cities ought to enter more actively into decisions affecting its use by regulating the development potential of private property to achieve public policies, such as landmark preservation and more efficient spatial distribution, that are presently going by the board.

But isn't it anomalous to refer to urban space in the same breath as both a municipal asset and an attribute of private property? If we draw a hard and fast line between public regulation and private property, yes. To do so, however, is to permit ourselves to be tyrannized by English property jurisprudence of the seventeenth century as we enter the last quarter of the twentieth.[7] Anachronistically, that jurisprudence takes as its paradigm of ownership a model that prevailed in an agrarian society lacking any but the crudest of land use controls. Worse still, it defines property in sterile conceptual terms, largely ignoring the multitude of contexts in which land is actually encountered in the real world. Consequently, it glosses over the essential differences in the permissible scope of public regulation of, for example, a tract of land in the central Illinois cornbelt, a half-acre in a Cook County suburb, and a lot in Chicago's Loop by assuming that the constraints that govern public regulation of the cornbelt tract should apply with equal force in suburbia and in the city.

Fortunately, such wooden thinking was rejected by the U.S. Supreme Court at least as early as the *Euclid* decision itself. In a passage that deserves far more attention than it has received, the court stated unequivocally in *Euclid* that a "regulatory or zoning ordinance, which would be clearly valid as applied to the great cities, might be clearly invalid as applied to rural communities."[8] At a minimum, this passage intimates that the prerogatives of private ownership — and, conversely, the permissible scope of public regulation — are relative to the type and setting of the real estate in question. They are not absolutes, "inherent" in the very concept of property itself and rigidly fixed for all time and without regard to context.

It is precisely this rationale, of course, that accounts for the expanded role that the Plan ascribes to the city in fashioning its space management policies. The real estate in question, to stay with the foregoing illustration, will be located in Chicago's Loop, not in the cornbelt. This locational difference would seem to justify the greater latitude accorded to the city in its space management policies on at least two counts. First, decisions affecting the allocation of development potential have a far greater impact within the city than in the farmbelt because the web of land use relationships is spun so much more closely in urban than in rural areas. Second, governmental programs and actions affect land values more pervasively in the former than in the latter. The astronomical value of the parcels in the central business districts of our cities would be unthinkable in the absence of

[7] The contrasts between the major postulates of that jurisprudence and those of incentive zoning are discussed at pp. 34-39 *supra*.

[8] Euclid v. Ambler Realty Co., 272 U.S. 365, 387 (1926).

SERENDIPITY IN THE CITY

Landmarks lend to urban areas a feeling of rhythm, atmosphere, variety — exemplified by the vertical contours of Chicago's Water Tower framed against the John Hancock Building.

the capital improvement programs, public facilities and services, zoning and development control policies, and the numerous other governmental initiatives considered throughout this study. These initiatives are seldom paralleled in the rural context. Accordingly, the equities supporting public recoupment of some portion of the economic opportunity represented by land are generally more compelling in the city than in the farmbelt.

Both of these considerations will loom even larger over the last quarter of this century. As more of the nation's population becomes concentrated on less of its land mass,[9] proper management of urban space will become indispensable to community well-being. The luxury of continued space mismanagement will no longer exist. And the rebuilding of our cities, which must come about eventually despite our seeming inability to tackle the job at the present time, will be possible only through massive public investment. The latter will inevitably be accompanied by forms of governmental entrepreneurship that are scarcely hinted at by present renewal programs.

The same conclusions are implicit in visions of the "city of the future" offered by Buckminster Fuller and other urban theorizers.[10] Fuller's well-publicized concept of the domed city[11] is illustrative. Construction of the dome and the provision and management of its attendant urban support systems are functions that clearly fall outside the scope of private enterprise. Both in their capital requirements and in their policy implications, they call for centralized control and management. Encasing limited land areas within physical superstructures, moreover, increases the necessity for efficient management of the enclosed space. Given the enormous costs of this endeavor and the heightened physical and social interdependence of the domed city's residents, wasted or otherwise misused space would prove intolerable.

The foregoing thoughts should serve to dispel an apparent inconsistency in the Plan. At first blush, the Plan seems, in effect, to rob Peter to pay Paul by compensating landmark owners through the sale of development potential to which the owners of transferee sites should perhaps be entitled as a matter of right. But the "right" to additional density is not absolute. Within reasonable limits, cities may and should restrict that right on the basis of demonstrable public needs, such as efficient space management, and of compelling public equities, such as those arising from the role of governmental investment in creating economic values in the development potential.

Is it not inconsistent, then, to restrict the rights of the transferee site owners in this way while not similarly circumscribing the right of landmark owners to develop their parcels to their most profitable use? Landmark preservation, after all, is no less an object of community value than efficient space management.

Some commentators might well agree with this position. As much seems to be implicit, for example, in Professor Stone's thesis that, though inanimate, environmentally significant

[9] Between 1900 and 1960 metropolitan areas absorbed 78 percent of the total population growth of the United States. P. Hodge & P. Hauser, "The Challenge of America's Metropolitan Population — 1960 to 1985" 5 (National Commission on Urban Problems, Res. Rpt. 3, 1968). Projections indicate that even greater concentrations of population will be found in metropolitan areas in the future. Between 1960 and 1985, the metropolitan population can be expected to increase nationally by 57.8 percent while that in non-metropolitan areas will increase only by 11.7 percent. By 1985, 70.6 percent of the nation's population will live in metropolitan areas. *Ibid.* at 9 (Table 1-4).

[10] See, e.g., B. Fuller, "World Design Science Decade, 1966-1975" (World Resources Inventory, Phase I, Doc. 2, 1963) ; P. Soleri, *Arcology: The City in the Image of Man* (1969).

[11] One application of the domed city concept is Professor Fuller's proposal that a geodesic tensegrity dome two miles in diameter and twice the height of the Empire State Building be constructed over mid-Manhattan. See B. Fuller, "World Design Science Decade," *supra* note 10 at 93-94.

objects should have rights of their own, chief among these being immunity from destruction or pollution. In my view, however, singling out individual property owners to bear the costs of preservation in this manner is constitutionally dubious,[12] potentially unfair, and almost certain to run into a blistering cross-fire in the political arena. The compensatory features of the Chicago Plan promise to avoid or, at the very least, minimize these disadvantages.

BEYOND LANDMARK PRESERVATION

The causes of the nation's landmark dilemma and a proposal for its resolution are the raison d'etre for this study. Yet many of the obstacles confronting historic preservation are common to environmental protection generally. Hence, it seems appropriate to conclude the study with a question: could the Chicago Plan, suitably modified, serve as an effective tool on behalf of larger environmental concerns? Although investigations of comparable or greater breadth must obviously be undertaken in answering the question, the Plan's potential in this regard is an intriguing topic for speculation.

Consider, for example, Puerto Rico's imperiled Phosphorescent Bay. The bay is one of the island's and the world's unique maritime resources. It is inhabited by countless millions of tiny organisms, known as dinoflagellates, which give its waters their phosphorescent glow, causing them to explode in brilliant colors and hues during the evening. The dinoflagellates and their supporting ecosystem have thrived to date, primarily because the privately owned lands surrounding the bay have remained undeveloped. Land values, however, have been moving steadily upward, a sure sign that hotels or perhaps industry are not far behind. Public acquisition of these lands is not feasible in the face of the crushing

economic and social needs that have prior claim on Puerto Rico's embattled treasury.

The scenario is all too familiar to historic preservationists. It would be identical to that encountered throughout this study if a landmark building were substituted for the bay and the setting changed from rural to urban. Would it not then be possible to view the presently dormant development potential of the land surrounding the bay in much the same manner that we have viewed the excess development rights of threatened landmarks? If so, couldn't a preservation restriction be imposed on this land and its development potential transferred to other locations on the island to obtain the sums necessary to acquire the preservation restriction? And if the scheme could protect the Phosphorescent Bay, couldn't it also safeguard woodlands, nature preserves, estuaries, and other environmental resources that are similarly threatened?

Use of the Chicago Plan to safeguard the Phosphorescent Bay or any other feature of the natural environment of course raises a host of issues that will require careful study. Appraising the values of the preservation restriction imposed on the environmentally sensitive land and of the development rights at their new locations presents somewhat different economic questions than those treated in this study. Similarly, choosing the transferee site or sites and accommodating the increased density with the existing or proposed development patterns there will require modified analysis. And devising a legal rationale compatible with the broader geographical scope of the transfers may entail legal difficulties not fully resolved in the earlier examination of the Chicago Plan and the law.

But the dissimilarity of the two contexts poses issues that differ in degree, not kind. These differences, moreover, may facilitate rather than complicate the Plan's application in the larger environmental context. The

[12] See pp. 12-19 *supra.*

Aaron Gallup photo; courtesy California Historic Landmarks Advisory Committee

THREE EMBATTLED VICTORIANS

Among San Francisco's most notable Victorian residences are, from left to right above, the Wornser-Coleman (1876), Lilien-thal-Pratt (1876), and Edward Coleman (1895) houses. Designated as San Francisco landmarks in 1973, they are endangered by market pressures for intensive apartment development within the area.

Phosphorescent Bay problem is again illustrative. Certainly, appraising the value of unimproved land is simpler than determining the value of a preservation restriction on a downtown office building and site. The troublesome questions of duration, physical and functional obsolescence, financing, and continued competitiveness affecting downtown buildings either do not arise at all or are considerably less complex in the case of unimproved land.

Selecting the location of transferee sites may raise greater or lesser difficulties than drawing the boundaries of a development rights transfer district depending upon local circumstances and needs. It is clear, however, that the broader geographical scope of environmental transfers offers public agencies greater leverage in advancing other urban design policies that are influenced by the concentration or dispersal of density. Because of the relatively small percentage of habitable land in relation to its rapidly growing population, for example, Puerto Rico is attempting to formulate and implement policies for channeling population to pre-selected areas. By transferring the development rights of the bay to these areas, Puerto Rico could both safeguard the bay and distribute population efficiently.

The legal implications of the transfer of development rights across local governmental lines must also be considered in adapting the Plan to the environmental context. Transfers of a broader geographical scope threaten to provoke severe intergovernmental conflicts unless the government having territorial jurisdiction over the transferee location agrees or is compelled to accept the additional density. Two possible ways of avoiding conflict can be suggested. First, the relevant local governments can enter into appropriate agreements providing for joint review and approval of proposed transfers. Second, the state can confer the power to approve transfers upon a state or regional planning agency. In Puerto Rico at the present time, for example, essentially all zoning and planning powers are centralized in a single commonwealth board. Some states are also beginning to exert greater control over what have traditionally been regarded as local land use matters. They have, for example, vested regulatory powers over environmentally sensitive areas such as bays and estuaries in newly created agencies at the state level.[13] These powers could quite logically be extended to include the review and approval of development rights transfers undertaken in aid of environmental protection.

These comments are not intended to minimize the obstacles that confront the successful implementation of the Plan, whether for the purpose of historic preservation or of environmental protection generally. These obstacles are formidable. They cut across economic, legal, design, and, above all, political lines. And they leave little doubt that there will be many instances when a good deal more is required to safeguard a Grand Central Station or a Phosphorescent Bay than the Plan alone. But the comments are meant to call attention to a point that would be a truism if it were not so often overlooked: government too is not without its opportunities and advantages in waging the struggle for a better environment.

[13] See, e.g., N.C. Gen. Stat. §§113-229, 230 (Supp. 1971); R.I. Gen. Laws Ann. §§46-23-1 to -12 (Supp. 1971).

Appendixes

I
Federal Preservation Grant Programs

U.S. DEPARTMENT OF THE INTERIOR

The National Park Service, an agency of the U.S. Department of the Interior, has established a preservation grants program under the National Historic Preservation Act of 1966.[1] The regulations[2] promulgated by the service identify the states as the grant recipients. The states, however, may transfer the grants to local governments or to private entities but they remain responsible for insuring compliance with grant conditions.

To be eligible for grant assistance, a property must be listed on the National Register and identified in a comprehensive state preservation plan previously approved by the National Park Service. The historically significant features of the property must, in addition, be accessible to public view in order to satisfy the act's requirement that preservation serve the "public['s] benefit." The requirements for accessibility depend upon whether the building's significant features are exterior, interior, or both. If exterior only, the public must be able to view the building's facade from a public way; should the facade be visible only from the property's own grounds, public access to these grounds must be provided at reasonable intervals. If the interior portions of the building are also sig-

nificant, a similar requirement applies with respect to these portions as well.

Grants are made on a 50 percent matching basis. No maximum dollar amount per project is prescribed. The service may not award grants for projects that also receive funds from other federal programs or activities.

Grant monies may be expended for architectural and technical services as well as acquisition, restoration, and relocation of eligible properties. States or their transferees may acquire properties outright (in fee) or may obtain less than fee interests, including development rights, facade, and access easements. Allowable costs for restoration projects depend upon whether a building's exterior, interior, or both are being restored. Expenses incurred in facade restoration and related structural work as well as necessary improvements in wiring, plumbing, and other utilities are eligible costs for exterior restoration projects. Interior restoration expenses may also be included in total project costs if the interior has architectural or historic merit.

Grantees must be prepared to assume certain continuing obligations as a quid pro quo for federal assistance. They must agree to maintain, repair, and administer the properties to preserve their historic or architectural

[1] 16 U.S.C. §470 et seq. (1970).
[2] "Policies and Procedures for Historic Preserva-

tion Grants-in-Aid" (National Park Service, Jan. 1972).

integrity. They must, moreover, surrender their right to demolish or substantially alter the landmark building. If grant monies have been used to acquire a property, the grantee must accord his state a right of first refusal (the power to buy the property on the same terms as those offered by any third party). He must also obtain the service's consent to any proposed transfer of the property.

Other reasonable conditions insuring that the property will be preserved for public benefit may also be imposed. They may include guarantees of public access, controls respecting commercial uses of the property, and like matters. They must be incorporated into a contractual agreement and, to insure that future owners of the property will be similarly bound, into deed covenants as well. Although primary responsibility for their enforcement rests with the states through their respective liaison officers, the service itself will also be a beneficiary of these instruments.

U.S. DEPARTMENT OF HOUSING AND URBAN DEVELOPMENT

The federal government's support of local preservation efforts is further reflected in two programs administered by the Department of Housing and Urban Development (HUD). The first, the Open Space Land Program,[3] consolidates three undertakings — the Open Space, Urban Beautification, and Historic Preservation programs — that HUD had previously administered on an independent basis. The second is HUD's Urban Renewal Program,[4] which contains a noteworthy historic preservation component.

[3] Housing and Urban Development Act of 1970, 42 U.S.C. §1500 d-1, amending 42 U.S.C. §1500 *et seq.* (1970). In late 1972 President Nixon declared a funding moratorium with respect to both the Open Space Land Program and the Urban Renewal Program. The President has expressed a preference for terminating these category programs in favor of a special revenue-sharing approach

Open Space Land

The historic preservation element of the Open Space Land Program bears many similarities to the preservation grant program administered by the National Park Service. Like the 1966 Historic Preservation Act, the 1970 Open Space Land Act enables a federal agency (HUD) to assist communities in their efforts to acquire, restore, relocate, and preserve architectural and historic properties for public use and benefit. Under the 1970 act and applicable HUD regulations,[5] the property must be listed on the National Register and may not be aided by other federal programs. Grants are made on a matching basis for up to 50 percent of project costs; unlike the National Park Service Program, which includes private entities as eligible grantees (as transferees of the state), HUD grants are made only to public agencies.

The two programs deal with the same types of activities: preservation, acquisition, relocation, restoration, and related technical services. HUD grants may be used to acquire landmark properties outright; their use to acquire less than fee interests must be approved by HUD on a case-by-case basis. Eligible restoration expenses under the HUD program also depend upon the public benefits arising from the project. If the historic structure is to be used for private purposes, only the expenses of external restoration and those of making the structure safe may be included as project costs. If it will be open to the public on a regular basis, on the other hand, complete restoration of the interior will also be eligible.

under which local governments would receive federal monies largely free of the restrictions recounted in the text. A shift of this nature would increase the city's flexibility in utilizing federal funds for a Chicago Plan approach to historic preservation.

[4] National Housing Act of 1949, 42 U.S.C. §1460 (1970).

[5] See 36 Fed. Reg. 17496 (1971).

HUD also imposes rigorous restrictions on the subsequent use and transfer of aided properties. Grant recipients become responsible for perpetual maintenance of the property. They may not convert it to any use incompatible with its landmark status without the joint permission of the Secretaries of HUD and the Department of the Interior. Nor may they lease, mortgage, or convey it or any interest in it without similar joint approval. Any lease or conveyance must, in addition, contain restrictions acceptable to HUD which assure that the public benefits of preservation will not be diluted. And HUD also requires that grant recipients record these restrictions as deed covenants in order to make them binding on subsequent owners of the assisted property.

Unlike eligible properties under the National Park Service Program, HUD-assisted properties may be located only in urban areas. They must, moreover, be identified in a HUD-certified comprehensive plan for the urban area in question. Additionally, grant preference is given to properties that will be used in ways that serve the needs of the neighborhoods in which they are located.

Urban Renewal

Communities may also receive federal assistance for preservation under the rubric of HUD's Urban Renewal Program.[6] Urban renewal grants are made exclusively to local redevelopment agencies; they cover two-thirds of allowable costs in cities of over 50,000 population, and three-fourths of those costs in cities of 50,000 population or less. To be eligible for assistance, a landmark property must be in an urban renewal area and meet

[6] The regulations implementing the sections of urban renewal legislation affecting historic preservation appear in "Project Planning," ch. 2, at 4 (RHA 7207.1, 1969), "Site Preparation and Project Improvements," ch. 1, at 10 (RHM 7209.1), in U.S. Department of Housing and Urban Development, *Urban Renewal Handbook* (1971).

criteria comparable to those prescribed for properties in the National Register. Actual listing, however, is not necessary. In addition, the local agency must demonstrate that the objectives of its urban renewal plan warrant the expenditure; the agency must also provide reasonable assurance that the property will continue to be maintained for historic or architectural purposes.

Among the activities that may be aided are various forms of technical assistance as well as the acquisition, restoration, and relocation of historic properties. More general urban renewal undertakings, such as removal of blight or upgrading of public improvements, may be coordinated with specific preservation goals. The local agency may acquire either the fee or a lesser interest in eligible properties. It may itself choose to restore properties acquired in fee, or may sell them to public or private buyers subject to recorded covenants that obligate the latter to restore and maintain the properties. The resale price must be the fair market value of each property, a figure that should reflect the obligations of the purchaser to restore and maintain the property as well as any enhancement in value that may be attributable to preservation and other renewal project activities.

A number of conditions circumscribe the local agency's power to restore a property. It must first acquire it in fee. (Under the Open Space Land Program, a public agency may restore any property in which it holds a "permanent interest.") It may not relocate the property outside of the urban renewal area. If the building will be transferred to private ownership, the agency may only restore those sections of its exterior facade that are accessible to public view. In addition, it may undertake only such interior work as is needed for the building's safety and salability. Buildings retained in public ownership, on the other hand, may be restored inside and out. The

180

maximum federal contribution for restoration work is $90,000 per building.

The local agency need not acquire properties that it relocates. It may move them within or without the renewal area. The

maximum federal contribution per project is $50,000, which is provided only if the structure's owner agrees to record covenants respecting the building's restoration, maintenance, and use.[7]

[7] Also worthy of note is HUD's comprehensive planning assistance program, also known as the Section 701 Program, which provides funds in two areas: for planning and surveys in statewide or metropolitan areas and for specific programs in local areas. See Demonstration Cities and Metropolitan Act of 1966, 40 U.S.C. §461 (1970), amending Housing Act of 1954, 40 U.S.C. §461 (1964). Funds received under the program can be used by local governments to finance the planning activities incidental to historic preservation activities, and presumably could cover many of the planning costs associated with the preparation of a development rights transfer program for the pres-

ervation of urban landmarks. See Biddle, "Historic Preservation," 28 *Journ. of Housing* 221, 226 (1971); Gray, "The Response of Federal Legislation to Historic Preservation," 36 *Law & Contemp. Prob.* 322-25 (1971). In the spring of 1973, the comprehensive planning assistance program, like the other HUD programs referred to in text, was undergoing substantial reformulation and was expected to be replaced by a successor program, entitled "The More Responsive Government Act." Letter from Edwin A. Stromberg, Program Analyst, HUD Division of Community Planning, Development and Conservation, to author, June 11, 1973.

II

Legislative Implementation of the Chicago Plan: The Illinois Model

THE STATE PRESERVATION ENABLING ACT

The keystone of the legal framework governing preservation is the state preservation enabling act. Because that act defines the powers of the city in preservation affairs, it is the logical focus of proposals for legislative reform. In recognition of this fact, the Illinois legislature comprehensively revised its enabling act in 1971 to empower local governments to adopt the Chicago Plan.[1] As the only state act that has been expressly amended for this purpose, the Illinois statute (reproduced at the end of this appendix) merits detailed consideration by other states that regard the Chicago Plan as a realistic basis for municipal preservation efforts.

The amendments to the Illinois statute fall into two categories, definitions and operative sections. Among the key terms defined are "development rights," "transfer of development rights," "preservation restriction," and "development rights bank." The reason for the definitions section is obvious enough: for the most part these terms are new to the law and each has a distinct but complex role in the Plan's operation. The operative sections are two in number. The first deals with the acquisition and resale of development rights by the city; the second, with the transfer of rights by private landmark owners who participate voluntarily in the Plan.

[1] Ill. Rev. Stat. ch. 24, §11-48.2-1A (1972).

Definitions

The term "development rights" has become a favorite of planners and of legislative draftsmen, but it is typically employed with distressing imprecision. To remedy this problem, the act provides: "The development rights of a landmark site are the rights granted under applicable local law respecting the permissible bulk and size of improvements erected thereon. Development rights may be calculated in accordance with such factors as lot area, floor area, floor area ratios, or any other criteria set forth under local law for this purpose." The term has been defined operationally by linking it to the zoning bulk authorized for the landmark site. But it has also been defined flexibly because of the variety of methods by which zoning bulk is measured in American cities.[2]

"Development rights transfers" have been defined as follows:

A transfer of development rights is the transfer from a landmark site of all or a portion of the development rights applicable thereto, subject to such controls as are necessary to secure the purposes of this Division. The transfer of development rights pursuant to sound community planning standards . . . is hereby declared to be in accordance with municipal health, safety and welfare because it furthers the more efficient utilization of urban space at a

[2] See pp. 80-83 *supra*.

182

time when this objective is made urgent by the shrinking land base of urban areas, the increasing incidence of large-scale, comprehensive development in such areas, the evolution of building technology and similar factors.

This definition emphasizes that development rights transfers must comport with sound planning standards; the actual content of these standards, however, is left to the determination of the local governments. In addition, the non-preservation advantages of transfers, e.g., the "more efficient utilization of urban space," are specifically delineated to provide legislative confirmation of the principle that density zoning may properly be substituted for lot-by-lot regulation in the interests of improved urban design.

The act's definition of the term "preservation restriction" was reviewed in the earlier discussion (Chapter 6) of the legal ambiguities affecting that interest.[3] As that discussion concludes, statutory modification of the common law rules governing less than fee interests provides the most satisfactory method for insuring that outmoded technicalities do not endanger the transfer proposal.

The "development rights bank" device is spelled out in the following manner:

A development rights bank is a reserve into which may be deposited development rights associated with publicly and privately-owned landmark sites. Corporate authorities or their designees shall be authorized to accept for deposit within the bank gifts, donations, bequests or other transfers of development rights from the owners of said sites, and shall be authorized to deposit therein development rights associated with (i) the sites of municipally-owned landmarks and (ii) the sites of privately-owned landmarks in respect of which the municipality has acquired a preservation restriction through eminent domain or purchase. All transfers of development rights from

[3] See pp. 152-57 *supra*.

the development rights bank shall be subject to the requirements of the [Illinois Surplus Public Property Disposal Act] and all receipts arising from the transfers shall be deposited in a special municipal account to be applied against expenditures necessitated by the municipal landmarks program.

Three features of this definition should be noted. First, the three separate sources of the development rights are identified. Second, the definition mandates that all sales from the bank be subject to the same public bidding procedures that are applicable to the disposal of surplus public property generally, thereby insuring fair access to the purchase of the rights by property owners within a transfer district. Finally, the definition limits the amount of the rights that a community may put on the market to a quantity that will cover "expenditures necessitated by the municipal landmarks program." This provision should meet the potential fear of private realtors that the Chicago Plan will expose them to ruinous, unrestrained competition from the city.

Operative Sections

With these definitions as a foundation, the two operative sections of the 1971 revision are quite straightforward. Both appear under the paragraph of the act that enumerates "measures appropriate for [the] preservation, protection, enhancement, rehabilitation, reconstruction, perpetuation, or use" of designated landmark properties. The first addresses the options open to the city if a landmark owner refuses to participate in the transfer program, and insists instead upon a cash award or demolition of his building. To deal with this situation, it empowers the city to undertake "the acquisition by purchase or eminent domain of a fee or lesser interest, including a preservation restriction, in property so designated; the deposit, as appropriate,

in a development rights bank of the development rights associated with said property; and . . . the transfer of any development rights so acquired, all in accordance with such procedures and subject to such conditions as are reasonable and appropriate to carrying out the purposes of this [act]."

The second section speaks to the powers of the city in those cases in which the landmark owner's cooperation is forthcoming. It allows the city to establish "procedures authorizing owners of designated property to transfer development rights in such amount and subject to such conditions as are appropriate to secure the purposes of this [act]."

THE STATE ZONING ENABLING ACT

The Chicago Plan accomplishes preservation goals in part through zoning techniques, such as special development districting and density zoning. Does its reliance upon these techniques require that the state zoning enabling act must also be revised?

This question is not entirely free from doubt. The willingness of many state courts to interpret zoning enabling acts liberally in litigation challenging cluster and PUD zoning suggests that these acts may already provide the necessary statutory foundation for the zoning techniques employed in the Chicago Plan.[4] New York City presumably took this view because it adopted its landmarks transfer program as a section of its zoning ordinance and pursuant to a rather traditional state zoning enabling act.

The Illinois legislature proceeded more cautiously. When it amended its preservation statute, it also modified the Illinois Zoning Enabling Act[5] by declaring that one of the statutorily recognized purposes of zoning is "to insure and facilitate the preservation of

sites, areas and structures of historical, architectural and aesthetic importance." This modification does two things. It eliminates any lingering doubts concerning the propriety of using the zoning power in aid of preservation. In addition, it impliedly validates as legitimate zoning techniques the transfer mechanisms spelled out in the revisions to the preservation statute.

THE MUNICIPAL PRESERVATION AND ZONING ORDINANCES

Local as well as state legislative authority is a prerequisite to implementing the Chicago Plan. Two patterns of local legislation are conceivable. The first would incorporate the bulk of the necessary amendments into the municipal preservation ordinance, and make only minor changes in the zoning ordinance. The second would reverse this emphasis by treating the Plan essentially as a zoning measure. Of the two, the former is clearly the more desirable. The Plan is a good deal more than a simple zoning measure, as its condemnation and title encumbrancing features, among others, point up. The inclusion of these latter elements in a state or local zoning enactment would be anomalous, to say the least. But municipalities are likely to base their choice not on logical niceties but on the content of the applicable state preservation enabling act. Cities that enjoy the advantages of an Illinois-type act should adopt the first pattern. Those that are less fortunate will probably decide to follow New York City's lead and implement the Plan or, more likely, a diluted version of it as a zoning measure authorized under the state zoning enabling act.

What should be included in a preservation ordinance adopted pursuant to an Illinois-type statute? No single, concrete answer can be given because of the diversity of needs,

[4] See pp. 157-59 *supra*.
[5] Ill. Rev. Stat. ch. 24, §11-13-1 (1971).

practices, and legal requirements that exist among American cities. It does seem possible, nonetheless, to identify certain provisions that would appear to be fundamental in any legislative treatment of the Chicago Plan at the local level.[6]

Definitions

Like the state, the city should define the key elements of the proposal. Terms already defined in the state act should be given specific content based upon local practice. For example, zoning bulk may be measured locally under the FAR system, by building height and yard requirements, or in some other manner. The technique used in the municipality should be reflected in, e.g., the definition of the term "development rights." Terms not defined in the state act but crucial to the functioning of the proposal, such as "development rights transfer district," should also be defined in the local measure.

Allocation of Responsibilities among City Agencies

The city agencies that will participate in the Plan are three in number: the landmark commission, the planning department, and the city council. The preservation ordinance should delineate the respective roles of each agency. As envisaged under the Plan, the landmark commission will make recommendations to the city council regarding the following matters: the designation of development rights transfer districts and individual landmarks; the development rights–tax relief pack-

[6] A set of proposed amendments to the Chicago Landmarks Ordinance, Chicago, Ill., Municipal Code §21-64 (1970), which would permit the implementation of the Chicago Plan in that city, may be found in J. Costonis & J. Shlaes, *Development Rights Transfers: A Solution to Chicago's Landmarks Dilemma*, App. 3 (Chicago Chapter Foundation of the American Institute of Architects & National Trust for Historic Preservation, May 1971).

age that should be granted in specific cases; and the commencement of condemnation procedures to protect threatened landmarks. The commission will also oversee the appraisal of individual landmark properties, and conduct the negotiations with landmark owners leading to municipal acquisition of preservation restrictions.

The municipal planning department will advise the landmark commission and city council of the planning impact of the designation of proposed development rights transfer districts. In addition, it will administer all phases of the operation of the development rights bank, including, especially, the coordination of the sale of development rights with the city's overall planning goals.

The city council will designate development rights transfer districts and individual landmarks, approve development rights transfers by private landmark owners, and initiate condemnation proceedings in appropriate cases.

Designation

Most preservation ordinances call for the designation of individual landmarks and of historic districts. The Chicago Plan adds the third category of development rights transfer districts. The latter must be carefully defined to avoid their confusion with traditional historic districts. Unlike these districts, transfer districts are intended to serve essentially as marketing areas for development rights, and will contain only a small number of architecturally or historically significant buildings in relation to the total number of buildings within their boundaries. Further, the landmark commission reviews only those applications for alteration or demolition that relate to designated individual landmarks within transfer districts. In contrast, it engages in permit review with respect to all buildings within historic districts.

Restrictions on the Transfer of Development Rights

The framework for regulating development rights transfers set forth earlier (Chapter 5) views the individual transferee site and the overall transfer district as the pressure points, so to speak, of the transfer system. Suggestions are set forth concerning quantitive, qualitative, and procedural criteria that promise to avoid overloads at these two impact points. Devising specific safeguards for both, however, is a job that can only be undertaken on a community-by-community basis. What might be appropriate for the central business districts of New York and Chicago, for example, could wreak urban design havoc in Sante Fe or Savannah. Accordingly, the indicated planning controls are intended to serve local draftsmen and planners as a point of departure only. The final choices should derive from a sensitive evaluation of local conditions and preferences.

The Incentive Package

The landmarks commission will attempt to obtain a preservation restriction on designated landmark properties in exchange for the transfer authorization–tax relief package. Co-operating owners will prepare an appropriate instrument for this purpose that will be recorded at the time the city authorizes the transfer. Provisions respecting these procedures and the circulation of the restriction to interested city and county officials should be included in the revised ordinance.

Authority to reduce the assessed value of an encumbered landmark property will probably not appear in the municipal ordinance because real estate assessment is a county function in most states. What will be required, therefore, is an intergovernmental agreement between the city and the county obligating the county assessor to reduce the assessed value of the landmark property upon notice from the city that a preservation restriction has been recorded against the property. The legal framework for an agreement of this nature is outlined in Appendix IV.

Miscellaneous Provisions

Cities may wish to include in the ordinance any number of additional provisions selected on the basis of local preference or of the peculiarities of local law. A prodigally administered zoning bonus program, for example, may impair the attractiveness of the Chicago Plan. If developers can obtain additional density under these programs at a lesser cost, why should they pay a big price for development rights? Communities facing this problem may choose to require developers to look to the development rights bank for some portion of their "bonus bulk" before turning to the regular zoning bonus provisions of the code. Cities with a one-track commitment to encouraging development to the exclusion of other urban design values are not likely to find this option attractive. But those having a genuine commitment to historic preservation should find in it a reasonable quid pro quo for a successful preservation program.

A second problem that cities may wish to address is posed by the requirement that owners of condemned property must be compensated not only for the property actually taken but for damage to any remaining property of the landowners. This problem can be especially acute in the case of landmark properties because their value as part of a larger land assemblage may considerably exceed their value when considered in isolation from contiguous properties. By acquiring contiguous parcels, therefore, the landmark owner can substantially inflate the city's preservation costs.

This problem could arise under the Chicago Plan if the city chose to defer the acquisition of a preservation restriction in a designated landmark to some future time. The city may find that the funds in the development rights bank are insufficient for acquisition on the designation date, or it may conclude that the landmark is under no imminent threat either because of its profitability or because of a bearish office space market. To insure that the landmark owner does not increase the amount of the eventual condemnation award by obtaining adjoining land in the interim, the city might wish to require him to give it reasonable notice prior to acquiring the additional land. With this notice, the city can step in quickly and condemn the landmark parcel at a price that largely discounts its assemblage value.

Examples of other special provisions could be multiplied at length. But to do so would only obscure the fundamental point that the Chicago Plan is a flexible instrument that municipalities can shape as they see fit to meet their perceived needs.

ILLINOIS HISTORICAL PRESERVATION
ENABLING ACT,
ILL. REV. STAT. CH. 24, SECS. 11-48.2-1
et seq. (1971)[7]

11-48.2-1. Declaration of policy.

§11-48.2-1. It is hereby found and declared that in all municipalities the movements and shifts of population and the changes in residential, commercial, and industrial use and customs threaten with disappearance areas, places, buildings, structures, works of art and other objects having special historical, community, or aesthetic interest or value and whose preservation and continued utilization are necessary and desirable to sound community planning for such municipalities and to the welfare of the residents thereof. The granting to such

[7] 1971 amendments authorizing local governments to adopt the Chicago Plan are italicized.

municipalities of the powers herein provided is directed to such ends, and the use of such rights and powers for the preservation and continued utilization of such property is hereby declared to be a public use essential to the public interest.

11-48.2-1A. Definitions.

§11-48.2-1A. (1) *The development rights of a landmark site are the rights granted under applicable local law respecting the permissible bulk and size of improvements erected thereon. Development rights may be calculated in accordance with such factors as lot area, floor area, floor area ratios, height limitations, or any other criteria set forth under local law for this purpose.*

(2) *A preservation restriction is a right, whether or not stated in the form of a restriction, easement, covenant or condition, in any deed, will or other instrument executed by or on behalf of the owner of the land or in any order of taking, appropriate to the preservation of areas, places, buildings or structures to forbid or limit acts of demolition, alteration, use or other acts detrimental to the preservation of the areas, places, buildings or structures in accordance with the purposes of the Division. Preservation restrictions shall not be unenforceable on account of lack of privity of estate or contract, or of lack of benefit to particular land or on account of the benefit being assignable or being assigned.*

(3) *A transfer of development rights is the transfer from a landmark site of all or a portion of the development rights applicable thereto, subject to such controls as are necessary to secure the purposes of this Division. The transfer of development rights pursuant to sound community planning standards and the other requirements of this Division is hereby declared to be in accordance with municipal health, safety and welfare because it furthers the more efficient utilization of urban space at a time when this objective is made urgent by the shrinking land base of urban areas, the increasing incidence of large-scale, comprehensive development in such areas, the evolution of building technology and similar factors.*

(4) *A development rights bank is a reserve into which may be deposited development rights associated with publicly and privately-owned landmark sites. Corporate authorities or their designees shall be authorized to accept for deposit within the bank gifts, donations, bequests or other transfers of development rights from the owners of said sites, and shall be authorized to deposit therein development rights associated with (i) the sites of municipally-owned landmarks and (ii) the sites of privately-owned landmarks in respect of which the municipality has acquired a preservation restriction through eminent domain or purchase. All transfers of development rights from the development rights bank shall be subject to the requirements of Sections 11-76-1 through 11-76-6 of the Municipal Code of Illinois, and all receipts arising from the transfers shall be deposited in a special municipal account to be applied against expenditures necessitated by the municipal landmarks program.*

(5) *The term, public easement, shall have the same meaning and effects herein as it has in Article IX, Section 3 of the Illinois Constitution of 1870 and Article IX, Section 4(c) of the Illinois Constitution of 1970.* This amendatory Act of 1971 does not apply to any municipality which is a home rule unit.

11-48.2-2. Powers of corporate authorities.

§11-48.2-2. The corporate authorities in all municipalities shall have the power to provide for official landmark designation by ordinance of areas, places, buildings, structures, works of art and other objects having a special historical, community, or aesthetic interest or value; and in connection with such areas, places, buildings, structures, works of art or other objects so designated by ordinance, whether owned or controlled privately or by any public body, to provide special conditions, to impose regulations governing construction, alteration, demolition and use, and to adopt other additional measures appropriate for their preservation, protection, enhancement, rehabilitation, reconstruction, perpetuation, or use, which additional measures may include, but are

not limited to, (a) the making of leases and subleases (either as lessee or lessor of any such property) for such periods and upon such terms as the municipality shall deem appropriate; (b) inducing, by contract or other consideration, the creation of covenants or restrictions binding the land; (c) *the acquisition by purchase or eminent domain of a fee or lesser interest, including a preservation restriction, in property so designated; the deposit, as appropriate, in a development rights bank of the development rights associated with said property; and the reconstruction, operation or transfer by the municipality of any such property so acquired or the transfer of any development rights so acquired, all in accordance with such procedures and subject to such conditions as are reasonable and appropriate to carrying out the purposes of this Division;* (d) appropriate and reasonable control of the use or appearance of adjacent and immediately surrounding private property within public view; (e) acquisition by eminent domain or by other contract or conveyance of immediately surrounding private property, or any part thereof or interest therein, the alteration or clearance of which is important for the proper preservation, reconstruction or use of the designated property; (f) cooperative relations, including gifts, contracts and conveyances appropriate to the purposes of this Division, by and between the municipality and any other governmental body or agency and by and between the municipality and not-for-profit organizations which have as one of their objects the preservation or enhancement of areas, places, buildings, structures, works of art or other objects of special historical, community or aesthetic interest or value; (g) acceptance and administration by the municipality of funds or property transferred on trust to the municipality by an individual, corporation or other governmental or private entity for the purpose of aiding, either in general or in connection with some specific designated property, the preservation or enhancement of areas, places, buildings, structures, works of art or other objects designated by law under the provisions hereof; (h) issuance of interest

bearing revenue bonds, pursuant to ordinance adopted by the corporate authorities, payable from the revenues to be derived from the operation of any one or more areas, places, buildings, structures, works of art or other objects designated by ordinance and acquired by the municipality under the provisions hereof, such bonds to mature at a time not exceeding 50 years from their respective dates of issue and to be in such form, carry such registration privileges, be executed in such manner, be offered for sale in such manner and be payable at such place or places and under such conditions and terms as may be provided in the ordinance or in any subsequent ordinance adopted pursuant hereto for the purpose of refunding or refinancing any bonds issued hereunder; and the holder or holders of any such bonds may bring suit at law or in equity to compel the municipality to perform any covenant or duty created by the ordinance authorizing their issuance; and (i) *establishment of procedures authorizing owners of designated property to transfer development rights in such amount and subject to such conditions as are appropriate to secure the purposes of this Division.*

Any such special conditions, regulations, or other measures, shall, if adopted in the exercise of the police power, be reasonable and appropriate to the preservation, protection, enhancement, rehabilitation, reconstruction, perpetuation, or use of such areas, places, buildings, structures, works of art, or other objects so designated by law, or, if constituting a taking of private property, shall provide for due and just compensation. The amendatory Act of 1971 does not apply to any municipality which is a home rule unit.

11-48.2-3. Administrative agency.

§11-48.2-3. The foregoing purposes and powers may be administered by such special commission, board, department or bureau of the municipality or by such one or more existing commissions, boards, departments or bureaus of the municipality, or by any combination thereof or division of functions thereamong, as may be provided by ordinance adopted by the corporate

authorities, and the words "the municipality" as used in reference to the administration of this division include any commission, board, department, bureau, officer, or other agency of the municipality given any such administrative powers by ordinance adopted by the corporate authorities.

11-48.2-4. Notice — Hearing — Review.

§11-48.2-4. No action taken by the municipality under this section directing a private owner to do or refrain from doing any specific thing, or refusing to permit a private owner to do some specific thing he desires to do, in connection with property designated by ordinance hereunder, shall be taken by the municipality except after due notice to such owner and opportunity for him to be heard at a public hearing, and if such action is taken by administrative decision as defined in Section 1 of the "Administrative Review Act," approved May 8, 1945, it shall be subject to judicial review pursuant to the provisions of said "Administrative Review Act" and all amendments and modifications thereof and rules adopted pursuant thereto.

11-48.2-5. Acts constituting taking or damage for public use.

§11-48.2-5. The denial of an application for a building demolition permit by reason of the operation of this Division, or the denial of an application for a building permit to add to, modify or remove a portion of any building by reason of the operation of this Division, or the imposition of any regulation solely by reason of the provisions of this Division which requires, directly or indirectly, an alteration or cessation in the use to which the interior space in any building is put, or which requires any addition or modification in or to any building, or which requires any unusual or extraordinary provisions for upkeep and maintenance of any building, shall be deemed to constitute a taking or damage for a public use of such property for which just compensation shall be ascertained and paid.

11-48.2-6. Valuation — Deduction of encumbrances or restrictions.

§11-48.2-6. *Any encumbrances or restrictions imposed upon designated property*

pursuant to subsections (a)-(i) of Section 11-48.2-2 of this Division shall be deemed public easements, and any depreciation occasioned by such encumbrances or restrictions shall be deducted in the valuation of such property. This amendatory Act of 1971 does not apply to any municipality which is a home rule unit.

11-48.2-7. Severability clause.

§11-48.2-7. If any provision, clause or phrase of this Division or the application thereof to any person or circumstance is held invalid, such invalidity shall not affect other provisions or applications of this Division which can be given effect without the invalid provision or application, and to this end the provisions of this Division are declared to be separable.

III

Section 170 of the Internal Revenue Code and the Deductibility of the Donation of a Less than Fee Interest in a Landmark Property

The principles governing the deductibility of charitable contributions for federal income tax purposes are found in Section 170 of the Internal Revenue Code[1] and in the accompanying regulations of the Internal Revenue Service.[2] These provisions authorize individuals and corporations to deduct from their taxable income the value of contributions to cities and other units of local government, provided that the contribution serves exclusively public purposes. The contribution is valued on the basis of its fair market value at the time it is made. In consequence, the donor of appreciated capital gains property may deduct from ordinary income the full value of the donated property without having to pay a capital gains tax on the increase in value.[3] The deduction may be taken in the year of the contribution and, if not exhausted in that year, may be carried forward over the succeeding five years. For most individuals,

the deduction for the contribution of capital gains property may not exceed 30 percent of their adjusted gross income. For corporations, the limitation is 5 percent of taxable income.

Initially, there was some question whether the donation of a less than fee interest in real property would qualify as a charitable contribution. That question appeared to have been put to rest by a U.S. Tax Court opinion and, subsequently, by a formal ruling of the Internal Revenue Service itself. In *Fair v. Commissioner of Internal Revenue*,[4] the taxpayer donated to a charitable foundation a "property right to erect, maintain, own and use" five additional stories over a site owned by the taxpayer and improved with a two-story building. The service sought to disallow the deduction on two grounds: first, the rights granted "do not constitute property";[5] second, the rights at best amounted to an easement rather than a fee in the airspace.

[1] Int. Rev. Code of 1954, §170.

[2] Treas. Reg. §1.170 (1972).

[3] This proposition is illustrated by the following example. Assume that Taxpayer purchases a landmark property in 1965 for $5,000,000 and that the property's fair market value at the present time is $10,000,000. Assume further that Taxpayer wishes to donate a preservation restriction valued at $5,000,000 to the city. Upon donation of the restriction, Taxpayer will receive a deduction (subject to the qualifications enumerated in the text and in Section 170) of $5,000,000, which he may

offset against his ordinary income. If, on the other hand, Taxpayer were to sell the preservation restriction for $5,000,000 and contribute the proceeds to charity, his deduction would be the same but he would be required to pay a capital gains tax based on the difference between what he receives for the restriction and its cost, or basis. The latter amount would be fixed by allocating the initial $5,000,000 purchase price between the preservation restriction and the remaining property.

[4] 27 T.C. 866 (1957).

[5] *Ibid.* at 872.

The U.S. Tax Court rejected both contentions. As to the first, it reasoned: "Property is the sum of rights and powers incident to ownership. The right to use the airspace superadjacent to the ground is one of the rights in land. These air rights are frequently the most valuable rights connected with the ownership of land since the value of commercial property consists almost exclusively of the right of the owner to erect business and industrial structures thereon. . . ."[6]

It adopted a similar commonsense approach to the service's second argument:

The [service's] position is that the rights and interests conveyed could only be and were a license, or at most, an easement, since no interest in the ground was conveyed.

The significant thing in a valuation of this type . . . is that the evaluators understood what property is to be valued regardless of the characterization placed upon the property to be valued by different parties. . . . The air rights that were evaluated were clearly the rights and interests that were described in the conveying instrument as the property contributed.[7]

Seven years later, the service itself formally ruled that a property interest would not fail to qualify as a charitable contribution under Section 170 simply because it does not constitute the taxpayer's full fee interest in the property granted.[8] In Revenue Ruling 64-205, the service held that "the gratuitous conveyance to the United States of America of a restrictive easement in real property is a charitable contribution within the meaning of Section 170(c) of the Code. Accordingly, the taxpayer is entitled to a deduction under Section 170 of the Code in the manner and to the extent therein provided, for the fair market value of the restrictive easement."[9]

The *Fair* opinion and Revenue Ruling 64-205 would seem to leave little doubt that landmark owners who donate preservation restrictions (and the attendant development rights in landmark property) will not be barred from the benefits of Section 170 simply because these restrictions are less than fee interests. As the *Fair* court emphasizes, the manner in which the donated interest is characterized makes little difference per se. What is important is that the interest be enforceable and that it be capable of reasonably precise valuation. Subject to the qualifications noted in Chapter 6 regarding the enforceability of these interests,[10] preservation restrictions satisfy both criteria.

The remaining two requirements of Section 170 that bear upon the question offer even less difficulty. Contributions must be made, first, to a "State . . . or any political subdivision of [a State],"[11] and, second, "for exclusively public purposes."[12] Municipalities, the donees of the restrictions, are political subdivisions of the states in which they are located. And the object of the donation — the preservation of designated landmarks — has repeatedly been deemed a public purpose by the nation's courts and legislatures.

This happy picture has been somewhat clouded by the amendment of Section 170 in 1969. In that year Congress added a new subsection, 170(f)(3), which provides, in essence, that a contribution of an interest in property that consists of less than the taxpayer's "entire interest in such property" shall not be deductible unless the contributed interest is "an undivided portion of the taxpayer's entire interest in property." A preservation restriction is not the landmark owner's entire interest in his property. Its deductibility

[6] *Ibid.*
[7] *Ibid.* at 873.
[8] Rev. Rul. 205, 1964 — 2 Cum. Bull. 112.
[9] *Ibid.*
[10] See pp. 152-57 *supra.*
[11] Int. Rev. Code of 1954, §170(c)(1).
[12] *Ibid.*

under the 1969 amendment, therefore, depends upon whether or not it qualifies as an "undivided portion" of the owner's entire (fee) interest.

Had Congress or the Internal Revenue Service offered no clue as to the meaning of the vague phrase "undivided portion," this question might have proven very troublesome indeed. Fortunately, the reports of the congressional committees that drafted the amendment as well as the service's proposed regulations implementing it are unequivocal that it was not intended to overrule the interpretation of Section 170 found in the *Fair* opinion and Revenue Ruling 64-205.

The Senate[13] and House[14] reports spell out in identical language the type of problem at which subsection 170(f)(3) was directed.

5. Gifts of the use of property.
Present Law. Under existing law a taxpayer may claim a charitable deduction for the fair *rental* value of property which he owns and gives to a charity *to use for a specified time.* In addition, he may exclude from his income the income which he would have received and been required to include in his tax base had the property been *rented* to other parties.

Problem. By giving a charity the right to *use* property which he owns *for a given period of time* a taxpayer achieves a double benefit. For example, if an individual owned an office building, he may donate the *use* of 10% of its rental space to a charity *for one year.* He then reports for tax purposes only 90% of the income which he would otherwise have been required to report if the building were fully rented, and he claims a charitable deduction (equal to 10% of the rental value of the building) which offsets his already reduced income.

In short, Congress by its amendment wished to eliminate the charitable deduction for do-

nations of the use of property for a fixed period of time which gave rise to a double deduction. The donation of a preservation restriction, of course, is easily distinguished from such contributions because the landmark owner parts irrevocably with a present, less than fee interest in his property. The city, as donee, holds this interest not for a "specified period of time" but in perpetuity, and therefore on an undivided basis.

Any further doubts on this score would seem to be laid to rest by the following comment, which appears in the joint House and Senate report[15] on the 1969 amendment and, somewhat modified, in the service's proposed regulations implementing subsection 170(f)(3): "A gift of an open space easement in gross is to be considered a gift of an undivided interest in property where the easement is in perpetuity."[16]

Until the service or a court addresses the specific question, the status under Section 170 of the donation of a preservation restriction will not be entirely free from doubt. Despite this uncertainty, there seems little reason to doubt that, in principle at least, the donation of a preservation restriction should give rise to a charitable deduction. The likely area of difficulty, it can be ventured, will be one of evidence and proof, not one of substantive tax law. The taxpayer must be prepared to demonstrate that preservation restrictions are indeed recognized, enforceable property interests in his jurisdiction. And he should be able to buttress the amount of the claimed deduction with competent appraisal data and other evidence establishing that it in fact reasonably approximates the fair market value of the preservation restriction. While his burden on both counts will not be light, it certainly should not prove insuperable.

13 *S. Rep. 552,* 91 Cong., 1 Sess. 29 (1969) (emphasis added).
14 *H.R. Rep. 413,* 91 Cong., 1 Sess. 57 (1969) (emphasis added).

15 *H.R. Rep. 782,* 91 Cong., 1 Sess. 294 (1969).
16 Treas. Reg. §1.170(f)(3) (1972).

IV
Real Estate Taxation and the Landmark Property

The legal principles governing the entitlement of landmark owners to real estate tax relief can be stated quite simply. But predicting the manner in which they will be applied is another matter altogether. The practices of local taxing officials tend toward the inscrutable and, when exposed to public view, are found not infrequently to conflict with the requirements of law. Securing the tax relief for landmark owners envisaged under the Chicago Plan, therefore, may well prove a difficult challenge for municipal officials because tax assessment, the key to relief, is typically a county rather than a city function. Success will depend upon alertness both to principles and to practice.

THE PRINCIPLES

State constitutions typically provide that taxation of real property must be "uniform"[1] and "according to value"[2] (*ad valorem*). As might be expected, a uniform tax regulation is one that treats all property owners equally, avoiding disproportionate benefits or burdens for individual taxpayers. Taxation according to "value" may mean either that real property

must be assessed at 100 percent of its fair market value or at some fraction of that value uniformly applied to all real property within the taxing jurisdiction. Two points should be noted regarding *ad valorem* taxation. First, it guarantees uniformity because all property within the jurisdiction is dealt with on the same basis — assessment at full or fractional fair market value. Second, "fair market value" refers not to the value of the parcel as determined by its *present* use but to its value if devoted to the most *profitable* use permitted by zoning, the state of the market, and other relevant factors.[3]

These constitutional provisions are supplemented by state taxing statutes which specify whether the constitutional reference to "value" means full or fractional value.[4] Some states also include within their preservation enabling acts a provision directing the local assessor to take restrictions upon landmark properties into account when valuing these properties.[5] At first blush, the function of this provision is puzzling. Under the *ad valorem* taxing method, the "value" of any property — land-

[1] See, e.g., Penn. Const. art. VIII, §1; Tenn. Const. art. II, §28.

[2] See, e.g., Ky. Const. §174; Tenn. Const. art. II, §28.

[3] See Bonbright, "The Valuation of Real Estate for Tax Purposes," 34 *Colum. L. Rev.* 1397 (1934).

[4] See, e.g., Nev. Rev. Laws §361.225 (1969); N.J.S.A. ch. 54, §1-33 (1960).

[5] See, e.g., Conn. G.S.A. ch. 12, §127a (1972); N.M.S.A. ch. 4, §27-14 (Supp. 1971).

mark or otherwise — is reduced *pro tanto* by any encumbrance upon it. A landmark property burdened with a preservation restriction is no different in this respect than a farm that is subject to a pipeline easement. Thus, it would seem that the landmark provision adds nothing to the tax statute.

But the anomaly vanishes if the provision is viewed as intended to strengthen the hand of the landmark owner in his quest for tax relief. Assessors, like most public administrators, tend to approach their duties conservatively. Confronted with a landmark owner seeking a reduced assessment, they are likely to insist upon showings that designation has deprived him of recognized property rights, and that the public policy of the state favors offsetting these losses through tax relief. Deriving the proof for either proposition without the aid of statute will be difficult. With the landmark provision, on the other hand, neither issue is troublesome and the inquiry shifts to the factual and relatively more simple question of fixing the dollar amount of the actual loss.

State constitutional provisions authorizing the "classification" of real property also merit attention. Under these provisions,[6] taxing authorities may single out certain categories of real property for preferential tax treatment. To avoid invalidation, the categories must be "reasonable,"[7] a requirement typically met by a showing that the class of real property in question serves an important social or economic function. For example, a number of states grant preferential treatment to agricultural and timber land on the basis of the community benefits that they associate with keeping these lands in their natural state.[8]

The tax relief envisaged under the Chicago Plan is not tied to the power of local officials to classify real property. Rather, it is an instance of *ad valorem* taxation because it is keyed directly to the drop in value that a landmark property sustains upon designation. But the validity of other types of tax abatement programs could well turn on the power of local officials to classify. Suppose, for example, that a state chooses to abate the real estate taxes of landmark owners by an amount equal to their restoration and maintenance costs,[9] while taxing all other property on an *ad valorem* basis. On its face, the disparity in the mode of taxing the two groups of property violates the uniformity requirement. In all likelihood, however, the power to classify would save the situation because it validates the taxation of different classes of property according to different standards, provided that the classes are reasonable and that the standards within each class are uniform.

THE PRACTICE

The complications that may arise in the application of these relatively simple principles can best be illustrated by the following example. Smith owns a landmark property with a fair market value of $2,000,000. Upon its designation, he conveys to the city a preservation restriction worth $500,000 as determined by the appraisal procedure outlined in Chapter 3. If the state constitution and real estate tax code require that all real estate must be assessed at fair value, the assessed value of Smith's property should be reduced to $1,500,000 ($2,000,000 minus $500,000). If the state uses a fractional assessment figure of, let us say, 50 percent, the assessed value will be $750,000 ($1,000,000 minus $250,000).

[6] See, e.g., N.M. Const. art. VIII, §1; Vir. Const. art. X, §1.
[7] See, e.g., Gruschus v. Bureau of Revenue, 74 N.M. 775, 399 P.2d 105 (1965).
[8] See, e.g., Minn. Const. art. XVIII, §1; Wash. Const. art. VII, §11.

[9] New Mexico follows this approach. See N.M.-S.A. ch. 4, §27-14 (Supp. 1971).

Actual practice, however, often fails to reflect these results. Contrary to express constitutional and statutory mandate, local taxing officials frequently assess property on some basis other than full or fractional fair market value. They may, for example, assign values calculated on the property's *present* use, ignoring its potentiality for more profitable development.[10] Under this approach the initial valuation of Smith's property would be $1,500,000 rather than $2,000,000. He would not be entitled to any reduction in assessment upon conveying the preservation restriction because his property was initially assessed as though it were already so encumbered. What this means, of course, is that Smith must pay higher real estate taxes relative to other property owners than he would if his — and their — property were assessed at fair market value as required by law. Similar disadvantages attend assessment methods that value properties on the basis of their present rental income or, in the case of fractional assessments, that employ a higher percentage rate for landmark properties than for other properties in violation of the uniformity requirement.

The problems created by prejudicial assessment may be resolved either through intergovernmental agreement or by court action. Under the former alternative, the city and the assessing unit, usually a county body, would agree upon a formula that insures implementation of the legislative policy favoring tax relief for landmark owners, whatever the assessment method used locally. Suppose, for example, that properties are being assessed at present rather than fair market value. The assessor could agree to lower landmark property assessments by a percentage reflecting the difference between the property's fair market value and its value as reduced by the preservation restriction.

Would the agreement be invalid because it

incorporates an assessment standard, present value, that itself is contrary to law? Whether a court would so rule is not absolutely certain for the reasons indicated below. Even if it did, however, its action would be entirely consistent with the city's wishes. By directing the assessor to employ the fair market value standard required by law, the court guarantees the very result that the city had intended to secure through the intergovernmental agreement.

It is the aggrieved landmark owner, not the city, who pursues the second alternative, court action. His challenge will depend, of course, upon the particular defect in local assessment procedure. If properties are uniformly assessed at their present value instead of their fair market value, he will charge that this practice conflicts with the fair market value standard required by state constitution and statute.[11] If landmark properties are assessed at higher fractional rates — whether computed on the basis of present or fair market value — than apply to other properties, he will claim a violation of the uniformity requirement in the taxing article of the state constitution and of the equal protection clause of the state and federal constitutions.[12]

What relief may the landmark owner expect? The court can move in one of two ways if it elects to provide direct relief. It may leave his assessment untouched while requiring that the assessment of all other properties be increased to the proper standard, be it 100 percent of fair market value or some fraction of that figure uniformly applied to all properties within the jurisdiction.[13] Or the court may ignore the assessment of other properties, re-

[10] See pp. 76-79 *supra*.

[11] See, e.g., statutes cited in note 4 *supra*.
[12] See, e.g., Sioux City Bridge Co. v. Dakota County, 260 U.S. 441 (1922); Bettegole v. Assessors of Springfield Mass., 343 Mass. 223, 178 N.E.2d 10 (1961).
[13] See, e.g., Walter v. Schuler, 176 So.2d 81 (Fla. 1965); Russman v. Luckett, 391 S.W.2d 694 (Ky. Ct. App. 1965).

stricting itself to an order mandating a pro-portional decrease in the assessment of the landmark owner's property to assure the favored treatment envisaged for encumbered properties under the state's taxing and landmark laws.[14]

But the courts are not comfortable with either option. Ordering a general increase in the assessed value of all property within a county or perhaps even the state could bring about any number of undesirable consequences. Constitutional bonding, taxing, and spending limits, for example, are usually tied to the assessed value of property within the state's political subdivisions. A sharp increase in total assessed value, as would occur by shifting from a present to a fair market value standard, might encourage windfall spending and other unfortunate behavior by local governments.[15] Despite these risks, a few instances of this relief appear in the case reports.[16]

An order reducing the assessment of single properties is less controversial because of its more limited impact. But this relief too requires courts to become entangled in the com-

plexities of local government finance, a role for which they are not particularly well suited. Accordingly, although they grant the latter more frequently than they grant petitions for generalized assessment increases, they typically sidestep the mechanics of reassessment by remanding that issue to the local tax appeals board for resolution.[17]

Because of these uncertainties, an intergovernmental compact is preferable to litigation. Local assessment procedures are so flexible that the agreement should prove relatively easy to fashion. Basically, it need cover only two points. First, it should include a valuation formula, modeled upon the one set forth in Chapter 3, for assessing landmark properties encumbered with preservation restrictions. Second, it should establish procedures coordinating the actions of the city and the assessing authority at the time individual landmark properties are designated. Without this coordination, the city's negotiating position vis-à-vis the landmark owner will be hampered by its inability to detail the amount of tax relief that it can offer him in partial exchange for a preservation restriction on his property.

[14] See, e.g., Tax Lien Co. v. Schultz, 213 N.Y. 9, 106 N.E. 751 (1914); First Merchants National Bank v. County of Amherst, 204 Va. 585, 132 S.E.2d 721 (1963).
[15] See Switz v. Middletown, 23 N.J. 580, 130 A.2d 15 (1957).
[16] See, e.g., cases cited in note 13 *supra.*

[17] See, e.g., Helmsley v. Detroit, 320 F.2d 476 (6th Cir. 1963); Louisville & Nashville R.R. Co. v. Public Service Comm'n, 249 F. Supp. 894 (M.D. Tenn. 1966).

Bibliography

American Society of Planning Officials, "Floor Area Ratio." Planning Advisory Service Rpt. 111, 1958.

Anderson, "A Comment on the Fine Line between 'Regulation' and 'Taking,'" in N. Marcus & M. Groves, eds., *The New Zoning: Legal, Administrative, and Economic Concepts and Techniques* 66 (1970).

Babcock, R., *The Zoning Game.* 1966.

Baldwin, "Historic Preservation in the Context of Environmental Law: Mutual Interest in Amenity," 36 *Law & Contemp. Prob.* 432 (1971).

Barnett, "Case Studies in Creative Urban Zoning," in N. Marcus & M. Groves, eds., *The New Zoning: Legal, Administrative, and Economic Concepts and Techniques* 125 (1970).

Bassett, E., *Zoning.* 1940.

Biddle, "Historic Preservation," 28 *Journ. of Housing* 219 (1971).

Bonbright, "The Valuation of Real Estate for Tax Purposes," 34 *Colum. L. Rev.* 1397 (1934).

Brenneman, R., *Private Approaches to the Preservation of Open Land.* 1967.

Brooks, M., "Bonus Provisions in Central City Areas." American Society of Planning Officials, Planning Advisory Service Rpt. 257, 1970.

Brugmann, B., Sletteland, G., *et al., The Ultimate Highrise.* 1971.

Burks, "City Wants Air Rights to Hop, Skip and Jump," *New York Times,* Apr. 26, 1970, §8, p. 1, col. 1.

———, "Planners Seek to Shift Custom House Air Rights," *New York Times,* Apr. 9, 1970, §8, p. 56, col. 4.

Clark, C., *Real Covenants and Other Interests Which Run with Land,* 2nd ed. 1947.

Comment, "Aesthetic Zoning: Preservation of Historic Areas," 29 *Fordham L. Rev.* 729 (1961).

Comment, "Assignability of Easements in Gross," 32 *Yale L. J.* 813 (1923).

Comment, "Bonus or Incentive Zoning — Legal Implications," 21 *Syr. L. Rev.* 895 (1970).

Comment, "Landmark Preservation Laws: Compensation for Temporary Taking," 35 *U. Chi. L. Rev.* 362 (1968).

Comment, "The Landmark Problem in New York," 22 *N.Y.U. Intra. L. Rev.* 99 (1967).

Comment, "Legal Methods of Historic Preservation," 19 *Buffalo L. Rev.* 611 (1970).

Committee on Cultural and Economic Development, "Special Report Relative to Designation of the Old Stock Exchange Building." Aug. 1970.

Conard, "Easement Novelties," 30 *Cal. L. J.* 125 (1942).

Condit, C. W., *The Chicago School of Architecture: A History of Commercial and Public Building in the Chicago Area, 1875-1925.* 1964.

Conti, "Preserving the Past," *Wall Street J.,* Aug. 8, 1970, p. 1, col. 1.

Coons, Clune, & Sugarman, "Educational Opportunity: A Workable Constitutional Test for State Financial Structures," 57 *Calif. L. Rev.* 305 (1969).

Costonis, "The Chicago Plan: Incentive Zoning and the Preservation of Urban Landmarks," 85 *Harv. L. Rev.* 574 (1972).

———, "Formula Found to Preserve the Past," 38 *Planning* 307 (ASPO, 1972).

Costonis, J., & J. Shlaes, *Development Rights Transfers: A Solution to Chicago's Landmarks Dilemma.* Chicago Chapter Foundation of the American Institute of Architects & National Trust for Historic Preservation, May 1971.

Cribbet, "Changing Concepts in the Law of Land Use," 50 *Iowa L. Rev.* 245 (1967).

Cushman, R., *Excess Condemnation.* 1917.

Department of City Planning, "San Francisco Downtown Zoning Study." 1966.

Department of Transportation of Wisconsin, "A Market Study of Properties Covered by Scenic Easements along the Great River Road in Vernon and Pierce Counties." Spec. Rpt. 5, 1967.

"Dollars and Sense: Preservation Economics," 23 *Hist. Preservation* 15 (1971).

Dukeminier, "Zoning for Aesthetic Objectives: A Reappraisal," 20 *Law & Contemp. Prob.* 218 (1955).

Dukeminier & Stapleton, "The Zoning Board of Appeals: A Case Study in Misrule," 50 *Ky. L. J.* 273 (1962).

Dunham, "A Legal and Economic Basis for City Planning," 58 *Colum. L. Rev.* 650 (1958).

Elliott, Introduction, in N. Marcus & M. Groves, eds., *The New Zoning: Legal, Administrative, and Economic Concepts and Techniques* xv (1970).

Fonoroff, "Special Districts: A Departure from the Concept of Uniform Controls," in N. Marcus & M. Groves, eds., *The New Zoning: Legal, Administrative, and Economic Concepts and Techniques* 82 (1970).

Ford, G., *Building Height, Bulk and Form.* Harvard City Planning Studies II, 1931.

Fuller, B., "World Design Science Decade, 1966-1975." World Resources Inventory, Phase I, Doc. 2, 1963.

Gilbert, "Saving Landmarks: The Transfer of Development Rights," 22 *Hist. Preservation* 13 (1970).

Goldston & Scheuer, "Zoning of Planned Residential Developments," 73 *Harv. L. Rev.* 241 (1959).

Gray, "The Response of Federal Legislation to Historic Preservation," 36 *Law & Contemp. Prob.* 314 (1971).

Haar, "In Accordance with a Comprehensive Plan," 68 *Harv. L. Rev.* 1154 (1955).

Haar & Herring, "The Determination of Benefits in Land Acquisition," 51 *Calif. L. Rev.* 833 (1963).

Hagman, D., *Urban Planning and Land Development Control Law.* 1971.

Hanke, "Planned Unit Development and Land Use Intensity," 114 *U. Pa. L. Rev.* 15 (1965).

Hanna, "Subdivisions: Conditions Imposed by Local Governments," 6 *Santa Clara L. Rev.* 172 (1966).

Heyman, "Innovative Land Regulation and Comprehensive Planning," in N. Marcus & M. Groves, eds., *The New Zoning: Legal, Administrative, and Economic Concepts and Techniques* 40 (1970).

Heyman & Gilhool, "The Constitutionality of Imposing Increased Community Costs on New Subdivision Residents through Subdivision Exactions," 73 *Yale L. J.* 1119 (1964).

Higbee, E., *The Squeeze: Cities without Space.* 1960.

Hodge, P., & P. Hauser, "The Challenge of America's Metropolitan Population — 1960 to 1985," National Commission on Urban Problems, Res. Rpt. 3, 1968.

Hodgman, "Air Rights and Public Finance: Public Use in a New Guise," 43 *So. Cal. L. Rev.* 625 (1969).

Huxtable, "Bank's Building Plan Sets Off Debate on 'Progress,'" *New York Times,* Jan. 17, 1971, §8, p. 1, col. 2.

———, "The Chicago Style — On Its Way Out?," *New York Times,* Nov. 29, 1970, §2, p. 27, col. 1.

———, "City Landmark Gets a Chance for Survival," *New York Times,* Aug. 2, 1970, §8, p. 1, col. 1.

———, "Concept Points to 'City of Future,'" *New York Times,* Dec. 6, 1970, §8, p. 1, col. 3.

———, "Non-Fables for Our Time," *New York Times,* Nov. 14, 1971, §2, p. 22, col. 4.

———, "A Plan for Chicago," *New York Times,* Apr. 15, 1973, §8, p. 23, col. 2.

———, "The Plot Thickens," *New York Times,* Feb. 14, 1971, §2, p. 25, col. 1.

———, "A Solid Dross City," *New York Times,* Mar. 14, 1971, §2, p. 16, col. 5.

———, "Thinking Man's Zoning," *New York Times,* Mar. 7, 1971, §2, p. 22, col. 1.

Isbrandsten, "South Street Seaport Museum," 21 *Hist. Preservation* 7 (1968).

Krasnowieki, J., "Legal Aspects of Planned Unit Development." Urban Land Institute, Tech. Bull. 52, 1965.

———, "Planned Unit Development: A Challenge to Established Theory and Practice of Land Use Control," 114 *U. Pa. L. Rev.* 47 (1965).

Lloyd, "Enforcement of Affirmative Agreements Respecting the Use of Land," 14 *Va. L. Rev.* 419 (1928).

Lovelace, E., & W. Weismantel, "Density Zoning: Organic Zoning for Planned Residential Development." Urban Land Institute, Tech. Bull. 42, 1961.

Mandelker, "The Basic Philosophy of Zoning: Incentive or Restraint?," in N. Marcus & M. Groves, eds., *The New Zoning: Legal, Administrative, and Economic Concepts and Techniques* 16 (1970).

———, "Delegation of Power and Function in Zoning Administration," 1963 *Wash. L. Q.* 60, (1963).

———, "Public Purpose in Urban Redevelopment," 28 *Tul. L. Rev.* 96 (1953).

———, "Reflections on the American System of Planning Controls: A Response to Professor Krasnowiecki," 114 *U. Pa. L. Rev.* 98 (1965).

Marcus, "Air Rights Transfers in New York City," 36 *Law & Contemp. Prob.* 372 (1971).

Marcus, N., & M. Groves, eds., *The New Zoning: Legal, Administrative, and Economic Concepts and Techniques* (1970).

Michelman, "Property, Utility, and Fairness: Comments on the Ethical Foundations of 'Just Compensation' Law," 80 *Harv. L. Rev.* 1165 (1967).

Montague, R., & T. Wrenn, *Planning for Preservation.* American Society of Planning Officials, 1964.

Morris, "Air Rights Are 'Fertile Soil,'" 1 *Urban Lawyer* 247 (1969).

———, "The Quiet Legal Revolution: Eminent Domain and Urban Renewal," *A. B. A. J.* 355 (1966).

———, "School Air Rights Development Fund Will Stimulate Building Construction," *Real Estate F.* 36 (Mar. 1967), 74 (Apr. 1967).

Morrison, J., *Historic Preservation Law.* 1965.

———, *Historic Preservation Law, Supplement.* 1972.

Mott & Wehrly, "The Prohibition of Residential Developments in Industrial Districts." Urban Land Institute, Tech. Bull., Nov. 1948.

National League of Cities, "Air Space Utilization." Staff Rpt. 68-1, 1968.

National Park Service, "The Chicago School of Architecture: A Plan for Preserving a Significant Remnant of America's Architectural Heritage." 1973.

Nelson, "Appraisal of Air Rights," 23 *Appraisal J.* 495 (1955).

Nichols, P., *Nichols' Law of Eminent Domain,* 3rd ed. 1970.

Note, "Building Size, Shape, and Placement Regulations: Bulk Control Zoning Reexamined," 60 *Yale L. J.* 506 (1951).

Note, "Conveyance and Taxation of Air Rights," 64 *Colum. L. Rev.* 338 (1964).

Note, "Development Rights Transfers in New York City," 82 *Yale L. J.* 338 (1972).

Note, "Exclusionary Zoning and Equal Protection," 84 *Harv. L. Rev.* 1645 (1971).

Note, "The Police Power, Eminent Domain and the Preservation of Historic Property," 63 *Colum. L. Rev.* 708 (1963).

Note, "Preservation of Open Spaces through Scenic Easements and Greenbelt Zoning," 12 *Stan. L. Rev.* 638 (1960).

Note, "The 'Public Purpose' of Municipal Financing for Industrial Development," 70 *Yale L. J.* 764 (1961).

Note, "The Public Use Limitation in Eminent Domain: An Advance Requiem," 58 *Yale L. J.* 599 (1949).

Note, "State Constitutional Limitations on the Power of Eminent Domain," 77 *Harv. L. Rev.* 717 (1969).

Note, "Techniques for Preserving Open Spaces," 75 *Harv. L. Rev.* 1622 (1962).

Note, "Zoning, Aesthetics and the First Amendment," 64 *Colum. L. Rev.* 81 (1964).

Pyke, J., *Landmark Preservation.* Citizens Union Research Foundation, Inc., 1970.

Randall, "The Question of Size: A Re-approach to the Study of Zoning," 54 *Arch. Forum* 117 (1931).

Ruth, "Economic Aspects of the San Francisco Zoning Ordinance Bonus System," in N. Marcus & M. Groves, eds., *The New Zoning: Legal, Administrative, and Economic Concepts and Techniques* 159 (1970).

Sax, J., *Defending the Environment.* 1971.

———, "The Public Trust Doctrine in Natural Resource Law," 68 *Mich. L. Rev.* 473 (1970).

———, "Takings, Private Property and Public Rights," 81 *Yale L. J.* 149 (1971).

Sher, "'Air Rights' Lease, Zoning," 164 *N.Y. L. J.* 1 (1970).

Shultz, E., & W. Simmons, *Offices in the Sky.* 1959.

Siegel, A., *The Law of Open Space.* 1960.

Soleri, P., *Arcology: The City in the Image of Man.* 1969.

Special Committee on the Exchange, "Report to Mayor Richard J. Daley: Old Stock Exchange Building." 1970.

Stone, "Should Trees Have Standing? — Toward Legal Rights for Natural Objects," 45 *So. Cal. L. Rev.* 456 (1972).

Strong, A., *Open Space for Urban America.* 1965.

Svirsky, "San Francisco Limits the Buildings to See the Sky," 89 *Planning* 9 (ASPO, 1973).

———, "San Francisco: The Downtown Development Bonus System," in N. Marcus & M. Groves, eds., *The New Zoning: Legal, Administrative, and Economic Concepts and Techniques* 139 (1970).

Symposium, "Planned Unit Development," 114 *U. Pa. L. Rev.* (1965).

Toll, S., *Zoned American.* 1969.

Turnbull, "Aesthetic Zoning," 7 *Wake Forest L. Rev.* 230 (1971).

U.S. Department of Housing and Urban Development, *Urban Renewal Handbook.* 1971.

Urban Land Institute, "Air Rights and Highways." Tech. Bull. 64, 1969.

———, "New Approaches to Residential Land Development: A Study of Concepts and Innovations." Tech. Bull. 40, 1961.

Von Eckardt, "Getting Charm and Height," *Washington Post,* Feb. 27, 1971, §C, p. 1, col. 5.

Weinstein, "How New York's Zoning Was Changed to Induce the Construction of Legitimate Theaters," in N. Marcus & M. Groves, eds., *The New Zoning: Legal, Administrative, and Economic Concepts and Techniques* 131 (1970).

Whipple, "Height Limitations in Zoning," 88 *Am. Soc'y of Civil Engs.* 840 (1926).

Whyte, W., *Cluster Development.* 1964.

———, *The Last Landscape.* 1968.

———, *Securing Open Space for Urban America: Conservation Easements.* 1959.

Williams, N., *Land Acquisition for Outdoor Recreation — Analysis of Selected Legal Problems.* Outdoor Recreation Resources Review Commission, Study Rpt. 16, 1962.

Wilson & Winkler, "The Response of State Legislation to Historic Preservation," 36 *Law & Contemp. Prob.* 329 (1971).

Wolf, "The Landmark Problem in New York," 22 *N.Y.U. Intra. L. Rev.* 99 (1967).

Wolfe, "Conservation of Historic Buildings and Areas — Legal Techniques," in 2 *ABA Section on Real Property, Probate, & Trust Law Proceedings* 18 (1963).

Wright, "Airspace Utilization on Highway Rights of Way," 55 *Iowa L. Rev.* 761 (1970).

———, R., *Law of Air Space.* 1968.

Index

Index

Index